Crossing the Boundaries

Crossing the Boundaries

Christian Piety and the Arts
in Italian Medieval and
Renaissance Confraternities

edited by

Konrad Eisenbichler

Early Drama, Art, and Music
Monograph Series, 15

Medieval Institute Publications

WESTERN MICHIGAN UNIVERSITY

Kalamazoo, Michigan
1991

Cover design by Linda K. Judy

ISBN 0-918720-45-1 (casebound)
ISBN 0-918720-46-x (paperback)

Contents

Illustrations

1. Andrea di Buonaiuto, *Pentecost.*

2. *Laudario della Compagnia dello Spirito Sancto.*

3. *La festa del Miracolo dello Spirito Santo* (Florence, c.1490).

4. Sodoma, *St. Sebastian.*

5. Sodoma, *Madonna and Child with Saints and Confraternity Members.*

6. Attributed to Battista di Biagio Sanguigni. *Libro dei Capitoli della Confraternita di S. Maria della Pietà.*

7. Attributed to Battista di Biagio Sanguigni. *Libro dei Capitoli della Confraternita di S. Maria della Pietà.*

8. Attributed to Antonio di Filippo di Ventura, *S. Girolamo penitente entro medaglione.*

9. Domenico Fantini and Liborio Bracci, *Scanni da compagnia.* Florence, Oratorio di S. Girolamo e S. Francesco Poverino già di S. Filippo Benizi.

10. Emblem of the Confraternite del Bigallo e della Misericordia.

11. Santi Buglioni, *Annunciazione.*

12. Florentine (anon.), *Scatola per votazioni.*

13. Church and Oratory of San Giovanni Decollato, Rome.

14. Interior of the Oratory of San Giovanni Decollato (view towards the entrance).

15. Interior of the Church of San Giovanni Decollato (view towards the altar).

16. *Tavola* with Decollation of St. John the Baptist and Crucifixion.

17. A *confratello* of the Arciconfraternita di San Giovanni Decollato dressed in black robe and hood and holding a *tavola* and lantern.

18. Annibale Carracci, *A Hanging*.

19. Battista Franco, *Arrest of St. John the Baptist*. Rome.

20. Altar wall of the Oratory of San Giovanni Decollato, Rome.

21. Jacopino del Conte, *Descent from the Cross*.

22. Giorgio Vasari, *Decollation of St. John the Baptist*.

23. Battista Naldini, *Martyrdom of St. John the Evangelist*.

24. Cappella del Crocefisso. San Giovanni Decollato, Rome.

25. Jacopo Zucchi, *Crucifixion*.

26. Jacopo Zucchi, *Crucifixion*.

27. *Crucifixion*. Sacristy, San Giovanni Decollato, Rome.

28. Nicolò Circignani, *Martyrdom of St. John the Evangelist*.

Introduction

Konrad Eisenbichler

Confraternities hold a special place in the growth and development of theater in late medieval and Renaissance Italy. They commissioned plays, staged them, performed in them, and took advantage of their impact on the audience either to advertise their activities or to educate their members. Theater, like music or the visual arts, was not anathema to the devout brothers who on a more regular basis also met to praise God, chastise the flesh, and perform the seven corporal works of mercy. It is not surprising, therefore, that the combination of devotional ritual, confraternal piety, and group entertainment blended into a living drama that was to its performers the natural expression of a Christian life. The confraternity was the context within which such diverse activities could be brought together.

From the late Middle Ages through the Renaissance and up to the end of the eighteenth century every Italian city and many towns could boast a rich and varied array of confraternities. In 1400, Florence, for example, had fifty-two confraternities; by the time of the Council of Florence (1439), there were more than a hundred; by the end of that century the number had risen to 156.[1] In some regions of Italy confraternities continue to exist and prosper to this day. In Florence and most of Tuscany, for example, the Archconfraternity of the Misericordia is the preeminent ambulance and first aid service, a function it has fulfilled for more than seven hundred years. In Puglia confraternities are still an important aspect of local urban life.[2]

Scholars in increasing numbers are now turning to the study of Italy's confraternities. They are aware, as Ronald F. E. Weissman

1

has said elsewhere, that "beyond being a place to pray, and an institution providing charitable distributions and other services to the community, the confraternity, like the family and guild, was one of the principal forms of sociability available to males in premodern European society."[3] Nearly all males belonged at some point in their lives to a confraternity. Some belonged to several, others to only one. Some participated sporadically in confraternities, others devoted their entire lives to them. Few if any males lived their lives without some contact with a confraternity or without ever needing to draw upon the confraternity's invaluable services. For the child in need of instruction in the basic elements of Christian life and devotion or for the adult in need of spiritual, physical, or financial assistance, for the solid citizen who had led a virtuous life and now lay on his death-bed, or the condemned criminal about to climb on the scaffold to suffer his sentence, for the joyous Christian singing the praises of the Lord or the somber flagellant chastising his own flesh for mankind's sins the confraternity was there to provide a service and a context. The civic fiber of Florence, Rome, Venice, Perugia, Milan, or any other Italian city in late medieval and early modern times cannot be understood without some knowledge of the confraternities that functioned and served within it.

Strangely enough, however, past scholarship has tended to overlook the role played by confraternities not only in the society in which they flourished but also in the arts, thought, and letters of that society. A great variety of visual art was commissioned to decorate oratories, meeting rooms, and objects owned by confraternities. Some of the art is unquestionably mediocre, but some, on the other hand, is without a doubt important. As Barbara Wisch points out in her article in this collection, some confraternity art could set precedents—as was the case for the oratory of the Confraternity of the Gonfalone at Rome and its iconography of the Flagellation of Christ (1573). Jean S. Weisz examines the rituals and processions of a comforting confraternity—S. Giovanni Decollato at Rome—and underlines the close relationship between the decorative program of its chapel and the charity that it extended to the condemned. Her analysis of the confraternity's activities, the motivations that may

have inspired some of its members, and the frescoes that illustrated the confraternity's activities clearly points to the heightened emotionalism in both art and life within the context of Counter-Reformational piety and devotion. Ellen Schiferl's detailed analysis of contracts signed between confraternities and artists brings to light valuable information on the mechanics of confraternity patronage and on the presence of group consciousness in confraternities' commissions. Her macroscopic model is a contribution to our understanding of how confraternities advanced and advertised their corporate identity through the representation of their self-image in the art that they commissioned.

The minor arts are examined by Ludovica Sebregondi, whose study of the ephemera that were part of a confraternity's daily life illuminates an important but obscure range of objects. It clarifies the form and use of a number of objects from books to ballot boxes, from habits to halls, from choir stalls to sleeping mats. By their very nature such items were discarded as soon as they became worn out or had ceased to fulfill their function. As the shape, the use, or even the names of these objects fell from current usage they became archaic, forgotten. For the first time in English, an array of such objects is identified, labelled, and described. In the process a technical vocabulary is created that allows English-speaking scholars to discuss them in their own language. The minor arts and the works of *artigianato locale* found in confraternities suddenly reveal their relevance and importance.

Confraternities were important for the development of music as well. In 1430 the youths' confraternity of the Archangel Raphael at Florence gained the prominent patronage of Pope Eugenius IV when it performed a *rappresentazione* on the Nativity. At the end of the sixteenth century, the confraternity became well known for its musical performances and experimentation, so much so that its services attracted the attention and attendance of the Florentine nobility and upper clergy. Evening Vespers on 31 January 1590, for example, were attended by the Grand Duchess of Tuscany, Christine of Lorraine, who was so impressed by the musical abilities and the devotional spirit of the brothers that she decided, there and then, to

enroll her new-born son, Cosimo II de' Medici, in the confraternity. Edmond Strainchamps examines the confraternity of the Archangel Raphael and its connections with Marco da Gagliano, *Maestro di Cappella* at the Medici court and one of the more important Italian musicians at the beginning of the seventeenth century. The madrigals composed by Gagliano for the confraternity's service in memory of Jacopo Corsi—a member of the Florentine *camerata* that played a crucial role in the development of early opera as well as a person with close personal ties to the confraternity of the Archangel Raphael—are among the few extant examples of occasional music composed for Florentine confraternities. Jonathan Glixon's contribution to music and the confraternities brings to our attention a previously unknown manuscript that sheds light on the manner in which music was part of the rituals and processions of the Venetian Scuole Grandi. These scholars illustrate not only how integral music was to confraternal life and how it developed according to the confraternity's needs, but also how confraternities themselves were at the forefront of musical developments and practices.

Some years ago Paul Oskar Kristeller pointed out the close parallels between Ficino's Platonic Academy and Florentine confraternities,[4] while Cesare Vasoli underlined the importance of lay sermons recited within confraternity walls.[5] In this volume Olga Pugliese argues that there is a common philosophical ground that links the rules and guidelines of the constitution of the confraternity of the Buonomini di San Martino at Florence with the advice given in such Renaissance "how-to" books as Machiavelli's *The Prince*, Guicciardini's *Ricordi*, or Castiglione's *The Courtier*. Nicholas Terpstra's contribution examines the nature of confraternal piety as it applies to death and points both to the significance of confraternities as vehicles of lay piety and to the continuity of confraternal and mendicant piety in late Renaissance Italy. Thus both the earthly, pragmatic thought of Renaissance materialism and the heaven-bound, idealistic aspirations of medieval and Renaissance spirituality find their echoes in confraternity statutes and practices.

Although scholars since Alessandro D'Ancona's time have been aware of the importance of confraternities in the field of drama and theater,[6] few have examined closely the confraternities' archival

documents for detailed information on their theatrical practices. Recently scholars such as Cyrilla Barr, Kathleen Falvey, and Nerida Newbigin have expanded and opened the field to suggest far-reaching possibilities, as their contributions to this volume clearly attest. Barr examines the Marian laments of Holy Week *laude* recited in flagellant confraternities and points to the transition that gradually took place between the *lauda lirica* and the *lauda drammatica* within the structure of *disciplinati* services. Her presentation thus deals with the very beginnings of religious drama, with that nebulous area of devotion and play in which it is difficult to extract the expression of religious piety from the undertones of entertainment (or vice versa).

The blending of life and theater, of fact and fiction assumes new meaning in Kathleen Falvey's study of the comforting rituals and the dramatic entertainments of the *conforterie*, those confraternities which devoted themselves to the charitable work of comforting the condemned and burying their bodies. A close analysis of an official comforting manual for the penitential confraternity of Santa Maria della Morte at Bologna, an awareness of the "props" used by the brothers in comforting the condemned (the *tavolette*), a re-examination of words and actions from a well-known Passion Play (the Passion of Revello), the personal recollections of a saint (St. Catherine of Siena) and of a layman (Luca della Robbia) who assisted two condemned men at their execution lead to a re-examination of the boundaries between Christian devotion (exemplified by participation in a work of mercy) and popular entertainment (the staging of Passion or martyrdom plays). When does the executioner's *mannaia* cease to be an instrument of justice and become a stage prop? The movement from Christian piety to Christian education through the performance in costume of a public act (comforting or entertaining) is a gray area that needs further study and consideration.

The semantic ambivalence of the word *festa*, where feasting (i.e., eating) is an integral part of the feast (i.e., celebration), leads Nerida Newbigin into an examination of celebratory eating in two Florentine confraternities, Sant'Agnese and Spirito Santo, each renowned in fifteenth-century Florence for the plays of the Ascension and Pentecost which they were accustomed to present. The connec-

tion between communal eating and the sacrament of the Eucharist had already been recognized in the decoration of Florentine refectory walls with scenes of the Last Supper—within the precinct of the monastery, art and life regularly gazed upon each other at mealtime. Within confraternity walls special *colazioni* marked the yearly routine of prayers and commemorations and entered into the preparations for—and performance of—the confraternity's plays. After an examination of confraternal records and the scripts for plays performed by confraternities, Newbigin reveals that actors, audience, and even the workers who built the stage set participated in festive meals offered by the confraternity. And the conclusion is that the two confraternities of Sant'Agnese and Spirito Santo saw their festive meals as "joyful celebrations, and they incorporated them into their iconographic repertoire"; thus "in their own modest way the confraternities [contributed] to a long tradition of convivial spectacle or feasts that make spectacles of themselves."

This collection of papers illustrates how that thin line between reality and fiction—between devotion to God or the performance of charitable acts of mercy, the decoration of confraternity chapels or the staging of plays—is often crossed in that very real *giuoco delle parti* (to take a phrase from Pirandello) that was Italian Renaissance society. "Things are not as they appear to be" is a thought to be kept in mind when dealing with the activities of early modern confraternities. Whether it be participation in a confraternal *colazione* or the staging of a festive dinner, whether it be the comforting of a condemned man or the representation in painting or on stage of a martyr's death, whether it be the musical celebration of the Divine Office or the virtuosity of musical composition and performance, confraternities crossed the boundaries between art and life, between charity and self-interest, between worship and spectacle. And in this crossing over they reflected the ambivalence and the richness that were operative in the ritual and festive life of early modern society.

The twelve articles in this volume stem from a conference which my colleague William R. Bowen (Faculty of Music) and I organized in April 1989 at Victoria College (University of Toronto). The conference, the first on confraternities to be held in North

America,[7] sought to be international and interdisciplinary both in its subject matter and in its participants. Twenty-four speakers from Australia, Europe, and North America presented the fruit of their research. They spoke not only of Italian but also of French, Belgian, Netherlandish, German, English, and Spanish confraternities. Their research and their discoveries aroused great enthusiasm and respect for the work already accomplished as well as hearty encouragement for the continuation of such work. At the end of the conference a number of participants joined together to found the Society for Confraternity Studies and to launch a newsletter, *Confraternitas*. Both the society and the newsletter are to be a link among scholars working on confraternities from the viewpoints of different and differing disciplines.

The first collection of proceedings from the Toronto conference was edited by William R. Bowen and published in 1989 as a special issue of the journal *Renaissance and Reformation* (Vol. 25, No. 1, Spring 1989). The papers thus gathered under the conference title of *Ritual and Recreation in Renaissance Confraternities* are: "The German *Bruderschaften* as Producers of Late Medieval Vernacular Religious Drama" by Ralph Blasting; "Confraternities and Lay Leadership in Sixteenth-Century Liège" by D. Henry Dieterich; "Midsummer in Salisbury: The Tailors' Guild and Confraternity 1444-1642" by Audrey Douglas; "Rituals of Solidarity in Castilian Confraternities" by Maureen Flynn; "English Guilds and Municipal Authority" by Alexandra F. Johnston; "Les confréries et l'iconographie populaire des sept péchés capitaux" by Joanne S. Norman; "Master by Any Other Means" by Betsey B. Price; "Cornelis Buys the Elder's *Seven Works of Mercy*: An Exemplar of Confraternal Art from Early Sixteenth-Century Northern Europe" by Perri Lee Roberts; and "Music and Merchants: The *Laudesi* Companies in Early Renaissance Florence" by Blake Wilson.

The present volume, containing presentations dealing solely with Italian confraternities, is thus the second collection to come from the Toronto conference. Except for the presentations by Marsha Groves ("Devotional Activities in the Sienese Confraternity of Santa Maria degli Angioli in the Early Fourteenth Century"), John Henderson ("Penitential Confraternities in Renaissance Florence"),

and Barbara Sella ("The *Scuola delle Quattro Marie*: Charity in Fifteenth-Century Milan") which will be published elsewhere by their authors, the conference's bill of fare has now been laid on the larger table of published scholarship available to all who are interested in medieval and Renaissance confraternities.

The Toronto conference saw the happy union of personal research and free-wheeling collegial discussion. In preparing the results of this meeting for publication, I have allowed differences and disagreements between the presentations to remain as an indication of the ongoing nature of our discussions. The diversity present in these articles reflects the multi-faceted reality of confraternity studies and the vitality of the different interpretive methods. For these reasons I have resisted the temptation to structure the volume along any other lines than by alphabetical order by author because the contributions, though a reflections of common interest, are also integrally independent of one another. And this diversity is a contribution in its own right.

I wish to express my sincere appreciation to all those whose generous financial assistance made possible the organization of the conference and, ultimately, the publication of this volume: the Toronto Renaissance and Reformation Colloquium, the Centre for Reformation and Renaissance Studies (Germaine Warkentin, Director), Victoria University (Eva Kushner, President), the Department of Italian Studies at the University of Toronto (Massimo Ciavolella, Chairman), the Faculty of Arts and Science at the University of Toronto (Robin Armstrong, Dean), the Faculty of Music at the University of Toronto (Carl Morey, Dean), the Italian Cultural Institute in Toronto (Francesca Valente, Director), the Ministero degli Affari Esteri (Government of Italy), and the Social Sciences and Humanities Research Council of Canada. I would also like to thank Medieval Institute Publications, especially Clifford Davidson and his graduate-student assistant Earl Hawley, for their enthusiastic support, their understanding, and their invaluable help in seeing this book through the press. Lastly, I wish to express my personal gratitude to William R. Bowen, whose patience, cheerfulness, and hard

work contributed greatly to the success of the conference and the initiatives that emanated from it. *Grazie a tutti.*

Notes

1. Massimo D. Papi lists the confraternities present in 1400 and gives a brief description of each: "Per un censimento delle fonti relative alle confraternite laiche fiorentine: primi risultati," in *Da Dante a Cosimo I: ricerche di storia religiosa e culturale toscana nei secoli XIV-XVI*, ed. Domenico Maselli (Pistoia: Libreria Editrice Tellini, 1976), pp. 92-121. John S. Henderson lists the confraternities in 1499 and gives some basic facts about each in Appendix I, "Confraternities Meeting in Florence, 1240-1499 (provisional list)," in his unpublished Ph.D. dissertation ("Piety and Charity in Late Medieval Florence. Religious Confraternities from the Middle of the Thirteenth Century to the Late Fifteenth Century" [Univ. of London, 1983], pp. 393-432).

2. As evidenced by the research, conferences, and publications on Pugliese confraternities fostered by the Centro Ricerche di Storia Religiosa in Puglia, under the aegis of the Università di Bari.

3. Ronald F. E. Weissman, *Ritual Brotherhood in Renaissance Florence* (New York: Academic Press, 1982), p. ix.

4. Paul O. Kristeller, "Lay Religious Tradition and Florentine Platonism," *Studies in Renaissance Thought and Letters* (1956; rpt. Rome: Edizioni di Storia e Letteratura, 1984), pp. 99-112.

5. Cesare Vasoli, "Giovanni Nesi tra Donato Acciaiuoli e Girolamo Savonarola: Testi editi e inediti," *Umanesimo e Teologia tra '400 e '500, Memorie Domenicane*, n.s. 4 (1973), 103-79. See also Olga Zorzi Pugliese, "Two Sermons by Giovanni Nesi and the Language of Spirituality in Late Fifteenth-Century Florence," *Bibliothèque d'Humanisme et Renaissance*, 42 (1980), 641-56. See also my edition of Giovan Maria Cecchi, *Ragionamenti spirituali* (Ottawa: Dovehouse, 1986), for a collection of lay sermons written to be recited in a youths' confraternity, probably that of San Giovanni Evangelista, in Florence.

6. See Alessandro D'Ancona, *Origini del teatro in Italia* (Torino: Ermanno Loescher, 1891), 3 vols.

7. Two similar previous conferences, though not strictly on confraternities because they focused on the flagellant movement in general, were held some twenty and thirty years ago, in Perugia, Italy; see the two published volumes of proceedings: *Il movimento dei disciplinati nel settimo centenario del suo inizio, 1260* (Perugia: Deputazione di Storia Patria per l'Umbria, 1962), and *Risultati e prospettive della ricerca sul movimento dei disciplinati* (Perugia: Deputazione di Storia Patria per l'Umbria, 1972). The first conference, held in 1960, gave birth to the Centro Documentazione sul Movimento dei Disciplinati at Perugia, which then organized the second conference in 1969.

From *Devozione* to *Rappresentazione*:
Dramatic Elements
in the Holy Week *Laude* of Assisi

Cyrilla Barr

Plaints of the Madonna are common in medieval literature, both in the Latin of liturgical drama and later in the vernacular as well.[1] Although these Marian laments are a rich part of the development of the *planctus*, it is important to recognize that they are a later achievement of a literary tradition that was already well established in both classical and Byzantine literature. The tradition, continuing to flourish in the later Middle Ages, resulted in a proliferation of plaints, both sacred and secular, in most of the European vernaculars.[2] The Italian language is particularly rich in Marian laments, many of which are actually *laude* that not only would have been sung but also in some instances were dramatized. It is important at the outset to note the role of the Mendicant Friars whose use of *laude* and popular sermons in their evangelization greatly facilitated the dissemination of this poetry. The numerous *lauda* manuscripts belonging to various fourteenth-century confraternities of flagellants—usually under the direction of the Mendicant Orders—are a rich repository of lamentations that contain mutations demonstrating the gradual transition from *lauda lirica* (usually short hymns of praise) to *lauda drammatica* which might vary from simple dialogue to more elaborate and complex dramas with music performed for the public. This study will emphasize the function of these dramatic lamentation *laude* within the quasi-liturgical religious exercises of the *disciplinati* and will examine evidences of Franciscan influence upon one company in particular.

The *lauda* as a genre developed along lines sharply differentiated not only by geography, function, and time but also by the mark-

edly different orientation of the *laudesi* and *disciplinati*, the two main types of confraternity responsible for the dissemination of these popular vernacular hymns. While Tuscan *laude* of the thirteenth and early fourteenth centuries tend to be lyrical in style, Umbrian examples of the same period are more often dramatic and closely associated with the physical act of self-flagellation.

There is considerable evidence that by the fifteenth century both types of confraternity were deeply involved in theatrical activities. Examples contained in the great playbooks of *disciplinati* from Perugia and Orvieto[3] suggest that by the Quattrocento these major centers were presenting fully theatricalized productions. However, Florentine companies of *laudesi* of the same period were also much occupied with dramatizations in the form of *rappresentazioni*, plays in which the *lauda* figured prominently. These were often very colorful productions mounted in the churches of the city. The most elaborate and best chronicled are those in the conventual parishes of the Oltrarno: the Pentecost Play in Santo Spirito, the Ascension Play in Santa Maria del Carmine, and the Annunciation Play in San Felice in Piazza.[4]

Although a discussion of the Florentine plays is by definition beyond the scope of this brief study it is important to remember, as a point of comparison, that the representations mounted in the churches mentioned above were elaborate, involving complex machinery, lighting devices, and other contrivances aimed at achieving special effects, "cose da fare stupire." Often these were designed by such eminent artists as Filippo Brunelleschi and Masolino da Panicale, while the texts of the plays were frequently the work of known authors such as Feo Belcari. Although these representations were certainly not devoid of sincere religious motivation, there is evidence of a strong element of Medici propaganda, especially in those instances when the plays became a vehicle to flaunt Florence's magnificence before visiting foreign dignitaries.[5]

In contrast, the early dramatizations of Umbrian *disciplinati* origin seem to have grown gradually and quite naturally out of actual penitential prayer services of a popular quasi-liturgical nature. From such modest beginnings as Holy Week observances—them-

selves inchoate dramas—grew the later full-fledged plays preserved
in the great Perugian playbooks which often indicate large numbers
of characters and choruses and in some instances seem to require
fairly elaborate stage business. However, with the exception of
surviving inventories of costumes and properties, the production-
related aspects of these dramas are not as thoroughly documented in
confraternity financial records as are those of their Florentine coun-
terparts.[6] Although both of these groups are currently the subject of
serious study, relatively little attention has been paid to the impor-
tant activities of the minor Umbrian centers which are the repository
of early incipient dramatic *laude*, many of which are important in
the development of the *planctus Mariae*. Of these smaller Umbrian
centers Assisi is the most significant, and the Confraternity of Santo
Stefano is the most richly documented.[7]

The cathedral of San Rufino in Assisi possesses nearly a hun-
dred manuscripts of this company alone—documents that date from
its primitive rule to as late as 1869.[8] Apparently its Latin statutes of
1327 became the prototype for several other confraternities in Assi-
si, and Gubbio translated them into the vernacular almost verbatim.[9]
However, since statutes were revised only periodically, a much more
accurate record of the history of the confraternity and the role of
music in its activities must be sought in other types of documents,
which require to be examined together. Rules prescribe, Rituals and
Ordines embellish with their rubrics, *laude* supply some of the texts,
and inventories provide the physical trappings.

Of particular importance to this study are the Rule of 1327,[10]
two early fourteenth-century *Ordines* (Ad 20 and 21),[11] and various
inventories that list among other things books for singing *laude*.[12]
Of the *laudari* today identified as once belonging to Santo Stefano,
the oldest and most important is MS. 705 (formerly of the Biblio-
teca Comunale, now at Sacro Convento) popularly known as the
Codex Illuminati.[13] The *Ordines* in particular often provide a more
detailed elaboration of ceremonial that is otherwise only prescribed
in the Rule. First among these is the *devozione*—the exercise con-
ducted twice weekly in the oratory and in the dark, during which the
brothers scourged their bare backs while singing *laude*. The Rule di-

rects the brothers to gather in the oratory, and then "when the prior rings the bell as a signal to take the discipline, all genuflect saying together the Our Father. And then at another sign they all rise and go to dress themselves again."[14] A more detailed description of the same activity, including now the mention of singing, is provided by the *Ordines*. Once again the sound of the bell announces the *devozione*, and

> immediately they rise and sing *laude* in the vernacular. He who sings them moves the hearts of the brothers to tears more than words move the mind.
>
> The *laude* are performed in this manner: On Fridays or other days when the Passion is commemorated . . . *laude* in honor of Our Savior Jesus and his most sorrowful Mother are sung. But on Sundays or feast days the *lauda* of the day or of the feast is sung. If the discipline is to be taken in the habit all of the verses are sung and at the end of each stanza they scourge themselves. But when the cantor sings they rise, and at the sound of the bell or some other signal they cease the discipline. And thus it proceeds until the aforesaid *lauda* is completed by the singer.[15]

From yet a third source comes an even clearer idea of the actual context into which this *devozione* was incorporated. Two folios within the *Codex Illuminati* itself outline this exercise as a complex of liturgical prayers beginning with words borrowed from the Divine Office, *Adiutorium nostrum in nomine domini*, followed by a psalm and the exhortation *Apprendite disciplinam*. The devotion continues with an *Oremus*, a blessing, and the Our Father, and closes with "a devout *lauda*."[16] Clearly this is a popular office which combines elements of the Divine Office along with the discipline and the singing of vernacular *laude*. Moreover the statement that "on Sundays or feast days the *lauda* of the day or of the feast is sung" indicates a sense of ritual arrangement over a broad expanse of time as in the liturgical cycle of the Church year. That the company considered this hybrid service a kind of office is reflected in the rubric at the end of the *Ordo* after the Gregorian music for the Requiem Mass: *Incipit offitium sancte discipline domini nostri iesu christi*. Follow-

ing the *Tu autem domine miserere nobis* is the annotation *Deinde dicatur lauda.*[17]

From a comparison of the documents described here it is possible to ascertain a dual orientation within the life of the community. While the discipline taken in private was clearly an exercise intended to contribute to the personal sanctification of the members themselves, the Good Friday *Rappresentazione* suggested in the statutes was meant for the edification of the public. Although the first was confined to the privacy of the oratory, this representation was clearly considered a public and apostolic work. The distinction between the two is further reflected in the Rule which describes the very private *devozione* in Chapter IV under the heading *De modo interius conversandi*, while the more dramatic rendering of the bitter laments of the Virgin was performed *cum reverentia populo representent*—that is, publicly and outside of the oratory. Directives for this are contained in Chapter VIII of the Rule under the designation *De processionibus*. A comparative study of the Rule and the *Ordo* thus elucidates the growing distinction between the two modes of devotion.

These differences become even more clearly articulated in that portion of the statutes concerning Holy Week observances. The Rule required that on the eve of Holy Thursday the *fratelli* should gather in the oratory to keep a solemn vigil until the morning of Good Friday. In the course of the evening the discipline was taken in a "most devout manner," and the prior washed the feet of the brothers in a re-enactment of Christ's actions at the Last Supper. This *mandato* was patterned after the ritual washing of the feet in the *mandatum* of the Mass for that day. The Rule admonishes the brothers thus:

> to celebrate with devout reverence and profound humility the example
> of the Divine Majesty who humbled himself to wash the feet of fisher-
> men and servants, thus showing us an example of our Lord and Master.
> So we, with the discipline and in charity and humility of a servant,
> serve one another thus by the greater washing the feet of the lowlier.
> The prior begins with the sub-prior and the other officials, down to the
> lowliest and poorest, thus providing a *mandatum* for those who are
> gathered in our place on that most holy night in expiation, weeping
> tears blessed by God.[18]

The *Codex Illuminati*, in fact, contains a *lauda* for the occasion which bears the rubric *La lauda per la dì de Jovedi sancto*.[19] The *mandato* would have taken until the early hours of the morning, at which time the Rule provided that those brothers who for some legitimate reason could not remain through the night in prayer might be permitted to return to their homes. However, they were strictly admonished to return to the oratory at the hour of Prime to partici-pate in the Good Friday portion of the services which included the reading of the Passion and the singing of the "sad songs of Christ."

> At the hour of Prime all of those wearing the habit go to the church of Blessed Francis and the Blessed Virgin Mary of the Angels [the *Porziuncula*] to sing tearful *laude*, sad songs, and bitter laments of the Blessed Virgin Mary bereft of her Son. *These are enacted with rever-ence for the people who understand above all more with tears than with words* [italics mine]. After singing the *laude* all must return to our place.[20]

The kind of vernacular representation suggested here in the statutes of 1327 undoubtedly involves one of the earliest references to such practices. And the "tearful *laude*, sad songs, and bitter la-ments" to which the Rule makes reference may in fact be found in the *Codex Illuminati*. The manuscript is a small one, but half of its fourteen *laude* are in honor of the Passion of Christ and the sorrows of Mary.[21] Together they comprise some of the earliest evidences of the transformation of the *lauda lirica* into *lauda drammatica* and at the same time exemplify an important phase in the developing tradi-tion of the *planctus*. In the course of these *lauda* texts, both primary and secondary characters are added to the drama, and the narrative strophe is altered to include dialogue, thus directing the *lauda* on a course that would eventually culminate in its later theatricalization.

Progress in development of the dramatic lamentation may be divided into phases, the first of which is the lament in narrative monologue. This is exemplified by the first *lauda* of the codex ("Voie ke al mio figliuol servete," fols. 2r-3r). The text, consisting of fifteen stanzas of eight lines each, is narrated by Mary to the listener in the person of her companions at the foot of the Cross who clearly

represent the assembled *confratelli*. The language is full of pathos as the sorrowful mother begins with an invitation to the company to join in her lament. "You who serve my son, . . . out of your love for him, hear me, sorrowful Mary" ("Voie ke al mio figluol servete . . . per lo suo amor m'entendete la dolorosa Maria").

The *lauda* proceeds immediately to the scene before Annas and Caiaphas where Mary relates that the first injury that her delicate son sustained was the spitting in his face ("La prima eniuria ke sostenne lo mio filglo dilicato . . . e ella facia gl ave sputate"). Helpless, he was stripped naked ("Nudo, nudo lo spoglaro lo mio filglo sença aito") and scourged mercilessly ("Tanto tanto el flagellaro tutto lo fiero sanguenare"). Thus the Passion story unfolds as we view it through the eyes of the sorrowful mother who, in the penultimate stanza, exhorts the spectator to consider the salutary effect of reflection on this sad spectacle ("Pensate del mio filgliol morto e della sua dolente matre . . . questa e summa medicina ke l anema en ben fare affina").

The next phase of development is represented in the second *lauda* of the manuscript (fols. 3r-4v) in which the ancient monologue form expands into simple dialogue with another character, an interlocutor usually designated in the rubrics as *homo devotus* and addressed within the *lauda* itself as *fratello* or *sorella*. Early examples of this stage usually assign only a very small portion of the text to *homo devotus* while Mary continues to sing the major portion of the *lauda*. Once again the poem begins with an invitation to the listener to join the sorrowful mother and to go "weeping night and day" ("vay piangendo nocte e dia"). Mary responds gratefully and commences to reflect on the joys of her life with her son—joys which she contrasts now with the sad spectacle of his torments—and ends with yet another exhortation to the faithful to stay by the foot of the cross and never to depart from it ("Dal pie del crocefisso non te partire mai da esso").

The third *lauda* ("O descipogl della croce," fols. 4v-6v) is likewise a plaint of the Virgin in which the role of the interlocutor is now assumed by the holy women, who are identified in the rubrics as "devote di Maria." The poem is interwoven with admonitions

clearly directed to the assembled members of the company ("et tu filgluol desciplinato") as well as with references to that ever-present instrument which insured forgiveness and eternal bliss: *quista disciplina*. Near the end of the *lauda* is a stanza in which Mary describes the Deposition from the Cross, praising the kindness of Joseph of Arimathea and Nicodemus who place the body of Christ in her arms, thus effecting the *pietà* posture. The text ends in this instance with Mary's expression of gratitude to the brothers for their efforts to compensate for the sufferings of her son.

The third progressive stage is that of expanded dialogue which is characterized by the addition not only of the *sorores* but also of Magdalene, Maria Jacobi, and John. The holy women sometimes speak in chorus and sometimes solo. An excellent example of this development is the text, "Levate gl ochi e resguardate," which is significant for its references to what appear to be costumes and movements (to be discussed below).

In the preceding examples the characters seldom have more than small parts, and their speeches are usually directed to the spectator, most often designated as the *fratelli*. It is a mark of significant development, therefore, when the personages introduced into the lament begin to be assigned longer speeches and still more when they commence to dialogue with each other or to apostrophize the absent. This is exemplified in the last *lauda* of the manuscript ("O alto Patre onipotente," fols. 17ᵛ-18ᵛ), which bears the rubric "This *lauda* is very devout and is sung in memory of the Passion of Christ. The sisters of Mary begin."

Here the holy women as usual admonish the spectator to give attention and heed the mournful lament of Mary bereft of her son. In the course of what follows, Mary reproaches the Jews and recounts the torments of Christ. The momentum of the drama increases as the dialogue becomes more direct, alternately accusatory and pleading. She addresses Pilate: "Have mercy, Pilate, and crucify me with him" ("chiamate merce, Pilato fa crocefigere me con esso"). The text proceeds as usual through the familiar events of the Passion, concluding with the scene in which the soldier pierces the side of Christ with a lance. The codex thus ends on this dramatic note.

Some of these same texts are subjected to greater development in the *Frondini Codex* (MS. Rn 478), also from Assisi and once erroneously thought to belong to Santo Stefano.[22] And they are even more greatly expanded in the versions from Perugia. But one *Illuminati* text in particular deserves special study here for its inherent dramatic qualities; "Levate gl ochi e resguardate" (fols. 10[v] and 13[r]-15[r]; concerning pagination, see note 21), which is found in a number of manuscripts of the period and which is preceded by the rubric "This *lauda* is sung in memory of the Passion." The *lauda* begins:

HOC DEVOTI

> Levate gl ochi e resguardate
> morto e Cristo ogi per nui
> le mano e i pie en croce a chiavate
> aperto el lato o triste nui
> piagnamo et feciamo lamento
> e nariamo del suo tormento

(Lift your eyes and see, Christ has died for us today. His hands and feet are nailed to the cross. His side is opened. Oh, sad are we! Let us weep and lament and tell of his torments)

The next stanza is Mary's first speech in which she asks the holy women to bring her a black mantle so that she may clothe herself with this symbol of widowhood.

MARIA

> O sorelle della scura
> or me daite uno manto nero
> a quilla che giamai non cura
> ne bei drappo ne buon velo
> puoi ch io so si abandonata
> e del mio filglo vedovata

(O sorrowful sisters, now give a black mantle to her who cared neither for beautiful silk nor fine veil, for I am abandoned, and widowed by my son)

The *sorelle* respond in the third stanza as they fulfill her request and present Mary with the black mantle.

LE SORE DI MARIA
O di pien de vedovanza
pien de pena e de dolore
mort e la nostra speranza
Christo nostro salvadore
ciascun facia novo pianto
e a Maria date esto manto

(O day of widowhood, filled with pain and sorrow. Dead is our hope, Christ, our Savior. Let us each make a new lament and give to Mary this mantle)

Specific mention here of the black mantle of the Virgin as well as of the act of the Holy Women in bringing it to her indicates the use of costume and suggests some movement and gesture.

However, the documentation in the inventories actually provides solid proof for the use of costumes since these contain listings of clothing and properties. Entries from inventories dating from 1412 to 1442 thus provide reference to the Virgin's costume, the wrapping of the crucifix, and a few simple properties needed for the presentation.

1412 Also a book for saying the little office
Also two books of *laude*
Also one black mantle for our Lady[23]
1427 one black mantle for our Lady and a black covering for the crucifix
1429 Also a black cover and black wrappings for the crucifix
Also a black mantle for our Lady
1442 Also a locked chest inside of which is the black mantle for the madonna[24]

A longer version of the text *Levate gl ochi* is contained in the only surviving *laudario* from Gubbio, MS. Landau Finaly 39 (Eugu-

bino), now in the Biblioteca Nationale Centrale, Florence.[25] The Rule of the *disciplinati* of Gubbio, which was patterned on that of Santo Stefano, provided for the *mandatum* and the *rappresentazione* for the people on Good Friday, and there is considerable evidence in the various inventories of the company that on that solemn occasion the Passion *lauda* was dramatized in costume. Confraternity records of the period testify to the vitality of *lauda* singing among the *disciplinati*, and inventories record lists of properties and costumes belonging to them. The oldest surviving inventory, dated 1428, identifies it as "the new inventory," suggesting an already well established practice.[26] The text of *Levate gl occhi* in the Gubbian version—though it lacks rubrics identifying the characters' speeches—is a much more complete rendition of the narrative, containing forty-three strophes as compared to the twenty-eight in the Illuminati manuscript. (Even when *laude* 7 and 11 are combined, the Assisi version totals only thirty-one strophes.)

Admittedly the items in the inventories from Assisi are fewer in number and less diverse than those of the major Perugian companies as preserved in the Archivio Braccio Fortebracci.[27] There is, however, evidence of some consorting of the *disciplinati* of Santo Stefano with one of the Perugian companies already quite early in the fourteenth century. Administrative records contain a payment between Christmas 1338 and February 1339 "for those who came from Perugia to make the representation of the Lord's Judgment."[28] This is almost certainly a reference to the great Judgment Scene from the St. Andrew Advent Play contained in PEc 955.[29]

Documents such as these, though often ambiguous, nevertheless confirm that the Santo Stefano company was already involved in some type of dramatization well before the middle of the fourteenth century. It is essential, however, to consider the function and the frequency of these dramatizations as well as to attempt to determine the degree to which they actually were or were not adapted for theatrical performance.

It is evident from the Rule that as significant as this "representation for the people" was, it occurred only once a year, on Good Friday, and although inventories exist throughout the next century

they continue to repeat the same few items without the multiplication of furnishing and clothing that would suggest a proliferation of theatrical activity. Most importantly, the weight of the evidence contained in the documents gives much more importance to the incorporation of these dramatic *laude* into what might be called the marginal liturgy of the Santo Stefano Company. The very dependence of these private popular offices upon liturgical models suggests a close association of the company with its ecclesiastical guardians. This association may indeed be a key to a more accurate assessment of the true nature of this repertory of early dramatic *laude* in Assisi, for the guardians were from the beginning Franciscans, whose spirituality was known for its emphasis upon the humanity of Christ and in particular the role of Mary in the redemption.

But is there an exemplar for these emotional Passion *laude*? Certainly all of the characters in the Passion drama are presented to us in Scripture. The simple fact of Mary's presence at the foot of the Cross is recorded only in *John* 19.25-27, while only *Luke* 23.27-31 speaks of the holy women who followed Jesus to Calvary. Scripture says nothing of their feelings, whereas these *laude* may be said to plumb the lyrical and dramatic elements that are inherent in the Gospel. However, laments over the body of Christ were found in hymns, sermons, and apocrypha of Byzantine origin.[30] It is well known that elements of Eastern origin had found their way into the Roman liturgy, most notably the *Improperia* sung during the veneration of the Cross on Good Friday.[31] These emotional texts may well represent something of the transition from the restrained scriptural narrative to the lachrymose, febrile expressions of the Holy week lamentation *laude*. In medieval tradition the Latin *Planctus Mariae* was sometimes inserted into the liturgy at the culmination of the veneration of the Cross.[32] Perhaps it is no accident that the representation made by the Company of Santo Stefano on Good Friday is a *planctus* and that it occupies the same position in their marginal liturgy of Holy Week as it does in the Church's liturgy. Moreover, many of the expressions in the *lauda* for that occasion have their analogue in certain of the conventions codified by rhetoric in antiq-

uity and found in Byzantine usage.[33] The lament had already become a literary fixture in the rhetorical curriculum of classical tradition and was most often used in funeral oratory that took the form of imagined speech in which a personage from history or mythology might express his/her emotions at the death of a loved one. Christian writers were quick to adapt the convention to include imagined speeches of characters from the Bible, and the lament of the Virgin became a kind of "rhetorical set piece" in the Byzantine tradition.[34]

The following excerpts demonstrate certain characteristics of these lamentation *laude* that bear some relationship to the Eastern tradition of the *planctus*. It was required, for example, that the orator should at the outset arouse the emotions of the listener. Nearly all of the plaints of the *Codex Illuminati* begin with a call to participate in the lament. For example:

> *Lauda* 3, strophe 1:
>> O descipogl della croce
>> venite a piangere cum Maria

> *Lauda* 8, strophe 1:
>> Venite a pianger con Maria
>> voi figlol disciplinati

> *Lauda* 11, strophe 1:
>> Piangiamo e feciamo lamento
>> e narriamo del suo tormento

Often there is a question regarding the bleak future without the deceased, as in strophe 3 of *Lauda* 3: "O Maria che faceste quando remaneste sola[?]" The requisite description of the corpse and the painful recitation of the catalogue of injuries so common in laments of Eastern origin are reflected in the following examples from *Lauda* 11:

> Strophe 7: MARIA
>> cosi aliso e nsanguenato
>> che per noi fo flagellato

Strophe 8: MARIA

> Qual e l core che non piangesse
> de veder pur cristo orare
> del sangue le gocci spesse

Strophe 10: MARIA

> Puoi che Cristo aver legato
> commencarlo a tormentare
> ello volto gle fo sputato
> ne non se podea nectare
> quelle carne pretiosi
> delli sputi obrobriose

Strophe 12: MARIA

> Et Pilato a una colona
> mantene el fe legare
> en fine [] el sangue abunda
> delle frustate che i fe dare

Strophe 13: JOHANNES APOSTOLOS

> Puoi che l avero flagellato
> de porpore el fier vestire
> de spine una corona en capo

Since some of the earliest examples of Christian speeches for the dead were patterned upon the biblical story of the Widow of Naim, there is much emphasis upon widowhood, which would explain the curious references in the second and third stanzas of *Levate gl ochi* to Mary being widowed by her son.

Much early meditative literature of Franciscan origin is rich in imagery and is often emotionally charged.[35] It is not surprising, therefore, that Trecento Franciscan spirituality, already so in tune with the emotive language of the *planctus*, should resemble these affective Eastern remnants, and in turn should so animate the devotions of this company which was guided by spiritual directors from the Friars Minor.[36] Maguire, in his *Art and Eloquence in Byzantium*, notes that many of the same motifs are evident in the visual arts

sponsored by the early Franciscans as well. He emphasizes that although representations of the fainting Virgin Mary are common in Crucifixion scenes, the swooning Virgin is not usually found in a lamentation scene of Western origin in this period. It is thus all the more striking that one of the earliest known is a fresco found in the Lower Church of St. Francis in Assisi.[37] In this same Lower Church where the *disciplinati* of Santo Stefano were privileged to have their company's burial place are also found Lorenzetti's frescoes depicting the Flagellation, the *Mandatum*, and the Deposition—the very devotions to which the company was dedicated.

The question of Eastern influence upon Franciscan tradition, though worthy of serious study, is beyond the scope of this brief essay. There is, however, no doubt concerning the influence of the Order upon the Company of Santo Stefano. Archival sources repeatedly demonstrate its close relationship with the Friars Minor, a friendship that manifested itself on many levels. One homely example was prompted by the influx of friars for the Pentecost Chapter held in Assisi in 1354, when the friars found it necessary to borrow sheets from the Company of Santo Stefano.[38] But far more important and profound spiritual bonds between the company and the Order are suggested in an unprecedented document issued at the time of this same General Chapter by the Master General, William Farinier of Aquitaine, in which it was officially decreed as an act of the Chapter that all the spiritual benefits of the Order should extend to the *disciplinati* of Santo Stefano and all of their relatives.[39]

Also, the Franciscans are known to have been musically active in medieval Assisi. Already in the thirteenth century Salimbene speaks of several friars in his acquaintance who were gifted singers and composers of *laude*.[40] And throughout the fourteenth century, during the formative years of the Company of Santo Stefano when the Rule, the *Ordines*, and the *laude* were being written, there was an active musical life in the Church of St. Francis that is vigorously chronicled in the archives of Sacro Convento. Of special interest are the entries of payments to singers and disbursements made for the construction of an organ in the Lower Church as early as 1389.[41]

It should thus not be surprising that the *disciplinati*, who maintained a chapel in this church and patterned their devotions—and in-

deed their way of life—upon the Order with which they were affiliated, should also promote *lauda* singing in their activities. And with regard to the question of exactly when *devozione* became *rappresentazione*—that is, when the act of piety actually became a literary genre—it is well to keep in mind that however important these early evidences of drama in the lamentation *laude* from Assisi might be, their real significance lies more in the province of popular religion than in the theater. They are undoubtedly an important benchmark in what should be considered a continuously developing textual tradition of the *planctus Mariae*, but viewed in the context of confraternal life these documents justify their own existence as devout religious expressions not so much intended to entertain as to move to true penitence. Their real motivation is, after all, stated simply in the Rule, which recognizes the value of spiritual catharsis and unabashedly acknowledges the salutary effects of such lamentation "for the people who, above all, understand more with tears than with words."[42]

Notes

Archival and library sources quoted are cited according to the following abbreviations:

Ac Assisi, Biblioteca Comunale
Ad Assisi, Duomo San Rufino
Fas Florence, Archivio di Stato
CRS Compagnie Religiose Soppresse
PEbf Perugia, Archivio del Pio Sodalizio Braccio Fortebracci
PEc Perugia, Biblioteca Comunale Augusta
Rn Rome, Biblioteca Nazionale Centrale Vittorio Emanuele II
Rv Rome, Biblioteca Vallicelliana

Transcriptions from manuscript sources are given without critical commentary, diacritical markings, or modern punctuation. Exception has been made in long passages that lack punctuation in the original, in which case periods and capitalization have been silently added for the convenience of the reader.

1. I have treated the subject of the present study previously in my monograph *The Monophonic Lauda and the Lay Religious Confraternities of Tuscany and Umbria in the Late Middle Ages*, Early Drama, Art, and Music, Monograph Ser., 10 (Kalamazoo: Medieval Institute Publications, 1988), esp. chap. 2, which surveys "Non-Musical Documents: *Disciplinati*."

2. The widespread popularity of the genre is attested in Janthia Yearley, "A Bibliography of Planctus in Latin, Provençal, French, German, English, Italian, Catalan and Galician-Portuguese from the Time of Bede to the Early Fifteenth Century," *Journal of the Plainsong and Mediaeval Music Society*, 4 (1981), 12-52. For a substantive treatment of the Marian Lament, see Sandro Sticca, *Il Planctus Mariae nella tradizione drammatica del medio evo* (Sulmona: Teatro Club, 1984).

3. Rv A26, the *Laudario* of the Company of San Simone e Firenze in Perugia; PEc 955 (formerly Giustizia 5), *Laudario* of the Company of Sant'Andrea, Perugia; Rn 528, *Laudario* of the Company of San Francesco, Orvieto.

4. For a study of the Pentecost and Annunciation Plays, see Nerida Newbigin, "The Word Made Flesh: The *rappresentazioni* of Mysteries and Miracles in Fifteenth-Century Florence," in *Christianity and the Renaissance* (Syracuse: Syracuse Univ. Press, 1990), pp. 361-75. For the Ascension Play see, in the same volume, Cyrilla Barr, "Music and Spectacle in the Confraternity Drama of Fifteenth-Century Florence: The Reconstruction of a Theatrical Event" (pp. 376-404). The *Annunciazione* of Feo Belcari is addressed by Newbigin in "Between Prophecy and Redemption, the *disputa delle virtù* and Florentine Plays of the Annunciation," in *Atti del IV Colloquio della Société Internationale pour l'Etude du Théâtre Médiéval* (Viterbo: Centro Studi sul Teatro mediovale e rinascimentale, 1984), pp. 261-73.

5. Extensive expenses for 1438, the year preceding the Council of Florence, are contained in Fas, CRS 98, *Entrate e uscite B, 1424-41*, esp. fols. 141r-143r; and for the visit of the Duke of Milan in 1471, see Fas, CRS 125, *Entrate e uscite B, 1471-1502*, esp. fols. 51v ff. Similar expenditures are recorded for the visit of the Ambassador of the King of Spain in 1486. The plays continued to be a part of such special occasions as the visit of Margaret of Austria in 1533, the marriage of Joan of Austria to Francesco de' Medici in 1565, and the marriage of Virginia de' Medici to Cesare d'Este in 1586; see Barr, *Monophonic Lauda*, p. 163n.

6. For studies of the Perugian plays, see Kathleen Falvey, "Scriptural Plays from Perugia," Ph.D. diss. (State Univ. of New York at Stony Brook, 1974), and "The First Perugian Passion Plays: Aspects of Structure," *Comparative Drama*, 11 (1977), 127-38. See also Anna Maria Vinti, "Precisazione sul movimento dei flagellanti e sui maggiori laudari perugini," *Studi di filologia italiana*, 8 (1950), 316-19, and Nerida Newbigin, "Appunti sul testo della lauda perugina del Sabato Santo," *Miscellanea di Studi Romanzi offerta a Giuliano Gasca Queirazza*, ed. Anna Cornagliotti, Lucia Fontanella, Marco Piccat, Alda Rossebastiano, and Alessandro Vitale-Brovarone (Turin: Edizioni dell'Orso, 1988), pp. 781-91. Recent studies of the Florentine plays are cited in n. 4, above.

7. It is true that considerable attention was paid to Umbrian sources by such late nineteenth- and early twentieth-century authors as d'Ancona, Catalano, Galli, and Monaci, for example, but there is need for a fresh investigation of the rich tradition of confraternal life in

Assisi. Significant among more recent studies of the Assisi documents pertaining to the subject are Angela Maria Terruggia's writings from 1960. Although some of the opinions expressed in the present article are at variance with those of Terruggia I am very indebted to her work as contained in "Lo sviluppo del dramma sacro visto attraverso i codici di Assisi," *Atti del Centro Studi Origini del Teatro Italiano*, estratto dall'*Annuario XI, Accademia Etrusca di Cortona* (Cortona, 1960), pp. 171-98, and "In quale momento i disciplinati hanno dato origine al loro teatro?" in *Il movimento dei disciplinati nel VII centenario del suo inizio* (Perugia: Deputazione di Storia Patria per l'Umbria, 1960), pp. 434-59.

8. The earliest date, 1327, is found in the statutes Ad 78 and the latest in Ad 43, Libro Santo Stefano, which contains administrative records from 1697 to 1869. The company's statutes were revised as late as 1900 and published in 1901.

9. These include Ad 74 (Sant'Antonio), Ad 75 (San Rufino), and Ad 76 (San Lorenzo) in Gubbio the *Statuti della Fraternita del Disciplinati di Gesu Cristo e di Sant'Agostino*, MS. II 14. This nearly literal copying of the Santo Stefano statutes has resulted in erroneously applying the term protomartyr to a variety of other patron saints. It should be noted also that Ad 74 does not include the phrase referring to the representation for the people.

10. There is reason to believe that the company was already established by the time the statutes, which are dated 23 August 1327, were written. Other archival sources note that it was founded in May 1324 during the pontificate of Pope John XXII (quoted in Arnoldo Fortini, *La Lauda in Assisi e le origini del teatro italiano* [Assisi: Edizioni Assisi della società internazionale di studi francescani, 1961], p. 95).

11. Ad 20 contains rituals of the company, written partly in Latin and partly in Italian. Part I (12 folios) is entitled *Incipit ordo ad faciendam disciplinum*. Part II (24 folios) begins pagination over again and, containing readings and orations for the Temporal Cycle as well as lessons for the Sanctoral Cycle, is written in two columns with space left for illuminated initials which were never completed. It begins with the first Sunday of Advent and ends with a lesson for the feast of St. Catherine, 25 November. Part III (10 folios) contains various orations as well as the Gregorian music of the Requiem Mass. Ad 21 is essentially a copy of Ad 20, only rendered in a finer hand. Made up of five fascicles, in all 43 folios, it is written in two columns of Gothic characters in red and black.

12. For example, Ad 59, *Libro di amministrazione dell'ospedale di Santo Stefano, 1389-1394*, contains scattered entries marked *Inventario di sagrestia*. Fol. 45r, entry for 1412: "Item una quaterno de laude in carta bambacina." Fol. 84v, 1421: "Item unus liber cum coperta lingni ad dicendum laudes," and "Item due libri veteri ad dicendum laudes carte bobicinis."

13. The manuscript is named for a former owner, Emanuelle Illuminati. It is more than a collection of *lauda* texts, for its prayers for the Office and formulae for such ceremonies as the investiture in the habit reflect the communitarian nature of confraternal life. In addition to the *laude* for Passiontide, the codex contains *laude* for Corpus Christi (No. 4), St. Francis (No. 5), Easter (Nos. 6 and 10), St. Stephen (No. 12), Holy Innocents (No. 13), and All Souls (No. 14). For explanation in the numbering of the texts, see n. 21, below.

The Cathedral Archives contain also five other small manuscripts of *laude* under the shelf mark 36/i/ii/iii/iv/v. They have been studied by Michele Catalano, "Laudari ignoti di

disciplinati Umbri," *Annuario Istituto Magistrale*, 7 (1928-31), 29-33.

14. Ad 78, fol. 3v: "quando vero prior fecerit campanelle pro faciendo disciplinam omnes genuflectent se dicendo semel pater noster. Ad aliud vero signum omnes surgant et vadant pro vestibus suis. . . ."

15. Ad 20, fol. 4v, and Ad 21, fol. 4, as previously quoted in Barr, *Monophonic Lauda*, p. 167n.: "Et immediate surgat debens laudes vulgares cantare. Qui cantando illos ex devotionae moveat corda fratrum ad plantum et lacrimas intendentium magis ad verba quam ad voces.

"Laudes autem huiusmodi tali ordine disponantur quia diebus veneris vel aliis quibus de passione ageretur vel disponitis passioni cantentur laudes de passione salvatoris nostri iesus et mestissime matris eius. Sed diebus dominicalibus et festivis et quocumque alio tempore cantentur laudes diei vel festi si de esto agitur disciplina vel alias secundum diei devotionem vel sollempnitatis festi et temporis dispositionem. Et incantus cuiuslibet stantie seu versus si disciplina nunc agitur investibus facti. Finita stantia sive versu fiat disciplina set dum cantor cantaverit laudes. Ad sonum campanelle vel aliud signum surgens disciplina quiescat et hic prosequatur et fiat donec laudes predicte complete fuerint per cantorem laudabis."

16. Ad 20, fols. 25v-26v.

17. Ibid. Ad 40 also contains numerous references such as "libris dicendis offitiis," "livere da dire 1 officio."

18. Ad 78, fol. 7r: "celebraturi cum reverentia devotam et profundam humilitatem qua se divina maiestas abluendis piscatorum et servorum pedibus inclinavit prebens nobis humilitatis exemplum ut quemadmodum ipse fecit Dominus et magister ita et nos condiscipuli et servi in caritate et humilitate invicem faciamus scilicet lavantes pedes maiores minoribus. Et incipiant prior et subprior et officiales omnes minores et pauperiores lavare quo mandato finito in devotissima nocte predicta qui voluerint in loco nostro manere ut totam noctem illam lacrimosam et dolorosam expendant in lacrimis benedicantur a Domino." For the vernacular equivalent contained in the Statutes of San Lorenzo, Ad 76, fol. 17, see Barr, *Monophonic Lauda*, p. 170n.

19. Ac 705, fol. 11v. The second stanza of the *lauda* repeats almost verbatim the words found in the statutes quoted above:

Avemo assempio dumilitade

per Dio ciascun depona el core

vedere quell alta maiestade

lavare i pie ai pescadure

quil che fra nui e piu onorato

de essere piu humilitate.

For a translation, see Barr, *Monophonic Lauda*, p. 44.

20. Ad 78, fol. 7r. "In hora autem prime omnes induti vestibus vadant ad ecclesiam beati Francisci et beatae Mariae Angelorum lacrimosas laudes et cantus dolorosos et amara lamenta Virginis matris proprio orbate filio cum reverentia populo representent magis ad lacrimas intendentes quam ad verba vel voces factis vero laudibus omnes ad locum nostrum insimul revertantur" (cited in Barr, *Monophonic Lauda*, pp. 48, 172n).

21. The subject of the Passion of Our Lord is treated in seven *laude* of the codex: Nos.

1, 2, 3, 7, 8, 11, and 15. There is an apparent discrepancy in the numbering of the texts, for although there appear to be fifteen *laude*, No. 7 is actually the completion of No. 11. This is clear from the rubric accompanying No. 11: "Questa si ene della lauda levavate [sic] gl occhi et resguardate cioe la fine d'essa la quale e scripta quine per se en per cio k e molto divota per se." A reading of the two *laude* in sequence places the events of the Passion in proper chronology and results in a text comparable to the version contained in the Gubbian *laudario* Landau Finaly 39, Biblioteca Nazionale Centrale, Florence.

22. The attribution has been corrected in Arturo del Pozzo, "Contrasti spirituali in un codicetto assisiano del secolo XIV," *Giornale storico della letteratura italiana*, 86 (1925), 80-99, and is reaffirmed by Angela Maria Terruggia, "Lo sviluppo del drama," p. 53n, and "In quale momento," p. 445. See also Barr, *Monophonic Lauda*, p. 46.

23. Ad 59, *Libro di amministrazione dell'ospedale, 1412*, fol. 45v: "Item uno mantello nero della dopna nostra." Entry repeated on fol. 46r; 1421, fol. 84r: "Item unam clamidem coloris nigri per Maria"; see also Barr, *Monophonic Lauda*, pp. 20, 173n.

24. Ad 40, 1427, fol. 17v: "uno mantiello de nero per la nostra donna et gle vestimenta nire per lo crocefisso"; 1429, fol. 18v: "Item uno mantello negro della nostra donna"; and 1442, fol. 20v: "Item uno chofano serrato dentro ce giace el mantiello nero della nostra dompna."

25. It is clear from other records of the Gubbian confraternities that there were at one time several other *lauda* manuscripts. Mazzatinti cites records of payments to singers for performing *laude* for Christmas, for the feast of Sant'Ubaldo, and for the ascent of the famous hill of Santa Maria di Marco as well as for other feasts of the year. Landau Finaly 39 contains no such *laude*.

26. On the Gubbian companies, see Giuseppe Gali, "I disciplinati dell'Umbria del 1260 e le loro laudi," *Giornale storico della letteratura italiana*, 9 (1909), 107-08, and *Laude inedite dei disciplinati umbri scelte di sui codici più antichi* (Bergamo: Istituto italiano d'arte grafiche, 1910). See also Giuseppe Mazzatinti, "I disciplinati di Gubbio e i loro uffizi drammatici," *Giornale di filologia romanza*, 3 (1880), 80-109, and "Laudi dei disciplinati di Gubbio," *Il Propugnatore*, n.s. 2 (1889), 145-96; and Guglielmo Padovan, "Gli uffizi drammatici de' disciplinati di Gubbio," *Archivio storico per le Marche e per l'Umbria*, 1 (1884), 1-19. For excerpts from the inventories, see Barr, *Monophonic Lauda*, p. 51.

27. PEbf, A 440.

28. Ad 52, fol. 23v: "Tra natale 1338 e febbr 1339 . . . pro vino, pro illis qui venerunt de Perusio ad faciendum representationem de iudicio Domini XX den"; "Item pro uno pari cirothecarum pro dicte representatione 11 sol, vi den" (quoted in *Documentazione di vita assisana 1300-1448*, ed. Cesare Cenci [Grottaferrata: Editiones Collegi S. Bonaventurae Ad Claras Aquas, 1974], I, 77).

29. The Judgment Play to which reference is made here comprises 390 verses in *sestina semplice* and contains a large number of characters, including the Antichrist and Satan, as well as choruses of the people of Jerusalem, the damned, demons, etc. There are elaborate rubrics indicating such dramatic effects as the darkening of the sun, falling stars, and thunder. I am indebted to Kathleen Falvey for permission to use her unpublished article, "Two Judgment Scenes in the 'Great' St. Andrew Advent Play."

30. Henry Maguire, *Art and Eloquence in Byzantium* (Princeton: Princeton Univ. Press, 1981), pp. 91-108, is a valuable study of the development of the lament which traces it to its Byzantine sources.

31. This adoration rite is very ancient, written in the form of reproaches of the dying Jesus addressed to the assembled community. "The Adoration rite, imported from Jerusalem, was well developed by the fourth century, as the circumstantial account in the *Peregrinatio Etheriae* demonstrates" (O. B. Hardison, Jr., *Christian Rite and Christian Drama in the Middle Ages* [Baltimore: Johns Hopkins Press, 1965], pp. 131f).

32. Giulio Cattin, *Music in the Middle Ages I*, trans. Steven Botterill (Cambridge: Cambridge Univ. Press, 1984), p. 122.

33. Maguire, pp. 91-111.

34. Maguire, p. 97.

35. Notably the *laude* of Jacopone and the *Meditations* formerly attributed to St. Bonaventure; see *Meditations on the Life of Christ: An Illustrated Manuscript of the Fourteenth Century*, trans. Isa Ragusa (Princeton: Princeton Univ. Press, 1961).

36. There is much archival evidence of this close association, and some of the friars who served as spiritual guides of the Company of Santo Stefano are named in various records of the confraternity. See, for example, Ad 41, fol. 1, which refers to "Symone Lelli de Assisio visitatore eiusdem fraternitatis ord fr Minorum" and the book in which are written the "defectus notabilis" of the brothers along with the punishments levied for these by the *visitator*.

37. Maguire, p. 105.

38. Ad 52, fol. 136ᵛ, V 15, 1354: "La fratemita de s Stefano presta a fr Simone visitatore de ord Min 10 paia de lenzuoli per il capitolo generale dei frati Minore."

39. Ad Pergamenae numeratae 24 VII 15 1354: "fr. Guilielmus ord fr Min generalis minister consede i suffragi dell'ordine ai confratribus fraternitatis sancte discipline d n Iesu Christi que de a Stephano vulgariter nuncupatur. Datis Assisi tenpore nostri generalis capituli." The actual document granting the privilege is given in its entirety in Fortini, p. 108.

40. *Cronica Fratris Salimbene de Adam Ordinis Minorum*, in *Monumenta Germania Historia, Scriptores*, XXII (Hanover: Societas Aperiendis Fontibus Rerum Germanicorum Medii Aevi, 1905), 181ff. See also Heribert Holzapfel, *A History of the Franciscan Order*, trans. Antonin Tibesar and Gervase Brinkmann (Teutopolis, Ill.: St. Joseph Seminary, 1948), p. 237.

41. Archivum sacri conventus s. Francisci, Archivi amministrativi, MS. 373, fol. 24ʳ, XII, 18, 1387: "pro actatione organorum in coro sol VII den VI"; fols. 169ʳ-170ᶠ, VI 4 1389: "in pisscibus pro fratribus ieiunantibus in uno martello pro organis faciendis sol XXX"; VI 6: "pro magistro organorum in tribus pellibus de camoscio pro organo, sol XLII"; VI 8: "habuit Symon Luminate, pro sera et pluribus aliis feramentis pro copertura organorum, sol XLV"; VI 14: "in sexaginta libris stagni pro organis, Lib XXIIII"; VI 15: "in lampadibus pro ecclesia in filo ferreo pro organis"; VI 21: "in duabus libris acutorum pro solario organorum, sol XIII"; VI 29: "habuit Franciscus de Bictonio carpentarius pro tribus diebus quibus servivit ad faciendum organa, sol L, . . . pro magistris carpentariis et organistis habuit fr. Nicolaus inquisitor pro tunica sua, Lib XIII fr Iacobus de Aquasparta vicarius conventus pro tempore quo servivit flor i habuit fr Fernandus pro salario facture organorum ecclesie inferioris flor XVI."

42. Research for this study was supported in part by a Grant-in-Aid from the American Council of Learned Societies. I wish also to express my gratitude to Don Aldo Brunacci, Archivist of the Cathedral of San Rufino in Assisi, and his associate, Don Elmo Antonini, for their interest in this study and their generous assistance to me during my work in Assisi.

Early Italian Dramatic Traditions
and Comforting Rituals:
Some Initial Considerations

Kathleen Falvey

Beginning in the fourteenth century, the ancient religious prac-
tice of ministering to prisoners about to be executed became institu-
tionalized and regularized within some Italian lay confraternities
often designated with the title *della giustizia* ("of justice").[1] Many
of these confraternities were of a penitential nature, and the devotion
to Christ's Passion that took on for their members a participatory
quality influenced their delicate mission to those facing the shame
and terror of public execution. Confraternities of Justice became
widespread throughout Italy. The ritualized practice itself was some-
times referred to as the *conforteria* more in the primary sense of
"strengthening" but also with all the resonances of human and reli-
gious consolation.[2] At times the lay brothers saw to the burial of the
executed criminal, especially in the case of indigence. This *con-
forteria* continued, with many modifications, until the gradual aboli-
tion of the death penalty in the various jurisdictions of Italy. There-
after, some groups dedicated themselves to serving prisoners and
their families in other ways, while some were dissolved.

Roughly speaking, from the early fourteenth until the mid-six-
teenth century, the role of the laymen within the confraternities was
pronounced with regard to the *conforteria*. (With the Council of
Trent and attendant reforming influences, clerics and theologians
became more involved, especially the Jesuits.) During these same
two hundred years, vernacular religious plays flourished throughout
Italy, among them to a marked degree Passion and Saint Martyrdom
Plays, in the same areas where the *conforteria* was an established

33

and well-known practice.[3] Because of the complex interweaving of religious and civic affiliations, a lay member of a confraternity could be involved in formulating civic statutes and ordinances; in instituting criminal proceedings against a defendant on the basis of them; in comforting him should he be condemned under capital sentence or, by special privilege, in obtaining his liberation; and in composing, producing, and acting in Passion and Martyrdom Plays. Of course, such a citizen could run afoul of the law and find himself in need of either pardon or comforting. Given the immanence of symbolic actions in the tightly-knit society of Renaissance Italian towns, it comes as no surprise to us that the same religious and secular themes animate a notable interpenetration of dramatic and penal forms.

It is the purpose of this essay to offer some initial considerations about the profound correspondences that existed between dramatic traditions and the efforts of dedicated laymen to transform a brutal penal event, public execution, into a ritualized and very "real" re-enactment of the death of Christ or one of the martyrs.

A Comforter's Manual from Bologna: Morgan MS. 188. A good way to approach an understanding of the nature of the *conforteria* during the period we are considering is to examine a copy of an official comforting manual of the penitential confraternity of Santa Maria della Morte in Bologna executed for a member of the Castelli family. The manuscript, now in New York at the Pierpont Morgan Library (MS. 188), is incomplete but is the best in its tradition to survive.[4] It dates from the second half of the fifteenth century and represents the long experience of the comforting group. Leaves numbered 1 to 50 contain two books. The first is divided into thirty-three brief chapters each preceded by an explanatory rubric or heading, and introduced by a decorated capital. Book I aims at preparing the comforter for his mission by furnishing him with explanations and arguments to move the prisoner to receive worthily the sacraments of penance and the Eucharist as an immediate prelude to death. Book II is of a more practical nature, instructing the comforter how to act, and again what to say, from the mo-

ment he enters the prison on the eve of the execution, through the night, and up to the very moment of the prisoner's death. It, too, is divided into brief sections—twenty-five of them—introduced by headings and decorated capitals, but these are neither numbered nor identified as "chapters."

The fifty numbered leaves of the Morgan manual are preceded by four unnumbered ones, the first three consisting of a Table of Contents for the manuscript in its original state—that is, listing the headings of the divisions of Books I and II and also the incipits of eighty-six "lauds and prayers" contained on leaves 51-98, now missing. The designation "laud" refers to a poetic composition, often a hymn. It is an open question whether these were sung or merely recited during the comforting process. "Prayer" refers probably to a prose composition; many such are found throughout Books I and II. Evidence from these books indicates that the same poetic composition could be called a "laud and prayer." This lost repertory of lauds and prayers was available to the comforter to use at his discretion during the various steps in the process according to the needs and dispositions of the condemned.

Significant bands of illustrations decorate the recto side of the first numbered leaf where the text of Book I begins. Across the top two scenes are depicted. On the left, within an open doorway, a figure dressed in black and white holds up before a prisoner's face a small painted board with a handle on it. The prisoner's arms are crossed in front of him seemingly in an attitude of devotion. Behind him are three confraternity members in white robes and hoods with eye holes. The scene on the right pictures a raised loggia above an open gate in a wall. By a desk on the right are two men with books and papers. Off to the right the prisoner stands bound to a column, a hooded brother holding the board in front of his face. Another brother appears in the background. In the bottom left-hand corner the upper part of a figure on horseback can be seen. These two scenes depict the condemned man leaving the prison proper to hear his sentence read publicly and being comforted by the painting of a sacred subject on the board held before his face; and the actual reading of the sentence. Across the bottom of the page is pictured

the beginning of the procession through the city to the place of execution. A small number of horsemen and guards precede two hooded brothers who walk backwards in front of the bound prisoner. The figure in black and white walks between the brothers holding up the board. An officer seems to push the prisoner from behind. These illustrations will take on clearer meaning as we consider the text.

Book I. The treatise opens with an exhortation to the comforter to undertake his delicate task only for the love of God and the salvation of the prisoner to whom he will minister. The comforter must eschew all worldly praise or fame to be gained from such an exercise as well as the unworthy motivations of vengeance or vain curiosity. He must arouse in himself the fear of God and compassion for the "miserable case" with which he is about to deal, feeling more sorrow for the sins committed by the prisoner than for the painful death he is about to suffer. The comforter must be abstemious in food, drink, and sleep so that his mental faculties will be at their best as he participates with the unseen angels of God in the mystery of converting a sinner. Before attempting to prepare the prisoner to confess his sins and receive the Eucharist, the comforter himself should go to confession and then pray humbly before an altar where he knows the Body of the Lord to be reserved.

The rest of Book I constitutes for the most part a kind of model script provided to the comforter for his use, sections of which are of universal application, others for special cases. In all probability this script was principally suggestive, to be used at the discretion of the comforter in individual situations, the numerous divisions and subdivisions serving as memory aids. The tone and diction of the model addresses are familiar, gentle, and loving, as indicated by the first words to be spoken on entering the prison and meeting the prisoner for the first time. After calling down a blessing on the "house," one of the comforters was to say:

> My dearest brother and friend, God and the Virgin Mary who accompany me know well that we belong to that blessed charitable company [of

Santa Maria della Morte] and that we would rather come to visit you in any manner but this, wearing any other habit, and for any other purpose. (fol. 2r)

Although the comforter repeats that he regrets the situation in which he finds the prisoner, he asserts that such is the will of God and no one may go against it; not that God wills the violent death of anyone, but he "lets it happen" and allows the world to inflict suffering on the body in this life so that the soul may not suffer in the next. And since the brother prisoner is at the end of his days, he needs to understand very clearly that his sufferings will not be meritorious unless he accepts voluntarily the providence allotted him and the unappealable divine sentence. He should consider how great and secret is the judgment of God. The prisoner is exhorted to humble himself and refrain from nurturing too much compassion for his bodily state and sufferings since his flesh is destined to rot anyway, and to raise his mind to God.

Notable emphasis is given to detailing the miseries of the body before and after death, and of life in this world in general. The example of Christ is presented, specifically a consideration of his Passion; his patience in suffering is praised. The comforter assures his "sweet brother" that Christ's torment on the cross brought about the diminution of his own impending sufferings, and this should be a great source of solace to him. He should be inflamed with love for that Jesus who "waged battle on the wood of the cross as author of salvation" and also should consider well the "great passions the holy martyrs bore":

It will be a great comfort to your soul and body when you remember that they were neither more nor less than you, of flesh and blood and sinews. But they wanted to suffer most bitter pains and terrible torments because they considered the mercy they would afterward receive, the prize of glorious eternal life. So, have in your soul the devotion of the martyrs. (fol. 6v)

Special attention is given to ensuring that the prisoner pardon all offenses against him and that he prepare to ask pardon for his own

before his final confession and reception of the Eucharist. The comforter urges him to leave behind the things of this world and to turn to Christ "the spouse of your soul" as, receiving the Eucharist with devotion and tears, he repeats this prayer:

> By the merit of your holiest passion may this sacrament wash me of my sins, strengthen me . . . and be my guide . . . at the moment my soul will be separated from my body. Into your arms . . . my sweetest Lord . . . I commend my soul. Amen. (fol. 12ᵛ)

Three times in various chapters of Book I care is taken to counteract the shame the prisoner will experience during his public ordeal. Although he is encouraged to have the right kind of shame for his sinfulness while preparing for confession, that other shame which is rather human respect is something he must scorn. When the condemned man hears the bell begin to ring, summoning his fellow citizens to gather for the public reading of his sentence and the other rituals leading up to his execution, during which he will be bound and led through the crowded streets and squares, especially then he must remember how Christ was likewise bound and led away like a thief and how the people of Jerusalem heaped scorn on him. Christ was innocent, yet was as meek as a lamb during his ordeal and offered no defense. The martyrs were also innocent and did not seek to excuse themselves. The prisoner is to take these examples and determine not to speak in his own defense during the public rituals. It would do neither his body nor his soul any good. The sentence cannot be changed; no one was ever saved at this point in the penal process by offering excuses, whether or not those excuses were valid.

The prisoner is assured that if he accepts his sufferings and death in the spirit of Christ and the martyrs the heavens will open to him at the end of his ordeal and he will find himself at once welcomed into Paradise by the vast and delightful company of the blessed. Fully twelve chapters are dedicated to evoking the various orders of this company, after mention of the Trinity and the Virgin Mary: angels, prophets, apostles, martyrs, doctors, confessors, virgins.

A special chapter is dedicated to John the Baptist, traditional patron of condemned prisoners because the manner of his death, by decapitation, was still a usual means of public execution. The prisoner is reminded of this correspondence and is exhorted to humility and patience: "You know that you are not so just and holy as John; so, you must be patient about the fate that has overtaken you" (fol. 18).

Again and again the prisoner is urged to think intently upon the torments of the various martyrs, and these are enumerated in detail. Included are some the prisoner may have himself already experienced (such as flogging) or may have to look forward to (such as being torn with heated pincers, having a member cut off, being hanged, burned, or beheaded). He is reminded that eternal life is not given to the one who indulges in bodily delights; it is won by great labors only by those who do battle in manly fashion. "So," the comforter reasons, "my brother, you must fight, and get your strength from the examples of the glorious martyrs." Further, imitating the martyrs can transform his own sufferings into the same sweetness which they experienced; so inflamed were they with the love of God that they were often oblivious of the torments inflicted on them. But a warning is added. At this extreme hour, when the prisoner has the opportunity of soon entering into the company of the "cavaliers of Christ," he may also lose his soul just as he is about to lose his body. So, he must pray to the martyrs for strength and constancy.

Toward the end of Book I there is clearly explained the theme that underlies and informs all the extended arguments and exhortations furnished the comforter for his intensive efforts: whatever the state of the prisoner's soul may be at the moment of his death—that is, his human and spiritual dispositions—so it will remain fixed for eternity and determine his salvation or damnation. Book I concludes with a heady "laud and prayer" exhibiting neoplatonic influences that the comforter is urged to have the prisoner say along with him in order to arouse this necessary "devout state before God" as he goes to his death. The poem is replete with spousal images and themes; intellectual glory is promised to the redeemed person

who bears fervent love to beloved Jesus,
and who ever seeks, wholly enamored,

the spouse of his soul who is a perfect lover
and who transforms him into transforming love. . . . (fol. 33v)

The concluding stanza warns that human imperfection can never be put aside except by tasting deeply of Christ incarnate, and that whoever wishes to find this beloved Jesus will experience a "spousal immersion" to be tightly embraced with rectitude and heart-felt longing.

Book II. Like Book I, this book opens by outlining the necessary dispositions the comforter must possess for his charitable mission and by reminding him of the brotherhood of sinfulness and need for mercy that unites the "poor unfortunate one" condemned to death with the comforter himself. Book II seems almost another, more practical version of the first book, the two having been composed separately and copied into the manuscript in question. Book II is written in the first person, probably by an official or spiritual director of the confraternity. Throughout, the author, addressing the comforter directly, tells him how to act, what gestures to employ, what sentiments to foster in the prisoner, and, as in Book I, supplies him with an actual script of exhortations and prayers. Various unnumbered sections instruct the comforter about ways to handle the needs of individual prisoners. Some may want to see their families, especially their wives; some may want to listen to the words of the comforter; others may prefer to read or pray quietly; some may be distracted or hardened and not want to be led to God; some may want to make a will. Particularly difficult is the case of the very young prisoner who simply does not want to die. And then there is the prisoner who asks: "What is the soul?"

Evidently the preceding instructions apply to the task of the comforter from his arrival on the eve of the day of execution and through the night, for the next heading reads: "What you must do when morning dawns, that is, when day comes" (fol. 44r). The comforter is urged to keep the prisoner's mind occupied with consoling words and prayers and not to abandon him especially now, for with the coming of new light and the bustle of various officials setting

about the business of the day the prisoner will realize that the moment of his death draws very near and will experience the struggle of his flesh. When the comforter hears from afar the ringing of the small bell accompanying the priest who comes to hear the prisoner's last confession and bring him the Eucharist for the last time, he is to step up his efforts even more. Once the priest has administered the sacraments and has left, the comforter's instructions concern another bell: "What you must do when they begin to ring the bell for the citizens to gather" (fol. 47r). The comforter is warned to be especially alert, "for you will find that the greater number of condemned prisoners are struck with terror at the sound, and many lose their bearings" (fol. 47v). He must mince no words but tell the prisoner that in the next two or three hours that remain to him he will enter into the fiercest battle of his life, and he may lose it. His enemies are the devil, the world, and his own flesh. The devil will tempt him to despair, but against this all of the comforter's exhortations heretofore will strengthen him. Under the category "world" the comforter once again emphasizes the shame the prisoner will experience when he is bound and led in the sight of the people. He is urged to see all his humiliations as a crown for his soul, and is once again reminded of the martyrs who also experienced painful and shameful deaths and who now continue to be celebrated by the Church because of their victories. The third enemy to assail him will be his own flesh, and the only way to conquer it is to have recourse to prayer as Christ did when his own flesh rebelled against him and he said: "My soul is sad unto death" (fol. 47v).

The comforter then lets him know what to expect next:

> Very soon now the Cavalier will come to bind your hands and lead you to the railing of the loggia, and there your condemnation will be read. And then, lastly, he will bring you to your death. And at all these points I will be with you. (fol. 47v)

The instructions concerning the entrance of the Cavalier into the prison display the delicacy of feeling the comforter is to maintain at all costs now that the public ritual is to begin. He is not to go to the

Cavalier himself, but actually to make believe that he does not hear him when he calls "so that the prisoner who has to die may not have reason to think that you want him to get on his way too soon" (fol. 48r). The comforter is to keep the *tavoletta*, the little board with a sacred subject painted on it—the instruments of the Passion, a depiction of the crucifixion of Christ or of the martyrdom of a saint such as John the Baptist—immediately in front of the prisoner's face so that he cannot see anything else. And if he seems to waver, the comforter is to remind him that, whatever his "distraction" may be, it is another battle that his enemies are waging against him, and he is not to submit since that would be defeat.

While the prisoner is on public display during the reading of his sentence, the comforter is to be very bold in his speech and to give him no rest, keeping his attention fixed either on himself, the comforter, or on the *tavoletta*, lest he look around or even hear the accusations proclaimed against him. For, if he should hear something of which he feels innocent, he may become angry and cry out to the notary: "You lie in your throat"; and this would cause great harm. After the reading of the sentence, the procession moves to the Church of St. John the Baptist where the prisoner kneels in the doorway for the elevation of the consecrated host. The comforter will suggest to him the most beautiful prayer he knows, not just for the good of the man about to die but also for the honor of the confraternity and the edification of the people gathered in the church. From there they go to the "place of justice," and the brother speaks with sweet words:

> O creature of God, you have taken up the arms of blessed Sir Jesus Christ with very great devotion, and with them you are armed. You must be a brave cavalier and battle in manly fashion, for I tell you that you are near death and have but little time left to live. This is your cross with which you must follow the sweet Jesus Christ who bought you back with his precious blood. (fol. 49r)

And when they reach the hill of the marketplace, or wherever else the execution is to take place, the comforter, urging the prisoner to kneel and avail himself once again of the priest for confession in

case he has held something back, will say to him openly: "See, my brother, Death is right behind you." And when he has finished his confession and rises from his knees, the comforter will suggest a prayer to him as he approaches either the block or the gallows. Detailed instructions are given concerning the way the comforter is to deal with the technical aspects of the two usual forms of execution, decapitation with the small guilliotine-like apparatus called the *mannaia*, or hanging. In either case he is to keep the *tavoletta* directly in front of the prisoner's face until the very last moment and to continue to suggest to him that he should repeat the same words with which Christ died: "Lord, into your hands I commend my spirit."

The Missing Morgan Laudario. As mentioned above, the Morgan manual once contained ninety-eight leaves, more than half of them (fols. 51-98) occupied by a *laudario* or collection of lauds and prayers from which the comforter might select appropriate texts. Indicated, on missing fol. 90, is Jacopone da Todi's *Dona del Paradiso*, one of the most dramatic, if not theatrical, poetic treatments of Christ's Passion to come down to us from early Italian traditions. During the comforting ritual the prisoner was urged to conform his humiliation and suffering to that of Christ and to comport himself with love and dignity as Christ himself did—to "perform," so to speak, in an all-too-realistic Passion play. And one of the inspirational works the comforter could employ at his discretion, according to the disposition and status of the prisoner—learned, "rustic," or female—was a well-known Passion drama.[5]

Passion plays are well documented in Italy as having been performed in the same civic spaces that on other occasions were sites of public executions. The active participation of the faithful aimed at in the dramatic presentations could clearly have colored the reactions of this same "audience" to the successfully comforted prisoner going to his death with piety and dignity. And, if the same laymen participated in both Passion play and *conforteria* as members of a penitential confraternity, an important aspect of their corporate spirit needs to be borne in mind: the impetus to view both themselves and the prisoner under sentence as "brother penitents" seeking intimate

union with Christ in his redemptive sufferings which were sometimes contemplated under the title of his *gran penitenza.*

The Passion of Revello. If the traditions of presenting Passion plays need to be taken into consideration in an attempt to understand the phenomenon of the *conforteria* in the period we are studying, it is also important to discover if the energy also operated in the opposite direction, whether the rituals of comforting influenced the composition and performance of Passion plays. Such seems to be the case for the three-day *Passion* of Revello, composed, in the form that has come down to us, in c.1479-90. In her magnificent edition of this work Anna Cornagliotti makes no mention of such an influence, but the portrayal of the sufferings and deaths of both Jesus and John the Baptist offer significant possibilities for consideration.[6]

The *Passion* is actually a dramatization of the life of Jesus with a separate Mary Magdalen play appended. During the first day of performance a curious stage direction marks the passage of time from Jesus' infancy until he enters upon his public life as well as the necessary change of actors. After scenes of the Slaughter of the Innocents and a brief Council in Hell, this stage direction reads: "And little Jesus does not appear any more, and big Jesus, he who has to be piteously crucified, takes leave of Mary and Joseph" (I.3458ff). It is both striking and fitting that as soon as the actor portraying "big Jesus" enters the play, the brief commentary embedded in the stage direction refers to his death. This thematic orientation is soon borne out in action and text. Upon leaving Mary and Joseph, Jesus goes to John to be baptised, and at the end of the ceremony withdraws alone to another part of the acting area. Immediately the Angel Uriel comes to announce his redemptive mission to him and already comforts him for his death: "Sta' forte" ("Be strong," I.3846). Jesus acknowledges:

> You have been sent to comfort me,
> true angel and my friend (I.3847-48)

and then goes alone into the desert to pray.

Uriel's "Sta' forte" is especially effective, indicating succinctly the whole point of the comforting effort. Christ himself gives this same loving imperative to John the Baptist in the Florentine Beheading play when he appears to him in prison in the guise of comforter: "Ista' forte, Giovanni."[7] And, in the three-day Sienese *Feast and History of St. Catherine, Above All Others Devout and Beautiful*, the Alexandrian philosopher and martyr converts many of the Emperor's court, including the Empress herself.[8] Death sentence follows soon after conversion, and Catherine comforts the other woman about to die: "O Empress, be strong and constant." Comforting scenes occur frequently in Martyrdom plays and invite further study for their relationship with actual comforting rituals.

I have mentioned the use of a *tavoletta* painted with an image to strengthen the prisoner for his ordeal, to keep him from being distracted, from perhaps seeing a loved one or an enemy along the route—or the instruments of torture, if these were to be employed.[9] Up to the moment of death the comforter would keep this image literally before the eyes of the prisoner according to explicit and detailed instructions. For the one being comforted the *tavoletta* became at once an object of intense devotional concentration and a kind of ritually reflecting mirror in which he was urged to see himself conformed to the Passion of Christ or a martyr in order to be strengthened, consoled, and ultimately transformed. However, when such an image is presented to Christ himself in the *Passion* of Revello, in the Garden Scene just before his arrest, it has a disturbing effect and seems at first not to comfort him but to terrify him.

The scene in question portrays, with characteristic embellishments, the action of *Luke* 22.43: "And there appeared to him an angel from heaven, comforting [*confortans*] him." It is the second day of the performance. Annas and Caiaphas have just dispatched Judas accompanied by a centurion and his knights to the garden where Jesus is known to be. As they move through the acting area toward the garden station, Jesus offers His first prayer:

Abba Pater, if it is possible for you to do it,
let this death pass me by.
Do it, my Father, for I am greatly suffering. (II.561-63)

Rising, he goes to find his disciples sleeping, and, returning to pray a second time, expresses himself willing to "drink from this chalice" if it is necessary. Although stage directions are quite explicit in the Passion sequence, none here indicates whether or how "this chalice" is offered to him. Instead, after he goes once again to find his friends asleep, an unusually long stage direction mentions that something else is offered to him by his original comforter, the Angel Uriel, an image of his imminent sufferings and death. Contemplating it, Jesus sweats blood:

> And, as he is positioned to pray, let the Angel Uriel come to show him the Passion painted on a cloth. And then Jesus lies down on the platform, and underneath let there be someone to paint his face and hands red, as if he sweated. And when he will have been thus a little while, let him get up. And let one of the angels come without saying anything and dry his sweat. And, that having been done, Jesus prays piteously saying:

> O my Father in heaven.
> I see well, and clearly understand
> that I need to die.
> This is heavy for me. . . . (II.578ff [sd], 579-82)

Attention is next drawn to the heaven station where God the Father summons the Angel Michael and orders him to go down to comfort Jesus, for the day has come for him to accomplish the redemptive mission:

> He needs to suffer a cruel death
> and drink vinegar mixed with gall.
> At a column he will be beaten,
> for thirty coins he will be sold. (II.589-92)

The Father wants Michael to know that no one ever suffered so cruel a death as that prepared for Jesus, who is experiencing such great fear that he has just sweat blood:

Go at once. . . .

. . .

Say to him: "Don't be at all discomforted.
This has been ordained from all eternity."

. . .

Beg him to take courage
and not go against his death
because without fail I will be always with him
and never in those sufferings will I abandon him.
Tell him not to be afraid of Satan,
because I will hold his soul in my hands.
He is my only child,
and above all others I will exalt him,
for I love him with all my heart. (II.599, 604-05, 615-23)

The Father again urges Michael to hurry since the Jews are already
on their way to arrest Jesus. (The protestations of love and care in
the speeches of the Father are undercut by his insistence that he will
not abandon Jesus in his sufferings. As expected, line 1230 of the
Third Day of the play will be the familiar: "My God, my God, why
have you abandoned me?")

Michael descends to the garden, delivers the Father's message,
and encourages the agonizing, bloody Son:

Now be comforted, and be courageous
in accepting your death and torment.
This is how it has to be,
there is no other way.

. . .

Now watch yourself, if you should be afraid. (II.655-58, 665)

Jesus retorts:

If I should be afraid!
O Michael, say whatever you want—
it is not the head of the good comforter that aches!
How well I know that I have to die. . . .

. . .

but if you were now in my place. . . . (II.666-69, 673)

Jesus describes the struggle he is experiencing and exclaims that, in spite of the rebellion of his body, "I will *make* it die!" He concludes by sending Michael back to tell his Father that he is ready, but to beg him, in courtesy, not to allow Satan to be near him when he is dying: "I am very much afraid of him" (II.698).

Michael now seems to understand somewhat the terror Jesus is experiencing and urges him to "Sta' forte" and not to lose his way. However, the Angel's words on leaving are anything but comforting:

> Be constant and do not be troubled.
> I see that your friends are running away! (II.706-07)

The Revello Book of St. John the Baptist. It is conjectured that the *Passion* of Revello, of vast proportions, was composed by making use of shorter pre-existing plays, among them dramatizations of the Conversion of Mary Magdalene and the Beheading of John the Baptist. And, in the case of the latter, it seems clear that the dramatization of John's martyrdom was later extrapolated from the *Passion* text and repeatedly printed as a separate *Book of St. John the Baptist.*[10] Reproductions of the woodcuts illustrating the 1522 edition were used by Anna Cornagliotti to illustrate pertinent details in her edition of the *Passion*; she supposes that they bear some affinity with staging practice.[11] In these woodcuts John is shown being beheaded not with the usual swing of the sword familiar from so many near-contemporary representations but anachronistically with the *mannaia*. This is an unusual detail, the only such illustration I have come upon so far. One wonders whether a local comforting group employed an image of John being martyred by the same instrument that awaited the condemned prisoner at the end of the ritual procession to the place of justice. Or, was the actual *mannaia* used for public executions lent to the players for the production of a drama that called for wide cooperation and involvement in its production.

Ten years after the appearance of Cornagliotti's edition of the *Passion*, Marco Piccat published a companion volume studying the background and context of the play based on extensive research

which he had carried out as he had put the Revello town archives in order.[12] He documents the preparations made in August 1461 for a *ludus* of Mary Magdalene as well as the fact that the local nobleman, the Marquis of Saluzzo, lent drapes and tapestries for the production. Piccat also studies evidence for the production of a three-day Passion Play beginning on Easter, 22 April 1481, in the square in front of the Church of the Magdalen. A number of scaffolds were constructed, the timber being lent by various persons and institutions and later returned or paid for. In the context of such widespread lending and cooperation at all levels for the production of a play that would include the dramatization of John the Baptist's beheading, the question arises: since the actual instrument employed for public executions would not be in use during such celebrations, would it be lent to the group of actors putting on the play? In such a small, tightly-knit community the answer might possibly be yes, but neither Cornagliotti nor Piccat addresses the question.

The Radiant Cell and a Joyful Outcome. Two examples of successful comforting will suffice, both well documented: the first an act of private enterprise, so to speak, by Catherine Benincasa on behalf of Niccolò di Toldo in Siena in 1375; the second by the brothers of the Company of Santa Maria della Croce al Tempio, in Florence, on behalf of Pietro Pagolo Boscoli on 22 February 1512.

When Catherine took up the desperate case of the political prisoner Niccolò di Toldo, the practice of comforting the condemned had already become institutionalized in Siena in a Compagnia della Morte probably founded about 1335 under the influence of the Dominican Venturino da Bergamo. She seemed to follow the ritual in certain key aspects such as holding the severed head in her hands until all indications of pulse ceased.

Catherine was intimately involved with penitential confraternities in Siena, which among other activities fostered religious drama. Many of her close friends and followers were prominent members of such groups, and her letters to some of them survive, as do letters to prisoners confined in the city's jails. Her rapport with the latter seems part of her mystical program centered on the concept of the

"cell in the mind" to which she counseled her followers to retreat in order to achieve transforming union with the sufferings of Christ.

It is in what is perhaps her best known letter that, writing to her confessor, mentor, and future biographer, Raymond of Capua, she describes her conversion and comforting of Niccolò on the eve of his execution and her visionary participation in the events surrounding his decapitation.[13] It was as if she were able to transform his final moments into the closing actions of a *sacra rappresentazione* portraying a saint's martyrdom, a joyful passage to the divine nuptials. Catherine arrived at the place of execution before Niccolò and, since she felt an overwhelming desire for martyrdom, stretched her own neck on the block.

> Then he arrived, as a meek lamb, and, seeing me, he began to laugh, and he wanted me to make the sign of the cross. When he received the sign, I said: "Come on! to the nuptials, my sweet brother! for soon you will be in life without end." He got down with great meekness, and I stretched out his neck, and leaning down, I reminded him of the blood of the Lamb. His mouth said nothing but "Jesus" and "Catherine." And, as he was saying thus, I received his head in my hands, closing his eyes on divine goodness and saying: "I want this!"

The second case is described by Luca della Robbia, great-grand-nephew of the famous sculptor.[14] Pietro Pagolo Boscoli had been condemned to death for plotting against the newly restored Medici regime. On the eve of his execution comforters passed the night with him in prison. Luca spent the final hours with him and describes how, as the time came to set out for the place of execution,

> as he descended the stairs he kept his eyes on the *tavoletta* and with most loving accent said: "Lord, thou art my love; I give thee my heart; I love thee only and therefore I love all things, for I love all for love of thee. Here I am, Lord; I come willingly; grant me courage and strength. . . . Let me, I pray thee, partake of thy Passion."

As the procession went on, Boscoli continued, praying, "Lord, into thy hands I commend my spirit," the same words Christ is reported to have said when near death.

Although Christ's Passion and death—in its iconographic, literary, and dramatic representations—remained the primary model for comforting the prisoner about to die, it is clear that this model was in a number of ways most *dis*comforting. Christ sweat blood when contemplating what was about to happen to him, his human companions deserted him, and his Father abandoned him. His dying was not marked by the ecstasy experienced by some of his followers. The heavens opened for the protomartyr Stephen, but they did not for Christ. It was as if the enormity of the "model" passion had sucked the pain out of the martyr's imitative act and allowed bliss to move backward a little in the sequence of events and overtake the dying. It was this example of the martyr's death that proved most cogent for the process of comforting.

The already-mentioned Sienese *Feast and History of St. Catherine* contrasts the hermit's cell at the beginning with extended prison sequences during the second and third parts. While a prisoner herself, the philosopher-saint converts a number of wise men, who had been summoned to dispute with her, as well as members of the Emperor's household, and then she comforts them as they prepare for their deaths. The third day of the play opens with a stage direction describing the Empress' sense of wonderment. She directs the gaze of the chief officials of the Court to the *grande splendore* noticeable in Catherine's cell and invites them to accompany her there. A second rubric and brief dialogue portray the Empress arriving at the prison, expressing her sorrow at Catherine's plight, and asking her whence comes the great splendor that surrounds her. The saint replies that she has received it from the Creator of all persons and, proceeding to instruct and convert the Empress, eventually comforts her for her own death.

In a later episode Catherine confronts the Emperor, who had arranged to have her starved to death in her cell, with the assertion that she remained alive by eating no human food. Rather, her sovereign spouse Jesus gave her the strength to continue to live. After a heated dispute she challenges the Emperor to do the worst he can with her: she thinks he is worth not even a button.

Catherine continues to convert those around her, and the Emperor promptly condemns the new converts to death. Catherine com-

forts them. Finally, he has her brought before him and calls her an enchantress whose spells have undone so many of those around him, even his wife. He asks her to sacrifice to his gods and marry him, and she responds by telling him to keep still. He orders her quickly beheaded. An angel, coming to comfort her, tells her heart to rejoice, for at her departure she will have a legion of angels as escort. Catherine sings a prayer, beginning "O my beloved Spouse,/ O Jesus Christ my sweet Lord," which asks him to receive her soul lovingly within his arms. Once she is beheaded, the executioner remarks that milk, not blood, issues from both head and trunk.

In the Florentine *Beheading of John the Baptist* play it is Christ himself who visits John in prison just as armed men dispatched by Herod's seneschal conduct the executioner "through straight streets" to the prison where—trembling all over, begging the saint's pardon, and making clear that he is forced to do the act—he will behead John. Christ's comforting message is marked by significant prison references. For John himself death will mean assured Paradise and a preliminary special mission to the Fathers imprisoned in Limbo to inform them of Christ's own imminent visit to release them and bring them to share the eternal feast and singing and laughing. They will see Christ coming to them glorified, just, and strong to break down the gates that confine them, then crushing Satan under his feet and binding him forever in the same prison he once ruled. Christ's final exortation begins with the "Istà forte, Giovanni" mentioned above as he assures the Baptist that his sufferings will bear great fruit and urges him not to be afraid. John's response is to tell Christ to look at his face: it is happy and dry; he is tormented by neither sorrow nor tears. He even has the courage to tell Christ to leave: "Go now, Lord, for my time is coming" (l. 543).

It is possible that the Beheading play under consideration, or another similar to it in its tradition, was the one given a grandiose production just outside the walls of Florence on Sunday, 29 August 1451, feast day of John's martyrdom.[15] The audience was estimated at 50,000. What is remarkable is that the site chosen, the Meadow of the Gate of Justice, was the actual place of public executions where on other days criminals were either beheaded or hanged after

the ritualized comforting. Such martyrdom plays provided the local populace with valuable models for the successful outcome of this process, for when things really "worked" the prisoner's cell could become radiant with spiritual light and consolation, with the sweet presence of Christ himself, while the subsequent procession to the place of justice became suffused with joy and even spousal anticipation.

As mentioned above, Book II of the Bolognese manual now in the Morgan Library contains practical advice about the comportment of the comforter during the last hours of the prisoner's life. A section that deals with the early morning of the day of execution bears the heading: "What you are to say when you hear the priest coming with the Body of Christ" (fol. 44ʳ). The comforter is instructed that as soon as he hears from far away the small bell rung before the priest, he should say with great gentleness to the man about to die: "My brother, listen. Our Lord Sir Jesus Christ is coming to visit you even in this place." When the priest arrives and is opening the pyx to remove the wafer, the comforter has the prisoner repeat a prayer expressing humility and the desire to be cured of his moral infirmity and to be incorporated into the Mystical Body of the Church, spouse of the Eternal Father. Only briefest mention is made of the prisoner's imminent death. After he receives communion, the comforter reminds him sweetly what great consolation he has, possessing within himself the Lord of heaven and earth, and urges him to repeat a prayer of gratitude asking the Eternal Father to be admitted to that ineffable and magnificent banquet where he himself is the light, full satiety, perfect joy, and eternal happiness. The priest gives his blessing and leaves, and the next instruction concerns what the comforter is to say when the first sounds of another bell are heard, summoning the citizens of the town to the execution rites. The comforter's efforts are to turn even these dreaded sounds into a means of consolation.

Even so brief and tentative an examination of disparate materials suggests the profound correspondences that existed between the rituals of public execution and the performance of Passion and Martyrdom plays. In the case of the penitential confraternities it seems

clear that a sense of brotherhood in sinfulness and need for mercy informed the efforts of the truly devout comforter during the last hours of the condemned—as well as an impulse toward spousal union with Christ. The discovery of the latter aspect may seem surprising, for it indicates that the comforting process held open to the prisoner the possibility of achieving in a very short period of time the sweetness and ecstasy of mystical union. When I first read the heady "laud and prayer" that concludes Book I of the Morgan manual I dismissed it as an example of inferior poetry replete with inelegant repetitions and imprecise formulations. But when I re-examined it in the light of Catherine Benincasa's invitation to Niccolò di Toldo as he approached the place of justice laughing: "Come on! to the nuptials, my sweet brother!" and of Pietro Pagolo Boscoli's repetitious and intoxicated "Lord, thou art my love," I realized that the "laud and prayer," inferior poetry though it might be, corresponded well with established formulations of mystical elation. In the theatrical tradition numerous martyrs go to their stage deaths singing such expressions, perhaps none more memorably than the Alexandrian Catherine in her Sienese *Feast and History Above All Others Devout and Beautiful*:

> O my beloved Spouse,
> O Jesus Christ my sweet Lord,
> You know with what affection
> I have always carried you in my heart.
> Receive my soul
> With love within your arms. (fol. 45r)

Such examples, on the stage or on the way to the scaffold, took on deep meaning in an audience urgently concerned with the Art of Dying.

Notes

1. An excellent introduction to this topic is given by Adriano Prosperi, "Il sangue e l'anima: Ricerche sulle compagnie di Giustizia in Italia," *Quaderni storici*, 17, No. 3 (1982),

959-99. See also two recent local studies: Clara Cutini, "I condannati a morte e l'attività assistenziale della Confraternita della Giustizia di Perugia," *Bollettino della Deputazione di Storia Patria per l'Umbria*, 82 (1985), 173-86; Alessandra Parisini, "Pratiche extragiudiziali di amministrazione della giustizia: la 'Liberazione dalla morte' a Faenza tra '500 e '700," *Quaderni storici*, 23, No. 1 (1988), 147-68. For a discussion in English, see Samuel Y. Edgerton, Jr., *Pictures and Punishment: Art and Criminal Prosecution during the Florentine Renaissance* (Ithaca: Cornell Univ. Press, 1985), pp. 165-210.

2. In addition to the works cited in n. 1, see Mario Fanti, "La Confraternita di S. Maria della Morte e la Conforteria dei condannati in Bologna nei secoli XIV e XV," *Quaderni del Centro di Ricerca e di Studio sul Movimento dei Disciplinati*, 20 (1978), 3-101.

3. For the diffusion of the *conforteria*, see Prosperi; a guide to the widespread popularity of Passion and Martyrdom plays for the period in question may be found in my "Italian Vernacular Religious Drama of the Fourteenth through the Sixteenth Centuries: A Selected Bibliography on the *Lauda drammatica* and the *Sacra rappresentazione*," *Research Opportunities in Renaissance Drama*, 26 (1983), 125-44.

4. Morgan Library MS. 188. I wish to express my thanks to the authorities of the Pierpont Morgan Library for permission to consult this manuscript and pertinent catalogues. For an extended discussion of the manuscript and its tradition, see Fanti, pp. 55-101.

5. For a discussion of how this work might figure in theatrical traditions see my "The First Perugian Passion Play: Aspects of Structure," *Comparative Drama*, 11 (1977), 135-37.

6. *La Passione di Revello: Sacra rappresentazione quattrocentesca di ignoto piemontese*, ed. Anna Cornagliotti (Torino: Centro di Studi Piemontesi, 1976).

7. "La Rappresentazione di San Giovanni Battista quando fu decollato," in *Nuovo Corpus di Sacre rappresentazioni fiorentine del Quattrocento*, ed. Nerida Newbigin (Bologna: Commissione per i testi di lingua, 1983), pp. 109-33.

8. Siena, Biblioteca Comunale degli Intronati, MS. I.II.33, fols. 12-45v. I am grateful to the authorities of the Biblioteca for the opportunity to consult this manuscript and others pertinent to its study.

9. For an excellent illustrated discussion of the use of the *tavoletta*, see Edgerton, chap. 5.

10. *La Passione di Revello*, pp. xix, xxiv, xxvi.

11. Ibid., p. xc.

12. Marco Piccat, *Rappresentazioni popolari e feste in Revello nella metà del XV secolo* (Torino: Centro di Studi Piemontesi, 1986). I am grateful to Nerida Newbigin for bringing this work to my attention.

13. Santa Caterina da Siena, *Epistolario*, ed. Umberto Meattini (Rome: Edizioni Paoline, 1979), pp. 1298-1302.

14. I follow here the discussion of Edgerton, pp. 183-84, and give his translation of the passage of Luca della Robbia's *recordanze* from Filippo Luigi Polidori, "L. della Robbia: Recitazione del caso di Pietro Paolo Boscoli e di Agostino Capponi, scritte da Luca della Robbia, l'anno 1513," *Archivio storico italiano*, I, Pt. 1 (1842), 278-312.

15. *Nuovo corpus*, p. 109. See the excellent illustrated discussion in Edgerton, pp. 126-64.

Music and Ceremony at the Scuola Grande di San Giovanni Evangelista: A New Document from the Venetian State Archives

Jonathan E. Glixon

European archives, while certainly unparalleled treasure-houses of historical information, have been for scholars also unending sources of frustration. The documents necessary to answer important questions in the history of peoples and cultures are often lost, incomplete, damaged, illegible, or simply unfindable (at least until after a book or article is in the proof stage). Some of the lacunae may date from centuries past, but others result from the ravages of wars, floods, or other disasters of this century (including mice, insects, and mold, or even, occasionally, negligent or incompetent archivists). Even when documents do survive, can be located, and can be deciphered, they are often totally contradictory or simply too vague to be helpful. As a result, the scholar is often faced with the task of piecing together from many disparate sources a story that, if all the original documents had been accurately prepared and carefully preserved, might have been simply and coherently told.

Such is the case with the Scuole Grandi, the great lay confraternities of the Venetian republic. These six institutions, the first of which were founded in the mid-thirteenth century and which survived until the fall of the Republic at the time of Napoleon, were among the principal charitable organizations of Venice, long famous for their patronage of art and architecture, and carried on active ceremonial and musical roles for over five centuries.[1] The Scuole were carefully organized institutions, modeling many of their procedures on those of the Venetian government. Each maintained an extensive archive of its activities, including records of council meet-

ings, account books, membership lists, and many other sorts of documents. At the time of the fall of the Republic, the documents were transferred to the newly-established state archives located in the suppressed monastery of I Frari, where they remain today.

When scholars in the 1960's first began to attempt to document musical activities at the Scuole, it became clear that the documents of the Scuole were in exactly the state described above. The archives were almost completely unindexed (only one of the six had an inaccurate index) and disordered; many of the documents were incomplete; and much had apparently been lost at some point in the previous several centuries.[2] Thus an accurate picture of musical activities at the Scuole had taken several decades to piece together and still remained tantalizingly incomplete.

In attempting to determine the ceremonial activities of the Venetian confraternities, the scholar must ask a number of questions. What were the occasions for ceremony, and why were those occasions chosen? Where did the ceremonies take place? Who participated in the ceremonies, and what were their roles? (The musicologist, of course, has a particular interest in the musicians who were present.) What were the practices and rituals associated with the various ceremonies? What role did music play in the processions and other ceremonial activities of the Scuole?

When Denis Arnold did his pioneering research on two of the Scuole in the 1960's, he was able to provide a few answers. Most importantly, he established that, at least by the end of the fifteenth century, the Scuole maintained paid ensembles of singers and instrumentalists who participated in ceremonies in the Scuole and churches as well as in outdoor processions.[3] Still uncertain were, for example, the number of singers, the number and type of instrumentalists, the makeup and character of the processions and other ceremonies, and the exact musical content of those events. To these and other problems I have been addressing my research.[4] The recent discovery of the important document that is the topic of this study—Archivio di Stato di Venezia, Scuola Grande di San Giovanni Evangelista, Registro 16—has finally provided further answers.

First it will be useful to outline the state of knowledge about ceremony and music at the Scuole that was available before this

recent discovery, particularly regarding musicians and their roles in the activities of the Scuole in the sixteenth century. The question of the occasions on which the Scuole performed significant ceremonies, along with the origins of most of them, could be answered with some certainty. The Scuole conducted a regular series of processions and other ceremonies during the year, most of which included some sort of musical participation: the first Sunday of each month, when each Scuola performed an elaborate Mass; the annual celebration of the feast of each Scuola's patron saint; processions to the Cathedral of San Pietro di Castello on the Sundays of Lent; individual processions of each Scuola to nearby churches; and the great civic processions centering on the Piazza San Marco. In addition, each Scuola provided an elaborate funeral for each of its members.[5] Before the finding of the document that is the topic of this paper, however, the routes taken by the processions were understood only in a very sketchy manner. In all cases, only the final destination was recorded in the previously known documents. The information about the timing and location of ceremonies was gathered principally from the *Notatori* or day-books of the Scuole, which recorded the deliberations of the governing councils.

The *Notatori*, along with account books of various types, helped to indicate who participated in processions and other ceremonies and what their roles were. For example, the archive of the Scuola di San Marco includes several annual registers maintained by the *Vicario* or *Guardian da Matin*, the second and third ranking officers of each Scuola (after the *Guardian Grande*), who were responsible for the majority of the ceremonies performed by the organization. Unfortunately, such registers have been located for only eight of the years between 1400 and 1600, and those that survive are frustratingly incomplete. While each does list the singers and instrumentalists (as well as those who performed other duties such as carrying the banners or candles) employed during a particular year and identifies the processions in which the Scuola participated, the particular makeup of each procession (i.e., how many singers, banner carriers, etc., as well as their order) is not specified, nor is the route of the procession or the music performed when musicians were present.

One portion of the archives of the Scuola di San Rocco remained at that Scuola, which was allowed to continue some of its activities after the others were suppressed. Included in the collection is a *Ceremoniale* that provides further information. Prepared in 1521, it lists each of the ceremonies to be performed during the year and indicates, apparently, the order of each. For example, for the feast of the Translation of San Marco, in June, the book says that in the morning the Scuola went to San Marco. The procession comprised a Crucifix, four large candles in golden candlesticks ("cirii grossi d'oro"), the instrumentalists playing in front of the Crucifix, the singers coming after the crucifix, and twelve golden double-candles ("dopieri XII d'oro").[6]

The extant documentation made possible the determination of the processions and other ceremonies in which each Scuola participated as well as the categories of the various processions, each with its own particular form of participation involving differing assortments of musicians and other *fadighenti* (as those brothers who carried candles, banners, etc. were known). The available information also enabled us to calculate how much money each Scuola spent on ceremony and how those amounts related to its overall budget.

Before the discovery of the latest document upon which I shall focus below, it had been possible, using both *Notatori* and account books as well as lists of various kinds, to know with some precision the musicians used by the Scuole in their ceremonies—even, in many cases, their names and something of their backgrounds. Each Scuola maintained at least two small choirs, each of four to six men: one, the *cantadori di morti* or *cantadori vecchi,* sang principally at funerals; the other, usually called the *cantadori de laude* (but also known as the *cantadori nuovi* or sometimes, as is the case in the document to be discussed below, *cantadori solenni*), performed at Masses in the building of the Scuola and at processions. One of the confraternities, the Scuola di San Marco, also employed a third choir, the *cantadori solenni*, which sang only on important processions. (There was, obviously, no attempt at standardizing terminology among the Scuole, and terms are not even consistent from year

to year within the same Scuola.) Most of the Scuole also hired instrumentalists (though financial difficulties sometimes made this impossible). Until the 1520's, the instrumental ensemble consisted of a harp, a lute, and a *lira da braccio*, a development of the medieval fiddle.[7] The Scuole then switched to an ensemble of four or five *lire* and later, towards the end of the century, to one of the instruments of the violin family.

The men hired as *cantadori di morti* were often poor brothers of the Scuole who could probably best be described as semi-professional singers, earning only alms for their efforts. The instrumentalists and, at first, the *cantadori de laude* were only slightly higher in prestige. These were professional musicians of little or no fame (and uncertain ability) whose annual salaries at the Scuole were far too small by themselves to support them. The *cantadori solenni*, however, and from the 1530's also the *cantadori de laude* were among the best singers in the city. In fact, these men were often singers from the Ducal Chapel of San Marco or from important monasteries. The salaries were not surprisingly somewhat higher than those of the other musicians of the Scuole, but they apparently still saw this work as merely supplemental to their principal employment.[8]

Until now, it had also been possible to determine the musical repertoire of the singers and players during the ceremonies of the Scuole only in a very general sense. Though no musical sources connected with the Scuole survive, the ceremonies of the Venetian Scuole evidently involved the performance of *laude*, vernacular songs, for voices alone or with instruments, of the type circulating in Venice and in Northern Italy in general.[9] Still unknown, however, was the manner in which the music was integrated into the ritual and the selection of musical works used in it.

Registro 16 of the *fondo* Scuola Grande di San Giovanni Evangelista in the Archivio di Stato di Venezia is entitled *Libro Vardian da Matin 1570*. The book is copied on good quality paper in a clear, if somewhat archaic hand. The folios are unnumbered, but the volume was carefully thumb-indexed into twelve sections. It is bound in boards and tooled leather, and is in an excellent state of preserva-

tion. A description of the thirteen sections of this document, with summaries of their contents, is presented in the Appendix, below. Apparently the book was once part of an annual series of registers of the Scuola and is similar to the previously mentioned books from the Scuola di San Marco. It is, however, unique. Like the books of San Marco, it records the activities supervised by the *Guardian da Matin*. Unlike those books, which were hastily and carelessly written somewhat in the manner of personal account books from which the details would be submitted in a more careful form later, this document was meticulously prepared and far more comprehensive. While the expected running accounts for processions and other activities are included (but done neatly and consistently), at least half of the book, containing information copied at the beginning of the term of the *Guardian da Matin*, presents detailed prescriptions for the activities to be carried out during the following year. These records are replete with information about the personnel, routes, and actions of many of the ceremonies.

The occasions for ceremony. Section 8 of the document opens with a listing of thirty-three occasions on which major ceremonies were enacted, and there is reference to several others in the prescriptions that follow (see Table I). While nothing essentially new emerges in this information, it nevertheless provides an accurate picture of activities in a given year, in this case 1570.

The location of the ceremonies. As mentioned above, previous knowledge about the locations of the ceremonies of the Scuole was restricted to the ultimate destination of any given procession. Much more detail is provided in Section 8 of the document. Intermediate stops required along the route of the procession are carefully specified and in fact establish a rather different picture than had been suggested by previously known documents. However, the exact route is unfortunately not described, so the exact streets and bridges to be taken or the location at which the Grand Canal was crossed by ferry, if necessary, cannot be known. Therefore, in constructing the maps that accompany this discussion, an attempt has been made to

follow what appear to be the most logical routes between stops
—i.e., the most important thoroughfares in use in the sixteenth
century. Thus the routes indicated on the maps must be considered
to be merely educated guesses.

In many instances, the ultimate goal of a procession seems in
fact to have been the only stop. This is the case with Easter Monday
(where the goal was the church of San Zaccaria), Sunday of the
Apostles (the church of the Santi Apostoli), San Giacomo (the
church of that name), and Santa Caterina (the altar of that saint in
the church of Santi Giovanni e Paolo), Corpus Domini (San Marco,
with a second procession to the church of Corpus Domini), the
Nativity of Our Lady (San Giobbe), San Lio (the church of that
name), the feast of the Holy Cross (Santa Croce), the Conception of
Our Lady (the Scuola della Misericordia), the Annunciation of Our
Lady (the Scuola della Carità), San Rocco (the Scuola di San
Rocco), and San Martino (the church of that name). There were also
several civic ceremonies at the Piazza San Marco during the feast of
San Marco, the feast of the Translation of San Marco, and Sant'Isi-
doro. On the first Sunday of each month, the Scuola went in proces-
sion in the nearby Campo of San Stin and on ordinary Sundays as
far as San Rocco. All of these single-destination processions are
shown on Map 1. Twice each year the civic processions in which
the Scuole took part went to one church in addition to the Piazza
San Marco: Santa Marina and San Vio (see Map 2). On several
days, elaborate ceremonies were held at the Scuola itself but without
a procession.

In two cases, our previous knowledge is augmented, though the
picture is not greatly changed. On Carnival Sunday (see Map 3) the
Scuole were all known to have gone in procession to the Cathedral
of San Pietro di Castello at the far eastern tip of the city. The new
information is that the Scuola di San Giovanni made a stop at the
church of San Salvatore on the return trip. Also, on the feast day of
San Lorenzo (see Map 3), in addition to the church of San Lorenzo
we now know that stops were made at San Marco and on the bridge
of San Lio, with ceremonies to be described below.

1. San Marco (numerous occasions)
2. San Zaccaria (Easter Monday)
3. San Martino
4. Santi Appostoli (Sunday of the Apostles)
5. SS. Giovanni e Paolo (Santa Catherina)
6. San Giacomo al'Orio
7. Corpus Domini (after San Marco)
8. San Giobbe (Nativity of Our Lady)
9. San Stin (first Sunday of the month)
10. San Rocco (San Rocco; sundays)
11. San Lio
12. Scuola della Misericordia (Conception of Our Lady)
13. Scuola della Carità (Annunciation of Our Lady)
14. Santa Croce

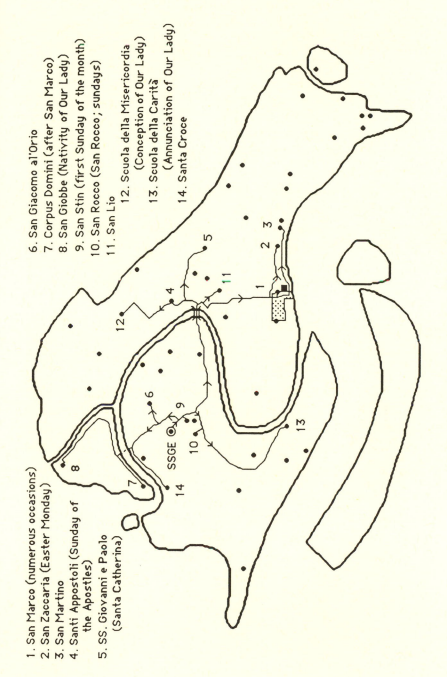

Map 1: *Miscellaneous Single-Destination Processions*

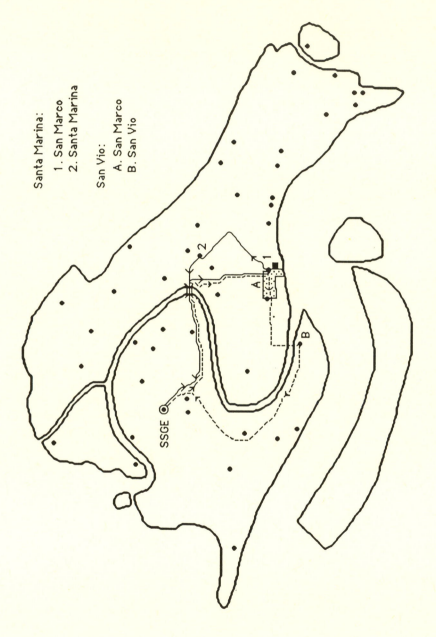

Santa Marina:
 1. San Marco
 2. Santa Marina

San Vio:
 A. San Marco
 B. San Vio

Map 2: *The Processions for Santa Marina and San Vio*

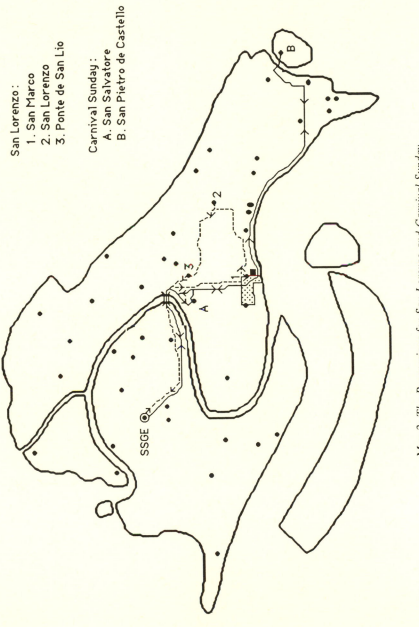

San Lorenzo:
1. San Marco
2. San Lorenzo
3. Ponte de San Lio

Carnival Sunday:
A. San Salvatore
B. San Pietro de Castello

Map 3: *The Processions for San Lorenzo and Carnival Sunday*

However, there remain a number of occasions for which our view of the ceremonies is drastically expanded by the prescriptions included in the newly discovered document. The previously available documents had indicated that on the Sundays in Lent, Palm Sunday, and Good Friday as well as on Carnival Sunday the Scuole went in procession to the Cathedral of San Pietro di Castello. It is now clear that the Good Friday procession made nine stops and that the processions on the Sundays in Lent and on Palm Sunday normally made fourteen stops (fifteen on one of the Lenten Sundays) (see Maps 4-5). All of these covered a large portion of the *sestiere* or district of Castello, including some of the poorest areas of the city, and must have made a considerable impact.

Previously known documents had provided no information at all about the procession on the night of All Souls (2 November) other than the mere fact that a procession was performed. The prescriptions contained in this document detail, on the other hand, quite elaborate processional activities. Often, the procession went only to San Marco and San Zaccaria and on the return trip to the church of Sant'Aponal, the location of one of the principal tombs of the Scuola, where the *Guardian da Matin* led the commemorative services. On other occasions, however, the procession could be much more extended, covering a large portion of the city in visits to each of the churches that possessed a tomb used by the Scuola (see Map 6). The brothers began with the nearby church of I Frari, proceeded to Santa Maria dei Carmeni, and then crossed the Grand Canal by boat to Santo Stefano. Then, after stops at San Marco and San Zaccaria as in the shorter procession, they went to the far eastern end of the *sestiere* of Castello to the church of San Domenico. Next, heading back to the west, the brothers went to Santi Giovanni e Paolo, and then to the far northwestern portion of the *sestiere* of Canareggio and the churches of Santa Maria dei Servi and the Madonna dell'Orto. Finally, recrossing the Grand Canal, most probably on the Rialto Bridge, they stopped at Sant'Aponal before returning to the Scuola.

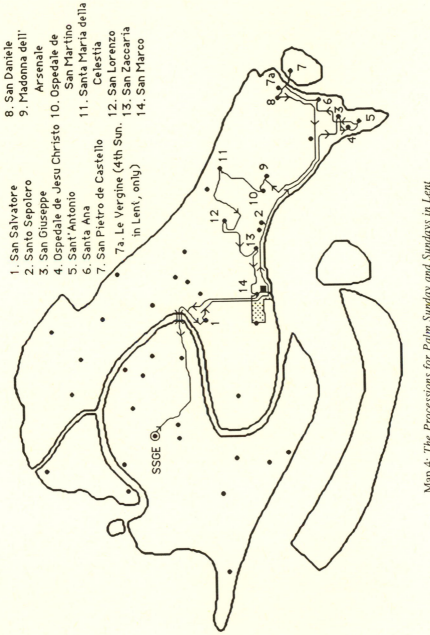

1. San Salvatore
2. Santo Sepolcro
3. San Giuseppe
4. Ospedale de Jesu Christo
5. Sant'Antonio
6. Santa Ana
7. San Pietro de Castello
7a. Le Vergine (4th Sun. in Lent, only)
8. San Daniele
9. Madonna dell' Arsenale
10. Ospedale de San Martino
11. Santa Maria della Celestia
12. San Lorenzo
13. San Zaccaria
14. San Marco

Map 4: *The Processions for Palm Sunday and Sundays in Lent*

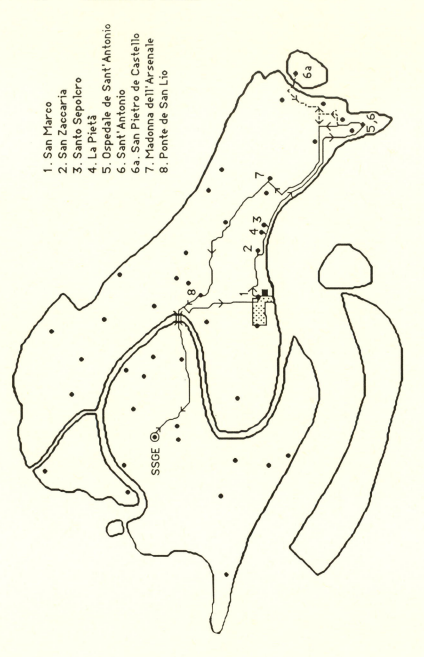

1. San Marco
2. San Zaccaria
3. Santo Sepolcro
4. La Pietà
5. Ospedale de Sant'Antonio
6. Sant'Antonio
6a. San Pietro de Castello
7. Madonna dell'Arsenale
8. Ponte de San Lio

Map 5: *The Procession for Good Friday*

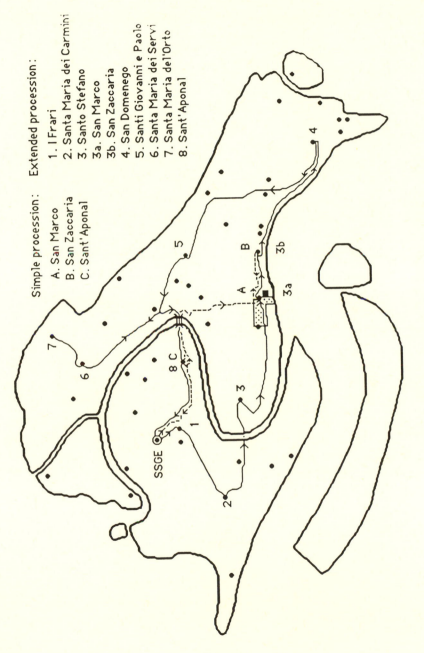

Simple procession:

A. San Marco
B. San Zaccaria
C. Sant'Aponal

Extended procession:

1. I Frari
2. Santa Maria dei Carmini
3. Santo Stefano
3a. San Marco
3b. San Zaccaria
4. San Domenego
5. Santi Giovanni e Paolo
6. Santa Maria dei Servi
7. Santa Maria dell'Orto
8. Sant'Aponal

Map 6: *The Processions for the Night of the Dead*

Even for funeral processions much more information is now available. The brothers were required to go to the home of the deceased to retrieve the body and to carry it in procession to one of the tombs of the Scuola or to some other church designated in the dead person's will. As Map 7 indicates, brothers of the Scuola di San Giovanni who died during 1570 had resided in all parts of the city, though the greatest number were from the three *sestieri* on the same side of the Grand Canal as the Scuola. Fifty-four of the burials took place in the Scuola's own cemetery, but the remaining thirty-five were scattered among twenty-three other churches, as indicated on Map 7. In many cases, the place of death and the place of burial were quite distant, providing for an extended funeral procession. No attempt has been made to trace the routes of all eighty-nine funeral processions.

Participants in the ceremonies of the Scuole and their roles. Section 7 of the document includes lists of all the *fadighenti*, those brothers who carried out specific tasks in processions. Noted first (see Table IIa) are those men who were required to "accompany the Scuola, that is, in all the processions and funerals."[10] In recompense, each man was to receive as a gift (*per regalia*) one pair of white shoes per year as well as specific payments mandated by Scuola regulations and spelled out elsewhere. This list includes the four *cantadori vecchi*, the singers for funerals. Next is a list (see Table IIb) of those *fadighenti* who received pairs of shoes but were not obligated to attend all of the processions. Though it is not indicated here, these men were required to participate in the more important functions, for which they received payments specified elsewhere. The list concludes with the names of the five *sonadori de lironi* or *lira* players.

Further details about the participants in specific processions are included in Section 8 with its prescriptions for individual occasions and in Section 10, which includes the financial accounts for the processions of 1570. For example, the prescription for the procession on the first Sunday of each month in the Campo San Stin calls for the carrying of the Scuola's valuable relic of the True Cross. In

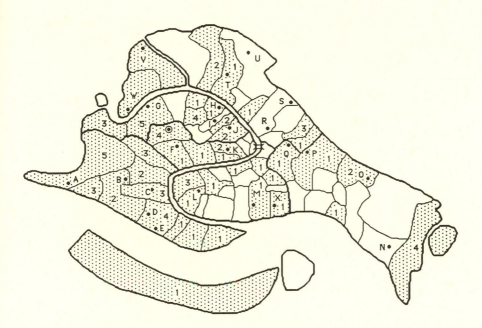

Map 7: *Funerals*

The shaded areas are those parishes from which bodies of the deceased were collected in 1570. Also indicated are the number collected from each.

The locations of the funerals and burials are also indicated by letters, as below. The numbers in parentheses indicate the number of funerals at each location.

Scuola di San Giovanni (54)

A. San Nicolo dei Mendicoli (1)
B. Santa Maria dei Carmini (3)
C. San Barnaba (1)
D. San Trovaso (1)
E. I Gesuati (1)
F. I Frari (3)
G. San Simeon Profeta (1)
H. San Stai (1)
I. Santa Maria Mater Domini (1)
J. San Cassiano (1)
K. Sant'Aponal (1)
L. Santo Stefano (1)

M. San Geminiano (1)
N. San Domenico (4)
O. San Francesco della Vigna (3)
P. Santi Giovanni e Paolo (2)
Q. Santa Maria dei Miracoli (1)
R. Santi Apostoli (1)
S. I Crosechieri [now I Gesuiti] (1)
T. Santa Maria dei Servi (1)
U. Santa Maria dell'Orto (1)
V. San Giobbe (2)
W. Corpus Domini (1)
X. San Marco

addition to those *fadighenti* required to attend all processions, men were also needed to carry "12 golden large candles, the pennant, torches, small escutcheons, and the large candlestick." Players of *lironi* were also noted.[11] The ceremonies on ordinary Sundays, however, were much more restricted. A procession without the relic of the Cross and led only by one of the *masseri* with two torches and the pennant was to go "at least as far as San Rocco" ("va almen fino a San Rocho") unless there was a special reason to go to some other church with greater ceremony.

Many of the other processions were similar to those for the first Sunday of the month. For many of these days (including most with only one or two stops in the procession), the large candles were not adorned with the gold used on the first Sunday of each month but instead with greenery. On two other days, San Rocco and the Conception of Our Lady, the brothers of San Giovanni also carried the large canopied float with a relic. On the feast of the Annunciation of Our Lady, the procession to the Scuola della Carità could be done either with the float (adding also small escutcheons with white candles adorned with greenery) or without.

A special and unusual assortment of items was carried by *fadighenti* in the Good Friday procession:

> Large candles covered in black . 50
> The crucifix that is kept on the column downstairs [in the Scuola],
> covered in black. And with this hand-carried torches . . .
> that is 10 in front and 10 behind the said crucifix 20
> Large candles, covered in black, with the pennant 4
> . . .
> The [relic of the] Most Holy Cross on the black float, and over
> that the black canopy.
> Golden small shields covered with black. And also black ones with
> large white candles on top, that is, 10 in front and 10 behind
> [the crucifix] . 20
> Hand-carried torches, six in front and six behind 12
> . . .
> One large candle of 60 to 70 lire in front of the Most Holy Cross.
> Sacks of small candles [to be] carried by the candelieri.
> A box of candles to replace those that are consumed
> . . .

Golden lanterns that are kept in the Scuola 14
Our usual black lanterns that are carried by the brothers 24
Black lanterns with golden decorations 16
Flails for those that need them for their devotions . . .[12]

On other major celebrations various assortments of the *fadighenti* listed in Tables IIa and IIb participated. The accounts in Section 10 of the document list several occasions in which additional men were required. In the processions for the Sundays in Lent, for example, the same torches and lanterns to which reference was made in the description of the Good Friday procession were carried, and for the civic processions the Scuole also needed twelve men to carry large golden candlesticks (*dopieri d'oro*). In those processions for which the *Guardian da Matin* recorded precise accounts, the total number of *fadighenti* ranged from the thirty-one on Easter Monday 1570 to the ninety on Carnival Sunday, and the amount spent ranged from five *lire* ten *soldi* (L.5 s.10), or less than one ducat, on the Sundays of Lent to L.68 s.8, or more than ten ducats, on the feast of San Marco. In addition to the *fadighenti*, of course, all of the officers and many of the five hundred brothers would also have participated in the processions.

Many of the processions call for the participation of the *cantadori solenni*, the professional singers of the Scuola. These men are not included in the listings of Section 7 of this document (or in Tables IIa or IIb) because they, unlike the *cantadori vecchi* and *sonadori*, were not brothers of the Scuola and were not under the direct supervision of the *Guardian da Matin*. Though he was responsible for ensuring that they were present at the processions, they were elected by the council (*Banca*) of the Scuola (or at times appointed by the *Guardian Grande*) and paid from the regular accounts of the Scuola by the *Guardian Grande*. The moneys disbursed to *fadighenti* by the *Guardian da Matin*, however, were considered alms and came from the special charity accounts of the Scuola.

Tables IIIa and IIIb show the typical lists of *fadighenti* for funerals, including both those performed *amore dei*, that is, at the expense of the Scuola, and those for which the deceased had paid.

The difference in cost and splendor is quite clear. Note that the cost difference is due not only to the presence of more *fadighenti* at the funerals of wealthy brothers but also that the standard payment to many of them was greater in those cases.

Another clear difference in the two types of funerals appears in the total attendance figures. Attendance at funerals was in principle required only of *fadighenti* and recipients of rent-free houses and monthly alms. Though some other brothers undoubtedly attended out of a sense of devotion, the number in most processions was quite small. At most of those funerals performed *amore dei* no more than thirty to fifty brothers attended, and the highest figure for the year was ninety-eight. The funerals of the wealthier members were a different matter even though some of them were not in fact regular brothers but rather were members of the Venetian nobility. Though men of this class could not participate in regular activities of a Scuola, they could join as *fratelli nobeli* to gain the right to an elaborate funeral. Many of those buried at their own expense by the Scuola di San Giovanni in 1570 were actually *fratelli nobeli*, including members of the Pisani, Loredan, Marcello, Badoer, Contarini, Pesaro, and Vendramin families. The great importance in the city of these men was certainly one reason for higher attendance, but even more important was the fact that at many of these funerals every brother of the Scuola who participated received alms, ranging from four to twenty *soldi* each. Those funerals at the expense of the deceased at which no alms were provided averaged seventy to eighty participants, while the eight in 1570 with alms provided—with one exception (the deceased had stipulated a simple funeral with limited attendance)—had a minimum of more than one hundred brothers in attendance. Two had more than two hundred, two others had more than three hundred, and one, at which Piero Loredan, Doge of Venice, was buried, had a surprising total of 740. Since the official membership was only five hundred, all the *fratelli nobeli*, the priests that were nominal members so as to represent the Scuola in commemorative Masses in churches around the city, and many others with some kind of claim to membership must have been included.

The rituals performed at celebrations of the Scuola and role of music. For a musicologist or scholar of Renaissance ceremony, the most exciting information in the document under consideration is contained in Sections 8 and 9: detailed prescriptions for processions and funerals for the Scuola. For each event, along with an outline of the route of the procession and a listing of the numbers and types of extraordinary *fadighenti* (both discussed above), the document provides details of all of the ceremonies, including both processions and those ceremonies performed in the Scuola itself that were the responsibility of the *Guardian da Matin.* Following are accounts of the most interesting and complex of the ceremonies.

Palm Sunday, the Sundays of Lent, and Carnival Sunday. The rituals for Palm Sunday began in the early evening when the palms to be distributed during the procession were blessed. The document specifies that a number of palms should be prepared, including one each for the Doge, the Patriarch of Venice, the Grand Chancellor, and the chaplain of the Scuola at the Cathedral of San Pietro di Castello as well as six for the six *Guardiani da Matin* of the six Scuole Grandi (including San Giovanni itself), five for the Abbesses of the five convents of nuns associated with the Scuola, all of which would be visited during the procession, and four for the *cantadori solenni* of the Scuola. All of the Scuole then went in procession on Palm Sunday with the same ultimate destination, the Cathedral of San Pietro di Castello. When the Scuola di San Giovanni encountered one of the other Scuole, a ritual for exchanging palms took place as specified in this document: the respective Guardians were to shake hands, exchange the Kiss of Peace, say, "May the Peace of the Lord be always with us,"[13] and give each other the palms carried for the purpose.

The procession itself was to follow the route discussed above (and illustrated in Map 1). At each of the fifteen stops the *cantadori solenni* were to sing a *lauda*—a procedure not previously documented. Other accounts have implied the use of this musical genre, but they do not specify how such music was to be used or how many items were sung at any given event. However, the newly dis-

covered document does not indicate exactly which *laude* were sung or whether the same item was repeated at each stop.

Identical processions, lacking of course the distribution of palms, also took place on the various Sundays of Lent, though the Scuola di San Giovanni did not go out on the third Sunday since this date was also the occasion of one of the regular meetings of the General Chapter. On the fourth Sunday, the ritual was amplified with commemorations for those nuns of the associated convents who had died during the previous year. As each of those convents was visited (the convent of Le Vergini was added to the route for Palm Sunday), the Abbess informed the Guardian of any deaths that may have occurred, and the appropriate ceremonies (identical to those for funerals of brothers of the Scuola which will be described below) were carried out by the *cantadori vecchi* at the tomb maintained for the Scuola. A similar procession was sometimes also carried out on Carnival Sunday, but more often the brothers made only one stop on the way to San Pietro, at San Zaccaria, and then returned directly to the Scuola.

These processions traversed a large part of the city of Venice through three of the six *sestieri* (San Polo, San Marco, and Castello). They were undoubtedly witnessed by large numbers of citizens. The other five Scuole Grandi undoubtedly carried out similar processions though the details of their practices are still unknown.

Good Friday. The ceremonies for Good Friday were also quite elaborate and distinct. As with Palm Sunday and the Sundays of Lent, the procession was conducted in the evening. The time of departure from the Scuola was about one hour after sunset since no Scuola was allowed in the Piazza San Marco earlier in the day. The brothers proceeded from the Scuola to the church of San Marco where, with their crucifix on the pulpit and kneeling, they witnessed the display of the relic of the Miraculous Blood owned by San Marco. At this ceremony, the *cantadori solenni* of the Scuola sang a *lauda*. Then, at the altar of San Giovanni, the brothers, again kneeling, presented the float with the relic of the Most Holy Cross while the singers sang another *lauda*. The *Guardian Grande* then removed

the black covering from the relic, while the vicar uncovered the container with the sanctified Host; similarly, all the other objects were uncovered. The brothers then left the church of San Marco and continued along the route described above (see Map 2). At each stop the *cantadori solenni* sang a *lauda*.

San Marco (25 April). On the feast of the patron saint of Venice all of the Scuole joined the clergy and government of the city in a procession in the Piazza and at services in the Basilica. The Scuola di San Giovanni carried their relic of the Holy Cross on the large float with the golden canopy. After entering the Basilica, the float was set down in the middle of the choir, and the relic was presented by the Scuola's Chaplain in turn to the Doge, ambassadors, and the remainder of the Signoria (the Doge's chief counsellors); they and others of lesser rank were also given candles. This day was also the occasion for the distribution of boots and shoes to the *fadighenti.*

Exaltation of the Cross (14 September). Because of its possession of a famous and miraculous relic of the True Cross, the feast of the Holy Cross was of great importance for the Scuola di San Giovanni. On this day, all the Scuole came to San Giovanni for the celebrations. Our document states that in past years, until 1464, the procession had gone to the church of Santa Croce, but that was no longer the practice; it now went where the *Guardian Grande* and *Banca* desired. Nevertheless, in spite of the presence of all of the Scuole for the celebrations, only the brothers of San Rocco participated in the actual procession in return for San Giovanni's participation in theirs. In the council room (*Albergo*) of the Scuola, the four chief officers (*Guardian Grande, Vicario, Guardian da Matin,* and *Scrivano*) of the other Scuole were each given painted candles (*candele miniade*). In addition, the other *Guardiani da Matin* were given, by their counterpart at San Giovanni, a half-yellow, half-white candle. Similar ceremonies took place at the other Scuole on the feast days of their patron saints. It appears that on this day some of the most elaborate music to be heard at the Scuola di San Giovanni was employed. The document refers to the *cantadori solenni*

performing along with the the Doge's singers (*capela de San Marco*) and the instrumentalists of the Scuola. Unfortunately, no further details are provided. It seems likely that this fell under the purview of the *Guardian Grande*, who supervised most celebrations that took place at the Scuola itself, and not the *Guardian da Matin*, for whose use this document was prepared.

Corpus Christi. The feast of Corpus Christi was unique among the celebrations of Venice in that it always involved two processions, one at the Piazza San Marco and a second after dinner to the Church of Corpus Christi. These processions were also famous for the elaborate floats and other paraphernalia carried by the Scuole. The only indication of such elaborateness in this document is the statement that "Sometimes, some representation in old figures from the Holy Scriptures is made, according to the wishes of the Guardian and his companions."[14] Also present in the procession were boys dressed as angels. Though the number is not specified here, the inventory of items transferred to the serving *Guardian da Matin* (in Section 3) includes twenty-five corselets *da anzoli* of gilded leather and stucco along with twenty-three pairs of wings to be attached. There were also twelve pairs of wings to be used without the corselets. Between the two processions—a time when most of the brothers returned home—the Guardian and *Banca* were provided with a room at the Scuola to remove their processional cloaks and were served "uno pocho de refrescamento" while they waited to be called for the second procession. Also, a meal was provided for the boys impersonating angels who in addition also received a pair of boots each for their services.

San Lorenzo (10 August). The Scuola di San Giovanni celebrated the feast of San Lorenzo in commemoration of a miracle performed by their relic of the True Cross in 1369 while the brothers were crossing the bridge of San Lorenzo. Dropped accidentally into the canal, the relic evaded all attempts to recapture it until, as depicted in Gentile Bellini's painting now in the Accademia Museum in Venice, the *Guardian Grande* himself leaped into the water and

brought it back to safety. On this day, after singing High Mass in their church, the Scuola went in procession, carrying the relic on the large float with the golden canopy to the Piazza San Marco and then to San Lorenzo and stopping on the bridge to sing a *lauda*. On their return journey to the Scuola, the brothers stopped at the bridge of San Lio, the site of another miracle, and sang another *lauda*.

Nativity of the Virgin (8 September). For reasons the writer of our document admits he cannot discover,[15] on this day the Scuola, after a sung High Mass at their church, went in procession to the Church of San Giobbe. They were met at the Fondamenta San Giobbe by the brothers of the Scuola di San Giobbe (one of the numerous Scuole Piccole), who carried large candles and accompanied them into the church where, at the altar in the middle ("al'altar de meza giesia"), certain *laude* were sung and a friar of the convent gave the benediction. Then the Guardian of the Scuola di San Giobbe handed to the *Guardian Grande* of San Giovanni a wooden image of the Virgin Mary. This image, apparently the property of San Giovanni, had been adorned previously by the *Guardian da Matin* with silk and jewels and brought in the morning to San Giobbe. It would now be carried in the arms of the *Guardian Grande* back to San Giovanni after the conclusion of the ceremonies at San Giobbe.

Purification of the Virgin (2 February). On the feast of the Virgin of the Candles, during the sung High Mass at the Church of San Giovanni, candles and bread were distributed to the members and officers of the Council of Ten, the governmental body that oversaw the Scuole, to the Grand Chancellor of Venice, and to the *Guardian Grande* and other officers and employees of the Scuola. Among those to receive these donations were the priests of the Church of San Giovanni—in exchange for singing the Mass, the Gospel, and the epistle—and the organist.[16]

San Lio (20 April). The feast of San Lio was observed by the Scuola di San Giovanni for reasons similar to those for the celebra-

tions for San Lorenzo. During a ceremony of the Scuola in the Parish of San Lio in the early fifteenth century, the miraculous relic of the True Cross refused, according to the legend, to be carried by an unrighteous man; the miracle is depicted in another canvas in the cycle painted for the Scuola in the late fifteenth century and now in the Accademia Museum. After singing a High Mass in the Church of San Giovanni, the brothers, carrying the relic of the True Cross on the large float with the golden canopy, proceeded to the bridge of San Lio where, stopping with the relic halfway across the bridge, a *lauda* was sung. Entering the church, they brought the relic to the choir and showed it to the parish priest and other clerics prior to returning to the Scuola.

The Night of All Souls (2 November). In Venetian tradition, All Souls Day was the occasion for commemorating deceased relatives. The Scuole adapted this tradition to their own needs. Following one of the two routes outlined above (and on Map 5), they conducted memorial services for their departed brothers before returning to the Scuola. There, at the church, the candles left over from the previous Holy Thursday ceremonies were placed on a coffin that represented those deceased during the previous year, and the chaplains sang the Mass for the Dead. Finally, the coffin was carried to the cemetery, placed on a tomb, and the usual Office for the dead was conducted (see below).

Funerals. The funeral rituals, though simpler than those for public ceremonies, are described in the document in considerable detail. The brothers went to the home of the deceased to collect the body, which had already been prepared by the *bagnadori* of the Scuola, and there, with the *Guardian da Matin* standing and all the others kneeling, the *cantadori vecchi* said three times "Jesus Christ have mercy" (*Jexu cristo misericordia*), to which the assembled brothers responded with the same words. The body was then carried to its place of burial where the same ceremony was repeated, and the *cantadori vecchi* sang "their song" ("el canto suo"). This was probably either some portion of the Office for the Dead or an appro-

priate *lauda*. In any case, unlike the *cantadori solenni*, these singers probably sang the same music at every occasion. The *Guardian da Matin* then spoke the following words:

> Dearest Brothers, Our Lord God has chosen to take up to himself the soul of this our brother. I remind you that we are obligated to say fifty Pater Nosters and fifty Ave Marias, and we will cause to have said the fifty Masses, so that the eternal God will bring his soul to the blessings of eternal life.[17]

The brothers responded "Amen," and the ceremony was concluded.

There is one additional matter that is illuminated through the data presented in this document: the annual wages of the musicians, specifically the *cantadori vecchi*. These were the only musicians of the Scuola who depended entirely on the *Guardian da Matin* for their wages. The *cantadori solenni* and *sonadori* were paid salaries by the *Guardian Grande* as well (documented elsewhere), and they participated in ceremonies at the Scuola for which they received additional pay.

Section 7 of this document enumerated six specific occasions during the year in addition to the first Sunday of each month on which the *cantadori vecchi* were to receive payments. The amounts for all four musicians ranged from L.2 to L.6 s.4 (or one ducat), totaling L.43 s.8. The expenses for thirteen additional processions listed in Section 11 add up to another L.10 s.16 for the four men. They received L.1 for each of fifty-eight funerals *amore dei* and L.2 s.8 for each of thirty-one funerals done at the expense of the deceased for a total of L.132 s.8 for funerals, to which can be added L.12 s.16 in total alms distributed for attending certain funerals. In all, the four men were paid D.35 L.1 s.8, or eight ducats, five lire each. The annual salaries for *cantadori solenni* during this period ranged from eight to twelve ducats a year, but they also were paid for some individual events. Further, many also were full-time singers at the ducal Cappella and received annual salaries of fifty ducats or more. The *cantadori vecchi*, on the other hand, probably had few sources of income outside of the Scuola both because of their appar-

ently lower level of ability (none are ever found in the lists of sing-
ers at major institutions) and the large number of occasions on
which they were obligated to the Scuola—at least 120 days each
year when all of the processions and funerals to which reference is
made in this document are added together.

The *Libro Vardian da Matin 1570* of the Scuola di San Gio-
vanni Evangelista is one of those rare documents that seems to have
been tailor-made for scholars. It presents a wide variety of informa-
tion in a clear, interesting, and relatively complete form, is clearly
written and well-preserved, and, perhaps most remarkably of all,
actually answers the kinds of questions that initially draw scholars
to archival research.[18]

Table I

The Celebrations of the Scuola di San Giovanni Evangelista

First Sundays of each month	12 in all
Annunciation of Our Lady	25 March
Holy Thursday	— March
Easter Monday	— April
Sant'Isidoro	16 April
San Lio	20 April
San Marco	25 April
The Most Holy Cross	3 May
The Most Holy Corpus Christi	
San Vito	15 June
San Marco	25 June
The Visitation of Our Lady	2 July
Santa Marina	17 July
San Giacomo	25 July
San Lorenzo	10 August
The Assumption of Our Lady	15 August
San Rocco	16 August
The Nativity of Our Lady	8 September
The Exaltation of the Cross	14 September
The Commemoration of the Dead	2 November
San Martino	11 November
The Vigil of Santa Caterina	24 November
Santa Caterina	25 November
The Conception of Our Lady	8 December
San Giovanni	27 December
The Purification of Our Lady	2 February

Processions not entered in the primary list, but appearing in the prescriptions in Section 8:

> Every Sunday of the year
> Carnival Sunday
> The Sundays of Lent
> Palm Sunday
> The night of Good Friday
> Sunday of the Apostles

Table IIa
Fadighenti Obligated to Attend all Processions

three pennant carriers . . .
four torch bearers . . .
eight pallbearers . . .
four funeral singers
> Ser Zan Maria Caleger
> Ser Domenego Baso
> Ser Gasparo de Vetor
> Ser Batista de Zerolemo

two to prepare the body . . .
one boatman . . .
one bell-ringer . . .
two escutcheon carriers . . .
two reserve escutcheon carriers . . .
one captain to guide the Scuola . . .

Table IIb
Fadighenti with Limited Obligations

eight to carry the large float . . .
six to carry the large canopy . . .
four to carry the small float . . .
four to carry the small canopy . . .
one to carry the large candle . . .
six candle-carriers . . .
five players of *lironi*
> Ser Zuane de Antonio
> Ser Vizenzo de Lorenzo
> Ser Paze de Paze
> Ser Batista de Damian
> Ser Pasqualin de Canzian

Table IIIa
Payments for Funerals *amore dei*

To the Chapter of the parish	L.3 s.-
To the two embalmers	L.1 s.12
To the eight pallbearers	L.1 s.4
To the sacristan to open the tomb	L.- s.8
To the boat to carry the coffin	L.- s.8
To the bellringer	L.- s.2
To the singers	L.1 s.-
For fifty Masses	L.2 s.10
Total:	L.10 s.4

Table IIIb
Payments for Funerals at the Expense of the Deceased

To our Chaplain and his assistant	L.1 s.4
To the three who carry the banner	L.2 s.5
To the three candle carriers	L.3 s.-
To the two embalmers	L.4 s.-
To the eight pallbearers	L.5 s.12
To the four singers	L.2 s.8
To the four escutcheon carriers	L.- s.8
To the boat to carry the coffin	L.- s.10
To the bellringer	L.- s.6
To the Captain to lead the Scuola	L.- s.4
To the three *masseri*[19]	L.1 s.4
To have the candles brought to the Scuola	L.- s.6
For fifty Masses	L.- s.6
Total:	L.23 s.17

When necessary, there is an additional payment of s.16 for a *Peota* (a type of Venetian boat) to ferry the brothers across the Grand Canal.

Appendix

Summary of the Contents of Archivio di Stato di Venezia
Scuola Grande di San Giovanni Evangelista
Registro 16: *Libro Vardian da Matin 1570*

Section 1: [Introduction]. This portion announces the topic of the document and lists the serving officers (the *Banca*) for the year 1570.

Section 2: *Offitio del Vardian da Matin*. Included here are summaries of all of the regulations in the bylaws of the Scuola (the *Mariegola*) concerning the duties of the *Guardian da Matin*, along with the texts of the prayers to be said by the Guardian at the beginnings of functions over which he presided. This is among those sections copied at the inception of the Guardian's term of office.

Section 3: *Consignation*. Two inventories of the items used in processions (including floats, candlesticks, banners, etc.): one, written at the beginning of the year, of those turned over to the writer of this document by his predecessor, and a second, written at the end of the year, of those delivered by the writer to his successor. Neither list contains any items related to music.

Section 4: *Cappe*. List of robes (*cappe*) received by the Scuola and distributed to its members. In 1570, the total was 187.

Section 5: *Candelle*. List of candles distributed to brothers for carrying in processions; for the year 2,655 were recorded.

Section 6: *Dopieri*. Listing of large candles, 556 for the year, received from donors.

Section 7: *Case et mesi—e fadighenti*. This section opens with a list (compiled at the opening of the Guardian's term) of all those houses granted rent-free to poor brothers, with the names of the recipients, as well as a similar list of the holders of entitlements to monthly alms. Following are the lists of the *fadighenti*, or poor brothers who received alms in exchange for carrying out specific tasks in funerals or processions. See Tables IIa and IIb, above. The section also contains an enumeration of certain additional alms to be paid to specified *fadighenti* on indicated days. These payments included two *lire* to be divided among the four *cantadori vecchi* on the first Sunday of each month. In addition, the *cantadori vecchi*, the pennant carriers, and the torch bearers were each to receive payments on six other days: the night of Good Friday, Corpus Christi, San Lorenzo, the Nativity of the Virgin, All Souls Day, and San Martino.

Section 8: *Feste*. First there is a list of the processions to be performed by the Scuola during the year (see Table I). Then follows a detailed account (occupying fifteen pages) of the procedures and routes of each function, arranged, with one

exception, chronologically—i.e., beginning with those feasts that usually occurred near the beginning of the Venetian year (1 March), the Annunciation of the Virgin and Palm Sunday—and ending with those at the end of the year, the Sundays of Lent. All of this material was copied at the beginning of the Guardian's term, and most probably from a considerably older book. Evidence for the earlier date of the original text is the placement of the procession for the feast of San Lio, which takes place in April, at the end of the chronological list as an addition. This feast was instituted in the fifteenth century in commemoration of a miracle that occurred at the bridge of San Lio. While in 1570 the procession had been observed for more than a century, it still occurs out of place and with the notation that this is so because it has only been done "in recent times" ("da pocho tenpo in qua"). The document therefore preserves, at least in part, a text which dates from before the middle of the fifteenth century with an addition from that date.

Section 9: *Morti*. The section opens with material copied at the beginning of the year that details the participants and procedures for the funerals, including information about musical participation. Following the prescription for the funeral ceremonies, the *Guardian da Matin* recorded the details of the eighty-nine funerals performed during 1570. For each person, he entered the name, parish of residence, and place of burial. Also, he noted whether the funeral was performed at the expense of the Scuola (*amore dei*) or with funds supplied by the deceased in his will. In the latter case he also recorded the amount of money paid to the Scuola for this purpose, the number of large candles (*dopieri*) donated, and the alms offered to each brother who attended the funeral. Finally, the accounts list the total number of brothers who attended and the payments to the various *fadighenti*.

Section 10: *Spese*. Information about those non-funeral processions that involved the disbursing of specific amounts to *fadighenti* over and above the payments prescribed in Section 7.

Section 11: *Monestieri*. Accounts for the payments of annual fees to the ten monasteries that housed tombs for brothers of the Scuola.

Section 12: *Receveri*. Entered here are copies of the receipts provided to the Scuola by the priors of the monasteries.

Notes

1. For a broad study of the charitable activities of the Scuole, see Brian Pullan, *Rich and Poor in Renaissance Venice* (Cambridge: Harvard Univ. Press, 1971), chaps. 1-4.

2. The Archivio di Stato di Venezia has in the past several years begun indexing the remainder of the documents of the Scuole. I would like to thank Drs. Francesca Romanelli and Pietro Scarpa for allowing me to see their work in progress.

3. Denis Arnold, "Music at the Scuola di San Rocco," *Music and Letters*, 40 (1959), 229-41, and "Music at a Venetian Confraternity in the Renaissance," *Acta Musicologica*, 37 (1965), 62-72.

4. For a broad study of music in general at the Scuole in the Renaissance, see my doctoral dissertation "Music at the Venetian Scuole Grandi, 1440-1540" (Princeton University, 1979). See also Jonathan E. Glixon, "Music at the Scuole Grandi, 1440-1540," in *Music in Medieval and Early Modern Europe*, ed. Iain Fenlon (Cambridge: Cambridge Univ. Press, 1981), pp. 193-208, and "Music at the Scuole in the Age of Andrea Gabrieli," in *Andrea Gabrieli e il suo tempo*, ed. Francesco Degrada (Florence: Leo S. Olschki, 1987), pp. 59-74.

5. These ceremonies are classified and described in general terms and their origins and histories are discussed in Jonathan Glixon, "*Far una bella procession*: Music and Public Ceremony at the Venetian Scuole Grandi," in *Altro Polo: Essays on Italian Music in the Cinquecento*, ed. Richard Charteris (Sydney: Frederick May Foundation for Italian Studies, 1989), pp. 148-75.

6. Archivio della Scuola di San Rocco, *Ceremoniale, 1521*.

7. On the use of the lute at the Scuole, see Jonathan E. Glixon, "Lutenists in Renaissance Venice: Some Notes from the Archives," *Journal of the Lute Society of America*, 16 (1983), 15-26.

8. See Jonathan E. Glixon, "A Musicians' Union in Sixteenth-Century Venice," *Journal of the American Musicological Society*, 36 (1983), 392-421.

9. See Jonathan E. Glixon, "The Polyphonic Laude of Innocentius Dammonis," *Journal of Musicology*, 8 (1990), 19-53, and Francesco Luisi, *Laudario Giustinianeo* (Venice: Edizioni Fondazione Levi, 1983) (but see also my review in the *Journal of the American Musicological Society*, 41 [1988], 170-79).

10. "li quali ano la medema obligation de aconpagnar la Scuola cioè tute le procesion et corpi" (Archivio di Stato di Venezia, Scuola Grande di San Giovanni Evangelista, Registro 16, *Libro Vardian da Matin 1570*, Section 7. Henceforth, this document will be referred to as *Libro Vardian*).

11. "con dopieri d'oro no. 12, penelo, cierii, brazaleti, et cierio grosso" (*Libro Vardian*, Section 8).

12. "Dopieri inastadi in negro . . . no. 50/ El crocefiso che sta ala colona da baso coverto de negro. Et con quelo: torze da man . . . , cio x avanti et x da driedo all dito crocefiso . . . no. 20/ Cierii col penelo coverti de negro . . . no. 4/ . . ./ La santissima croxe sopra el soler negro et sopra quela la ombrela negra./ Brazeleti doradi coperti de negro, et an[c]o li negri con dopieri bianci suso, cioe x avanti et x da driedo . . . no. 20/ Torze da man

bianci, sei davanti et sei da driedo . . . no. 12/ . . ./ Uno cierio groso de lire sesanta in setanta avanti la santisima croxe./ Sacheti da candelete menude portano li candelieri./ Uno carnier da candele per cambiar alcune ce se consumano. . . ./ Ferali d'oro ce sono in scuola . . . no. 14/ Ferali negri nostri consueti se porta fra li frateli . . . no. 24/ Ferali negri con li prefili d'oro . . . no. 16/ Batudo queli che per sua devotione vegnerano . . . no. —" (*Libro Vardian*, Section 8). Though the Scuole Grandi began as flagellant societies, that practice had nearly ceased by this time, occurring, apparently, only on Good Friday.

13. "la pace del nostro signor Dio sia senpre con vui" (*Libro Vardian*, Section 8).

14. "Fase qualce volta qualce representation de figure antique segondo la sachra schritura, come apar a misser lo guardian et conpagni" (*Libro Vardian*, Section 8).

15. "La causa de questa cirimonia altramente non si sano, nenon si trova nele nostre schriture salvo quanto è dito di supra et in libro grando dela scuola a conto dela giesia de san jopo" (*Libro Vardian*, Section 8).

16. The organist is not mentioned elsewhere in this document since his responsibilities were confined to duties inside the Scuola and its church and thus not under the direction of the *Guardian da Matin*.

17. "frateli carisimi, la parso al nostro signor dio de tirar a se l'anima de questo nostro fratelo, et vi aricordo che semo obligati a dir cinquanta pater nostri et cinquanta ave marie, et nui li faremo dir le cinquanta mese acio che l'eterno dio conducha l'anima sua ali beni de vita eterna" (*Libro Vardian*, Section 9).

18. Research for this study was carried out with the aid of a grant from the American Philosophical Society.

19. The chief duty of the *masseri* was to notify the brothers of funerals, processions, and meetings of the Scuola.

Cene and Cenacoli in the Ascension and Pentecost Companies of Fifteenth-Century Florence

Nerida Newbigin

Students of the documents of the Sant'Agnese company in Florence's Santa Maria del Carmine (and we are now a large fellowship) are invariably impressed by the amount of food consumed by the *festaiuoli* in their preparation of the annual *festa* of the Ascension. This paper looks further at the way that the Cenacle, scene of the communal meal, is drawn into the dramatic iconography both of the Sant'Agnese company's Ascension play and of the Spirito Santo company's Pentecost play, and at the way in which *festa* by the fifteenth century is a term that incorporates not only the ideas of representation and play but also the notion of feasting, the communal meal in its most joyful sense.[1]

The semantic overlap of eating and festivity that we find in the English word *feast* from at least the end of the fourteenth century is not found in Italian.[2] The Italian *festa*, like the Latin *festum*, denotes a holy day and by extension a holiday—and then the ceremonies by which it is celebrated. Feasting is not part of the ceremony by which a feast day is celebrated; rather eating is so central to the notion of *festa* that it goes without saying.[3]

Celebratory eating constitutes the most solemn part of the Church's daily ritual, the sacrifice of the Lord's Supper, in which the consecrated elements of bread and wine are consumed by the faithful as the body and blood of Christ. The sacrament daily re-enacts the Last Supper of the Thursday of Holy Week, an event of spiritual communion whose images suffuse every aspect of conventual and confraternal life in the fifteenth century. While there is no

90

doubt that the breaking of bread and drinking of wine in the Lord's Supper commemorates (or symbolizes or *re-enacts*) the sacrifice of Christ's body, I would argue that the Lord's Supper also had a paradoxically joyful aspect that was far more spontaneous and found far easier expression than the penitential aspect.[4] Joyful, too, were the *colazioni* or festive meals of confraternities and convents and also the *pietanze* established by bequest, like the annual Annunciation dinner for the friars of Santa Maria del Carmine, for which Chiaro Ardinelli required the Sant'Agnese company to pay twelve lire annually.[5]

The Last Supper and its commemoration become fused with the immediate act of eating when the Last Supper is painted on the walls of convent refectories. The first Florentine refectory to be decorated with a Last Supper was Santa Croce (Taddeo Gaddi, c.1360).[6] It was followed closely by Santo Spirito (the Master of the Pentecost and the Master of the Santo Spirito Refectory, 1360-65),[7] San Marco (attributed to Fra Angelico),[8] Sant'Apollonia (Andrea del Castagno, c.1445-50),[9] Ognissanti (Ghirlandaio, 1480), San Giorgio alla Costa (Ghirlandaio, 1488), and San Marco (small refectory, Ghirlandaio, c.1489?). While we cannot verify Gilbert's assertion that "every . . . Quattrocento refectory in Florence has one,"[10] it is clear that many did bear a fresco which illustrated the Gospel narrative of Christ's celebration of Passover with his apostles.[11]

The scene of the Last Supper is invariably the *Cenaculum*, the "upper room" in the plain language of the Authorized Version of the Bible or the Cenacle, as I shall call it for my purposes here. *Cenaculum* originally meant a dining room, and hence the upper story, an upper room, a garret, an attic. The term is used three times in the Vulgate: in *Mark* 14.15 and *Luke* 22.12 to refer specifically to the upper room of the Last Supper, and in *Acts* 1.13 to identify the Cenacle to which the apostles returned after the Ascension.[12] This pattern of movement, of Christ's Ascension from the Mount of Olives and the apostles' return to the Cenacle, mirrors that of Christ's earlier supper with the apostles and departure for the Mount of Olives on Holy Thursday. The exegetes cannot resist the symmetry, and the two cenacles become the one.

The exegetes' love of symmetry is then responsible for inventing the third reference to the Cenacle. Fifty days after Passover, the apostles gather together to celebrate Pentecost. They gather together, according to the Vulgate, *in eodem loco* (*Acts* 2.1): "all in one place," according to the Authorized Version, but "in that same place," the Cenacle, according to the exegetes,[13] where the Holy Ghost descended on them in tongues of fire.

In the subsequent textual tradition, the Cenacle overlooking the towers of Earthly Jerusalem, the groves of the Mount of Olives, and the space between them are thus incorporated into the physical space of each of these three solemn feasts, the Last Supper, the Ascension, and Pentecost. The Ascension and Pentecost have a fourth—divine—dimension, which will be exploited in the plays, of communication between heaven and earth.

The visual tradition of the Cenacle is not as consistent as the textual tradition. The iconography of the Last Supper is too well documented to require further discussion here; and that of the Ascension does not, to my knowledge, incorporate the Cenacle in any way, and for this the sources may be responsible.[14] Pentecost, however, does incorporate the Cenacle in at least one of its two iconographical traditions.[15] In Andrea di Buonaiuto's Pentecost in the Dominican chapter-house of Santa Maria Novella, painted between 1366 and 1368 (fig. 1), the Cenacle is an upper-story *loggia*.[16] As Peter preaches, the fire of the Holy Ghost descends upon the apostles seated with the Virgin around the table of the upper room. Below, Pentecost pilgrims from many lands hear Peter preach, each in his own tongue, in fulfillment of Christ's last command to his apostles.[17]

I shall now turn to play texts and to records of the *laudesi* confraternities of the Carmine and Santo Spirito to determine the extent to which the two companies use the Cenacle (and suppers), Jerusalem, the Mount of Olives, and space between them as their *luoghi deputati*.

The extant Florentine *rappresentazione* of the Last Supper and Passion by Castellano Castellani dates from the last decade of the century.[18] There is no extant Florentine text of the mid-fifteenth

century that deals with the Last Supper, although the events of Holy Thursday are re-enacted in the ritual of a number of Florentine confraternities,[19] and are included in both the Maundy Thursday *laude drammatiche* of the Umbrian cycle.[20] Nevertheless, it appears that the Ascension company, like the Pentecost company, had a set of wooden Apostles and a table, and it displayed them on the Thursday and Friday of Holy Week.[21] The display of a table ("desco"), appropriately adorned and attended, was a standard part of a confraternity's obligations to its church on high feasts, but in this case the table is attended not by the company's *capitani* but by the wooden apostles.[22] The scene represented is clearly the Last Supper and establishes the Cenacle as part of the Ascension company's iconographic repertoire.

For the feast of the Ascension proper we have only one play text, which I shall examine before looking at the Santa Agnese records. It is a short work of only seventy-two lines composed by Feo Belcari.[23] Although his name does not appear in the records I have transcribed, we know that Belcari was associated with the Santa Agnese company since on behalf of the *festaiuoli* of the Ascension he composed a sonnet thanking Cosimo de' Medici for his gift of a barrel of wine.[24] He may be the person to whom reference is made in an expense for 1443: "For expenses in entertaining the person who was charged with redoing Christ's lines, 11 soldi, that is to entertain him."[25]

Belcari's Ascension begins, as all the later, formal *sacre rappresentazioni* will do, with an angelic salutation. There then follows a long section without words for which the stage direction reads: "Then Christ, having eaten with the apostles, leaves Jerusalem, and all the apostles have their insignia in their hands, and at the foot of the Mount Christ says to them. . . ."[26] This fusing of *Luke* 24 and *Acts* 2 is not canonical, but it probably comes from Meditation XCVII of the *Meditations on the Life of Christ*,[27] source of so much of the narrative detail of fourteenth- and fifteenth-century painting and drama, rather than from Belcari's own imagination. Since there is no dialogue to accompany the meal (implicit in "having eaten with the apostles"), it must have been acted out, perhaps in a visible

Cenacle on the ramparts of Jerusalem. At the foot of the Mount of Olives, one apostle speaks on behalf of all of them, Christ comforts them before going up onto the Mount ("sale sopra 'l Monte") and bidding them to go forth and preach. After the seventh stanza, the Ascension takes place without explicit stage direction. The text continues: "And when Christ has gone up into heaven, two angels come down from heaven and say to the apostles who are gazing up to heaven: 'Why do you gaze in amazement?' . . ."[28] The final stanza is spoken by the Virgin to the angels, but functions equally well as a *licenza* to the audience:

> *La Vergine Maria risponde a quegli duo Angeli:*
> Quando tornati sete al vostro loco
> pregate 'l sommo Padre, eterno Dio,
> che mandi presto a noi quel divin foco
> dello Spirito Santo dolce e pio.
> Tutti ci consumiamo a poco a poco
> non più vedendo il mio Figliuol giulio,
> e quel clemente preghiam che discenda
> che ci ammaestri, consòli e difenda. (ll. 65-72)

> *(The Virgin Mary replies to those two Angels:*
> When you return to your place,
> ask the highest Father, eternal God,
> to send us soon that divine fire
> of the Holy Spirit, sweet and good.
> We are wasting away gradually
> now that we cannot see my joyful Son,
> and we beseech him in his mercy to come down
> to teach, console, and defend us.)

The text of the play is, to an extent, an antidote for the action. In the earliest record that we have of the Carmine spectacle, Francesco Sacchetti's *novella* of c.1390,[29] no mention is made of music or speech or fireworks: he focuses on the figure of Christ being pulled up to heaven, without extraordinary machinery or great jubilation in heaven. In 1422, the year in which the roodscreen in the Carmine was completed, Paolo di Matteo Pietribuoni notes the spectacle and

fireworks and the presence of the apostles and the women but makes no mention of dialogue.[30] It is possible that in the early stages of the *festa* there were no spoken words and that the message of Ascension—the imminent gift of the Holy Spirit, the accompanying gift of tongues ("Di nuove lingue a tutti parleranno," l. 43), and the obligation to preach—was simply not made clear. The Belcari text that I have described is clearly reformist: it shifts attention from the spectacle to the spiritual implications of the mystery, the imminent sending of the Holy Ghost and the obligation to preach. The famous opening lines of his Abraham and Isaac play,

> L'occhio si dice ch'è la prima porta
> per la qual l'intelletto intende e gusta;
> la seconda è l'udir con voce scorta,
> che fa la mente nostra esser robusta (ll. 1-4)

> (It is said that the eye is the first gateway
> through which the intellect understands and savors;
> the second is hearing with a clear voice
> which strengthens our minds)

underline Belcari's desire to take the already well established Florentine *rappresentazioni* beyond the purely spectacular and into more complex doctrinal issues.

There can be little doubt that this Ascension text is related to the Ascension performed in Santa Maria del Carmine. The Carmine properties included a *castello* with towers[31] which represented Jerusalem, a *monte* from which Christ ascended, adorned with flowers and drapes, elaborate machinery for lowering angels and raising Christ, and two locations for heaven. And even though Belcari's play refers to one heaven only, to which Christ ascends and from which the two angels descend, it does not preclude the use of the two that are documented in the account books and in Abraham of Souzdal's description.[32]

Although marginal in the Ascension play, the Cenacle was central to the apparatus of the Spirito Santo company's Pentecost play.[33] According to Richa's description, wooden apostles sat in "un

Cenacolo, o sivvero una Sala illuminata dalle lingue di fuoco"[34] while actors acted the parts of live apostles below. The 1444 inventory in fact lists together "a platform and a castle for the *festa*" and "a castle where the apostles are arrayed."[35] A first castle had been constructed in 1431, but in 1437 a new castle-*cum*-platform was constructed. It consisted of a light roof ("tetacio") held on only by tacks ("autuzi da naserelare") but with real eaves over a portico ("14 gronde pe' tetacio de l'andito"). A week before the *festa*, the *castello* was carried from the refectory into the church, and its creator, Agnolo di Lazero d'Arezzo, master carpenter, and four others, continued to work on it. Carved capitals for the columns of the portico were delivered on 14 May, and on 17 May, two days before the *festa*, chestnut trees were arranged around the platform.

For the play, the Apostles and Virgin were seated around a table ("desco di nocie pe' gli apostoli") which had been crafted the year before by the same Agnolo di Lazero.[36] The scene must have differed little from the one that we see in Andrea di Buonaiuto's Pentecost fresco or the initial illumination of the Santo Spirito company's fourteenth-century *laudario* (fig. 2),[37] or, for that matter, from the open Cenacle of the Last Supper in the Santo Spirito refectory, of which only a small section remains on account of the nineteenth-century conversion to a bus depot.[38]

Both the extant Pentecost play texts appear to be associated with the Spirito Santo company's *festa*. In Belcari's three-stanza piece,[39] which is probably the earlier of the two, the narrative of *Acts* is telescoped so that the election of Mathias as the replacement twelfth apostle is immediately confirmed by the descent of the Holy Ghost: "Viene uno segno dal Celo sopra Mattia." The 1444 inventory confirms that this was part of the company's performance since it includes "1ª chorda pe' razo di Sa' Matio di chorda pisana" as well as the "due chorde da razi grande quant'è lunga la chiesa, di chorde da ragnia." But there is no explicit reference in the text to a communal meal, to the location of the event in an upper room, or even to the presence of the Virgin.

The scene illustrated in the woodcut that accompanies the printed play, *La festa del Miracolo dello Spirito Santo* (fig. 3),[40] is like-

wise not located, although the Virgin is clearly present. The text follows a pattern of action (and consequently implies a stage setting) similar to that of the Ascension. There is a hill ("colle") from which the Apostles descend in small groups but which has no further function. They meet and journey to Jerusalem where they join the Virgin and Mary Magdalene. Again there is no explicit reference to the meal, and there is no clear indication of the way in which the Holy Ghost descends in response to the Virgin's prayer. What is clear however is that, as in the Ascension play, the upper room in Jerusalem is visible: presumably it is again an open *loggia* that sits on top of the walls of the *castello*.

So far I have discussed only the location of the Cenacle but not the details of the scene. I cannot say whether the tables were round or rectangular[41] or how realistically any of these tables were laid. Were there plates, flasks of wine and glasses, fish, flowers, and fruits which in the visual arts gain such iconographical significance? There is no doubt that the decorations were opulent: wall drapes and bench covers were tacked on, garlands were strung along the walls, huge quantities of flowers were bought from ladies who delivered them to the door of the church—or agents went (with a horse and cart hired from Matteo the innkeeper) to buy them in the country.[42] It is inevitable, after the austerity of Lent, without feasting and without flowers, that the following weeks should be celebrated with flowers and fruits of the new season. We find above all broom and wild iris (*ginestra*, and *fioralisi* or *pancaciuoli*), cultivated flowers (*fiori dimestichi*) including roses and pinks, and the greenery of ivy, myrtle, oak, laurel and chestnut. They decorate the *monte* for the Ascension, and they are tied in bunches and garlands. From 1442 or even earlier the principal decorative element of the *festa* is a huge *giglio*, made of flour and glue, wool clippings ("cimature di guarnello") in red and white, all mounted on an armature of wire and hauled up, possibly onto the façade of the Carmine, with such effort that the helpers who took it down had a special feast of their own.[43] The binding force of this image cannot be overestimated: the red-on-white *giglio fiorentino* gave its name to the golden florin which in turn bore its image. At least until Louis XI allowed

Cosimo's son Piero to make it part of the Medici coat of arms, the *giglio* guaranteed the *festa* in the service of the city.

As indicated at the beginning of this paper, the apostles' meal is not the only meal in question. The Ascension company (to a greater extent than the Pentecost company) was generous in its provision of food for those who made a special effort for the *festa*. Both the *maestri* who were paid for major works and the *festaiuoli* who gave their time freely are regularly offered cheese, salad, and wine as a *merenda* when their work is done. The company also offered two feasts: the *colazione* for about fifty people on Wednesday evening before the Ascension which consisted typically of white bread and *berlingozzi*, pomegranates, and sometimes cherries, cheese, beans, peas, and meat; and a second *merenda*, for the *festaiuoli* on the Friday, which offered an ample meal of fish (*tinche*), salad, and cheese. By 1442, it had become quite grand: 179 bread rolls, 500 *cialde* ("wafers" or, perhaps, "waffles"), and six barrels of wine for the *colazione* are purchased by the company; in addition, bread, meat, and wine are offered to the angels in the house of Niccolò di Piero, and a special feast for the *garzoni* is offered by the Pope and other cardinals.[44] There is no suggestion that the papal retinue attended the feast: it is a celebration of togetherness, but only for those who are insiders already.[45]

By 1445 the company seems to be committed to supplying food to the *festaiuoli* at least once a week for the entire period from the Monday after Easter, when preparations began, until the play is taken down after Ascension; and for the first time we find them buying arsenic to poison the rats.[46] By now the company is richer than ever, and spends around 300 lire for its *festa*. But it continues to exclude outsiders from the preparation of the *festa*. It has become necessary for those involved to be identified by means of a colored bead on a string tied around their arms.[47] Besides the two *famigli* of the Signoria, who have always stood at the doors during the *festa*, the company must now hire a security guard for two days before the *festa* and two days after.[48] In 1447 there are more *cene* than ever: Wednesday evening, Thursday morning, Friday, and then separate *cene* for the angels (who were *cherichetti*, and not allowed to mix

with the *garzoni*) and the three teams of *festaiuoli*, each led by their Sant'Abate: the Sant'Abate of the Vaults (where the *castello* and the *monte* stood), the Sant'Abate of Paradise, and the Sant'Abate of the *Nughola* (on which Christ ascended). And even though the level of breakages regularly reaches a third of the glasses and flasks hired, they do not seem to have been particularly rowdy affairs.

The Ascension *festa* and the Pentecost *festa* flourished until the calamitous events of March 1470/71 when, together with the Annunciation *festa* in San Felice, they were put on (in spite of the Lenten date) for the visit of Galeazzo Maria Sforza, Duke of Milan. The old Santo Spirito church was destroyed as a result, and with it went the annual Pentecost play. Accounts for the Ascension plays peter out a few years later in 1474. Briefly, however, the events of 1471 established the Florentine *feste* as a diplomatic tool for the new Medici regime: the mid-summer San Giovanni processions enjoy unprecedented popularity, saints' plays (which rely far more on plot than on machinery) are being performed in Piazza Santa Croce and in front of San Iacopo tra le Fosse, and Florentine *festaiuoli* are summoned to Rome and Ferrara to perform. Pietro Riario, cardinal of San Sisto and nephew of Francesco della Rovere (who as Sixtus IV gave new luster to the politics of nepotism), became Bishop of Florence in July 1473, and in the six months until his death in 1474 he exploited the Florentine resources he suddenly found at his disposal. When Eleonora of Aragon and her entourage stayed at his Roman palace on their way from Naples to her marriage in Ferrara, Florentine *festaiuoli* performed as dinner entertainments the *sacre rappresentazioni* of Susanna, of Corpus Christi ("del giudeo che arrostì il corpo di Cristo"), of the Nativity with the Magi, of the Resurrection and Harrowing of Hell, of the Beheading of John the Baptist (a cautionary dinner-piece *par excellence*), and of St. James. The St. James play performed in 1476 in Ferrara by "uno fiorentino, inseme cum alcuni altri de la cità nostra" is possibly the same one.[49]

By the end of the decade, it seems, none of the three *laudesi* plays was being performed regularly, and for the decade after the Pazzi conspiracy in 1478 the San Giovanni plays lapsed too. The

overpowering mystery and spectacle of the strictly canonical scenes from the life of Christ and the Virgin, solemnly enacted within the precincts of the church, now exist alongside the often vulgar sensationalism of the miracles of saints. To meet this demand, the play in the Carmine is miraculously transformed into an Assumption of the Virgin: in 1480 Giusto d'Anghiari notes in his diary a performance in the Carmine of a "Representation of the Virgin Mary when she went up to Heaven and gave her belt to St Thomas."[50] From then on disputes and accidents seem to dog the company.[51] In 1483, Lorenzo de' Medici began to take an interest in the Ascension company,[52] but his presence transforms the company into a simple tool of Medici propaganda. Despite such patronage, other forces (not least the development in the northern courts of neoclassical dramatic forms) intervene to make this kind of popular theater redundant.

So what conclusions might we draw from this? My first is that the confraternities of Santa Maria del Carmine and of Santo Spirito perceived the three communal meals (of the Last Supper, before the Ascension, and of Pentecost) as joyful celebrations, and they incorporated them into their iconographic repertoire. Notwithstanding the dual images of the Crucifixion and Last Supper that decorated refectory walls until the middle of the century, they chose to dwell on the communal rather than the sacrificial nature of the meal. Their own *colazioni* reaffirmed their togetherness: while including the members of the confraternity, they exclude non-members and assert the select nature of the group.

Self-denial has no part in their celebrations: in their own modest way the confraternities are contributing to a long tradition of convivial spectacle or feasts that make spectacles of themselves. The apostles and the Virgin are dressed in richly embroidered robes and not as poor fishermen. They are crowned with golden crowns. The angels are decorated with as many colored ostrich feathers and gold and silver tinsel as a mardi-gras, and there is not a hint, at least until 1471 when the *festa* was mounted in Lent, that anyone thought this was excessive.

But the *festa* continued only where the confraternity was able to exist as a closed, independent network. While the Florentines

funded the plays collectively through a tax on citizens at the gates, the effort that even its lesser citizens expended on magnificence continued unabated, and the whole city benefitted. But when that collective patronage was usurped by an individual, who then directed the resources of the company towards his own aggrandizement, the plays and players could no longer respond.

Vincenzo Borghini provides a sixteenth-century postscript. In 1565 he was charged with resuscitating the three *laudesi* companies of the Annunciation, the Ascension, and Pentecost and mounting the festivities for the marriage of Francesco de' Medici with Giovanna of Austria. He writes:

> It would be good too to resurrect the companies of the Jug and of St. Agnes, and if possible of the Pigeon, and you could entrust it to Luigi Gianfigliazi, who is the Captain of St. Agnes, and could take responsibility for all the things for heaven since he has all the equipment that is still in existence for this *festa*. I don't know how things are with these three companies, and I think that the Pigeon is all but dead, but since the *festa* is moving to a different location, I think that at least just for this once they could join together to put it on.[53]

An Annunciation play was duly performed beneath Brunelleschi's dome in the new church of Santo Spirito,[54] but everything had changed. The transformation of that illusory dome of heaven, which had arched over the plays of the Annunciation and Ascension in the fifteenth century, into the dome of bricks and stone of the church roof had rendered the old machinery inoperable and the plays all but unperformable.

Notes

1. The archives of the Ascension company ("la chompagnia di Santa Maria [delle Laude] e di Santa Agnesa che si rauna nella chiesa di Santa Maria del Charmino di Firenze") and Pentecost company ("la chonpagnia dello Spirito Santo delle Lalde, . . . raghunasi in Santo Aghostino di Firenze") are preserved in the Archivio di Stato, Florence. The Ascension company's records are designated: *Archivi di Compagnie Religiose Soppresse, 1: Compagnia di Santa Maria delle Laudi, detta di Sant'Agnese*. The relevant items are:

4. Libro di partiti della Compagnia di Sant'Agnese, 1483-1509

24. Entrata e uscita dei Sindaci, 1440-47

29. Descrizione dei beni della compagnia, 1447-73

98. Entrata e uscita, 1424-41

99. Entrata e uscita, 1447-74, 1516-19

100. Entrata e uscita, 1466-81

In the notes that follow, they are cited as *Agnese 24* etc.

The Pentecost company's records are designated: *Archivi di Compagnie Soppresse, 4: Compagnia di Santa Maria delle Laudi e di Santo Spirito, detta del Piccione*. The relevant items are:

1. Memoriale del Sindaco, 1419-27

57. Debitori e creditori, Entrata e uscita, 1427-34, 1501-12

58. Entrata e uscita, Dare e avere, Obblighi, 1435-38

59. Debitori e creditori, Entrata e uscita, 1441-43

60. Entrata e uscita, 1455-57

61. Debitori e creditori, Entrata e uscita, 1461-67

78. Inventari, pietanze, partiti, ricordi e debitori e creditori de l'Ospedale di Via Chiara delle Convertite, 1444-1521

They are cited below as *Piccione 57* etc.

I wish to thank John Henderson, who introduced me to these archives, and the 1984 Fellows at Villa I Tatti with whom much of the material was discussed.

2. The *OED*'s earliest example of *feast* in the sense of "something delicious to feed upon" is dated 1393.

3. My thinking on food has been stimulated by the introductory chapters of two important works: Bridget Ann Henisch, *Fast and Feast: Food in Medieval Society* (University Park: Pennsylvania State Univ. Press, 1976), and Carolyn Walker Bynum, *Holy Feast and Holy Fast: The Religious Significance of Food to Medieval Women* (Berkeley: Univ. of California Press, 1987).

4. Creighton E. Gilbert examines the shift in refectory decoration from scenes of the Crucifixion to scenes of the Last Supper in "Last Suppers and Their Refectories," in *The Pursuit of Holiness in Late Medieval and Renaissance Religion*, ed. Charles Trinkaus and Heiko A. Oberman (Leiden: Brill, 1974), pp. 371-402, esp. p. 385.

5. The entry for 1429 is typical: "Io Frate Piero di Bartolomeo priore de' frati del Charminio confesso avere ricevuto da Vincienzio di Quasparre chamerlingo de la Compagnia lire dodici per la pietanza de la festa della Concetione pe' lascio fatto per Chiaro d'Ardinello" (*Agnese 98*, fol. II.99r).

6. For the date, see Andrew Ladis, *Taddeo Gaddi: Critical Reappraisal and Catalogue Raisonné* (Columbia: Univ. of Missouri Press, 1982), pp. 66-80, 171-82.

7. R. Offner's attribution is accepted by Leo Steinberg, "Leonardo's *Last Supper*," *Art Quarterly*, 36 (1973), 388n; previously attributed to Andrea Orcagna, while Gilbert proposes Nardo di Cione and an assistant ("Last Suppers," p. 375).

8. Martin Wackernagel, *The World of the Florentine Humanists: Projects and Patrons, Workshop and Art Market*, trans. Alison Luchs (Princeton: Princeton Univ. Press, 1981), p. 127.

9. Steinberg, pp. 297-410.

10. Gilbert, p. 381.

11. See *Matthew* 26.17-35, *Mark* 14.12-25, and *Luke* 22.7-38; *John* 13-18 does not mention the institution of the Holy Supper, but is alone in recounting the washing of the apostles' feet (13.4-17) and the promise of the Comforter (14.16, 14.26, and 15.26).

12. "Et ipse vobis demonstrabit cenaculum grande stratum," *Mark* 14.15; "Et ipse vobis ostendet cenaculum magnum stratum," *Luke* 22.12; "Tunc reversi sunt Hierosolyam a monte qui vocatur Oliveti qui est iuxta Hierusalem sabbati habens iter. Et cum introissent in cenaculum ascenderunt ubi manebant Petrus et Iohannes Iacobus et Andreas Philippus et Thomas Bartholomeus et Mattheus Iacobus Alphei et Simon Zelotes et Iudas Iacobi. Hii omnes erant perseverantes unianimiter in oratione cum mulieribus et Maria matre Iesu et fratribus eius" (*Acts* 1.12-14). *Cenaculum* translates 'anōgain' in the first two cases, and 'hyperōion' in the third.

13. See, for example, the gloss of Jacobus da Voragine, *Legenda Aurea*, cap. LXXIII: "De sancto spiritu": "Tertio loco secreti, quod notatur in hoc, quod dicitur in eodem loco, scilicet coenaculo."

14. Luke's account at the end of his gospel (*Luke* 24.34-53) suggests that just after his Resurrection Christ supped with the apostles at Bethany and ascended into heaven shortly thereafter. The disciples then returned to the temple in Jerusalem, "laudantes et benedicentes Deum." His account in *Acts*, on the other hand, puts the event on the Mount of Olives forty days after the Resurrection. The extant plays gloss over the discrepancies; see n. 27, below.

15. The iconography is discussed in Christa Gardner von Teuffel, "Ikonographie und Archäologie: das Pfingsttriptychon in der Florentiner Akademie an seinem ursprünglichen Aufstellungsort," *Zeitschrift für Kunstgeschichte*, 42 (1979), 16-40.

16. Closely related to this fresco and painted 1370-71 is the Pentecost in the style of Orcagna (London, National Gallery, 578), part of an altarpiece painted for the Benedictine nuns of San Pier Maggiore in Florence, cited by von Teufel.

17. Niels von Holst, "Zur Ikonographie des Pfingstbildes in der Spanischen Kapelle," *Mitteilungen des Kunsthistorischen Institut in Florenz*, 16 (1972), 261-68.

18. *Rappresentazione della Cena e Passione di Mess. Castellano Castellani*, in *Sacre Rappresentazioni dei secoli XIV, XV e XVI*, ed. Alessandro D'Ancona (Florence: Le Monnier, 1872), I, 303-27; for the date, see Giovanni Ponte, *Attorno al Savonarola: Castellano Castellani e la Sacra Rappresentazione in Firenze tra '400 e '500* (Genoa: Pagano, 1969), p. 11.

19. Ronald F. E. Weissman, *Ritual Brotherhood in Renaissance Florence* (New York: Academic Press, 1982), pp. 99-105, 225-35.

20. "Hec Laus XXXXIIII Evangelii die Iovis Sancti," in Rome, Biblioteca Vallicelliana MS. A.26, fols. 79ᵛ-82ʳ; and "Laus XXXXIIII die Jovis sancti," from Perugia, MS. Augusta 955, in *Laude drammatiche e rappresentazioni sacre*, ed. Vincenzo De Bartholomaeis (Florence: Le Monnier, 1943), I, 208-12. Notes concerning the performance of the Umbrian Holy Week plays are to be found in Cyrilla Barr, *The Monophonic Lauda and the Lay Religious Confraternities of Umbria and Tuscany in the Late Middle Ages*, Early Drama, Art, and Music, Monograph Ser., 10 (Kalamazoo: Medieval Institute Publications, 1988), pp. 43-59.

21. The expenses for 1436 are typical: "1ª piana d'abete pe' gli Apostoli del Descho

. . .”; “1ª libra d’aghuti per chonficchare gli Apostoli il Giovedì Santo . . .”; “A ’Ndrea di Filippo famiglio della Chonpagnia . . . per sua faticha di stare al Descho degli Appostoli cioè il Giovedì e ’l Venerdì Santo” (Agnese 98, fol. 125).

22. Statuto XXVII, “Come li capitani debiano fare tenere il descho,” of the Compagnia di Santa Maria Vergine e di San Zenobio is included in Luciano Orioli, *Le confraternite medievali e il problema della povertà: Lo Statuto della Compagnia di Santa Maria Vergine e di San Zenobio di Firenze nel secolo XIV* (Rome: Edizioni di Storia e Letteratura, 1984), p. 31.

23. Feo Belcari, *Le rappresentazioni ed altre di lui poesie* (Florence: Moutier, 1833), pp. 107-12.

24. *Feo Belcari a Cosmo de' Medici per contemplazione de' festaiuoli della Ascensione*, in Belcari, p. 156. Piero di Cosimo is recorded in the accounts as having sent wine in 1443: “Al portatore per 1° barile di vino che de’ (*cancelled*: Chos) Piero di Chosimo soldi 3” (Agnese 24, fol. VII.20ʳ). Cosimo may have been the person alluded to in 1441: “A spese lire tre per 1° barile di vino vermiglio si loghorò el ddì doppo la festa, fucci dato da 1ª buona persona” (Agnese 98, fol. 176ᵛ).

25. “Per ispese in fare onore a chi ebbe a rifare e versi di Christo soldi xi, cioè per fargli honore” (Agnese 24, fol. VII.17ʳ).

26. “Dipoi Cristo, avendo mangiato con gli Apostoli, esce di Ierusalem, e tutti gli Apostoli hanno in mano i loro segni, ed a piè del Monte Cristo dice a loro: . . .” (l. 8 *did.*); for the *segno*, cf. Agnese 24, fol. XV.9ʳ: “A Bettuccio dipintore soldi due per istangniatura d’uno sengnio d’appostolo, cioè una spada” (1447). In 1439, according to the description of Abraham of Souzdal’, each apostle received his sign at the foot of the Mount of Olives; see Abraham of Souzdal’, “Ascensio Domini,” in *Acta Slavica Concilii Florentini: Narrationes et Documenta*, ed. Joannes Krajcar, Consilium Florentinum: Documenta et Scriptores, 11 (Rome: Pontificium Institutum Orientalium Studiorum, 1976), p. 123.

27. *Meditations on the Life of Christ*, trans. Isa Ragusa, ed. Isa Ragusa and Rosalie Green (Princeton: Princeton Univ. Press, 1961), pp. 374-85. The *Meditations* give Christ two “speeches” after supper with his disciples and his mother in the Cenacle on Mount Sion: “It is time for me to return to Him who sent me; but you remain here in the city until you receive power from above, for in a few days you will be filled with the Holy Spirit, as I promised you [cf. ll. 9-16]. Afterwards you will go all over the world preaching my Gospel and baptizing believers, and you will be witnesses to me to the ends of the earth”; “Much more should you have believed the angels, even before you had seen me, than should the people, who will not see me, believe your preaching [cf. ll. 33-48]” (p. 375). See n. 14, above.

28. “E salito che è Cristo in Celo, duo Angioli discendono di Celo e dicono così agli Apostoli, che risguardano in Celo: Perché prendete ammirazion sì grande . . .” etc. (l. 56 *did.*)

29. Francesco Sacchetti, *Il trecentonovelle*, ed. Emilio Faccioli (Turin: Einaudi, 1970), Novella LXXII. A Servite bishop delivers a ridiculous and long-winded Ascension sermon, asserting among other things that the Ascension was as swift as a bird or an arrow fired from a crossbow, which leads the narrator to comment:

> Un mio amico veggendo il dì dell’Ascensione all’Ordine de’ frati del Carmine di
> Firenze, che ne faceano festa, il nostro Signore su per una corda andare in su
> verso il tetto, e andando molto adagio, dicendo uno:

—E' va sì adagio che non giugnerà oggi al tetto.

E quel disse:

—Se non andò più ratto, egli è ancor tra via. (p. 188)

(A friend of mine, one Ascension Day, when the friars of the Carmine in Florence were celebrating it, saw our Lord on a rope going up toward the roof. And he was going very slowly, and someone said, "He is going so slowly that he won't make it up to the roof today." And my friend said, "If he [i.e., Christ] wasn't faster than this, he is still on his way.")

30. "Giovedì a dì 21 di maggio 1422, il dì dell'Ascentione e lla vilia dinanzi, si fecie una solenne e bella festa al Charmino nella chiesa, e andò uno huom vivo in vecie di messer Domenedio in cielo, e fu tirato dalle volte insina al palchetto, et rasente il tetto pello diritto, e tutti atti e similitudine si fecie a vicie della Nostra Donna e di Santa Maria Maddalena e di dodici Apostoli, la quale festa fu tenuta bella et di molti ingegni e intorno alla nughola che quando la nughola viene in giù e vecie Christo in su acchozzandosi insieme s'acciende molti chandele, e chosì altri similitudine d'angioli come sarà noto a chi vederà la detta festa se a dDio piacerà lascialla seghuire." See Götz Pochat, "Brunelleschi and the 'Ascension' of 1422," *Art Bulletin*, 60 (1978), 233n.

31. "Dua ase d'abetto chonperai per lo Chastello per fare dua torre le quali erano rotte," Agnese 98, fol. II.89r (1427); cf. Abraham of Suzdal', "Ascensio Domini," p. 122.

32. Agnese 98, fols. 101v-102v. The Company constructed a tiny chamber and throne above the Cappella Maggiore of the church. The opening was supported by "una pietra di braccia 2 lungha per pore sopra l'archo del trono" (fol. 101v); Abraham of Suzdal' says it measured three square *sagene* (where a *sagene*, although nominally seven English feet, must be read in Abraham's description as a pace or a yard) ("Ascensio Domini," p. 122).

33. Preliminary findings are given in my paper "The Word Made Flesh: The *Rappresentazioni* of Mysteries and Miracles in Fifteenth-Century Florence," in *Christianity and the Renaissance*, ed. Timothy Verdon and John Henderson (Syracuse: Syracuse Univ. Press, 1990), pp. 360-75.

34. Giuseppe Richa, *Notizie istoriche delle chiese fiorentine* (Florence: Viviane, 1754-62), IX, 15-16. While there are echoes of Vasari's descriptions of the Annunciation and Ascension plays (*Vita di Brunelleschi, Vita del Cecca*) in the Pentecost description, there are also important correlations with documented Santo Spirito practice that indicate that Richa had access to unidentified documents.

35. "Uno palcho e 1° chastelo per la festa" and "uno chastello dove si vestono li apostoli," Piccione 60, fol. 5r.

36. Piccione 58, fols. 40v-41r, 77r.

37. Florence, Biblioteca Nazionale Centrale (hereafter BNCF), BR 18 (già II.I.122), fol. 1v.

38. Andrea Orcagna and helpers, c.1365; see Luisa Vertova, *I cenacoli fiorentini* (Turin: ERI, 1965), pp. 26-29, fig. 11, and detail of the two surviving apostles in Color Pl. VI.

39. *Ripresentazione dello Avvenimento dello Spirito Santo il dì della Pentecoste*, in Belcari, pp. 107-12.

40. [Florence: Bartolomeo de' Libri, 1490]; *unicum*, Florence, Biblioteca Riccardiana, ER 686 (566), 4.

41. See Laura Hibbard Loomis, "The Table of the Last Supper in Religious and Secular Iconography," *Art Studies*, 5 (1927), 21-88. Particularly suggestive are her observations (p. 73) on the twelfth-century mosaic representation of Christ and the apostles in the Descent of the Holy Spirit (St Mark's, Venice, West Dome). The twelve lines which radiate from Christ at the top of the dome to the apostles, seated at their table around the rim, anticipate Brunelleschi's "umbrella-spoke" design for the Annunciation apparatus by three centuries. See also Karl Lehmann, "The Dome of Heaven," *Art Bulletin*, 27 (1945), 1-27.

42. Agnese 24, fol. XV.5v: "A dì xii di maggio 1447 achattai da Matteo hoste uno chavallo a vettura per fare stagire i fiori che bisongniano alla nostra festa, in sul quale chavallo andò Lionardo di Ghualtieri a stagire i detti fiori, chostommi achattura soldi 9." The flowers were bought directly from some twenty-seven different people between Scandicci and Mosciano, in the *contado* outside Porta San Frediano.

43. It was already in existence in 1444: "Per 1/2 quaderno di fogli reali ghrosi per lo spolverrizo del giglo" (Agnese 24, fol. IX.16v), but it was moved and redesigned in 1445: "Pe' mangiare di xvi gharzoni a dì 31 di marzo 1445 chonperai 3 choppie e chacio e soldi xi di pane e per lo fornaio e per insalata, non chontando el vino, per tuto soldi quaranta, fu quando si tramutò el tondo del giglio ghrande ch'è di fuori e fecesi la giunta" (Agnese 24, fol. XI.9r). It was remade again in 1455 (Agnese 99, fol. 155r), and in 1466 when Neri di Bicci takes over the books (Agnese 100, fols. 70v-75v).

44. Agnese 24, fol. V.21r: "A' gharzoni lire 36 soldi 19 in danari e pane e vino e pesce e l'atre chose s'ebono dal Papa e altri chardinali e signori per aiuto alla festa e noi gli consumamo i' magiare del dì doppo la festa e in aito." The other items are recorded on fols. V.20v-21r.

45. The only record of outsiders at the *colazioni* of the Ascension or Pentecost companies that I have identified is in 1435. In that year the Pentecost company was in receipt of a subsidy, raised by a tax on citizens passing through the gates and spent exclusively on its *castello* (Piccione 58, fol. 75v). In spite of a dispute when the Pentecost company broke a rope belonging to the Ascension company, each company made an offering to the other's *festa* and hosted a *colazione* for them (Piccione 58, fols. 8r, 37r, 75r; Agnese 98, fol. 118). But in August 1435, the Ascension company applied successfully to the Commune for a subsidy (ASF, Consigli Maggiori, Provvisioni, Registri 126, fol. 195v, 28 August 1435) and seems to have replaced the Pentecost company as the recipient of the tax raised on citizens passing through the gates.

46. Agnese 24, fol. XIII.22r: "A lui detto [Baldasare Bonsi di fuori] detto dì per oncie 2 d'arsenicho per avelenare topi in sul tetto."

47. The purpose becomes cumulatively clearer: "Per 240 peternostri d'osso bianchi e neri pe' chontrasengni de' marchi e per oncie 1a 1/2 di refe sottile e . . . per ii ghomitoli di spagho da lettera . . ." (Agnese 24, fol. XIII.22v, 1446); "A Albizo a dì detto soldi due per due filze di paternostri, uno azuro e uno giallo per marchiare" (Agnese 24, fol. XV.7v, 17 May 1447); "A dì vi di giugno 1447 paghai a Giovanni di Domenicho Volenzi famiglio de' Singniori per sua faticha per istare all'usciolino delle Volte e lasciare entrare e uscire chi era marchiato, portò Giovanni sopradetto soldi 15" (Agnese 24, fol. XV.9v); "A Antonio di Iachopo merciaio a dì xxii d'aprile (i.e. first expense of all) per 1a lenza soldi dua, tollsi per

leghare i marchi al braccio a' festaiuoli" (Agnese 99, fol. 121ʳ, 1448).

48. They appear first in 1441, possibly as part of the reconstruction of the *festa* that followed the temporary withdrawal of their subsidy in 1440 (Agnese 98, fol. 158ʳ); see Agnese 98, fol. 176ʳ (1441), and Agnese 24, fols. V.22ᵛ (1442), IX.18ᵛ (1444), XI.12ᵛ (1445), XIII.23ᵛ (1446); in 1447: "A Neri Buchini spia d'Otto, grossi sei e quali gli die' per sua faticha ché ci servì iiiiº dì per la nostra festa dell'Asensione, cioè due dì inanzi e due dì poi" (Agnese 24, fol. XV.9ᵛ).

49. G. M. Ferrarini, *Cronaca estense*, cited in Anna Maria Coppo, "Spettacoli alla Corte di Ercole I," *Pubblicazioni dell'Università Cattolica del Sacro Cuore [Milan]: Contributi dell'Istituto di Filologia Moderna, Serie Storia del Teatro* (1968), I, 43.

50. "Domenica a dì 14 detto [di maggio 1480] si fece al Carmino una Rappresentazione della Vergine Maria quando ella n'andò in Paradiso, e dete la sua Cintola a San Tomaso" (Giusto d'Anghiari, *Memorie*, BNCF, *II.II.127 [già Magliabechi XXV.496]*, fol. 136ʳ).

51. They are documented in Cyrilla Barr's paper "Music and Spectacle in the Confraternity Drama of Fifteenth Century Florence: The Reconstruction of a Theatrical Event," in *Christianity and the Renaissance*, 376-404. In this article, and in "A Renaissance Artist in the Service of a Singing Confraternity," in *Life and Death in Fifteenth-Century Florence*, ed. Marcel Tetel, Ronald G. Witt, and Rosa Goffen (Durham: Duke Univ. Press, 1989), pp. 105-19, and notes pp. 216-24, Professor Barr discusses the 1466 inventory of the Sant'Agnese company, compiled by Neri di Bicci (Agnese 115, unnumbered folios at end). At the time of writing this paper, I did not know of the Sant'Agnese inventory.

52. See Weissman, pp. 171-73.

53. Vincenzo Borghini, BNCF, Fondo Nazionale II.X.100, fols. 8v-9ᵗ; reproduced in *Il luogo teatrale a Firenze: Brunelleschi, Vasari, Buontalenti, Parigi* (Catalogue of exhibition), compiled by Mario Fabbri, Elvira Garbero Zorzi, and Anna Maria Petrioli Tofani, introd. Ludovico Zorzi (Milan: Electa, 1975), p. 68, *scheda* 1.39.

54. *La rappresentazione dell'Annunziazione della gloriosa Vergine, recitata in Firenze il dì x di marzo 1565 nella Chiesa di Santo Spirito* (Florence: Ceccherelli, 1565).

The Good Works of the Florentine "Buonomini di San Martino": An Example of Renaissance Pragmatism

Olga Zorzi Pugliese

The basic aims, organization, and religious rites of the Buono-mini di San Martino of Florence during the Renaissance can be determined on the basis of three documents: (1) the brief one-paragraph deed which bears the date of the confraternity's founding and indicates the aspirations of the founders; (2) the early version of the *Capitoli* or constitution outlining, albeit in a sketchy manner, the standing rules which must have been drafted at the time of the founding or soon thereafter in the fifteenth century;[1] and, finally, (3) a more complete revised statute consisting of thirty-two rules and procedures which, although transcribed in the early seventeenth century and re-copied in the eighteenth century, probably dates from the sixteenth century. This last document is said to represent the long-standing practice of the Buonomini.[2]

The third text, although known to historians who have summarized portions of the contents, is still unpublished. It cannot boast proximity to the historical moment in which the association was established, but it is of great cultural significance, for it demonstrates the way in which the principles and procedures adopted by the *confratelli* were updated and interpreted in the high Renaissance. On close analysis, it reveals a connection with the type of psychological realism which characterized the man-centered thought of the period—a feature which appears to distinguish it from the statutes of similar institutions.

Founded in 1442 by the Dominican friar St. Antoninus of Florence (1389-1459), then prior of the convent of San Marco and soon

to become Archbishop of Florence, the San Martino confraternity was—and still is—an independent institution run by laymen.[3] Except for a brief period of government intervention from 1498 to 1502— an interval which saw a reduction in donations and in overall effectiveness—it was spared suppression in the late eighteenth century and has continued to this day to enjoy complete autonomy. The principal goal envisaged by the brotherhood was to alleviate the condition of a particular segment of Florentine society. These were the *poveri vergognosi* or "shame-faced poor"[4]—that is, individuals who had fallen on hard times and were too embarrassed to seek public assistance. As Amleto Spicciani, the leading expert on the Buonomini, has proved, most of the aid recipients were, at least at the beginning, craftsmen and workers. Members of a middle class, they found themselves in difficulty because of changing economic conditions caused by the upheavals that followed the return of the Medici in 1434 and by a decrease in mercantile activity.[5]

In the face of this pressing situation, rules that reflect biblical principles of charity were laid down for the company. Like the apostles, the Buonomini were instructed to feed the hungry and clothe the naked. Above all, they were to carry out these deeds anonymously and in secrecy, without seeking personal recognition.[6] The confraternity set up its oratory in what had been part of the church of San Martino. Quite appropriately it adopted as its patron the same St. Martin, Bishop of Tours, who, according to legend, cut his cloak in half with his sword and shared it with a poor beggar.[7] In the late fifteenth century a series of frescoes was commissioned for the oratory depicting two scenes from the religious experience of St. Martin as well as the works of mercy, not exactly as described by St. Antoninus in his *Summa theologica* but reflecting more closely the actual charitable practices of the Buonomini.[8]

The confraternity received support from all governments of Florence—republican, Savonarolan, and ducal alike (with the sole exception already mentioned). It attracted members of such prominent Florentine families as the Medici, who were eager to make donations and to serve as officers in the association. It is true that the motives of these wealthier members of lay confraternities have

been interpreted as being less than altruistic: charitable donations and good works were traditionally considered a means of ensuring personal salvation for the benefactor. Moreover, historians have argued, they may have implicitly constituted a strategy for the even more far-reaching goal of perpetuating the existing political and social order.[9] Yet, the anonymity which was to be maintained by the Buonomini along with their long-lasting spiritual and even financial commitment to the cause show without a doubt that true humanitarianism was at work here.

The high principles which inspired this form of poor relief are evident in the organization of the company as well, certain aspects of which reflected the Florentine tradition of communal government. Two officers were responsible for each of the six districts (*sestieri*) of the city. Twelve in number, like the apostles, these Buonomini, or *procuratori*, carried out the tasks of collecting and distributing alms. The membership was augmented c.1470 through the addition of six helpers (*aiutanti*), one for each of the city's *sestieri*. All eighteen members had an equal voice in the weekly meetings. Decisions concerning the merit of the cases being considered were made through a secret ballot, while one of the *procuratori*, acting as secretary, kept the records (*scritture*, Rule 19). To maintain equality among the twelve procurators, the *proposto*, or chief administrator in charge of funds, had a limited term attached to his office, which rotated monthly, while the outgoing *proposto* was required to make a personal donation to the association—at one time a specified quantity of grain but, in more recent times, a prescribed sum of money. The selection of those to be invited to serve as Buonomini was made by the entire membership after lengthy discussions and according to strict criteria set down by the constitution. To be eligible, a candidate had to be a capable and upright citizen, able to set a good example for others. He also had to be a religious person accustomed to spiritual exercises and committed to the practice of charity. The foremost qualification, stressed at the beginning and again at the end of Rule 24, was class origin. Although the first Buonomini represented a wider range of social levels, the group eventually drew its members from the upper middle class exclusively.

Barring any misconduct on the part of a member that would result in his discreet removal under some honorable pretext in order to save face before the public, the terms of office were for life or until resignation. Although mentioned only briefly in the last rule of the later document, the religious rites expected of the members are described in greater detail in the earlier statutes.[10] They consisted of Confession and Communion on a regular basis, daily prayers including a special one to the patron, St. Martin, and a memorial service within a month of the death of any of the *confratelli.*

Another facet of the association which deserves special attention is the system adopted for the handling of donations. It allowed for absolutely no capitalization of funds. Rule 1 stated quite dogmatically: "Non si tenghino Beni stabili, né Entrate ferme perpetue." It required instead that all monies (which, from 1492 on, included those received from repentant tax-evaders) be distributed as quickly as possible. There was to be no payment for the Buonomini themselves, administrative costs were to be kept to a bare minimum, and the bookkeeping was to be executed meticulously to ensure that nothing was lost. Furthermore, since the confraternity was permitted to hold no "Beni stabili," such properties, if donated, had to be liquidated just as non-useful items collected were to be auctioned off and the proceeds assigned to the needy. In these cases, members of the association were prohibited from making bids themselves.

Not all the allocations to the needy were made in the form of money, however; where appropriate, the association provided, as Spicciani's research has verified, flour and other foodstuffs along with household goods and clothing. Whatever the form of assistance granted, all recipients (and included in the target groups were young women to be dowered) had to meet one inescapable qualification: high moral standards of character and conduct as required by Old Testament concepts of charity and by the moral precepts of St. Antoninus, who had derived them from St. Ambrose.[11] Personal need and merit carried more weight in the Buonomini's decision-making even if recommendations from other persons were given some consideration. If doubts persisted during the deliberations, advice could be sought from theologians or other experts (Rule 14).

According to the earlier statute, a priest or his vicar took part regularly in the discussions and played other roles as well within the institution as spiritual director, assistant to members who had fallen ill, and overseer of the selection of the *proposto* by lot.[12]

The foregoing specifications, with the exception of the regular participation of the clergy, are included in the revised constitution of the Buonomini di San Martino (document No. 3, listed above). However, examination of this document shows that what matters is not merely the basic spirituality which, as Gilles Gerard Meersseman suggests, can be gleaned from a study of such confraternal statutes[13] but rather a certain affinity with the mainstream of the culture of the Renaissance. There is, to my knowledge, no evidence to indicate that the Buonomini sponsored the type of learned humanist activities such as the delivery of orations that took place in other confraternities. What the text of the constitution does reveal are special emphases on strategies for dealing with others, on tactics for handling internal matters among the brothers, and on negotiating with donors outside the institution. Analyzed from this perspective, the thirty-two articles comprising the revised statutes demonstrate the keen psychological insight into human nature typical of well-known thinkers of the Renaissance. This is evident in the manner in which a number of issues are discussed, ranging from the typology of the individuals to be appointed as members to a code of deportment considered proper when dealing with the poor, on the one hand, and with the donors, on the other.

In nominating potential members of their association, the Buonomini sought certain personal qualifications and, above all else, commitment to "il servizio di Dio, de' Poveri, e della Casa" (Rule 21). Niccolò Machiavelli, the chief political theorist of the Renaissance, can enlighten us on the soundness of such criteria, for on the subject of the selection of ministers he too singles out as the basic factor the individual's concern for the welfare of the prince and therefore indirectly for the good of the state, not for his own personal well-being (*The Prince*, chap. 22). The Buonomini's constitution, furthermore, urges that all members be drawn from the same social background, namely "Cittadini, e di buone famiglie," because "il far

mescolanza può partorire discordia" (Rule 24). This too appears to indicate an awareness of the inevitable friction between classes, like that between the basic "dua umori" of society, as Machiavelli terms them (chap. 9). It is obvious that, by positing such a condition, the lower classes are disqualified from serving as officers of the confraternity since they would have been too poor to be able to volunteer their time, to make the prescribed donations, and to support the institution financially in times of an eventual dearth of donations, as Rule 15 requires. On the other hand, the statute explicitly excluded the heads of the most eminent families and preferred instead "perché sono più utili alla Casa gli uomini nobili, ma di mezzana condizione" (Rule 24). This preference for the middle rank—that is, taking into consideration only those who qualified as proper citizens and therefore were part of the political class—was shared by many Renaissance political thinkers, including Francesco Guicciardini, who believed that power should be in the hands of the competent and respectable "uomini da bene" (and these were not necessarily to be equated with the *ottimati* of aristocratic birth) rather than in those of the popular and irrational *pazzi* (*Ricordi*, Nos. 212, 220).

If perfect homogeneity among the brothers was the Buonomini's ideal, an internal feature of the organization made it difficult to attain, for there existed within its structure two distinct groups, the *procuratori* and the *aiutanti*. On this point, the constitution proposes that, in order to maintain harmonious working relations between them, the secondary members must be treated as equals. In this way, as Rule 21 declares, the *aiutanti* will not be driven by ambition to strive to become full-fledged *procuratori*. It may be fitting to recall a parallel consideration by Machiavelli who identifies as the *populo*'s essential characteristic an inherent desire not to be oppressed by the overbearing *grandi* (chap. 9). In his view there can be some equilibrium in society if basic instincts, like the tendency to dominate, on the one hand, and the desire for freedom, on the other, are restrained. Such a balance can be achieved by the Buonomini too if they use diplomacy among themselves. They are urged as well to be tactful in their treatment of the *servo*, the employee hired to carry out manual tasks. It is efficacious to pay him well and

to use *amorevolezze* with him; yet, it is stated, the Buonomini must not be bound to be so kind and generous (Rule 25). This piece of advice bears some resemblance to Machiavelli's comment on the need for the prince to remain himself in control of his subjects and not place himself at their mercy even if this means relying on the fear which he can inspire rather than on the love which others may or may not show him (chap. 17).

The statutes go on, in Rule 26, to suggest another way for the procurators to manage their dependents: they must scrutinize the account books to determine whether the figures balance for the incoming grain and the flour dispensed. Moreover, this must be done separately for each district so that the source of problems can be pinpointed accurately. Not all discrepancies can be accounted for or avoided, it is acknowledged, but the very act of checking will promote honesty among the workers ("terrà in timore chi maneggia le farine").

This sort of prodding to help avert the temptation of erring is not reserved for subordinates. The constitution also recommends, without specifying the motives, that when the *proposto* at the end of his month-long term of office hands over the balance of funds to his successor, he must do so in the presence of at least one other member (Rule 2). Similarly, when a *procuratore* delivers alms to the needy in his district, he must always be accompanied by a colleague (Rule 13).

In addition to the stress on constant vigilance to prevent disorder and mismanagement, there is ever present in the statutes a heightened sense of the impact of appearances. This is a type of thinking readily associated in the Renaissance context with the art of courtiership as delineated by Castiglione in his *Book of the Courtier*. In the Buonomini's sphere of action, there are restrictions and procedures similarly devised to create a good impression. In offering assistance to the *poveri vergognosi*, for example, care must be taken to protect their good name by not having the same procurators make deliveries to the homes of the aid recipients each time and thus arouse suspicion in the neighborhood. As well as concern for the sensitivity of the *vergognosi*, Rule 13 also declares that, for the sake

of their own reputation, the Buonomini on their missions must not stay behind to chat with the women of the household. For the same reason, when the alms-seekers come to the oratory of San Martino, they are to be sent away quickly with kind words ("con buone parole," Rule 32) and the brothers must not sit around talking idly, especially in their presence. The same kind of midway tactic between cold superciliousness and undignified mingling is what Machiavelli too encourages rulers to adopt in their interaction with the people. The manual for princes (chap. 21) advises that carefully timed and not too frequent public appearances, especially orchestrated to demonstrate the prince's humanity and munificence, will allow him to maintain his majestic dignity.

In the thirty-two procedural regulations constituting the revised San Martino statutes, the subject of the confraternity's good reputation arises on four separate occasions in Rules 12, 22, 27, and 28. This insistence may also be reflected in the phrase in Rule 21 cited above regarding the required service to God, the poor, and the association, phrasing which is especially telling if it was formulated with an ascending rhetorical order in mind. The true patrimony of the Buonomini, we are told elsewhere (Rule 28), is "la buona fama, e la confidenza degli uomini particolari"—that is, a good reputation and the trust of private individuals. The idealistic principles of honor stressed here do not exclude sound practical considerations—a combination which makes for a rather unusual treatment of the theme of reputation dealt with only generically in other confraternal constitutions.[14] Rule 12 recommends that the brothers flee from "l'Ambizione delle Corti" because tarnishing the Buonomini's image will result in the loss of donations. In the case of Machiavelli's prince, of course, it is the eventual loss of power which is at issue: subjects will conspire against a prince who is scorned but not against one who is esteemed (chap. 19). Similarly, the institution of the Buonomini can exist only if, through its good reputation, it can obtain the resources needed to carry out its good works.

Machiavelli, as is well known, suggests an array of strategic tactics for gaining and maintaining power—all for the general welfare of the state—and Castiglione offers the courtier a key to winning the favor of the prince so that he may lead him and his coun-

trymen to virtue. In like manner, the Buonomini statutes delve into the specific organizational and managerial techniques representing the necessary means to an equally noble end—that is, the wise use of ample endowments in order to assist the poverty-stricken.

The topic of donations and, more precisely, the relations between the *procuratori* and the benefactors, or their heirs in the case of testamentary bequests, is discussed in another set of regulations (although, as with the other topics discussed, these are not all grouped together in the constitution). Human nature being what it is, the Buonomini rules recognize the fact that donations pledged to the confraternity under the guise of charity may actually have been made for some personal gain or out of malice (Rule 23). Consequently, there may be disgruntled heirs who had expected themselves to receive what is bequeathed to the confraternity (Rule 29). With these distressed persons, who have suffered the unforgettable "perdita del patrimonio," as Machiavelli's dictum goes (chap. 17), it is essential to show humility, courtesy, and kindness. This treatment exhibits delicacy of sentiment, of course, but the San Martino rule notes that these gentle manners are, in effect, the means to soothe angered spirits ("quieta[re] gli animi alterati") and to help the beneficiary obtain the balance and other effects easily and without causing a stir ("cagiona[re] agevolezza a cavare il restante, et impadronirsi degli altri effetti senza romore, o malagevolezza," Rule 29). In spite of the intricacies of will-making that historians of the Renaissance have described,[15] the Buonomini are instructed in Rule 23 to give the benefit of the doubt to their predecessors' charity and zeal for the cause and also to the original testators' good intentions. Major difficulties arise in attempting to recover bequests being withheld by the heirs in cases in which long-term pledges are involved (Rule 28). This may be due to the fact, the page-long Rule 30 explains, that fortunes (*le facultà*) are subject to *accidenti* and change, and the wealthy eventually become poor, just as the *fortuna* of the *poveri vergognosi* may vary (Rule 17). This was a basic truth to which all time-conscious Renaissance thinkers could attest.

It is worth noting at this point that Rule 30 is termed in the text itself a *ricordo*—a designation which may link the statutes to the

traditional Florentine genre of *ricordanze* in which the authors, in addition to recording significant events in their lives, handed down practical advice to their descendants. In fact, Rule 23 mentions the confraternity's "Libri de' Lasci, et Ricordi," and Rule 31 urges the Buonomini to read the old record books for useful information on relevant precedents and previous solutions to problems. Obviously a strong sense of tradition is in evidence here as in all the operations of the Buonomini.

Another striking feature of the constitutional document being analyzed is the recurrence of articles, five in number, dealing with litigation. This subject, like all the others, is approached with considerable realism and shows that the Buonomini who revised the document did more than repeat the traditional commonplaces of confraternal constitutions.[16] They knew well that they had to work in a world which was far from utopian, as Machiavelli, for instance, realized. The brothers are cautioned against having recourse to the law except in cases where the association is subjected to outright libel ("salvo che contro chi disprezzasse, o strapazzasse questa Casa," Rule 28). Normally they should attempt to settle with the other parties even if it means suffering a slight loss. Using a phrase which is also found in Guicciardini's *Ricordi* (No. 46), the same regulation states that when there is a disagreement one should settle for 15 of the 20 cents owed ("nelle liti, che occorrono si debbia contentare di soldi quindici per lira"). Whereas Guicciardini uses the saying in connection with a lenient concept of justice which would not seek to exact a full penalty but would still have the required effect of a deterrent, the Buonomini statute highlights its literal monetary meaning. The text proceeds to elaborate on the financial wisdom of this kind of negotiation, for to be too demanding, it is said, would only mean discouraging potential future donors.

What we find in this statement, as in the examples cited above, is the justification for the rule being laid down—a dimension which is entirely lacking in the schematic earlier draft of the constitution. The reasoning behind each problematic situation discussed, we learn, is directly related to a particular phenomenon of human thinking and reacting. This shows that the San Martino constitution,

revised quite clearly on the basis of extensive experience, is much more than a simple list of instructions to be followed passively. It is an important document which merits serious examination for its ideological content, especially for its characteristically Renaissance blend of written traditions (biblical, theological, and even quasi-literary) and first-hand experience of daily living among men.[17]

This first attempt at an analysis has perhaps drawn rather unusual and unorthodox comparisons between the kind of *saviezza* underlying the text and the ideas put forward by major Renaissance thinkers. But these comparisons may serve to indicate that there is a common denominator of profound thinking about human behavior that lies at the basis of the multifarious writings of the period. Admittedly, the present discussion has focused on the theoretical underpinnings of the brotherhood rather than on the actual practices of the *confratelli* which have only recently begun to be documented. Nevertheless, on the basis of the available information, it may be reasonable to argue that the endurance and success of the institution of the Buonomini di San Martino are in part attributable not only to the high moral standards and genuine dedication it has maintained over nearly five and a half centuries, but also to the psychological acumen which has informed its fundamental rules and thinking. It may not be a fortuitous fact that the thirty-two rules examined here are still given adherence by the Buonomini nowadays. In all likelihood it is good managerial know-how and administrative ability, based on solid pragmatism and realism, which have allowed them to keep order in the institution, to maintain their deservedly high reputation before the citizenry at large, and to channel their personal commitment to the achievement of good works for the wider human community. And for this they deserve our continued praise and scholarly attention.

Notes

1. The foundation deed, dated 1 February 1442, was published by Amleto Spicciani, in "The *poveri vergognosi* in Fifteenth-Century Florence: The First 30 Years' Activity of the Buonomini di S. Martino," *Aspects of Poverty in Early Modern Europe*, ed. Thomas Riis, Publications of the European University Institute, 10 (Stuttgart: Klett-Cotta, and Florence: Le Monnier *et al.*, 1981), pp. 119-72. A facsimile reproduction and transcription of the document are included in the plate opposite p. 126. The document itself is to be found on the flyleaf of the first "Libro Entrata e Uscita," covering the years 1442-68, in the Biblioteca Nazionale di Firenze, Fondo Tordi, filza XVIII.

The text of the early *Capitoli* was published by Richard C. Trexler, "Charity and the Defense of Urban Elites in the Italian Communes," in *The Rich, the Well Born and the Powerful: Elites and Upper Classes in History*, ed. Frederic Cople Jaher (Urbana: Univ. of Illinois Press, 1973), pp. 105-09. It was transcribed from the "Codice dei capitoli," No. 2, of the Fondo Pergamene of the Archivio dei Buonomini di San Martino (Florence), fols. 3-7. However, there is another more correct copy of this text in the same Fondo, MS. No. 1, excerpts of which are cited by Spicciani in the notes to his article cited above, on pp. 161-63.

It is interesting to observe that those who drafted the first set of rules anticipated modifications in the course of time. Consequently, as Buonomini, they granted themselves "auctorità et balia di giugnere et diminuire quello paresse loro a questi capitoli, secondo le occurrentie de' temporali" (Spicciani, p. 162n).

2. In addition to being included in MS. No. 1, this later revised version of the statute, consisting of thirty-two rules, is to be found on pp. 191-207 of MS. No. 2 (cited above, n. 1). It is included in an eighteenth-century copy of Vincenzio Pitti's "Memoriale della casa di S. Martino" of 1622 which presents it as evidence of the long-standing practices of the Buonomini—an indication that the statute was an old document. Indeed, the numerous and substantial differences it contains with respect to the earlier rules (e.g., the existence of the helpers, instituted c.1470; the division of the city into six *sestieri* which came about in 1494; along with the reference to the danger that monies could be diverted to the fund for the construction of St. Peter's) allow us to deduce that it was probably composed in the sixteenth century.

All references to the thirty-two rules will be given in the text of my paper on the basis of the typescript transcription kindly provided to me by the Buonomini and which I have checked against MS. No. 2 with the generous help of dottoressa Raffaella Zaccaria Viti. I wish to take this opportunity to acknowledge with sincere gratitude the assistance received from both former and present members of the company—the late count Alberto Guidi, Dr. Alberto Brini, and Dr. Francesco Giuntini—and also the permission kindly granted to me by the Sovrintendenza Archivistica per la Toscana to consult and quote from the manuscript.

3. For information on the Buonomini see Piero Bargellini, *I Buonomini di San Martino* (1972; rpt. Florence: Cassa di Risparmio, 1990); Niccolò Martelli, *I Buonomini di San Martino: discorso storico* (Florence: Scuola tip. Artigianelli, 1916); Luigi Passerini, *Storia degli stabilimenti di beneficenza e d'istruzione elementare gratuita della città di Firenze* (Florence:

Le Monnier, 1853), pp. 501-15; Giuseppe Richa, *Notizie istoriche delle chiese fiorentine*, I, Pt. 1 (Florence: Viviani, 1754), 207-32; Amleto Spicciani, "L'archivio fiorentino dei Buonomini di San Martino: fonti per lo studio della povertà nella seconda parte del XV secolo," *Bollettino storico pisano*, 44-45 (1975-76), 427-36.

The concept of the "shame-faced poor," to be distinguished from the public poor, is discussed by many historians (e.g., Trexler, p. 75). It can be traced back through St. Antoninus to St. Ambrose's treatise *De Officiis* I.xxx.158. At one time it was assumed that the *poveri vergognosi* assisted by the Buonomini di San Martino were impoverished aristocrats; more recently Spicciani's research has shown that the aid recipients in the first thirty years of the confraternity's operations were mainly artisans.

5. See Bargellini, pp. 19-20, and Spicciani, "The *poveri vergognosi*," p. 158.

6. See *Matthew* 6.1-4, 25.35-46.

7. On St. Martin, see Mariella Liverani's article in *Bibliotheca Sanctorum*, VIII (Rome: Istituto Giovanni XXIII della Pontificia Università Lateranense, 1966), cols. 1248-91.

8. The frescoes in the oratory of San Martino are reproduced in color in Bargellini's book. St. Antoninus discusses the works of mercy in his *Summa theologica*, Pars II, Titulus I (*De Avaritia*), cap. xxiv ("De Inhumanitate") (1750; rpt. Graz: Druck, 1959), cols. 328-37.

9. Brian Pullan, *Rich and Poor in Renaissance Venice: The Social Institutions of a Catholic State, to 1620* (Cambridge: Harvard Univ. Press, 1971), pp. 630-32, summarizes the various motives for alms-giving.

10. Early statute in Trexler, pp. 107-08.

11. *Ecclesiasticus* 12.1-7. See St. Antoninus, "De Inhumanitate," col. 330, for a quotation from St. Ambrose, *De Officiis* I.xxx.148, on the question of greater mercy being due to the just.

12. Early statute in Trexler, pp. 106-07.

13. Gilles Gerard Meersseman and Gian Piero Pacini, *Ordo fraternitatis: confraternite e pietà dei laici nel Medioevo* (Rome: Herder, 1977), III, 1319.

14. Ronald F. E. Weissman, a leading authority on Renaissance confraternities, points out the constant preoccupation with reputation. See his *Ritual Brotherhood in Renaissance Florence* (New York: Academic Press, 1982), p. 78.

15. Trexler, pp. 76-78.

16. Weissman, pp. 89-90, singles out, as one feature of confraternal constitutions, the insistence on avoiding discord among members.

17. Weissman discusses the tension between absolute principles of charity and their concrete interpretation in a specific cultural environment—a phenomenon very much in evidence in the statute being examined here ("Brothers and Strangers: Confraternal Charity in Renaissance Florence," *Historical Reflections*, 15 [1988], 27-45, esp. 30, 44).

Italian Confraternity Art Contracts: Group Consciousness and Corporate Patronage, 1400-1525

Ellen Schiferl

Confraternity art research typically focuses on specific confraternities and individual works of art. Detailed studies of confraternal art have contributed much to contextual art history, but the atomistic pattern created by individual studies does not readily support broad conclusions. Since the majority of Italian confraternity art still awaits thorough analysis, different strategies need to be developed to discuss the spectrum of confraternal commissions. Using a corpus of examples allows a more comprehensive assessment of confraternity patronage in Renaissance Italy. A panoramic view also provides a framework for determining whether an individual confraternity conforms to the general pattern or is atypical.

As a form of corporate patronage, confraternity art involves more than a binary relationship between artist and patron.[1] The interplay between the group as a unit, sub-groups, and individuals complicates patronage research. In theory, the art commissioned by a confraternity reflects corporate ideals conveyed through the unanimous consent of the group. In practice confraternity commissions were usually entrusted to company officials, a committee, or an individual. The difference between theory and practice provokes questions about the nature of corporate patronage. If the entire group is too unwieldy to manage a commission, is corporate patronage a myth? When individuals assume responsibility for implementation, negotiation, and supervision of a commission, are their actions dominated by personal taste or collective ideals? This study introduces

121

methods for assessing the balance of group consciousness and individual responsibility. By using artists' contracts, the research provides evidence supporting the concept of corporate patronage in confraternity art.

Confraternities acquired art through several different methods: (1) donation, (2) fulfillment of the stipulations of a will, (3) purchase of already existing work, and (4) direct commission. Donations made during the donor's lifetime or posthumously may demonstrate the individual's taste in terms of style, medium, and subject matter, but such works form a small percentage of Italian Renaissance confraternity patronage. Even more rare are purchases of existing works.[2] Because direct commissions comprise the majority of documented works and therefore typify the confraternity commission, they are the focus of this study. Corporate commissions, whether for guilds, communes, religious brotherhoods, or monasteries, usually involved a contract drawn between the patron and the artist.[3] For the Italian Renaissance, hundreds of art contracts survive. This study examines fifty-four contracts composed for confraternities between 1400 and 1525.[4] Contracts provide a valuable source for investigating the mechanics of confraternity patronage since they record the name of the brotherhood and individuals. Because specific people were named to assume legal and financial responsibility, the confraternity contracts also offer a useful tool for gauging the balance between individual and group consciousness. Number alone does not distinguish between personal and group identity. If individuals or a sub-group commission art in their own names, personal initiative is involved. In contrast, if individuals or a sub-group act as representatives for the entire group, then the commission reflects group consciousness.

To find affirmations of group identity, the contracts were analyzed for four different types of information: (1) descriptive clauses with visual references to the confraternity, (2) comparative clauses relating the projected work to existing confraternity art, (3) quantitative analysis of personal vs. confraternal references, and (4) quantitative analysis of individual names in confraternity and non-confraternity contracts.

Although participants tailored the contract to their own needs, they generally included similar information. First came the name of

the artist and patrons followed by a description of the object. Next the contract described the intended location and function of the art and often specified the size, subject matter, and medium. Contractees agreed on the cost of the project, the schedule of payments, and the deadline for completion. Guarantees of quality, particularly for pigments, and penalties for forfeiture also appear in many documents. The summary treatment of subject matter in contracts provides limited evidence of group consciousness. Iconographic subtleties are rarely included, and the complexity of the final product belies the scant wording of most contracts. For example, the Sicilian confraternity of San Pietro la Bagnara commissioned Domenico de Cufarati to paint twenty panels narrating St. Peter's life without indicating the content of the individual scenes.[5]

Descriptive Clauses with Confraternal Iconography. A simple barometer of group consciousness in contracts is the inclusion of the patron saint. Nineteen (or 35%) specify the patron saint of the confraternity. However, because contracts rarely provide detailed information on subject matter, this index requires caution. For the remaining 65%, the patron saint may appear in the art though not in the contract.

Another measure of group consciousness found in four commission documents is the visual image of a confraternity member. In contrast to portraits of specific people, these generic robed figures promoted group identity. In 1461, the Sicilian confraternity of St. Barbara in Naro commissioned Pietro de Lanzarocto to paint the patron saint flanked by eight scenes of her life. At the base of the narrative cycle, the patron directed the artist to depict flagellants wearing confraternal robes.[6] Even more detailed iconographic instructions accompany Sodoma's assignment to paint a banner for the Sienese Compagnia di San Sebastiano in 1525. The artist "is obligated to make the processional standard . . . in this mode: on one side a St. Sebastian tied to a tree with four [archers] that shoot him and an angel that crowns him; with background and fine colors and gold . . . and on the other side the Virgin Mary holding her Son and St. Roch and St. Sigismond with two flagellants and a landscape. . . ."[7]

The painting now in the Pitti Palace, Florence, reveals how faithfully the artist adhered to the document (figs. 4-5). The major deviations from the contract are the lack of the four archers and the presence of a group of flagellants rather than the two specified in the commission document.

For the contract signed between Jacopo de Vinciolo and the Spoleto confraternity of St. Francis, the confraternity supplied careful instructions about the identity of figures and their placement as well as the allocation of blue and gold pigment. Below the image of the Madonna, the artist will paint "the figures of St. Francis, St. Anthony of Padua, St. Bernardino and the figure of St. Lodovicus with a cross, crozier, mitre, and gold halo and with mantle painted in German blue . . . [and] six flagellants of said fraternal order. . . ."[8] As in the preceding two examples, the reference to the inclusion of confraternity members identifies the confraternity with the commission. In addition, because only two individuals assume responsibility for the confraternity in this contract, the six flagellants cannot be identified with these individuals and thus provide additional evidence for group consciousness.

For the altarpiece commissioned by the Florentine Compagnia di Santa Maria della Purificazione e di San Zanobi, the patrons directed the artist to employ confraternity figures in a more emblematic manner. In the 1461 contract, Benozzo Gozzoli agreed to paint "two boys dressed in white with olive garlands on their heads, holding the shield marked with these letters: P.S.M."[9] The boys (fanciulli) refer to the membership of adolescent males.[10] To identify the confraternity more completely, the letters signifying the company appear on the shield where a donor's coat of arms would normally appear.

In a 1486 contract, the Fraternita di Santa Maria della Misericordia of Castiglion Retino required Bartolomeo della Gatta to include the confraternal stemma. Below a central panel dedicated to the Stigmata of St. Francis, the artist agreed to paint "the predella with a pietà in the middle and on each side the sign of the confraternity."[11] This contract differs from the preceding examples in the brevity of its iconographic requirements. In contrast, the four pre-

ceding examples stem from unusually detailed iconographic direc-
tives. Since the tradition of representing confraternity members
extends from the early fourteenth century to beyond 1525,[12] contrac-
tual references to confraternal figures and emblems are significant.
Still, the more standard practice of minimal references to iconogra-
phy means that the artists often included such images without a
special notation in the contract.

Comparative Clauses. In some contracts, the abbreviated lan-
guage is explained by the reliance on comparisons to existing art-
works. By requiring the projected work to meet contemporary stan-
dards, the patron took advantage of visual associations that were
more inclusive than verbal descriptions. Patrons employed compara-
tive clauses for a variety of reasons such as assuring the quality of
colors, communicating the form and function of the object, specify-
ing the subjects and their interrelationship, and harmonizing the new
work with existing work.[13]

Comparative clauses appear in 33% of the confraternity con-
tracts and in 27% of the sample of non-confraternity contracts, a
statistically insignificant difference (Table I).[14]

Table I
Comparative Clauses in Artists' Contracts Italy 1400-1525

	Confraternity	Non-confraternity
Comparative Clause	18	19
Total contracts	54	70
Percentage	33%	27%

For eleven of the confraternity examples, the comparison refers to a
gonfalone or standard for use in procession. Standards assumed a
variety of forms from large double-sided canvas banners like
Sodoma's St. Sebastian to the smaller double-sided wood panels
with elaborately carved frames. Because the size and medium were
not standardized, comparative clauses served to eliminate confusion.

For example, the flagellant confraternity of San Benedetto of Corleone assigns Niccolò de Nuce to create a *gonfalone* "in manner and form like the gonfaloni made for the confraternities of Santa Maria Maddalena and San Michele of Palermo."[15] If comparative clauses are partly intended to insure pan-confraternal uniformity in the production of standards for street processions during feast days, they provide some evidence of group consciousness. Yet, the variety of purposes served by comparative clauses undermines this argument.

Competitive clauses, as a specific type of comparative clause, provide sounder evidence for group consciousness.[16] Visual rivalry manifested group consciousness by placing the identity of the group above the identity of a particular individual. In 1462, the Messina *disciplinati* confraternity of Sant'Elia required Antonello da Messina to make their standard at least as large as the one for the Confraternity della Carità. If his finished work was even larger, he would receive a higher payment.[17] More explicitly, Giovanni de Salonia agrees to make a *gonfalone* for the Noto confraternity of Sant'Antonio at least one-third larger than the standard of the confraternity of Santo Spirito.[18]

The use of comparative clauses to insure harmony between old and new work also reflects group consciousness. Initially these clauses may seem to communicate only information about size and format, but in their desire for conformity with existing works they emphasize the group rather than individuals. In the 1445 contract between Piero della Francesca and the Sansepolcro Compagnia della Misericordia, the artist agrees to "make, paint, decorate and assemble the said panel in the same breadth, height and shape as the wooden panel there at present."[19] When the Venetian Scuola di San Marco commissions Giovanni Bellini to paint a narrative from the life of Saint Mark "above the door of the meeting hall between the two walls, like the other painting above the bench where the Guardian and companions sit," they relay the size and location as well as the desire for visual compatibility.[20] Similarly, the Compagnia della Vergine Maria della Veste Nera enjoins Marco di Giovanni to paint narratives of Joseph's life for the façade of the church "in form similar to the other façade of the church."[21]

Confraternal References to Titles and Elections. In addition to
visual directives, contracts manifest group consciousness through
specific clauses that express the relationship between representatives
of the confraternity and the group as a whole. Frequently the open-
ing phrases in the contract establish this relationship, as in the 1478
contract drawn between Francesco Zavatarri and the Milan Confra-
ternity of the Immaculate Conception. A series of named representa-
tives appears with the statement that they act "in their name and in
the name of the other members of the Confraternity [Scuola] of the
Conception of the Glorious Virgin Mary."[22] In a further develop-
ment of this standard approach, the contract concluded between
Giovanni Pullastra and the Sicilian confraternity of San Vito de
Seralcadi lists the names of three rectors and three other confrater-
nity members. Not only does the document explain that the named
people represent the entire group, but it also explicitly includes ab-
sent members of the brotherhood as part of the agreement.

> Giovanni Pullastra, painter of the city of Palermo, be it known, willing-
> ly promises and agrees and solemnly obligates himself to Antonio de
> Pasquali, master Pietro de Billecta, Giovanni de Li Ferli, present and
> agreeing in the name of the venerable confraternity of the church of
> San Vito in the quarter of Seralcadi and as the rectors of the confrater-
> nity, and Niccolo di Li Ferli, Jacobo Barberio, Gasparo de Lombardo,
> Niccolo de Sanctoro, and Nardo de Michele, also members of said
> confraternity and in the name of other brothers of the confraternity who
> are absent.[23]

The contract drawn for the flagellant confraternity of Sant'Elia simi-
larly explains that the two officers cited in the document act on
behalf of the entire confraternity: "Nicandro Mazapedi and Giovanni
Iurba of Messina, officers of the Disciplinanti confraternity of the
Church of Sant'Elia, Messina, represent the entire confraternity of
said church."[24] Other Sicilian contracts employ comparable phras-
ing, while four central Italian contracts directly refer to the election
of company officials and thus declare their representative role. For
example, the contract between Luca Signorelli and the Fraternita of
Santa Maria of Lucignano confirms the authority of the six company

officers and company members by noting that they were duly elect-ed by the confraternity to oversee the commission.[25]

Some confraternities made a special effort to assure that the work sponsored by current officials also applied to future office holders. As legislated by their statutes, confraternity officials often served very short terms. Work on commissions, on the other hand, frequently exceeded the deadlines stipulated in the contract.[26] When the Sansepolcro Compagnia della Misericordia engaged Piero della Francesca to paint an altarpiece, they gave the artist a particularly generous amount of time to complete the work—three years. Per-haps because of this lengthy interval, the confraternity included a special provision that the pact would be honored by future office holders.[27] By binding future officials to the agreement, the contract affirms group consciousness over time.

Another form of election also connected individuals to the en-tire confraternity: the election of jurors. The Milan Confraternity of the Immaculate Conception agreed to pay 800 *lire imperiali* to Leo-nardo da Vinci, Giovanni de Predis, and Evangelista de Predis for their work on an altarpiece. If the quality of the work warranted a higher payment to the artists, this judgment would be made by Friar Agostino Ferrari and two jurors who would be elected by the broth-erhood at the time of completion.[28]

Quantitative Analysis of Personal vs. Corporate References. Another means of investigating group consciousness is through the proportional representation of personal names and corporate refer-ences. Almost all of the contracts contain the name of at least one responsible individual as well as the name of the confraternity. The contract between Carlo de Ruxano and the Confraternita della Nun-ziata of Caccamo provides a typical example of contractual format: "Belingario de Charito, master Giovanni de Vitali, rectors of the Nunziata confraternity of Caccamo, and also Jorlando Chachu and Niccolò Pancita, members of said confraternity, present and agree-ing. . . ."[29] A few contracts ignore individual names—e.g., the con-tract formulated for the *disciplinati* of Sant'Andrea of Empoli.[30] Rarer still is the inclusion of personal names without identifying the

confraternity, as in the 1454 contract with Mariotto di Cristofano.[31] Because the names of both individuals and the confraternity appear in most contracts (91%), the documents provide an opportunity to assess the balance between personal and corporate references.[32]

After the opening clauses identifying the artist and patron, contracts often designate personal or corporate responsibility in sections devoted to subject matter, financing, and deadlines. Table II outlines the distinctions between corporate and individual references for these three contract components.

Table II
Individual vs. Confraternal Names and Titles
Italian Art Contracts, 1400-1525

	Confraternity		Individual	
	No.	%	No.	%
Responsibility	50	93%	51	94%
Finances	38	70%	24	44%
Deadlines	17	31%	12	22%
Subject matter	16	30%	7	13%
Total number of contracts examined: 54				

"Confraternity" includes references to the name of the confraternity, to members by their company title, or to collective references to members. "Individual" refers to the presence of at least one personal name.

In the contracts, confraternal references assume three possible forms: (1) identification of the confraternity specifically or generically, e.g., the *disciplinati* of Santa Maria or the *scuola*; (2) use of title for confraternity officials, e.g., rector or *procuratore*; and (3) reference to members in a collective manner, e.g., *fratribus* or *confratres*. The tally records the presence of at least one corporate reference or at least one individual reference in the clause.[33] Confraternal references support financial sections in 70% of the confraternity contracts, while fewer than half (44%) specifically designate individuals to

assume financial responsibility. Sections defining responsibility for overseeing the deadlines and subject matter also demonstrate a more significant role for confraternities than individuals, 31% to 22% for deadlines and 30% to 13% for subject matter. For all three categories (financial, deadlines, and subject matter), confraternal references dominate personal names and reflect the greater importance of group identity over personal responsibility.

In contrast to the previous examination of personal vs. corporate responsibility for separate contract sections, Table III provides a summary analysis of the personal vs. corporate references for the contract as a whole.[34]

Table III
Contract References to Confraternity and Individuals
Italy 1400-1525

	No.	%
Emphasize confraternity	30	56%
Approximately equal	13	24%
Emphasize individual	11	20%
Total number of contracts	54	100%

Contract references include the name of the confraternity, official titles, or collective references to confraternity members.

To assess whether the contract as a whole emphasized personal names or the confraternity, three categories were established: (1) emphasis on the confraternity through references to corporate name, corporate title, or corporate membership, (2) emphasis on named individuals, (3) approximately equal weight between both. Three Sicilian contracts formulated in the 1440's exemplify these categories. The 1447 contract between Paolo Tifanu and a Palermo confraternity typifies the first category. Through repeated references to company titles, the patrons emphasize their corporate function rather than their personal contributions.

Master Paolo Tifano, of the noble city of Messina, agrees . . . and willingly makes it known that he promises and solemnly obligates himself to Gaspari de Vintimilia, rector of the Confraternity of San Giacomo la Masara of Palermo, and master Jacopo Caruso, procurer . . . of said confraternity, to paint and make a crucifix . . . for the price of four ounces standard measure, of which price Master Paolo makes it known that he receives from the procurator one ounce and six tarinos. The remaining amount the aforesaid rector and procurator promise to give and relinquish to Master Paolo. . . . Said Master Paolo promises to deliver said work to the rector and procurator seven months from now, in the city of Palermo, at the expense of said Master Paolo.[35]

The second category presents a more equal relationship between personal name and confraternal role, as demonstrated in Gasparo de Pesaro's agreement to make a *gonfalone* for an Agrigento brotherhood.

Master Gasparo de Pesaro, painter of the city of Palermo, be it known, willingly promises and solemnly obligates himself to Antonio de Pitralia de Agrigento, present and agreeing for himself and the members of the Confraternita della Nunziata of Agrigento, to paint and make a standard for said confraternity . . . according to the design on a piece of paper which was given to said Antonio. This standard should be three palms long and two and a quarter wide, and on one side he should paint the image of the Annunciation and on the other side what Antonio and the members of the confraternity have written. And this for three ounces standard measure, of which Master Gasparo, be it known, has received one ounce and the remaining amount Antonio, be it known, willingly promises to give and transfer to Master Gasparo in cash in Palermo when the assigned work is finished. This work said Master Gasparo, be it known, willingly promises to Master Antonio and the members of the aforesaid confraternity or confraternity itself by the next Easter.[36]

In the contract, the personal name of Antonio appears four times while corporate references appear five times, an approximately equal balance.

For the third category, the donor, Niccolò de Larcara, clearly dominates the 1449 contract for the *disciplinati* confraternity of San

Nicola of Corleone. In this relatively brief contract, the patron's name appears three times while the confraternity is identified only once.[37] As demonstrated by Table III, only 24% of the contracts present approximately equal references and 20% stress individual contributions. In contrast, confraternal references dominate in 56% of the contracts, more than the other categories combined.[38]

Quantitative Analysis of Individual Names. The balance between corporate and personal references provides one index to corporate identity; the number of individuals listed in the contract provides another index of group consciousness. Surprisingly, the number of individuals listed in contracts varies from one to ten. Since normally only one name was required to establish legal responsibility, the additional names must serve another function. Occasionally several names appear because each person contributes to the financing of the project, but in most instances the additional names affirm the representative role of the contractees. As noted above, contracts often list the officers of the brotherhood or the committee formed to oversee the commission. In confraternity contracts, names of officials frequently mix with names of confraternity members in the opening clauses. For example, when Cima da Conegliano agreed to paint an altarpiece for his native town, the document lists seven members including two officials.[39]

By listing more people, the contract presumably affirms the corporate nature of the commission. Yet non-confraternity contracts also feature a range of names. On the assumption that the greater the number of names, the more evidence the contract provides of group consciousness, a tally of names comparing confraternity and non-confraternity contracts will reveal which type of contract provided more substantial evidence of group consciousness.

For comparison purposes, seventy non-confraternity contracts were analyzed. As in the sample of confraternity contracts, examples cover painting and sculpture commissions from Italy dating from c.1400 to 1525. Tables IV and V summarize confraternity and non-confraternity contracts in terms of regional and chronological distribution.

Table IV
Regional Distribution by Artist
Confraternity and Non-Confraternity Contracts
Italy 1400-1525

	Confraternity		Non-confraternity	
	No.	%	No.	%
Sicily	27	50%	29	41%
Tuscany	16	30%	18	26%
Venetia	4	7%	1	1%
Umbria	3	6%	16	23%
Lombardy	3	6%	2	3%
Latium	1	2%	0	0%
Marches	0	0%	2	3%
Emilia	0	0%	1	1%
Piedmont	0	0%	1	1%
Totals	54	100%	70	100%

Table VI charts the number of named individuals listed as patrons in the contract. Predictably, the confraternity and non-confraternity documents both have high percentages for the inclusion of one name of a person who would assume legal responsibility, 96% and 91% respectively. A sharp difference appears with the addition of a second name, 74% of the confraternity contracts including a second name compared to 36% of the non-confraternity contracts. The difference between private commissions and corporate commissions in non-confraternal contracts could account for this sharp distinction, and further research would clarify this shift. Half of the confraternity contracts include a third name compared to only a quarter of the non-confraternity documents. Differences continue in

the presence of the fourth, fifth, and sixth names. For examples above eight names, the number of contracts of either type is too small to permit meaningful comparisons. As shown in Table VI, the confraternity documents often include more names than non-confraternity documents—further evidence for group consciousness in the commission of confraternity art.

Table V
Chronological Distribution
Confraternity and Non-confraternity Contracts
Italy 1400-1525

	Confraternity		Non-confraternity	
	No.	%	No.	%
1400-24	5	9%	10	14%
1425-49	14	26%	14	20%
1450-74	13	24%	16	23%
1475-99	15	28%	15	21%
1500-25	7	13%	15	21%
Totals	54	100%	70	100%

Totals may differ from 100% because of rounding.

In summary, contracts provide textual evidence for corporate identity in confraternity commissions. While individuals or committees were delegated to supervise commissions, the contract clauses reveal group consciousness through proportional data and demonstrative evidence. Without ignoring individual contributions, the study of proportional data reveals the dominant role of corporate identity in the balance of confraternity titles and personal names. Demonstrative evidence encompasses visual directives. Clauses requiring the artist to depict robed figures and to harmonize new work

with old enhance group identity. Appropriately, a corpus of examples validates the corporate character of confraternity patronage. For a field now dominated by microcosmic studies of specific confraternities and particular works of art, this comprehensive approach provides a macrocosmic model for investigating confraternity patronage in Renaissance Italy.[40]

Table VI
Number of Named Patrons Listed
Italian Art Contracts 1400-1525

	Confraternity		Non-confraternity	
	No.	%	No.	%
1 patron	52	96%	64	91%
2 patrons	40	74%	25	36%
3 patrons	27	50%	18	26%
4 patrons	22	41%	12	17%
5 patrons	13	24%	4	6%
6 patrons	8	15%	3	4%
7 patrons	5	9%	2	3%
8 patrons	3	6%	2	3%
9 patrons	1	2%	1	1%
10 patrons	1	2%	0	0%
Total contracts	54		70	

Notes

1. Studies emphasizing the relationship between an artist and a single patron include Ernst Gombrich, "The Early Medici as Patrons of Art," in *Norm and Form: Studies in the Art of the Renaissance* (Chicago: Univ. of Chicago Press, 1966); essays by Heather Gregory and Patricia Simons in *Patronage, Art and Society in Renaissance Italy*, ed. Francis William Kent and Patricia Simons (Oxford: Clarendon Press, 1987); essays by H. W. Janson, Charles Hope, and Werner L. Gundersheimer in *Patronage in the Renaissance*, ed. Guy Fitch Lytle and Stephen Orgel (Princeton: Princeton Univ. Press, 1981).

2. One example is the purchase of Boccatti's *Madonna del Pergolato* by the Perugian Confraternita dei Disciplinati di San Domenico after the original commissioners had rejected the work; see Pietro Zampetti, *La pittura marchigiana da Gentile a Raffaello* (Milan: Electa, n.d.), p. 82; Francesco Santi, *Galleria Nazionale dell'Umbria: Dipinti, sculture e oggetti dei secoli XV-XVI* (Rome: Istituto Poligrafico, 1985), p. 23.

3. The standard source on contracts is Hannelore Glasser, *Artists' Contracts of the Early Renaissance* (New York: Garland, 1977), a revision of her 1965 dissertation. For discussions of documentary evidence and the artistic economy of Renaissance Italy, see Peter Burke, *The Italian Renaissance: Culture and Society in Italy* (Princeton: Princeton Univ. Press, 1987); André Chastel, *A Chronicle of Italian Renaissance Painting*, trans. Linda and Peter Murray (Ithaca: Cornell Univ. Press, 1984); Bruce Cole, *The Renaissance Artist at Work: From Pisano to Titian* (New York: Harper and Row, 1983); Creighton E. Gilbert, *Italian Art, 1400-1500* (Englewood Cliffs: Prentice-Hall, 1980); Hanna Lerner-Lehmkuhl, *Zur Struktur und Geschichte des florentinischen Kunstmarktes im 15. Jahrhundert* (Wattenscheid: Busch, 1936); Martin Wackernagel, *The World of the Florentine Renaissance Artist*, trans. Alison Luchs (Princeton: Princeton Univ. Press, 1981).

4. In addition to contracts published in a variety of articles and monographs on particular artists, collections of contract documents appear in Scipione Borghesi and Luciano Banchi, *Nuovi documenti per la storia dell'arte senese* (Siena: Torrini, 1898); Geneviève Bresc-Bautier, *Artistes, patriciens et confréries: Production et consommation de l'oeuvre d'art à Palerme et en Sicile Occidentale (1348-1460)* (Rome: Ecole Française, 1979); *Patrons and Artists in the Italian Renaissance*, ed. D. S. Chambers (London: Macmillan, 1970); Giovanni Gaye, *Carteggio inedito d'artisti dei secoli XIV, XV, XVI* (1839-40; rpt. Turin: Molini, 1961), 3 vols.; Vittorio Lazzarini, *Documenti relativi alla pittura padovana del secolo XV* (Venice: Istituto Veneto di Arti Grafiche, 1908); Gaetano Milanesi, *Documenti per la storia dell'arte senese* (Siena: Porri, 1856), vols. II-III; Gaetano Milanesi, *Sulla storia dell'arte toscana: Scritti vari* (Siena: Lazzeri, 1873); Gaetano Milanesi, *Nuovi documenti per la storia dell'arte toscana dal XII al XV secolo* (1885; rpt. Soest: Davaco, 1973); Antonio Sartori, *Documenti per la storia dell'arte a Padova* (Vicenza: Neri Pozza, 1976); Leopoldo Tanfani Centofanti, *Notizie di artisti tratti dai documenti pisani* (Pisa: Spoerri, 1897).

5. Palermo, Archivio di Stato, not. Giovanni Traversa 783, fol. 335; transcribed in Bresc-Bautier, pp. 240-41, doc. L. Contract dated 1443.

6. "confratrum inductas sake seu vestimenti confratrie." Palermo, Archivio di Stato, not.

Giacomo Comito 851, fol. 79; transcribed in Bresc-Bautier, p. 276, doc. LXXXVIII.

7. "s'obrigha a fare il ghonfalone . . . in questo modo: da un lato un Sa' Bastiano leghato a uno arboro con quatro que lo saettino e un angiolo che lo coroni; con e paesi e color fini e oro . . . e da l'altro latto la Nostra Dona col suo figlio i' colo e San Rocho e Sa' Gismondo con due battenti e paesi" (Milanesi, *Documenti . . . senese*, III, p. 81, No. 38). This commission document is one of three confraternity contracts that more accurately should be labeled a contract record since the document is preserved in the confraternity archival records rather than in a notary's records.

8. "figuram sancti Francisci, S. Antonii de Padua, S. Berardini et figuram S. Lodovici cum crocchio, pastorali, mitria et diadema aureis et cum palio azurri de Alemania cum ornamentis et fulcimentis aureis in extremitatibus dicti palii quam et intra dictum palium, videlicet lilia aurea, ibi apponere sex disciplinatos dicti ordinis fraternitatis predicte" (Spoleto, Archivio di Stato, Notarile, 105, Giovacchino di Simone, fols. 1v-2r); see Silvestro Nessi, "Jacopo di Vinciolo da Spoleto: un pittore sconosciuto rivelato dai documenti di archivio," *Prospettiva*, Nos. 33-36 (1983-84), p. 82.

9. "due fanciulli vestiti di biancho cholle grillande dello ulivo in chapo, che tenghino in mano lo schudo drentovi queste lectere cioè P.S.M." (transcribed in Corrado Ricci, "Benozzo Gozzoli: La pala della Compagnia della Purificazione," *Rivista d'Arte*, 2 [1904], 11, and Tanfani Centofanti, p. 84; for an English translation, see Chambers, pp. 54-55); Fern Rusk Shapley, "A Predella Panel by Benozzo Gozzoli," *Gazette des Beaux-Arts*, 39 [1952], 87-88. The main panel of the dismembered altarpiece is housed in the National Gallery, London, No. 283; see Martin Davies, *The Earlier Italian Schools: National Gallery of Art, London* (London: National Gallery, 1986). With the exception of the lost confraternal emblem, predella sections are preserved in four different collections (Shapley, pp. 78-88).

10. Richard C. Trexler, "Ritual in Florence: Adolescence and Salvation in the Renaissance," in *The Pursuit of Holiness in Late Medieval and Renaissance Religion*, ed. Charles Trinkaus and Heiko A. Oberman (Leiden: Brill, 1974), p. 207.

11. "la predella con una pietà in mezzo et da ogni canto il segno della Fraternita" (Castiglion Fiorentino, Archivio dell'Ospedale; transcribed in Ubaldo Pasqui, *Di Bartolomeo della Gatta, monaco camaldolese: Miniatore, pittore e architetto* [Arezzo: Soci and Figli, 1926], p. 30, fig. 9). While the predella is lost, the Pinacoteca Civica di Castiglion Fiorentino houses the main panel. See Anna Maria Maetzke, *Arte nell'Aretino: Dipinti e sculture restaurati dal XIII al XVIII secolo* (Florence: Edam, 1980), pp. 58-59, figs. 115-17.

12. For discussion of the figural representation of confraternity members, see Ellen Schiferl, "Corporate Identity and Equality: Confraternity Members in Italian Paintings, c.1340-1510," *Source*, 8, No. 2 (1989), 12-18.

13. For *moda et forma* clauses, see Glasser, pp. 31, 65-70. In a 1417 contract, the Sicilian *disciplinati* confraternity of Castellamare guarantees the quality of color for their altarpiece by requiring pigments similar to those used for an altarpiece in the cathedral of Palermo (Bresc-Bautier, pp. 215-16, doc. XIV). For the importance of color in Italian Renaissance contracts, see Michael Baxandall, *Painting and Experience in Fifteenth Century Italy* (Oxford: Oxford Univ. Press, 1972), pp. 11-17. The Scuola di San Marco in Venice requires Giovanni Bellini to improve the painting finished earlier by his brother Gentile for the same

room (Chambers, p. 58). In the 1454 contract drawn between Mariotto di Cristofano and a *disciplinati* confraternity, the comparison defines the format of the work as a double sided processional panel (Milanesi, *Nuovi documenti . . . toscana*, p. 96, No. 115). For the double-sided standard commissioned by the Annunziata confraternity of Castronovo, Gasparo de Pesaro promises to paint one side with figures similar to the Last Judgment on the *gonfalone* of St. Demetrius, a comparison encompassing not only the subject matter but also the number of figures and their arrangement (Bresc-Bautier, p. 230, doc. XXXIII-A).

14. Chi-square test shows no significant difference. For regional and chronological comparisons of the samples, see Tables IV and V.

15. "ac modo et forma prout erunt confaloni quos facere tenetur confratrie Sancte Marie Magdalene et confratrie Sancti Michaelis dicte urbis" (Palermo, Archivio di Stato, not. ignoto, spezzone 369; transcribed in Bresc-Bautier, p. 281, doc. XCIII). Contract dated 1442.

16. For the role of inter-confraternity competition in art commissions, see Patricia Fortini Brown, *Venetian Narrative Painting in the Age of Carpaccio* (New Haven: Yale Univ. Press, 1988), pp. 27-30; Peter Humfrey, "Competitive Devotions: The Venetian Scuole Piccole as Donors of Altarpieces in the Years around 1500," *Art Bulletin*, 70 (1988), 404-08.

17. "magistri Antoni construhere et de novo frabricare quendam confalonum largitudinis confaloni confratrie sancte Marie de la Caritate . . . lu campu di quillu ki sera piu di quillu di la Caritati, reliqua vero medietas amplitudinis sive largize ultra di quillu di la Caritati" (document lost; originally Messina, Archivio di Stato, notaio Leonardo Camarda; recent transcription in *Antonello da Messina*, ed. Alessandro Marabottini and Fiorella Sricchia Santoro [Rome: De Luca, 1981], p. 231).

18. The artist promises that the new work "sia di terzu ammiglorato di quello di la confraternita di lu Spiritu Sanctu" (Noto, Archivio di Stato, notaio Francesco Musco, Vol. 6341, fols. CCXXIIv-CCXXIII; transcribed in Marabottini, p. 248, doc. IV).

19. "ad faciendum et pingendum unam tabulam in oratorio et ecclesia dicte Societatis ad foggiam eius que nunc est" (Florence, Archivio di Stato, Notarile Antecosimiano: Rogiti di Mario Fedeli dal Borgo, segnato F. 177 [Protocollo 1445/7], fol. 92r-92v; transcribed in Eugenio Battisti, *Piero della Francesca* [Milan: Istituto Editoriale Italiano, 1971], II, 220; English translation in Baxandall, p. 20).

20. Venice, Archivio di Stato, San Marco, Reg. 17, fol. 60; transcribed in full in Pietro Paoletti, *Raccolta di documenti inediti per servire alla storia della pittura veneziana nei secoli XV e XVI* (Padua: Prosperini, 1894), I, 14; partial transcription in Brown, p. 293. English translation in Chambers, p. 58. Contract dated 1515.

21. "nella forma stanno quelle dell'altra faccia della Chiesa" (Milanesi, *Documenti . . . senese*, II, p. 412, No. 287). Contract dated 1485.

22. "eorum nominibus et item nomine et vice aliorum scolarium et devotorum conceptionis gloriosissime Beate Virginis Marie" (Milan, Archivio di Stato, Notarile, Antonio de' Capitani, No. 1945; transcribed in Glasser, p. 314).

23. "Johannes Pullastra, pictor, civis Panormi, coram nobis presens, sponte promisit et convenit ac se sollempniter obligavit Antonio de Pasquali, magistro Petro de Billecta, Johanni de Li Ferli, presentibus et stipulantibus nomine venerabilis confraternitatis ecclesie Sancti Viti quarterii Seralcadi et ut rectoribus dicte confraternitatis, ut dixerunt, ac Nicolao de Li Ferli,

Jacobo Barberio, Gaspari de Lombardo, Nicolao de Sanctoro et Nardo de Michele, tamquam confratribus dicte confraternitatis et nomine aliorum fratrum dicte confraternitatis absentium" (Palermo, Archivio di Stato, not. Niccolò Grasso 1077; transcribed in Bresc-Bautier, p. 245, doc. LV-A). Another example is the 1460 contract between Gasparo de Pesaro and Guglielmo de Pesaro, his son, for a *gonfalone*: "dicti confratres pro se et aliis confratribus dicte confraternitatis absentibus [said confraternity members for themselves and the other absent members of the confraternity]" (Bresc-Bautier, p. 273, doc. LXXXV).

24. "Nicandro Mazapedi et Iohanni Iurba civibus Messane veluti magistris confratrie ecclesie sancti Helie disciplinancium Messane representantibus integram confratriam dicte ecclesie" (Marabottini, p. 231, doc. XI). Contract dated 1462.

25. "maestro Giovanni del Mannella, Mariano del Bruno et Mariano di Vivuccio operari chiamati per l'oratorio a chonpagnia deli spectabili homini Nicholò di Bartolommeo d'Agniolo, Mariano del Bruno, Francesco di Pietro, rectori dela Fraternita di Santa Maria da Lucignano, elepti dal detto Comuno a fare l'opere et ornamenti dell'Arboro di Sancto Francesco" (Girolamo Mancini, "Allogazione al Signorelli d'alcuni dipinti in Lucignano," *Rivista d'arte*, 2 [1904], 188); contract dated 1482. Other examples include Piero della Francesca's contract with the Sansepolcro Misericordia confraternity (1445), Benozzo Gozzoli's contract with the Florentine Compagnia della Purificazione (1461), and Pintoricchio's contract with the Perugian Confraternita di San Giuseppe (1489).

26. For the difference between contract deadlines and completion dates, see Glasser, pp. 80-82.

27. Piero della Francesca made his agreement with "the abovesaid prior and advisor or their successors in office [sicut sibi expressum fuerit per suprascriptos priorem et consiliarios vel per suos successores in officio]" (Battisti, II, 220; English translation in Baxandall, p. 20).

28. The confraternity promises to pay the artists "libris octocentum imperialium de quo supra, quod declarabitur per Venerabilem dominum fratrem Augustinum de Ferariis et duos ex scolaribus dicte scolle, qui scollares eligantur post fabricationem dicte ancone per dictas partes" (Glasser, pp. 336-37). The centerpiece of this commission is Leonardo da Vinci's *Madonna of the Rocks* which survives in two versions (Louvre, Paris, Inv. No. 777; National Gallery, London, No. 1093). For the lengthy litigation surrounding this work and arguments about which version is the original made for the Milanese confraternity, see Glasser, pp. 241-59; Cecil Gould, "The Newly-discovered Documents Concerning Leonardo's 'Virgin of the Rocks' and their Bearing on the Problem of the Two Versions," *Artibus et Historiae*, 3 (1981), 73-76.

29. "Belingario de Charito, magistro Johanni de Vitali, rectoribus confratrie Nunciate terre Caccabi, necnon Jorlando Chachu et Nicolao Pancita, dicte confratrie confratribus, presentibus et stipulantibus" (Palermo, Archivio di Stato, not. Pietro Goffredo, 1076; transcribed in Bresc-Bautier, p. 242, doc. LII). Contract dated 1443.

30. Milanesi, *Nuovi documenti . . . toscana*, pp. 132-33, No. 156. Contract dated 1484.

31. Milanesi, *Nuovi documenti . . . toscana*, pp. 96-97.

32. As shown in Table II, personal names appear in 93% of the contracts and confraternity names appear in 93%. The convergence of both individual and confraternal names appears in 91% of the contracts.

33. Because some clauses include both corporate and individual references, the com-

bined percentages are higher than 100. The practice of assigning the funds to a third party noted in a few contracts has not been included in either category.

34. Table III: Chi-square = 12.11; p < .01.

35. "Magister Paulus Tifanu, de nobile civitate Messane, consentiens prius in nos etc. coram nobis sponte promisit et se sollempniter obligavit nobili Gaspari de Vintimilia, rectori fraternitatis Sancti Jacobi de la Massa Panormi, et magistro Jacobo Caruso, procuratori . . . dicte confraternitatis, dipingere et facere crucifixum . . . pro precio unciarum quatuor ponderis generalis, de quo precio presentialiter coram nobis idem magister Paulus habuit et recepit ab eodem procuratore unciam unam et tarinos sex. Restans predicti rector et procurator dare et solvere promiserunt eidem magistro Paulo. . . . Promictens dictus magister Paulus dictum opus, dare, tradere assignare eisdem rectori et procuratori hinc per totum mensem septembris proxime futurum, in urbe Panormi, ad expensas dicti magistri Pauli" (Palermo, Archivio di Stato, not. ignoto, spezzone 272; transcribed in Bresc-Bautier, p. 251, doc. LXI-A).

36. "Magister Gaspar de Pisaru, pictor, civis Panormi, coram nobis sponte promisit et se sollempniter obligavit Antonio de Pitralia de Girgenti, presenti et stipulanti pro se et confratribus et confratria Nunciate dicte civitatis Agrigenti, depingere et facere confalonum unum ad opus dicte confratrie bene . . . et sicut designatum est in quodam pecio papiri, coram nobis assignato eidem Antonio. Quod confalonum debet esse longitudinis palmorum trium et amplicze palmorum duorum et unius quarti, et in uno latere depingerit ymaginem Nunciate et ex altero latere quod scriptum fuerit eidem Antonio et confratribus dicte confratrie. Et hoc pro unciis tribus ponderis generalis, de quibus idem magister Gaspar presencialiter coram nobis habuit et recepit ab eodem Antonio unciam unam, et totum restantem idem Antonius coram nobis sponte dare et solvere promisit eidem magistro Gaspari in pecunia numerata in Panormo, assignato dicto opere et expedito. Quod opus idem magister Gaspar coram nobis sponte dare et assignare promisit expeditum eidem magistro Antonio et confratribus prefatis seu confratribus in solidum, in festo Pasce Resurrectionis Domini nostri Jhesu Christi proxime futuro" (Palermo, Archivio di Stato, Miscellanea, 8, fasc. 70; transcribed in Bresc-Bautier, p. 253, doc. LXIII). Contract dated 1447.

37. Palermo, Archivio di Stato, not. Enrico Pittacoli (Corleone), 59; transcribed in Bresc-Bautier, pp. 256-57, doc. LXVII-A.

38. Chi-square test shows significant differences at .01 level.

39. Peter Humfrey, *Cima da Conegliano* (Cambridge: Cambridge Univ. Press, 1983), pp. 197-98. Contract dated 1492.

40. I am grateful to Kathleen Ashley and William A. Phillips for their suggestions with regard to this paper and to John Kinsella and William M. Owens for their aid with some translations. I am also grateful to Cathy Hartung for the preparation of charts and tables and to David Silvernail for statistical analysis. A grant from the University of Southern Maine Faculty Senate Research Fund supported my research.

Religious Furnishings and Devotional Objects in Renaissance Florentine Confraternities

Ludovica Sebregondi

In his *Storia fiorentina*, Benedetto Varchi mentions that there were seventy-three active confraternal gatherings (*ragunanze*) in Florence in 1529, and subdivides them into confraterities "di fanciulli" and "d'uomini fatti." He then subdivides the latter into confraternities "di stendardo," "di disciplina," "di notte," and "buche."[1] Some of the objects in their oratories were common to all confraternities, while others were peculiar to one or another group. The focus of this article will be not on liturgical objects (sacred vessels, candlesticks, reliquaries indistinguishable from those used in churches) nor on the art works (though they were executed in large numbers for Florentine confraternities) but rather on that collection of furnishings and equipment used in confraternities for administrative activities or for ceremonies typical of lay religious associations.

It is not easy to examine fifteenth- and sixteenth-century examples of such furnishings because, over the course of time, these objects for daily use were tampered with, restored, or adapted to current tastes. I will therefore examine only a few exemplars that have come down to us relatively intact and others which, though from a later date, reflect their prototypes (though their typology may have been dictated by contemporary styles). The importance of these objects lies not in their art-historical value (which is often rather modest) nor in their richness (which varied with the memberships' wealth) but rather in their function within the activities of the confraternity.

One basic distinction separates objects intended for public functions outside the oratory from those used for confraternal func-

141

tions inside the company's quarters. Confraternity statutes (*Libri dei Capitoli*), for example, examined at length by historians, art historians, and linguists, belong to this second group of "inside" objects. These statutes are important not only for what they intrinsically represent but also as documents or direct contemporary testimony both of the furnishings used in the society and of the manner in which they were used.

A large number of thirteenth- and fourteenth-century statutes of Florentine confraternities has survived. One of the most famous illustrated manuscripts is the *Capitoli dei Buonomini di San Martino*, probably executed by Francesco d'Antonio del Cherico in about 1481-82.[2] Another is that of the 1501 statutes of the Compagnia della Misericordia, attributed to Vante di Gabriello di Vante Attavanti.[3] The *Costituzioni della compagnia del Sanctissimo martire Sancto Sebastiano*, at the Laurenziana, are also by Vante.[4] The *Regolamenti della Compagnia di San Lorenzo in Santa Maria Novella* are less well known, but equally rich in illustrations,[5] as are the *Chapitoli della chonpagnia de la purifichazione della Vergine Maria che si raguna a Monte Uliveto* (1529)[6] and those of the Confraternity of San Frediano detta la Bruciata (1489).[7]

The Buca di San Girolamo, officially called the "fraternitas Sanctae Mariae Pietatis," was founded in 1410 at the Girolamini hermitage in Fiesole and then within three years was moved to the Spedale di San Matteo in Florence. In 1785 it was forced to abandon its quarters (which were given to the Accademia di Belle Arti) and transfer to the oratory under the loggia of the Serviti in Piazza della SS. Annunziata, vacated by the suppressed Compagnia di San Filippo Benizi. Because the Buca was one of the few confraternities spared from the 1785 suppression ordered by the Grand Duke Pietro Leopoldo,[8] its archive has remained at the society. Purely by accident, while sifting among some more recent papers of modest interest, I discovered several volumes of statutes, in particular those of 1413-14, whose text had already been partially known through an earlier draft kept at the Biblioteca Nazionale Centrale di Firenze.[9] The fascinating illuminations in the original manuscript at the confraternity, however, had been completely unknown.

The manuscript lacks the original binding which, as is often the case, has been transferred onto subsequent editions of the statutes, and it lacks a few sheets. Folio 5r contains both the beautiful humanist hand (or book-hand) present in the entire volume, and the official authorization by the archiepiscopal notary (in a different hand) dated 6 March 1413/14. An interesting scene, even as mere documentation, is depicted along the bottom margin of fol. 12r (fig. 6). Four brothers (*confratelli*) are shown comforting a bed-ridden man: two are *infermieri* who stand at the bedside of a sick man, while two others carry food and wine to a servant woman on the left. One of the chief functions of the confraternity, especially in its earlier years, was in fact the distribution of charity to the poor: some brothers were to go in twos ("a coppia") and take to the needy a gift of three loaves of bread and a flask of wine,[10] while others visited the sick.[11] The illuminated initial on that same folio shows a Madonna of Mercy (*Misericordia*) in a white dress with a number of faithful kneeling under the protection of her mantle. The figure, surrounded by white racemes, stands in a light blue background with hints of pink, green, and red. The inital L on fol. 36r is also illuminated; the white racemes emerge from a light blue, red, and green background. The initial A on fol. 56r (fig. 7) has a baby Jesus in swaddling clothes against a light blue background. The same image, though smaller, is repeated on fol. 61r. An initial S on fol. 60r encloses the figures of St. John the Baptist and St. John the Evangelist with white lateral plant volute on a light blue and red background. All the initials are gilded. The decoration with white vine-shoots (the so-called "bianchi girari") is extensively used and well documented in Florentine illuminations between 1435 and 1475.[12] Because it is almost certain that this volume is to be dated to 1413/14, it becomes an important reference point for an examination of this widespread ornamental motif. The men's clothes also confirm a date no later than 1420. In fact, even though the *infermieri* wear the long gown that is not easy to date, the other brothers wear a three-quarter-length gown and headwear that still reflect fourteenth-century styles.[13] These figures, as Mirella Levi D'Ancona pointed out to me, recall the work of Battista di Biagio Sanguigni, who began his ac-

tivity soon after 1410. The slim gothic figures, the round heads characterized by eyes with accentuated eyelids and by curved mouths, the delicate colors all recall Sanguigni's contemporary *San Paolo* in the Breviary for San Pietro in Perugia (now at the Laurenziana) and the *Divina Commedia* at the Riccardiana.[14]

The volume was bound in February 1471/72, as we gather from a payment to "Antonio di Filippo chartolaio" for "leghatura e miniatura e per un san girolamo chon un osso . . . del libro de' nostri chapitoli."[15] The figure described may be the medallion of *San Girolamo nel deserto* (fig. 8), where the saint kneels in front of a skull that may be the *osso* mentioned in the document. This medallion was transferred unto successive editions of the statutes. The illuminator mentioned in the document may be Antonio di Filippo di Ventura, but, not knowing his works, we have no other grounds on which to confirm this attribution to him. The uncertainty is also motivated by other entries in the document, where Antonio appears to be more of a *chartolaio*—that is, a shopkeeper—than an illuminator.[16]

Although statutes rarely offer information about a confraternity's quarters, they are nonetheless a valid indirect source of information for the manner in which such quarters were used. Confraternities that had their own independent building usually had an entrance room (often with an altar in it) called *vestibolo* or *ricetto*.[17] From there one entered into the oratory proper, usually a long rectangular room with a high altar on the far wall and choir stalls (called *scanni, manganelle*, or *prospere*) on the other three walls.

Although late, the seventeenth-century stalls of the oratory once belonging to the confraternity of San Filippo Benizi (fig. 9) conform to documentary evidence about the format of many sixteenth-century stalls no longer extant. Along each of the two long lateral walls there were an upper row and a lower row of stalls. The upper row consisted of a single bench sustained by corbels and by a high back-board (*postergale*) resting against the wall. The lower row consisted of three parts—a back-board that doubled as prie-dieu (*inginocchiatoio*) for those in the upper row, a seating bench for those in the lower row, and, in front of the bench, three shorter detatched prie-

dieus. On the short wall by the entrance stood two high stalls (*arcibanchi*), that is, two stalls raised higher than those on the lateral walls, as well as two large desks (*banconi* or *deschi*) containing religious furnishings. The entrance door divided the wall symmetrically between the two high-desks. Prie-dieus were attached to the bench-side of the desks. On top of each desk there was a book-stand (*scannello* or *leggio*) on which to rest books while reading from them. The main body of the confraternity (*corpo di compagnia*) sat in the lateral stalls, while those who held official positions (*officiali*) sat at the high stalls by the entrance. The specific structure of the lateral stalls allowed for a double orientation: towards the altar during religious celebrations, and towards the high stalls at other times in a confraternity meeting (*tornata*). Brothers would therefore never be obliged to turn their backs to the tabernacle. This same basic structure reappears in the oratory adjacent to the church of Sant'Ilario a Colombaja, near Porta Romana, with differences only in the decorative carvings, the value of the wood used, and wealth of ornamentation.[18]

There were also other rooms for various purposes—e.g., the *Governatore*'s room, the company's archive, the storage room (*arsenale*), etc. The sacristy was usually either behind or beside the high altar.

Confraternities called "buche" also practiced the *pernottazione* —that is, members would gather on the vigil of a feast, would attend evening devotions, and, sleeping in the company's dormitory, would rise at appointed times during the night to continue their prayers. This type of society differentiated itself from other confraternities in other ways as well: silence was obligatory and could be broken only by prayer, members could not be enrolled in more than one such confraternity, and the confraternity did not participate in civic processions nor could it possess real estate.[19] In the Buca di San Jacopo detta del Nicchio Oltrarno,[20] in that of San Girolamo, and in that of Sant'Antonio Abate[21] there was in each case a single large dormitory room on the second floor ("primo piano"); the confraternity of San Paolo had four dormitory rooms on the ground floor and three on the upper floor.[22]

The beds on which the brothers slept are described in the statutes of the Buca di Sant'Antonio: "Let the bed be a straw sack with a straw pillow and a low quality blanket."[23] Members of the confraternity of San Girolamo slept on wooden boards (*madielle*) in large sacks (*sacchoni*) with straw pillows ("ghuanciali ripieni di fieno") —though for novices the pillows were stuffed with wool—and with canvas quilts as blankets ("coltroni di tela").[24] None of these simple furnishings has survived because the suppression laws of 1785 stipulated that beds and bedding from the suppressed *buche*, as well as those from the two that had been exempted but for whom the *pernottazione* was now expressly forbidden, be distributed among the parish poor.[25]

Like other institutions, the confraternities used stone plaques to identify their ownership of buildings. Figure 10 shows one such plaque from 1450, carved in *pietra serena*, bearing the symbol of the two joint companies of the Misericordia and the Bigallo.[26] Such a device, or *segno*, would also appear on furnishings and objects belonging to the company. The emblem of the confraternity of the SS. Annunziata, later called "di San Pierino," carved on the confraternity's door, conforms to the emblem's description in the company's statutes: a *ghuastada* (that is, a two-handled amphora) with white lilies inside.[27] The amphora is repeated in the center of the glazed terracotta lunette of the Annunciation (fig. 11) attributed to Santi Buglioni (dated 1520-30) above the confraternity's main door on the via Gino Capponi (previously, Orto dei Servi).[28] The *segno* was also painted on the candles distributed among the members of the confraternity on the feast of the Purification of the Virgin, known as *candellaia* or *candelora* (2 February).[29]

Either the symbol or the representation of the titular saint appeared on the seal (*sugello*) used to authenticate documents and give them a quasi-legal status. The statutes of the Buca di San Girolamo prescribed a seal with the representation of the Misericordia or the confraternity's *segno* and the inscription "S. Maria de la Pietà."[30] The importance of the seals is revealed in the statutes of the confraternity of San Giovanni Battista detta dello Scalzo: the installation of the new governor (*governatore*) is ratified by the transfer to him

of the statutes, the keys to the confraternity's quarters, and the *sugello*.[31] Because this was the only confraternity named after the Baptist, perhaps the seal bearing the inscription "+S. FRATERNITIS SCI IOHANIS D. FLORĒ" (Museo del Bargello) may have belonged to it.[32]

Similar stamps, with a handle and a seal, were used to imprint the confraternity's emblem on loaves of bread that were then blessed and distributed on special feastdays, especially on the feastday of the confraternity's patron saint. Small buns the size of a Host and bearing the company's *segno* were distributed at the confraternity of the Purification of the Virgin in Monte Oliveto.[33] I have not been able to locate any extant examples of such stamps for Florence. There are some from other regions, but they are not fifteenth- or sixteenth-century examples.[34] The still-extant Florentine confraternity of San Niccolò del Ceppo continues the ancient tradition of distributing blessed bread to its members on the feast day of its patron saint (6 December). Its 1558 statutes say the bread (*panellino*) should bear the stamp of the company seal,[35] but nowadays the bread itself is in the shape of the emblem—that is, it is made up of three round buns in memory of the three gifts of gold which the saint gave to the three poor girls without a dowry.

One group of utensils in the confraternities consisted of furnishings related to the deliberations on and distribution of official positions within the company. Decisions were reached by way of secret election. The ballots themselves consisted of beans (*fave*), chick-peas (*ceci*), or balls (*palline*)—white for a vote against, black for a vote in favor. The appropriately colored *fava* was placed with a closed hand into a voting urn (*bussolotto*) composed of a conical body with two half-cups; the ballots that had been cast into it were then emptied into a basin (*bacinella*) for counting. The manner of casting a ballot, the shape of the voting urn, and the manner of counting the votes ensured the secrecy of the vote. A brass eighteenth-century voting set kept at the Misericordia reflects the structure dictated by centuries-old usage.[36] Earlier voting sets were often in wood, like the set mentioned in the 1587 inventory of the Buca di Sant'Antonio.[37] A fifteenth-century box for storing the

beans used as ballots (fig. 12), once belonging to the Compagnia del SS. Sacramento in the town of Calenzano, is now kept in the sacresty of the *Pieve* of San Niccolò. The wooden box is painted orange; on each side there is a painted medallion representing, alternately, the Virgin with the Child or St. Nicholas.[38] This box is one of the few extant examples of what was a vast production of artisanal painting and craftmanship in Renaissance Florence and of the small number of confraternal furnishings that have come down to us in their original condition. The now-lost storage box for *fave* mentioned in the 1441 inventory of the Buca di San Paolo must have been similar to this one.[39]

Some of the official positions were filled by lot. The 1485 statutes of the Fraternita di Sancta Maria delle Laude in Santa Croce prescribe a box with three different locks for storing the bags (*borse*) used in such draws (*le tratte*).[40] Each bag contained paper slips (*polize*) bearing the names of those eligible for the particular office assigned to that bag. In spite of its later decorative scheme, a late eighteenth-century box associated with the Misericordia reflects the basic structure, especially the three locks, peculiar to the boxes described above.[41]

Each confraternity had tablets on which were written the names of members, officers, and novices. Generally speaking, these are framed wooden boards divided into vertical columns by thin wooden bars and capable of accommodating the appropriate name-plates inserted horizontally within these columns. There is evidence of one such tablet which contains the names of all the brothers ("Rasegnia di tutti e frategli") belonging to the Buca di San Girolamo; this item was created in 1488 by "Antonio dipintore."[42] Another *Rassegna* is entered in the 1587 inventory of the Buca di Sant'Antonio where it is described as two lockable tablets containing the names of all the brothers and kept in the *Provveditore*'s desk.[43] Because of continued use, there are no surviving examples of older tablets; the more recent ones have been tampered with in accordance with changing tastes. At the Misericordia there is a *Ruolo dei confratelli* whose center panel is divided into seventy-two slots into which to this day the names of living *Capi di Guardia* are entered. The tablet, datable

to the turn of the seventeenth-century, is carved in the late mannerist style.[44] The tablet at the Buonomini di San Martino comes from the same period and reflects the same structure, but the internal subdivision of the tablet is dictated by the specific nature of this company, which was originally composed of twelve *Procuratori* (two for each *sestiere* of Florence) and their six assistants.[45]

Confraternity members followed the course of their meeting (*tornata*) on their "Libri da compagnia." These were used for the entrance of novices into the company, the recitation of the Office of the Dead, and other liturgical ceremonies or prayers. Although many illuminated manuscript *Libri da compagnia* were prepared,[46] most of the surviving examples are printed books. One such book for a flagellant company was printed by the Giunta press in 1552.[47]

Penance in these confraternities was done with a rope or wire whip (*disciplina*). One such whip is held by the brother on the right side in the glazed terracotta lunette of the confraternity of the SS. Annunziata (fig. 11). From the Annunziata's statutes of 1495 we know that their whips were made of rope.[48] The whips held by two hooded figures in Benedetto Buglioni's glazed terracotta on the portal of the Chiostro dello Scalzo seem slightly different.[49] Those used in the Compagnia di San Sebastiano in San Frediano were made of wire and had star-shaped knobs at the end to induce bleeding.[50] In these companies, self-flagellation (*divotione*) took place after prayers had been recited and an exhortation from the Governor had been heard. The lights were then blown out, and the brothers, who had now pulled their hoods over their heads, flagellated themselves through the opening in their gowns that left their bare backs exposed to the whips.[51] The statutes of the Buca di Sant'Antonio prescribe that during this rite only one lantern bearing the image of St. Anthony kneeling at the foot of the Cross embracing it should be kept lighted and placed at the altar.[52]

The woodcut engraving depicting a company in procession on the frontispiece of the *Libro da compagnia* mentioned above leads us to an examination of objects used outside the oratory. These are the furnishings used in processions or pilgrimages, two of the most important confraternal ceremonies and instances of high devotional

fervor. The major processions in Florence took place on the eves of Corpus Domini and of St. John the Baptist. Often there were major processions in celebration of the acquisition of new relics[53] or for present-day needs such as relief from droughts, floods, or plague.[54] The importance that the confraternities attached to their participation in such celebrations is evident in a document in which the archbishop of Florence established the order of procession for Florentine confraternities. Such a directive was the result of altercations created by questions of precedence between the men of San Lorenzo in Palco and those of the Compagnia della Carità. During one year's Corpus Domini procession (probably 1510), the two groups had unceremoniously come to blows with fists and torches.[55] Although processions manifested devotion, the order of precedence within the procession illustrated the relative importance and prestige of each society, easily recognizable by its banner (*stendardo*) and its habit.

The confraternal habit (see fig. 11) was composed of a long gown (*cappa*) with large sleeves, tied at the waist by a rope belt, and a hood (*buffa*) that covered the entire head and left only two slots open for the eyes. The color varied from gray (for the company of San Francesco Poverino),[56] to deep blue (the confraternity of the Pura), to red (the company of the SS. Sacramento in Santa Maria Novella),[57] to basic black (the confraternity of San Lorenzo in Palco) or white (the confraternity of San Benedetto Bianco). The habit's color could help distinguish two companies with an otherwise identical name, as in the case of the confraternities of San Benedetto Bianco and San Benedetto Bigio.[58] The symbol of the company was painted or embroidered on the shoulder or on the hood. The members of the company of the SS. Annunziata displayed on their hood the Annunciation, complete with dove and rays of the Holy Spirit,[59] while those of the Compagnia dello Scalzo showed their symbol on their right shoulder.[60] The sixteenth-century statutes of the confraternity of San Lorenzo in Palco stipulate the same.[61] As a sign of penance the brothers sometimes processed in bare feet, as did the cross-bearer for the confraternity of San Giovanni Evangelista, called "dello Scalzo" exactly for this practice. The members of the confraternity of San Giovanni Hyerosolimitano,

whose oratory was near the church of San Jacopo in Campo Corbo-
lini, wore black "apostolic" slippers and no socks, and held in their
hands a black rosary.[62]

Every confraternity was preceded in procession by its insigna
(*segno*), either a crucifix or a banner (*stendardo*). The Christ figure
on processional crosses was carved in the round or painted on a
modelled board. The processional cross called *delle Misericordie*,
now in the church of SS. Annunziata but previously in the confra-
ternity of San Lorenzino in Piano, belongs to this second group. The
cross has been variously attributed to Andrea del Castagno, Alessio
Baldovinetti, and Giovanni di Francesco del Cervelliera.[63] The back
of the small crucifix is also painted because, in procession, it would
have been visible.

Banners, too, were illustrated front and back. They could be
composed either of a cloth painted on both sides or of two paintings
joined back to back inside a wooden frame. Generally speaking, the
patron saint was depicted on the front of the banner while allegori-
cal figures or titular saints were painted on the back. The banner of
the confraternity of San Niccolò del Ceppo, a work by Giovannan-
tonio Sogliani datable to 1517-21, is an example of such a construc-
tion. The titular saint is represented on the front in episcopal garb,
while two youths at his feet, dressed in white confraternal robes,
have their hoods thrown back over their shoulders. One of the
brothers holds in his hands three gold balls, the confraternal symbol
which, as mentioned above, recurs in the blessed bread distributed
in the confraternity on 6 December. A *Visitation* is painted on the
back of the banner, an indication that originally the confraternity
was named in honor of the Visitation of the Most Holy Virgin and
St. Nicholas.[64] The two canvases are joined by a gilded wooden
frame (*adornamento*). Such a banner was carried in procession by a
porter specifically hired for this service.[65]

The banner of the children's confraternity of San Jacopo Mag-
giore detta del Nicchio is a splendid work of c.1525-28 by Andrea
del Sarto.[66] The canvas, now in the Uffizi, depicts the patron saint
as in a kind, paternal way he caresses one of the two children kneel-
ing in white confraternal robes at his feet. Del Migliore describes
the painting as "un S. Jacopo con due fanciulli inginocchiati, vestiti

di veste bianca a cappuccio . . . fatto per segno della Compagnia, da portarsi a processione" and indicates that it was hung opposite the main altar "in un ricchissimo adornamento, come bene il merita."[67]

Other famous painters also produced such banners, now unfortunately lost. Vasari tells that Cosimo Rosselli painted the banner for the children's confraternity of San Bernardino, which met near the church of Cestello, as well as the banner of the confraternity of San Giorgio,[68] and that Andrea del Castagno painted the banner, regarded as very beautiful ("tenuto bellissimo"), for the confraternity of St. John the Evangelist.[69]

On a seventeenth-century bell once belonging to the confraternity of Santa Maria della Croce al Tempio there is a relief depicting the Eucharist, a cherub, and two brothers kneeling with their hoods lowered.[70] It probably belonged to a sub-group of members (*conforteria*) of this confraternity whose charitable work was to escort, in sombre cortège, condemned criminals to the gallows. As the Florentine notary and dramatist Giovan Maria Cecchi mentions, on the eve of his execution the condemned criminal was left in the chapel of the Bargello, his feet in chains ("[con] ceppi ai piedi"), in the company of members of the confraternity of the Neri (from the color of their habit) who offered him comfort and helped him to prepare for death. The following morning, escorting him in procession to the scaffold, they offered him comfort until his last breath ("sino all'ultimo respiro") and then, once he had been executed, buried the body.[71] A 1501 painting at the Museo Stibbert depicts, in a number of panels, the *Storia di Giuseppe Rinaldeschi*, who was condemned to death for having offended an image of the Virgin. The eighth panel, Rinaldeschi's confession, shows two brothers from the confraternity of the Neri leading him to his execution.[72]

The present study is of necessity only an overview. Many other works (frescoes, paintings, sculptures) commissioned by confraternities are known but were necessarily omitted because of space considerations. For a general impression of the importance and extent of such commissions one need only glance at the list of paintings transferred to the Uffizi or to the Accademia as a result of the Leopoldine suppressions of 1785.[73] I also have not examined here those

devotional objects that were used in the religious rites. I have, instead, sought to describe briefly some of the furnishings and objects that were characteristic of the life of Florentine confraternities in the fifteenth and sixteenth centuries.[74]

Notes

The following abbreviations have been used in the notes:

AABA Florence, Archivio dell'Accademia di Belle Arti

AAF Florence, Archivio Arcivescovile

AUCF Archivio dell'Ufficio Catalogo della Soprintendenza per i Beni Artistici e Storici delle Provincie di Firenze e Pistoia

ACSG Archivio della Confraternita di S. Girolamo e S. Francesco Poverino in S. Filippo Benizi

ASI Florence, Archivio dello Spedale degli Innocenti

BLF Florence, Biblioteca Laurenziana

BNCF Florence, Biblioteca Nazionale Centrale

BRF Florence, Biblioteca Riccardiana

Fas Florence, Archivo di Stato

CRS Compagnie Religiose Soppresse da Pietro Leopoldo (a subcollection of Fas)

1. Benedetto Varchi, *Storia fiorentina*, ed. G. Milanesi (Florence: Le Monnier, 1858), II, 73.

2. Tommaso Sassatelli del Turco, "La chiesetta di S. Martino dei Buonomini a Firenze," *Dedalo*, 8 (1928), 610-32; Leonia Desideri Costa, *La chiesa di S. Martino del Vescovo, l'oratorio dei Buonomini e gli affreschi sulle opere di Misericordia in Firenze presso le case degli Alighieri* (Florence: Tipocalcografia classica, 1942), p. 44; Francesca Petrucci, "Oratorio dei Buonomini di S. Martino," AUCF, Schede OA (1989), scheda No. 76.

3. *La Misericordia di Firenze: Archivio e Arredi* (Florence: Officine Grafiche Firenze, 1982), pp. 232-33.

4. BLF, MS. Ashburnham 871; on the manuscript, see Paolo D'Ancona, *La miniatura fiorentina* (Florence: Olschki, 1914), II, 754; Anna Rosa Garzelli, *La miniatura fiorentina del Rinascimento 1440-1525: Un primo censimento* (Florence: La Nuova Italia, 1985), I, 232; and M. Tesi, *Biblioteca Mediceo Laurenziana* (Florence: Nardini, 1986), p. 234, Pl. CLXXIIII. Other manuscripts of confraternity statutes with noteworthy illustrations are the fifteenth-century statutes of the confraternity "dei Genovesi di S. Friano" (BRF, MS. Ricc. 1685; see D'Ancona, II, 528, and M. L. Scuricini Greco, *Miniature riccardiane* [Florence: Sansoni, 1958], p. 253) which, on fol. 1ʳ, have an illumination representing St. Sebastian, the confraternity's patron saint; and also the fourteenth-century statutes of the confraternity "di S. Pietro" (BRF, MS. Ricc. 2577; see Scuricini Greco, p. 274).

5. BLF, MS. Ashburnham 970. The statutes are dated 1511. See D'Ancona, p. 469.

6. BLF Acquisti e Doni 118. See D'Ancona, pp. 472-73.

7. Fas, Compagnia di S. Frediano, filza 1 "Capitoli." There is an illuminated initial A on fol. 1ʳ. The titles of the various chapters have initials with filigree decoration. Gennaro Maria Monti mentions a large number of manuscripts of confraternity statutes (*Le Confraternite Medievali dell'Alta e Media Italia* [Venice: La Nuova Italia, 1927], 2 vols.). The 1448 statutes of the Compagnia della Purificazione della Vergine e di San Zanobi detta di San Marco mentioned by Monti (p. 184n, where he gives their location as Fas, Compagnie P A—corresponding to the present Fas CRS 1640 fascio A) are now lost and listed as "mancanti" in the Fas catalogue. Perhaps it is the same manuscript written by friar Bartolomeo and illustrated in 1447 by Battista di Niccolò da Padova traced to the London antiquarian dealer Breslauer; see Mirella Levi D'Ancona, *Miniatura e miniatori a Firenze dal XIV al XVI secolo* (Florence: Olschki, 1962), p. 444. A copy of the "prohemio" to the statutes and the official approval of St Antoninus dated 3 April 1448 are to be found at the convent of San Domenico in Fiesole and have been transcribed by R. Morçay, *Saint Antonin* (Tours: Maison A. Mame et Fils, and Paris: Librairie Gabalda, [1914]), pp. 473-74.

8. The other confraternities not suppressed were those of the Vanchetoni, the Stigmate, San Benedetto Bianco, San Niccolò del Ceppo, San Filippo Neri, San Salvadore, the Misericordia, and the Buca di San Jacopo. See the *Gazzetta Toscana*, No. 14 (1785), pp. 55-56.

9. BNCF, Magliab. XXXII, No. 43: "Capitoli della compagnia di S. Girolamo"; cited in Bernhard Ridderbos, *Saint and Symbol* (Groningen: Bouma, 1984), p. 204n.

10. "limosina di tre pani di circa d'una libbra l'uno con una metadella di vino" (ACSG, Capitoli 1413/4, fol. 17ʳ); see also Ludovica Sebregondi, "Oratorio di S. Girolamo e S. Francesco Poverino, già di S. Filippo Benizi," AUCF, Schede OA (1988), scheda No. 99.

11. ACSG, "Capitoli 1413/4," fols. 17ᵛ, 30.

12. See Mirella Levi D'Ancona, "La miniatura fiorentina tra gotico e rinascimento," in *La miniatura italiana tra gotico e rinascimento*, Atti del II Congresso di Storia della Miniatura, Cortona, 1982 (Florence: Olschki, 1985), p. 451.

13. See Rosita Levi-Pisetzky, *Storia del costume in Italia* (Milan: Istituto Editoriale Italiano, 1964-69), II, 316, 318, 353.

14. For the artist see Mirella Levi D'Ancona, "Battista di Biagio Sanguigni," *La Bibliofilia*, 72 (1970), 1-35.

15. ACSG, "Entrata e Uscita 1467-1479," fol. 94ᵛ.

16. See Levi D'Ancona, *Miniatura e miniatori a Firenze*, pp. 13-14.

17. In the lobby of the Confraternita della Purificazione della Vergine e di San Zanobi detta di San Marco there was a chapel dedicated to SS. Cosmas and Damian. For the altar of this chapel Cosimo di Giovanni de' Medici donated a painting depicting the two saints. See the "Proemio" to the statutes, transcribed in Morçay, p. 474.

18. Sebregondi, "Oratorio," scheda No. 28; and Lucia Ragusi, "Chiesa di S. Ilario a Colombaja," AUCF, Schede OA (1980), scheda No. 92. Other such stalls, with similar structure and late date are to be found, for example, in the oratories of the Buca di San Jacopo Oltrarno, the Buca di San Antonio Abate, and the confraternities of San Niccolò del Ceppo and San Francesco dei Vanchetoni.

19. The most ancient *buca* was the confraternity of Santa Maria della Pietà detta di San

Girolamo mentioned above. Founded in 1410, its statutes were approved in 1413/14. The other *buche* were those of San Paolo (with its oratory in via dell'Acqua, today's via Guelfa), founded in November 1434 (Fas, CRS 1579, P I, No. 1, fol. 1ʳ); that of San Jacopo, located in the Oltrarno beside the church of San Jacopo (see D. Tordi, *La compagnia di S. Jacopo d'Oltrarno detta del Nicchio o della Notte* [Florence, 1927], p. 2); that of Sant'Antonio Abate (located in Borgo Pinti near the convent of Santa Maria Maddalena de' Pazzi, today on via degli Alfani), founded in 1485 (see its "Capitoli" in Fas, CRS 107, fasc. 1, fol. IIᵛ); and the Compagnia di S. Girolamo Oltrarno (located on the Costa S. Giorgio), founded before 1441 (see its Capitoli in Fas, Capitoli CRS 81).

20. See D. Tordi, pp. 2, 8-9.

21. Fas, CRS 107, fasc. 2, "Inventario 1587," unnumb. folio.

22. Fas, CRS 1579, fasc. 1, fol. 6.

23. "sia il riposo uno sacconcello di paglia con uno guanc[i]ale di paglia et una coperta [di] cosa vile" (Fas, CRS 107, fasc. 1, fol. xxv).

24. ACSG, "Deliberationi e Partiti 1562-1596," fol. xi.

25. Fas, "Segreteria di Stato," 1785, No. 441, xii-xiii, "Affari risoluti da S.A.R. fuori di Consiglio da 16 luglio a 6 agosto 1785," No. 43.

26. H. Kiel, *Il Museo del Bigallo a Firenze* (Milan: Electa, 1977), p. 128. The union of the two companies was established in 1425 and lasted until 1489. At the time of the union, the Senate also decided upon a new emblem that would unite the emblems of the two companies: "in uno scudo solo diviso per lo lungo, in parte da una croce rossa, in campo nero, con un F e dall'altra un M d'oro dalle bande, e dall'altra un gallo bianco in azzurro con le lettere sotto S.M.B." (F. L. Del Migliore, *Firenze città nobilissima illustrata* [Florence, 1677], p. 78). For the many confraternity stone plaques from the old city center of Florence and now at the Museo di San Marco, see *Il centro di Firenze restituito*, ed. Maria Sframeli (Florence: Alberto Bruschi, 1989).

27. "una ghuastada chon due manichi, dentrovi uno ramo di gigli bianchi" (Fas, Capitoli di compagnie soppresse, 314, fol. 2ᵛ). At the BNCF, Luca Chiari's "Priorista," written in 1630, gives illustrations of the emblems for all Florentine confraternities (BNCF, Magliab. XXVI, cod. 36 [now recatalogued as II.I.262], fols. 483ʳ-497ʳ). Although the short entries that accompany the illustrations are not always reliable, this is a unique repertory, very useful in the study on Florentine confraternities, especially those of the post-Counter-Reformation period.

28. See Allan Marquand, *Benedetto and Santi Buglioni* (Princeton: Princeton Univ. Press, 1921), pp. 159-60, and Anna Pieraccini, "Ex-oratorio di S. Pier Maggiore, già confraternita della SS. Annunziata," AUCF, Schede OA (1987), scheda No. 1. The presence of the amphora-symbol and the manner in which the kneeling brothers are represented laterally are proof that the terracotta relief is in its original location and does not come, as W. and E. Paatz tentatively suggested, from the Church of San Pier Maggiore (*Die Kirchen von Florenz* [Frankfurt am Main: Klostermann, 1952], IV, 680).

29. See, for example, Fas, CRS 107, fasc. 1, fol. xxvʳ.

30. "uno sugello colla figura di S. Maria de la pietà collo amanto steso . . . o col segno de la compagnia con lettere d'intorno che dicano la compagnia di S. Maria de la Pietà" (ACSG, "Capitoli 1413/4" fol. 31ᵛ). For seals, see G. Bascapé, *Sigillografia ecclesiastica* (Milan: Giuffre, 1978), esp. II, 309-14.

31. BRF, MS. Riccardiano 2535, "Capitoli di tre compagnie religiose fiorentine," fols. 1r-19r; "chopia de' chapitoli della chonpagnia di San Giovanni Schalzo," fol. 3r.

32. *Sigilli nel Museo Nazionale del Bargello*, I. *Sigilli ecclesiastici* (Florence: S.P.E.S., 1988), pp. 170-72. On the five Florentine confraternities dedicated to St. John the Baptist see BNCF II.I.262, fols. 483r-485r. The compilers of *Sigilli* tentatively suggest the seal bearing the motto "ANGELUS * DOMINI * NUNCIAVIT MARIAE" and depicting the Annunciation (p. 294, No. 768) belonged to the Compagnia della SS. Annunziata (mentioned above). Although such an ownership is not to be excluded, one ought to keep in mind that in Florence there were other confraternities with a similar dedication, the children's confraternity on the Costa San Giorgio and the men's confraternity "di disciplina" by the Arno. All three used an emblem depicting a vase with lilies in it; the only difference lay in the colors used (see BNCF II.I.262, fol. 483r).

33. "panellini benedecti col segnio di nostra purificatione facti di grandeza d'una hostia" (BLF, "Acquisti e Doni" 118, fol. 46r).

34. In fact, given the extensive use and the perishable material (generally, wood), the stamps that have come down to us are fairly recent. See *La Liguria delle Casacce*, Catalogo della Mostra (Genoa: Cooperativa Grafica Genovese, 1982), II, 178-80, and Bernadette Montevecchi and Sandra Vasco Rocca, *Dizionari terminologici*, I. *Suppelletile ecclesiastica* (Florence: Centro Di, 1988), p. 419.

35. "l'impressione del nostro segno" (BNCF, Conventi Soppressi, D 3 270, "Capitoli della compagnia di S. Niccolò del Ceppo," fol. 17). See also my *La compagnia*, p. 22.

36. See *La Misericordia*, pp. 170-71.

37. "4 bossoli da rendere partiti fra grandi e piccoli di legnio" as well as a *tafferìa* (wooden basin); Fas, CRS 107, fasc. 2 "Inventario 1587," unnumbered folio.

38. Gloria Cecchi, "Pieve di S. Niccolò a Calenzano," AUCF, Schede OA (1978), scheda No. 33. I am grateful to Giovanni Burigana, who pointed out this item to me. In a quick glance in the *fondo* CRS at the Fas I have not been able to find early documents on this confraternity. In the 1589 pastoral visit by archbishop Alessandro de' Medici, there is, as expected, no mention of this item. The official report from the visit says that the brothers "utriusque sexus" wore "vestes albas" and had "oratorium amplum optime architecturae cum altare lapideo et tabula . . . pulcherrima, manu. . . . Passignani, cum imagine coronationis spine" (AAF, "Visita pastorale 1589," fol. 326r).

39. "chasetta da fave col bosolo e coperchio dipinta" (Fas, CRS 1579, fasc. 1, fol. 5r).

40. "una chasetta nella quale stieno serrate tutte le borse degli uffici, la quale chasetta abia a stare nella chassa del choro e abia detta chassetta tre chiave: una ne tengha el chorrettore e una el primo proposto de' chapitani e una el proveditore" (BRF, MS. Riccardiano 2535, "Capitoli di tre compagnie religiose fiorentine," fols. 21r-34r, "chopia de' chapitoli della chonpangnia della Vergine Maria delle laude di Sancta +," fol. 33v). A box with three locks and keys is prescribed in the statutes of the society of Sant'Antonio Abate, founded in June 1438 "drento alla porta a Faença" (BRF, MS. Riccardiano 1748, "Capitoli della compagnia di S. Antonio," fol. 6r). This manuscript is mentioned by G. Monti, p. 184, and also by M. L. Scuricini Greco, p. 258; it was displayed as part of the exhibition "La comunità cristiana fiorentina e toscana nella dialettica religiosa del Cinquecento" (see *La comunità cristiana fiorentina e toscana nella dialettica religiosa del Cinquecento*, Catalogo della mostra [Flor-

ence: Becocci, 1980]); see Arnaldo D'Addario, "Aspetti dell'associazionismo cristiano nella Firenze del Cinquecento," in *La comunità cristiana*, pp. 181-82. In other confraternities the box had only two locks; in the confraternity of S. Frediano also known as "la Bruciata," for example, the ballot box was "[una] cassetta con due chiave nella quale s'abbino a tenere decte borse dello squittino" (Fas, Compagnia di S. Frediano detta la Bruciata, fasc. 1, fol. 11r).

41. *La Misericordia*, p. 154.

42. ACSG, "Entrata e Uscita 1479-1489," fol. 130dex.

43. "Una rassegna, cioè due tavole che si serrano a chiave, dove sono descritti e nomi de tutti e nostri fratelli" (Fas, CRS 107, fasc. 2, "Inventario 1587," unnumbered folio).

44. See *La Misericordia*, p. 152. The 1489 statutes fixed the number of brothers (today called Capi di Guardia) at 72, but did not limit the number of members (today described as "ascritti"); see *La Misericordia*, p. 12.

45. I am grateful to Francesca Petrucci, who pointed out this item to me; see Petrucci, scheda No. 35.

46. D'Ancona, p. 747, shows an illustrated *Libro da compagnie laicali* from the Biblioteca Comunale di Siena. See also the documented but now lost *libri di compagnia* mentioned by Levi D'Ancona, *Miniatura e miniatori a Firenze*, pp. 401, 404, 405, 410.

47. A copy, now at the Seminario Maggiore di Firenze (shelf mark: R 2 V 33), was shown at the exhibit "La comunità cristiana fiorentina e toscana nella dialettica religiosa del Cinquecento" and entered in the catalogue (*La comunità cristiana*, p. 180).

48. Fas, Capitoli di compagnie soppresse 314, fol. 2v.

49. Marquand, p. 18, fig. 11.

50. "certe stellette in punta, che inducano a chi si batte il sangue" (BNCF, II.I.262, fol. 487v). This was a company of Genoese who met in the church of San Frediano. See n. 4, above, for its statutes. For illustrations of other whips evident in the seals of many confraternities, see G. Bascapé, Pls. LXIII and LXIV, as well as *Sigilli*, Nos. 433, 437.

51. See also the statutes of the confraternities of San Bastiano (BLF, MS. Ashburnham 971, fol. vi), San Lorenzo in Palco (BLF, MS. Ashburnham 970, fol. 18v), and San Domenico detta del Bechella (BRF, MS. Ricc. 3041, fol. 19v). This last manuscript, mentioned by Monti (p. 263n), has been transcribed and examined by Gilles Gerard Meersseman, *Ordo fraternitatis: Confraternite e pietà dei laici nel Medioevo* (Rome: Herder, 1977), pp. 697-753.

52. "una lanterna che di fuori dimostri la imagine di sancto Antonio ginocchione a piè d'una croce et quella abracci" (Fas, CRS 107, fasc. 2, "Inventario 1587," unnumbered folio).

53. See *L'oreficeria*, pp. 266-68.

54. See, for example, BRF, MS. Moreni 191, "Memorie istoriche fiorentine diverse," fasc. 1, "Memoria di dove sia venuta l'inmagine del Sant.mo Crocifisso situato nella Venerabile Compagnia di S. Lorenzo in piano, posta dietro alla chiesa della Sant.ma Annunziata" (seventeenth-century manuscript). Many *ricordi* relating to processions that took place between 1570 and 1670 to seek divine assistance are to be found from on fols. 6r-12v. The "Memoria" published in 1778 is mentioned by Domenico Moreni, *Bibliografia storico-ragionata della Toscana* (Florence: Presso Domenico Ciardetti, 1805), II, 69.

55. "Atteso Monsig.re R.mo Arcivescovo fiorentino come pe' tempi passati sono nati molti scandoli et disordini, quando si fanno le processioni dove intervenghono le compagnie della Ciptà et dominio fiorentino, così di disciplina come di stendardo, per cagione del prece-

dere l'una a l'a[l]tra, o andare ne' luogho più degno e in chiesa e fuori di chiesa, talvolta asaltatisi e battutosi gli uomini et persone di quelle l'un l'altro con torchi et arme et con mano, turbando et disonorando il culto divino. Et nuovamente nella chiesa cathedrale fiorentina el dì della solenpnità del Corpo di Cristo proxima passata, gl'uomini et persone della compagnia di Santo Lorenzo in palcho et quelli de' la compagnia della Carità, ignominosamente con torchi e con mano perchossisi sanza alcuno rispecto o reverentia della chiesa et di quelli che a essa sono prepostii.

"Et volendo a detti disordini obviare . . . ha ordinato et deliberato le infrascritte cose cioè: In prima che gli huomini et persone di dette compagnie di san Lorenzo in palcho et della Carità non restino impuniti del delicto per loro commesso [pagando a metà una multa] all'Opra et Operai della detta chiesa cathedrale per convirtigli in paramenti per honore et hornamento del Corpo di Cristo. Item [ha ordinato] a tutte le compagnie della ciptà fiorentina che dovessino portare e libro et libri de' loro Capitoli al suo camarlingho per ordinare per l'ordinamento del modo come debbino procedere nelle processioni. . . . Item ha ordinato . . . per lo advenire le compagnie nelle processioni incedino nel modo infrascritto: C. del Jhesù/ C. di S. Domenicho/ C. di S. Francesco alias martellaccio/ C. di S. Felicita/ C. della Vergine Maria in S. Piero Ghattolino/ C. della Nuptiata/ C. di S. benedetto alias il chiaro/ C. della purità/ C. de' martiri/ C. dello Ignatio/ C. di S. Lorenzino/ C. del Crocifixo nel Carmino/ C. della Carità/ C. di S. Giovambatista alias il martirone/ C. di S. Bartolomeo/ C. di S. Francesco alias il Poverino/ C. di S. Vincentio/ C. di S. Giovanni Scalzo/ C. di S. Nicolao da Talentino/ C. di S. Bastiano alias freccione/ C. di S. Benedetto in S. Maria Nª/ C. di S. Zanobi/ C. di S. Brigita/ C. di S. Lorenzino in palcho/ C. dello Spirito Santo/ C. di S. Benedetto bigio/ C. del Pellegrino" (AAF, Compagnie, filza VI[1], insert "Compagnie").

Another document in the same fascicule lists the order of precedence for youths' confraternities: "Innocenti 1ª/ C. di S. Bastiano 2ª/ C. di S. Jacopo 3ª/ C. di S. Alberto 4ª/ C. di S. Bernardino 5ª/ C. di S. Giorgio 6ª/ C. di S. Giovanni Evangelista 7ª/ C. della purificatione della Vergine 8ª." The same fascicule also contains the notes on the statutes presented by the companies to the archbishop's *camarlingo*, with the date in which the statutes were approved.

56. In mons. Pietro Niccolini's pastoral visit of 1634 the robes are said to be "cinerinei coloris" (AAF, "Visita pastorale di mons. Pietro Niccolini agli oratori delle confraternite della città di Firenze," 13 maggio 1634).

57. Stefano Orlandi, "La cappella e la compagnia della Purità in S. Maria Novella," *Memorie domenicane*, 75, Nos. 2-3 (1958), 177.

58. On the confraternity see BRF, MS. Riccard. 2302, "Zibaldone," No. 22, "Varie notizie della compagnia di S. Benedetto bianco estratte fedelmente dal libro de' Capitoli della medesima compagnia"; cited in D'Addario, "Aspetti dell'associazionismo," p. 187.

59. "in sulla testa . . . la Nutiata colla colonba. Et co' raggi dello Spirito Santo" (Fas, Capitoli di compagnie religiose soppresse 314, fol. 4[r]).

60. "[per] andare a procesione . . . ciaschuno de . . . fratelli deba fare una veste nera di panno grosso a uso di disciplina, quanto sia sua possibilità, la quale veste abia el segnio della . . . chonpagnia in sulla spalla ritta" (1455 statutes in BRF, MS. Riccardiano 2535, fol. 11[r]). Two brothers wearing a black habit are depicted on the relief above the entrance to the oratory; see n. 49, above.

61. "la quale [confraternita] vada fuori processionalmente a' tempi soliti con veste nere."

Et segno in sulla spalla cioè. El nostro gratioso padre in sulla graticola, ardente per amore di Christo" (BLF, Ashburnham MS. 970, fol. 5ʳ).

62. "pianelle nere alla apostolica a piè nudi . . . una corona nera per ricordo sempre dell'oratione," in Fas, Capitoli di compagnie religiose soppresse 63, "Capitoli della compagnia di San Giovanni Hyerosolimitano 1573," fol. 4dex.

63. See Luciano Bellosi, "Intorno ad Andrea del Castagno," *Paragone*, 18, No. 211 (1967), 6-9; Eugenio Casalini, "Culto ed arte all'Annunziata nel '400," in *La SS. Annunziata di Firenze: Studi e documenti sulla chiesa e il convento* (Florence: Convento della SS. Annunziata, 1978), pp. 11-38; and *Tesori d'arte dell'Annunziata di Firenze*, Catalogo della Mostra (Florence: Alinari, 1987), pp. 104-05. For the attribution to Giovanni di Francesco del Cervelliera, see Maria Horster, *Andrea del Castagno* (Oxford: Phaidon, 1980), pp. 193-94. It is interesting to note that in 1458-59 Giovanni di Francesco completed the lunette on the door to the church of the Spedale degli Innocenti (Guido Morozzi and A. Piccini, *Il restauro dello Spedale di S. Maria degli Innocenti* [Florence: Giunti Barbèra, 1971], p. 38), in whose crypt the confraternity of San Lorenzino in Piano had its quarters between 1456 and 1471 (ibid., pp. 36, 38).

64. The Visitation is a copy of the well-known Visitation by Mariotto Albertinelli, painted for the Congrega di Santa Elisabetta and transferred in 1786 to the Uffizi in the wake of the Leopoldine suppressions. See below, n. 73.

65. Ludovica Sebregondi Fiorentini, *La compagnia e l'oratorio di S. Niccolò del Ceppo* (Florence: Salimbeni, 1985), pp. 3, 22-23, 49-51.

66. *Andrea del Sarto 1486-1530: Dipinti e disegni a Firenze*. Catalogo della Mostra (Florence: Centro Di, 1986-87), p. 155; Shearman, p. 268, has suggested that the painting of the banner can be related to the completion of the work of total renovation of the quarters. Whether or not this suggestion is acceptable, I do not think it has been noted that in those years the confraternity was not located near the Innocenti. It located itself there only in 1595 when the *spedalingo* Giovanni Battista Totti and the *Operai* of the Spedale degl'Innocenti granted "alla compagnia e huomini del gonfalone di San Jacopo vulgarmente detta il Nicchio" a plot of land to "potere fare un sito a uso della loro compagnia" (ASI, Serie XIII, 22, "Giornale 1593-1605," fol. 47ᵛ). Before that time, the confraternity had had several locations; see BNCF, Magliab. XXV cod. 418, fol. 121. For the transfer of the banner to the Accademia in 1786, see n. 73, below.

67. Del Migliore, *Firenze*, p. 306. So as not to damage it further, the painting was exchanged with a copy listed in the 1649-50 Inventory (Fas, CRS 1246, fasc. 10, "Partiti e Ricordi 1641-1760," fol. 28ᵛ).

68. Giorgio Vasari, *Le vite de' più eccellenti pittori, scultori e architettori*, ed. P. Barocchi, Testo III (Florence: Sansoni, 1971), pp. 443-44. This is so in the Torrentiniana edition; in the Giuntina, on the other hand, Vasari does not mention the banner for the Compagnia del Bernardino but "una tavola con molte figure."

69. Vasari, p. 345.

70. *La Misericordia*, pp. 165-66.

71. Giovan Maria Cecchi, "Sommario de' Magistrati . . . 1562," BRF, MS. Moreniano, Palagi 246, fols. 41ᵛ-44ʳ. The passage is transcribed in Arnaldo D'Addario, *Aspetti della Controriforma a Firenze*, Pubblicazioni degli Archivi di Stato, 77 (Rome: Ministero

dell'Interno, 1972), pp. 402-05. It was partially transcribed by F. L. Del Migliore, "Compagnie laicali di Firenze e del suo stato," in BNCF, Magliab. XXV, cod. 418, fol. 132. On the confraternity of the Neri, see L. Passerini, *Storia degli stabilimenti di beneficenza* (Florence: Le Monnier, 1853), pp. 482-96, and E. Cappelli, *La compagnia dei Neri, l'arciconfraternita di S. Maria della Croce al Tempio* (Florence: F. Le Monnier, 1927). But see especially the paper on the *conforteria* by Kathleen Falvey, above, and also the paper by Jean S. Weisz, below, in the present book.

72. Cantelli, p. 32. Contrary to what some have claimed, the brothers depicted in the panel do not belong to the confraternity of the Misericordia but to that of the Neri who, until the 1785 suppression, had the charge of assisting the condemned.

73. AABA, Filza B "Filza 1ª di documenti lettere e carte diverse della Accademia delle Belle Arti di Firenze dall'anno 1781 al 1790," No. 47. I transcribe only those works that seem datable to the Renaissance period, and I omit the many paintings from the late sixteenth and seventeenth centuries.

"Nota di Pitture da consegnarsi in esecuzione di Sovrano rescritto de' 20 maggio 1786 dall'Amministrazione del Patrimonio Ecclesiastico alla Reale Galleria e respettivamente alla Accademia Reale delle Belle Arti, avvertendosi che quelle a olio sono state già trasportate alla detta R. Accademia, cui pure sono già state mandate le chiavi dell'atrio della soppressa compagnia dello Scalzo, per ragione delle Pitture a fresco che vi sono. Alla R. Galleria [that is, the Uffizi]/ Un quadro rappresentante la Visitazione di S. Elisabetta, la più bell'opera di Mariotto Albertinelli che esisteva nella chiesa della soppressa Congrega di S. Elisabetta/ All'Accademia Reale delle Belle Arti/ L'Atrio della soppressa Compagnia dello Scalzo, separato dal rimanente della Fabbrica di detta Compagnia per ragione delle Pitture a fresco che vi sono/ Un quadro rappresentante un'Annunziata del suddetto Mariotto Albertinelli, della compagnia di S. Zanobi/ . . . Un quadro rappresentante un Santo con due Putti in cappa bianca d'Andrea del Sarto del Nicchio/ . . . Un quadro esprimente una Madonna col Bambino, S. Giovanni e S. Giobbe del Franciabigio, della Compagnia di S. Giobbe/ . . . Due figure sopra il legno di scuola antica della Compagnia della Croce/ Un quadro grande rappresentante un crocifisso, la Maddalena, S. Francesco ed altri Santi, della Scuola d'Andrea, della Congrega di S. Elisabetta/ . . . Un fregio bislungo, con diversi soggetti di devozione, dell'Albertinelli, della Congrega di S. Elisabetta/ . . . Una Deposizione di Croce in tavola, di gusto antico, della Compagnia del Tempio/ Il Battesimo di Nostro Signore, del Maestro di Leonardo da Vinci della Compagnia dello Scalzo/ . . . Due quadri in tavola esprimenti la traslazione di S. Zanobi e l'altro il miracolo del Bambino risorto, opera del Ghirlandaio, della compagnia di S. Zanobi."

74. I wish to thank the members of the Confraternita di San Girolamo e San Francesco Poverino in San Filippo Benizi and in particular Paolo Palmerini for their assistance and courtesy. I am also indebted to and wish to thank Dott.ssa Paola Benigni, the entire staff of the Archivio di Stato di Firenze, and the staff of the Ufficio Catalogo della Soprintendenza per i Beni Artistici e Storici di Firenze e Pistoia. For their help and kind advice I would like to remember Monica Bietti, Giovanni Burigana, mons. Carlo Calzolai, Lorena Dal Poz, Lisa Goldenberg, John Henderson, Simonetta Mazzoni, Maria Sframeli. In particular I would like to thank Mirella Levi D'Ancona for her careful and precise indications and Silvia Meloni for her continued assistance and keen suggestions.

Music in a Florentine Confraternity: The Memorial Madrigals for Jacopo Corsi in the Company of the Archangel Raphael

Edmond Strainchamps

In the spring of 1604 the Second Book of Five-part Madrigals by the young Florentine composer Marco da Gagliano was published in Venice.[1] And although only twenty-two at the time, Gagliano had already established himself as a notable musician in Florence: he was well trained (he had studied music, principally with Luca Bati, *maestro di cappella* to the Grand Duke of Tuscany and at the city's cathedral); he was active in music-making throughout the city (in various churches and religious institutions, at Pitti Palace and in several private residences); and he was well connected (as a member of the prestigious Compagnia dell'Arcangelo Raffaello, by way of an appointment to oversee music in the church of San Lorenzo, and through contacts with the Medici and other important patrons of music among the Florentine patriciate).[2]

The last four of the twenty-one madrigals from Gagliano's 1604 publication are especially notable. Only two of these are by Gagliano himself, however; the others are by two noble musical dilettantes publishing as guests in the book: Piero Strozzi and Giovanni del Turco, the latter a student of Gagliano and the book's dedicatee, and both of them associated with him in various ways including, significantly, as fellow members of the Company of the Archangel Raphael. Together, these four madrigals stand apart from the rest in the Second Book by being identified as memorials to Jacopo Corsi, the extraordinary Florentine patron, who had died a year and a half earlier, on 29 December 1602.[3] It is not surprising that Corsi was remembered in music since he had provided signifi-

161

cant support for music in Florence for more than a quarter of a century. But then he had been lavish too in his support of poetry, art, and science and of Florentine culture in general.[4] Indeed, at the time of his death tributes were paid to him from near and far by all manner of individuals and in Florence by academies, churches, and confraternities.

One of his academic eulogists, referring to the wide range of Corsi's interests, wrote: "He greatly delighted in painting, honored the sciences with the highest reverence, [and] exalted poetry greatly; but the art of music not only surpassed these, it was by him prized most highly." The same eulogist also commented further on Corsi's special commitment to music: "I dare not speak of how he exercised his generosity toward those who profess this glorious art [of music], fearing that some of those present would perhaps break forth in such a vast grieving and in such high laments that perhaps it would not be conceded to me to follow your orders, O Academicians, according to my duty. Only this I will say: that he cleaved to those [musicians] as though they were dear brothers, and as brothers he loved them, and as brothers they shared his things in common [with him]."[5]

Corsi had been the patron of an informal musical academy, or *camerata*, since the late 1580's in Florence, and this role has given him lasting fame in the history of music. His *camerata*, in addition to its interest in matters pertaining to musical aesthetics, took a more practical approach to the art by becoming a veritable musical/compositional workshop. It was under Corsi's aegis, and involving his own compositional efforts, that the first attempts to set dramatic poetry to continuous music, a *stile rappresentativo*, were undertaken. The eventual achievement, which amounted to no less than the founding of opera in the new style that had evolved through the efforts of the Corsi *camerata*, was the creation of *Euridice*. This, the oldest surviving opera, was first performed on 6 October 1600 before a select audience in a private apartment of Palazzo Pitti as Jacopo Corsi's wedding present to Maria de' Medici, who had the previous day become the bride of Henry IV of France.[6]

Until now Corsi's memorial madrigals have been thought to be isolated tributes by three Florentine musicians to the generous patron who had very likely welcomed them into the hospitality of his *camerata* and encouraged the development of their talent by his interest and his favors. Now, through the study of documents belonging to the Compagnia dell'Arcangelo Raffaello, it is clear that these madrigals were composed to be part of an actual service held for Corsi in the rooms of the Company.[7] From the study of other extant documents we now also know that Corsi had been a member of the Archangel Raphael for many years—at least from 1583[8]—and had been generous in his support of it. The Company in gratitude and in profound respect for "the many pious and worthy things that he did" held obsequies for Corsi on 21 February 1603 which, in the words of one of its members, "were so fine and magnificent that nothing similar had ever been done before for a private gentleman in our city."[9]

The description of the service for Corsi entered in the *Libro di Ricordi* of the Arcangelo Raffaello was expanded by Domenico Torsi, who added significantly to the official account in a lengthy "Description of the Obsequies Performed at the Death of Signor Jacopo Corsi at the Compagnia dell'Arcangelo Raffaello, 1603."[10] Torsi's manuscript, apparently prepared for publication though no printed copy of the text is known today, is now in the library of the Villa Corsi-Salviati in Sesto Fiorentino, where it was recently discovered by Professor Tim Carter.[11]

In his *Descrizione*, Torsi relates in considerable detail how the Company erected for the service an elaborate catafalque that was adorned with the Corsi arms and with mottoes and *imprese* celebrating Corsi's special relationship with the muses and comparing him to Apollo, Orpheus, and Arion. And this relationship was emphasized in a formal oration delivered by Neri Acciaiuoli.[12] A portion of Torsi's remarks, particularly those that bear on the music for the occasion—music which includes the four madrigals printed in Gagliano's *Secondo libro*—is as follows:

Description of the Obsequies Performed at the Death of Signor Jacopo Corsi at the Compagnia dell'Arcangelo Raffaello, 1603

Near the altar, at the left side, upon a pulpit covered with black cotton, spoke Signor Neri Acciajuoli, a very fine young man of this city who, aside from his nobility of blood, is surpassed neither in virtue nor in gentleness of manner by none. This young man, with speech, with gestures, with words perfectly chosen and full of grace, and with singular feeling, indicating with his hands and by his voice Signor Jacopo's portrait (a marvellous thing), beside which he was standing, brought tears to the eyes of many.

The music, which was as abundant, full, various, moving, and ingenious as possible, and at the same time—what is hard to join with such—in its words clear and easily understood, was sung by the most exquisite and excellent musicians who are in our city today. The words were in part by Signor Riccardo Riccardi who, to say nothing of his fine judgment and skill in all difficult things, in virtue and in rare qualities of spirit is one of the rarest gentlemen in this land. In part by Signor Lorenzo Franceschi, a noble young Florentine so experienced in things dealing with poetry that he is regarded as being inferior to no one, and today lives by this profession. In part by Messer Adamo Bertozzi, a priest, who because of his rare comportment is much honored in this city. And in the company of these three were some thoughts of this [present] writer.

The music of the first madrigal was by Signor Piero Strozzi who, because of his many virtues and especially for [his] music, in which he is most competent, equal to any who makes it his profession, is held in great esteem in this land. This madrigal was sung by five voices to the sound of five viols with such sweetness and with such an affecting manner that perhaps its like has never been heard.

The same voices sang the second madrigal accompanied in the same way by the same viols. The music of this and the fourth madrigal and of the responsories that were sung at each nocturn of the Office was by Marco da Gagliano, *maestro di cappella* of this place [the Company of the Archangel Raphael], a young man who, in the years when others [only] begin to have judgment, has given such proof [of himself] to the printing presses of the world, that he has already filled every knowledgeable man with astonishment.

The third [madrigal], sung by four voices, accompanied by a wooden organ and by a flute seconded by a soprano voice, was by Signor Giovanni del Turco, a knight of [the Order of] Santo Stephano, a noble youth of this land who so strives to spend his days gloriously that not only is he worthy to be honored by everyone for himself alone, but especially [is he] for this most

noble science of music, because of which his published works today give vivid testimony of how greatly he is to be praised.

The fourth [madrigal] was accompanied by the same instruments [used for] the first and the second.

The responsories were sung to four viols by a soprano so excellent that I do not find his equal among all those who have ever been heard in our time. And this was recognized when, with an extraordinary sweetness and in a touching manner, the voice drew perhaps more than one tear from the eyes of those who were listening.

At the close, to the sound of a wooden organ, at times a soprano all alone, at times the bass, sometimes the contralto, and very often the tenor sang a verse of the *Miserere*, and of the *Benedictus*, but with such grace that it seemed to be among the celestial and the sweetest melodies. And hardly were the ceremonies been completed than it seemed to everyone that those hours during which the Sacred Office [had been said] had flown by more quickly than usual.

And because of this, our city cannot yet be done with praising the magnificence of the *apparato* and the great merit of Signor Jacopo Corsi and everything regarding him and of all things together worthy of eternal faith.

Praise God.[13]

Though not entirely clear, the broad outlines and some details of what occurred on 21 February 1603 at the memorial service for Jacopo Corsi are available from Torsi's description and from various documents of the Arcangelo Raffaello. The Company's premises, fronting on piazza S. Maria Novella, included a small chapel and a larger room, each with an altar. The *apparato*, the catafalque, and the elaborate decorations, were very likely installed in the larger room. Because the Company ordinarily heard Mass and an Office at pre-dawn and mid-morning services on all Sundays and on about forty feasts during the year,[14] it was not unusual that the meeting on 21 February, a Friday, was for the mid-morning Office—except for the fact that on that occasion the Company used the Matins Office for the Dead with its three nocturns. The four-part responsories by Gagliano used on the occasion may well have been those he published in 1608 in his *Officium defunctorum*, which has not survived in complete form.[15] The singing of the four madrigals as well as the eulogy probably preceded the Office service. "Deh rivolgete il

guardo," one of the madrigals by Gagliano used in the service, is contained in Appendix I, below.

It was not remarkable that fairly extensive music for voices and instruments was heard in the rooms of the Archangel Raphael on that day. From at least the mid-sixteenth century on, the company's records show that there were, in addition to the morning service, evening assemblies for older members that took place on Sundays and many feast days after sunset. These included both sermons and some special music. This music, which ranged from simple *laude* through polyphonic madrigals (not infrequently accompanied by instruments) to monodic songs and, significantly, dramas on sacred themes that were enacted with costumes, *apparati* of various sorts, and several kinds of music—including the *stile rappresentativo*—became a regular part of the activities of the Arcangelo Raffaello, as the *Ricordi* make clear.[16] In fact, the music is very much praised in the *Ricordi*, not unexpectedly, since the preeminent composers and performers in Florence were nearly all members of the Company.

Complementing the musical activities of the official music of the Medici court, the music in churches, and the music supported by private citizens such as Jacopo Corsi whose musical *camerata* and its works have been so emphasized by music historians, then, are the much less understood but no less important musical activities in the religious confraternities in Florence, especially during the sixteenth and seventeenth centuries but continuing up to the time of their suppression in 1785. And the most important of these with regard to musical events was the Company of the Archangel Raphael.

Though the *Ricordi* of the Arcangelo Raffaello clearly indicate how frequently music was performed in the rooms of the Company and exclaim at how excellent and impressive it was on most occasions, the unhappy fact is that almost none of it has come down to us. It was music for particular feast days and music written especially for the performing members of the Company—and, indeed, some of it may have been partially improvised—all of which seems to have worked against its having sufficient further usefulness to warrant publication or even preservation in manuscript form. For whatever reasons, it is rare that there are musical scores to match up to

the reports of music in any of the Florentine confraternities during the Renaissance.

It is, therefore, all the more fortunate that music certainly used by the Compagnia dell'Arcangelo Raffaello—the four madrigals from Jacopo Corsi's obsequies—has survived and can be identified. This music, too, would likely have gone the way of the rest of the Company's music except for the opportunity provided by the ambitious young Gagliano's publishing of a new madrigal book into which it could be inserted. But more important is the fact that Jacopo Corsi's remarkable standing in Florence and abroad made the publication of musical laments on his death appropriate. That, in turn, has allowed us a glimpse into the musical life of a religious confraternity in late Renaissance Florence.

Appendix I

"Deh rivolgete il guardo" by Marco da Gagliano, from his *Secondo libro de madrigali a cinque voci* (Venice, 1604).

- pra - mi di me'l co - re pie - tà
- pra - mi di me'l co - re pie - tà vi
- pra - mi di me'l co - re pie - tà vi
- pra - mi di me'l co - re pie - tà vi
pie - tà vi

vi pre - go e'n co - sì vi - le ar - ne -
pre - go e'n co - sì vi - le ar - ne -
pre - go e'n co - sì vi - le ar - ne -
pre - go e'n co - sì vi - le ar - ne -
pre - go e'n co - sì vi - le ar - ne -

Appendix II

An extract from the manuscript by Domenico Torsi of "Descrizione dell'esequie fatte nella morte del Signor Jacopo Corsi nella Compagnia dell'Arcangelo Raffaello, 1603" (Sesto Fiorentino, Library of the Villa Corsi-Salviati, fols. 64r-67v).[17]

Appresso l'Altare a man sinistra sopra un Pulpito coperto di cotone nero orò il Signor Neri Acciajuoli, giovane gentilissimo di questa città, il quale lasciamo stare la nobiltà del sangue, non ha per virtù, nè per gentilezza di costumi chi a lui passi innanzi: questi colla favella, co' gesti, colle parole elette, e piene di grazia, e di singolare affetto col far segno con mano, e colla voce al Ritratto del Signor Jacopo, che gli stava di costa, trasse, cosa maravigliosa, a molti le lagrime dagli occhi.

La Musica, che fu copiosa, piena, varia, miserabile, ed artifiziosa al possibile, ed insieme, il che difficilmente può stare insieme, chiara, ed agevole ad intendere colle parole, fu cantata da' più isquisiti ed eccellenti Musici, che oggi sieno nella città nostra. Le parole furon parte del Signor Riccardo Riccardi, il quale per non dir nulla del suo accorto giudizio, e destrezza a tutte le cose più difficili per virtù, e per rare qualità di animo è uno de' più rari gentiluomini di questa Patria. Parte del Signor Lorenzo Franceschi, giovane nobile fiorentino, e così esercitato nelle cose di Poesia, che a niuno è stimato inferiore, che oggi viva in questa professione. Parte di Messer Adamo Bertozzi, Prete, che per gli rari suoi costumi, è molto onorato da questa città. E in compagnia di questi furono alcuni pensieri dell'Autore.

La Musica del primo Madrigale fu del Signor Piero Strozzi, il quale per le molte virtù sue, e per la Musica spezialmente della quale al pari di ogni altro, che ne faccia professione, è intendentissimo, e tenuto in grande stima in questa patria. Fu cantato questo Madrigale da cinque voci al suono di cinque Viole con tanta dolcezza, e con sì pietosa maniera, che forse non s'udì simile giammai.

L'istesse voci cantarono il secondo Madrigale concertato parimente sull'istesse Viole. La Musica sì di questo come del quarto Madrigale, e de' Responsi, che si cantarono a ciascun notturno dell'Offizio fu di Marco da Gagliano, Maestro di Cappella in questo luogo, giovane, che negli anni quando altri incomincia ad aver senno, ha dato saggio tale per le stampe al Mondo, che ogni uomo ancora bene intendente ha ripieno di meraviglia.

Il terzo cantato da quattro voci sopra un Organo di legno, e da una Traversa ajutato in voce di soprano fu del Signor Giovanni del Turco, Cavaliere di Santo Stefano, giovane nobile di questa patria; il quale tanto si avanza a spendere

gloriosamente i suoi giorni, che non pure è degno per se stesso di essere onorato da ciascuno; ma spezialmente per questa nobilissima scienza della Musica, nella quale oggi quanto sia in pregio ne rendono vive testimonianze le pubbliche Opere sue.

Fu il quarto, siccome il primo, ed il secondo concertato su gli stessi istrumenti.

I Responsi erano cantati sopra quattro Viole da un Soprano così eccellente, che io non gli do pari di quanti a i nostri giorni si sono giammai uditi, e si conobbe allora, quando con soavissima voce, e con modo miserabile, forse più di una lagrima trasse dagli occhi di chi ascoltava.

Nel fine al suono di un Organo di un Organo di [sic] legno, ora un Soprano tutto solo, ora il Basso, talvolta il Contralto, e bene spesso il Tenore cantava un versetto del Miserere, e del Benedictus, ma con tanta grazia, che esser parea tra le Melodie sopra umane, e soavissime. Nè si tosto le Cirimonie si trovarono esser finite, che a tutti parve, che quell'ore, mentre che durò il Sacro Offizio volassero fuori dell'usato frettolosamente.

Per questo la città nostra non si può saziare ancora di lodare la magnificenza dell'Apparato, ed il molto merito del Signor Jacopo Corsi, e ciascuna cosa verso di se, e tutte insieme degne di eterna fede.

Laus Deo.

Notes

1. *Il secondo libro de madrigali a cinque voci [di Marco da Gagliano. Fiorentino] novamente stampato* (Venice: Angelo Gardano, 1604).

2. For an account of Gagliano's life, along with remarks on his music, see *The New Grove Dictionary of Music and Musicians*, VII, 81-87. More detailed information concerning Gagliano's activities in the Company of the Archangel Raphael is presented in Edmond Strainchamps, "Marco da Gagliano and the *Compagnia dell'Arcangelo Raffaello* in Florence: An Unknown Episode in the Composer's Life," in *Essays Presented to Myron P. Gilmore*, ed. Sergio Bertelli and Gloria Ramakus (Florence: La Nuova Italia, 1978), II, 473-87.

3. The date of Jacopo Corsi's death, first announced in Edmond Strainchamps, "New Light on the Accademia degli Elevati of Florence," *The Musical Quarterly*, 62 (1976), 508, seems still not properly to have entered the scholarly literature. To reiterate: the documentary evidence, extant in Florence, Archivio di Stato (hereafter Fas), MS. 627, "Necrologio fiorentino, 1600-[19]," reports: "S.r Jacopo di Gio. Corsi morì a 29 X.bre [1602] in Domenica a 23 ore e mezzo d'anni 42 in circa [in fact, he was born on 17 July 1561] fu pianto da tutta la città per le sue virtù e particolarmente sendo stato grande limosiniero e giovato sempre a ognuno. Si sotterrò a 31 con grande concorso di popolo. Ha lasciato 6 figliuoli, 2 masti e 4 femmini. Dio li habbia dato luogo di salute." This is confirmed by "Medici e Speziali, 254 (Libro dei Morti in Firenze, 1591-1607)," also in Fas, at fol. 206ʳ, where for December 1602 it is recorded that Jacopo, the son of Giovanni Corsi, was buried in Santa Croce on the thirty-first.

4. The most up-to-date account of Corsi's life and an assessment of his importance in the culture of his time appear in *Dizionario biografico degli italiani*, XXIX, 576-77, and Tim Carter, "Music and Patronage in Late Sixteenth-Century Florence: The Case of Jacopo Corsi (1561-1602)," *I Tatti Studies: Essays in the Renaissance*, 1 (1985), 57-104.

5. "Egli della Pittura estremamento gustava, le Scienzie con somma riverenza honorava, la Poesia eccessivamente essaltava. Ma l'arte della Musica non solo oltre alle sopradette era appo lui in sommo pregio. . . . Come verso i professori di questa gloriosa arte egli la sua liberalità esercitasse mi tacerò, atteso che alcuni i quali presenti ascoltano forse in così largo pianto, et in così alti lamenti proromperebbono, che forse non mi sarebbe conceduto a' vostri comandamenti o Accademici secondo il debito sadisfare, ben' questo solo dirò, che a guisa di cari fratelli quelli teneva, e da fratelli gli amava e come fratelli delle cose sue comunemente godevano" (Florence, Biblioteca Nazionale Centrale, MS. Magliab. XXXVIII, 115, Pt. 2, fol. 142r).

6. For further information about Corsi's *camerata* and its achievements, see especially Claude V. Palisca, "The 'Camerata Fiorentina': A Reappraisal," *Studi musicali*, 1 (1972), 203-36; Nino Pirrotta, "Temperaments and Tendencies in the Florentine Camerata," *The Musical Quarterly*, 40 (1954), 169-89; and Claude V. Palisca, "The First Performance of 'Euridice'," *The Department of Music, Queens College of the City University of New York, Twenty-fifth Anniversary Festschrift (1937-1962)* (Flushing, N.Y., 1964), pp. 1-23. See also the entry on Jacopo Corsi in *The New Grove*, IV, 806f.

7. The *Libro di Ricordi e Partiti, 1581-1610* of the Compagnia dell'Arcangelo Raffaello (Fas, Compagnie religiose soppresse 162, fasc. 21) has information on the sodality's service for Jacopo Corsi, though the account is lacking in many details (fols. 228v-229r). Important additional knowledge of the service, including specific reference to the madrigals, however, comes from a newly found document quoted below and identified in n. 10.

8. The date is known from Fas, Corsi-Salviati-Guicciardini, *Libro 436*, opening 5, left, as reported in Carter, "Music and Patronage," p. 92n.

9. Quoted by Carter, "Music and Patronage," p. 103n. The remark was made by Domenico Torsi (see n. 10, below).

10. "Descrizione dell'esequie fatte nella morte del Signor Jacopo Corsi nella Compagnia dell'Arcangelo Raffaello, 1603."

11. Torsi's manuscript is only one of a number of important new sources pertaining to the Corsi that are reported in Carter, "Music and Patronage." I am grateful to Carter for telling me of his discovery at an early point and allowing me to read a draft of his very valuable article, which appeared subsequently as "Music and Patronage."

12. For Neri Acciaiuoli's oration, see Florence, Biblioteca Riccardiana, MS. 2241, fols. 78r-85v.

13. My translation is from the transcription of the extract from Torsi's *Descrizione*, first printed in Carter, "Music and Patronage," pp. 80-81.

14. John Walter Hill, "Oratory Music in Florence, I: *Recitar Cantando*, 1583-1655," *Acta Musicologica*, 51 (1979), 109-110, has listed the feasts celebrated by the Arcangelo Raffaello in this period.

15. Gagliano's *Officium defunctorum quatuor paribus vocibus concinendum una cum aliquibus funebribus modulationibus* (Venice: Angelum Gardanum & Fratres, 1608), dated 1607 in the Florentine style, contains also settings of the *Miserere* and the *Benedictus Dominus* that may be the ones used for the Corsi obsequies.

16. Fas, Compagnie religiose soppresse 162, fasc. 21, *Ricordi e Partiti, passim*.

17. Reprinted, with permission, from Carter, "Music and Patronage," pp. 80-81. I am also grateful for permission to use this text as the basis for my translation in my paper.

Death and Dying
in Renaissance Confraternities

Nicholas Terpstra

Eliseo Mamelini was slipping fast. Struck by fever, and conscious of his approaching death, the sixty-nine year old notary called on family and friends for assistance. His sons knelt around the bedside to recite prayers and psalms and to receive a blessing "like that which Isaac had given to his children." Mamelini's brothers of the Confraternity of S. Croce trekked daily through the cold Bolognese winter to join in traditional confraternal prayers and to help their *fratello* recite the Divine Office. They were joined by their sponsors, the friars of S. Domenico, and the notary's confessor for forty-eight years, Fra Giovanni da Bologna. For over a week these friends spent as much time raising his spirits as praying for his soul. After the Lateran Canons of S. Giovanni in Monte blessed the weakening man with holy oil, he spoke no more. Two friars of S. Domenico attended the sickbed through the nights and, at dawn on the eleventh day of his fever, Eliseo Mamelini died. The Dominicans recited the Office of the Dead, and, after *confratelli* dressed their brother's body in the robes of the Confraternity of S. Croce, the house was opened to any wishing to pay respect to the dead man. Before the funeral procession, the confraternal robes were exchanged for those of the Dominican friars. Attended by crowds of family, neighbors, and friends, a rich procession made up of representatives of the Confraternity of S. Maria della Morte, the guild of Notaries, the Lateran Canons, and a dozen priests followed the Dominican friars to the family sepulcher at S. Domenico. Thereafter, all returned to the family's house where a Dominican friar preached a sermon of comfort.

This account of Eliseo Mamelini's death in 1531 was written by his son Andrea to conclude the notary's chronicle of his life and times in Bologna.[1] Andrea rounded out the portrait of a man who lived "como buono et fedel christiano," attending Mass daily and reciting the Divine Office, entertaining himself by listening to public sermons, and enrolling in more than five confraternities to channel his piety. The conventions of the *ars moriendi* shape and improve the image of a man whose own diary reveals vices mixed with virtues, but the account nonetheless gives us a full view of the rituals which eased a Bolognese notary's passage to death. Family members, confraternal brothers, guild associates, friars, and priests all laid claim to Mamelini and shared in death-bed and funerary rites. This over-lapping and co-operation among potentially competing social networks provides a good starting point from which to examine the significance of death and dying in Renaissance confraternities. As James Banker's recent study of San Sepolcro demonstrates, death was an enormously important focus of confraternal life.[2] This paper will consider three aspects of the issue: the rituals surrounding *confratelli*'s mortal illness and death; the extent to which *confratelli* availed themselves of these rituals; and the meaning of membership in more than one confraternity. Examining these three aspects in the context of an individual *confratello*'s life and death reduces the two temptations of looking at death and dying in isolation as a purely confraternal affair and of seeing confraternities in strictly functional terms as mutual aid societies offering decent burial and requiem prayer. Confraternities also symbolized a life of charity and regulated worship directly patterned on and continuous with that of the mendicant friars. As voluntary lay communities of prayer, fellowship, and charity, they had a particular place and significance alongside other familial, professional, and ecclesiastical associations. From the late fifteenth century, changes in the intersection of politics and charity in the community of Bolognese confraternities deepened this symbolic value.

Confraternal rituals of death and dying reminded members individually and collectively of their bonds of brotherhood and

charity. Each member swearing the confraternal oath pledged to remember dead brothers in personal devotions and with prayers, offices, and Requiem Masses said in the confraternal oratory. Membership benefits were as much practical as spiritual, including financial assistance to the terminally ill and subsidized funerals and burials for the poor.[3]

Care began with the sick. When a brother fell ill, family or *confratelli* brought his misfortune to the attention of the brotherhood's chief lay official, the *Ordinario*. The *Ordinario* then set about caring for the member's physical and spiritual needs, perhaps by himself visiting him, but above all by calling on the collective resources of the brotherhood. He explained the sick man's needs at the next worship service and encouraged all to add prayers for his recovery to their daily devotions. In close-knit flagellant (*disciplinati*) companies, the *Ordinario* appointed some brothers as visitors charged with visiting daily to determine the sick man's condition and to keep him company should he wish it. Larger praising (*laudesi*) companies might authorize a single visit by the *Ordinario*. Visitors usually came in pairs, and in the case of a lengthy illness were relieved in weekly rotation on a schedule drawn up by the *Ordinario*. Poor brothers received alms from the confraternal purse. Such acts of mercy had the potential of draining the purse of less established brotherhoods, so a number of Quattrocento statutes required that the brothers hold special collections for this purpose either from first need or when the brotherhood's resources had come to their limit. As the sixteenth-century demographic crisis squeezed all forms of voluntary charity, a few companies turned these sporadic alms donated out of brotherly charity into exclusive confraternal insurance plans with prescribed weekly premiums and predetermined scales of assistance regardless of need. This effectively pushed the truly needy out of the confraternity since their inability to pay premiums robbed them of coverage.[4] Beyond attending to physical needs, the visitors assessed and reported on the spiritual health of the *confratello*, read to him from the Bible and devotional works, encouraged him to set the affairs of his soul in order, and kept the brotherhood informed of his progress. As death approached,

the confraternity's hired priest arrived and, spiritually armed with the plenary indulgences every company collected, administered the last rites.

Upon death the confraternal kin mobilized to mourn and prepare the body for burial, activities that had traditionally been the preserve of natural kin. Practices varied from group to group on these points, with some companies limiting observance to a few private prayers while others turned burial into a major confraternal ritual. In general, however, these services became more elaborate and more public in the later Quattrocento and Cinquecento, particularly in flagellant companies. Bologna's earliest major confraternity, the thirteenth-century Congregatio Devotorum, had brought its poorer members to the grave with apostolic simplicity on an unadorned bier and without great ceremony. Later confraternities continued underwriting the burial costs of poorer members. The practice became so associated with serving the poor that by the early Quattrocento statutes for companies of high-born *confratelli* were silent on members' burial. By the mid-Quattrocento companies began restoring the practical services of a co-operative burial society but on a more lavish scale. This no doubt helped many prosperous members overcome the traditional association of confraternal funerals with paupers' burial since more came to rely on spiritual kin to conduct them to their grave. In flagellant companies, the *Ordinario* called all members to the Oratory and dispatched seven or eight of the better cantors to go to the dead man's house ahead of the main procession. Armed with robes, candles, and psalters, on arrival they flanked the body, lit their candles, and kneeled to recite the penitential psalms. As the others arrived, this first group took up the body, and, with all members now bearing candles and singing psalms, the robed procession made its way behind the confraternal standard to the parish, mendicant, or confraternal church designated by the *defunto*. There was some exclusivity to the company's claim to the body; the brothers of S. Maria della Vita noted that they recited penitential psalms in procession because they were a devout form of grieving which could drown out the distracting racket made by female relations and professional mourners.[5] John Henderson has

suggested that increasingly elaborate confraternal funeral processions in Florence may have been motivated by members' desire to circumvent sumptuary laws which from 1281 limited the number of candles, banners, and mourners who might bring the *defunto* to his rest.[6] This may have been the case in Bologna as well since funerary rites began to expand at the time when civil and ecclesiastical authorities first began the attempt to limit funeral pomp. The papal legate Francesco Gonzaga had some initial success with a decree of 1476, but the frequent renewal of sumptuary laws directed at funerals shows that in Bologna, as elsewhere, old habits died hard.[7] The sumptuary laws may be a negative factor behind expanding confraternal funerary rituals, but a parallel growth of requiems and prayers suggests that *confratelli* put spiritual intercession on par with legal circumvention when increasing their collective role in the rituals of death.

Confraternal interest in the *defunto* did not end with his interment. As a rule, praising confraternities annually observed a single Requiem Mass for all those members who had "passed from this life to the other," but seldom marked the deaths of individual members. Flagellant confraternities had traditionally gone further, reflecting the greater personal ties formed between members of these small and intensely spiritual groups. Flagellant *fratelli* added prayers for particular dead brothers to their personal devotions with each brotherhood fashioning multiple recitations of *Paters* and *Aves* particular to itself and varied in some cases according to members' condition or gender.[8] Yet the flagellants' collective or communal rites, focusing on the dead as a group, also limited observance to frequent recitations of Offices of the Dead and monthly or annual Requiem Masses. Changes appearing in statute books from the mid-Quattrocento stand out not simply because they increased the practical services offered to dying members but because they turned confraternal recognition of individual deaths from a private into a collective act. They can be seen as examples of the idea of "dying well" which, spreading generally in Europe from the later fourteenth century, were stimulated by a growing preoccupation with mortality and assisted by numerous devotional guides patterned after the

anonymous *Ars moriendi*. This treatise circulated widely in manu-
script and print editions, with at least two published in Bologna in
the 1470's.[9] The *ars moriendi* was not a purely private exercise but
a process of questioning, catechizing, and comforting the dying man
in a circle of spiritual kin. Once the soul departed, these kin carried
the art to its earthly conclusion by ensuring proper funerary and
requiem observances. With its existing system of visitors, prayers,
and requiems, the confraternal community was a natural locus
around which this art could develop. Certainly flagellant brother-
hoods began surrounding death with an increasing number of spiri-
tual observances from the early Cinquecento. On the night death
struck, the confraternity of SS. Sebastiano e Rocco posted a guard
of four brothers reciting the penitential psalms and the Vespers
Requiem. Many companies followed the example of Eliseo Mameli-
ni's brothers and dressed the body in the robes which the *defunto*
had worn in worship, procession, and flagellation.[10] On the evening
of interment or at the next feast day, brothers assembled at the ora-
tory and recited an Office of the Dead. Here they also gave alms for
the Requiem Mass. Mid-Quattrocento *Ordinari* simply arranged for
a Mass to be said at a time and place of their own convenience; by
the early Cinquecento, more statutes specified that it be sung in the
mendicant church associated with the company's hired priest or, in
the case of SS. Sebastiano e Rocco, ordered that the Mass be con-
ducted by the priest in the confraternal chapel and be preceded by
all the brothers reciting the penitential psalms for an hour. All of
these multiplying collective observances were in addition to both the
prescribed series of private memorial devotions conducted by *con-
fratelli* in their homes and the annual requiem services for all the
dead brothers.[11] Bolognese confraternities did not follow their Vene-
tian counterparts in appointing professional visitors and mourners to
carry out obligations to the dead and dying in return for regular
alms or housing in confraternal properties.[12] Rather, by the early
Cinquecento, participation became a test of obedience, and some
companies severely censured members who failed to fulfill their
obligations to the dead.[13]

The second aspect of confraternal care for the dying and dead is the extent to which *confratelli* availed themselves of these rituals and provisions. What is at issue here is not the case of someone like Eliseo Mamelini who had to orchestrate the overlapping demands and provisions of his various professional, familial, and personal networks. Rather, it is the question of how many confraternal brothers and sisters were still members in good standing at the time of death. Had the confraternity functioned primarily as a form of social and spiritual insurance, one could expect most members to retain their membership investment until death. In fact, retention rates are quite uneven, ranging from a high of one-hundred percent to a low of under ten percent. Some members were expelled, while others simply dropped away, suggesting that the confraternity was less a mutual aid society dispensing automatic benefits than a religious community which chose and was chosen by its members.[14]

Making one's way onto a confraternal matriculation list was no easy matter. Brothers screened and voted on applicants at least twice: once before admission to the novitiate, and a second time before profession into full membership. Passing these hurdles did not guarantee permanent tenure in the brotherhood. Most confraternities readily expelled those members who violated the statutes through insubordination or serious moral lapses; they also periodically removed as "negligent" those absent for prolonged periods with no good reason. Confraternities patterned these entrance and expulsion procedures on those used by the mendicant orders in order to underline what they believed to be their identical character as self-disciplining, voluntary communities of believers who conducted worship and charity under a common rule. By all appearances, these procedures were not simply a dead letter; extant Bolognese matriculation lists show expulsion rates of between 2.49% and 49.41%, and one Trecento Florentine company annually expelled about sixteen percent of its members.[15] In both cities the greatest losses were not among long-serving members who had tired of the brotherhood but among recent recruits who had joined in heady periods of rapid growth and subsequently regretted an oath which put them under close moral surveillance and supervision.[16] Most confraternities

willingly welcomed back in mercy those whom they had expelled in judgment; between 17.6% and 40% of those expelled from Bolognese confraternities of the fifteenth and sixteenth centuries subsequently sought pardon and won re-acceptance into their brotherhoods.[17]

The brotherhood whose officials were reluctant to expel the disobedient or negligent was not without recourse; the final membership hurdle was admission to the confraternal Book of the Dead. The confraternity was not a social institution operating only in the present but a spiritual brotherhood transcending time. The dead were simply members who had passed one stage in the soul's ascent to heaven. They were assisted in their ascent by the prayers of the living, who would themselves be assisted after death by the prayers of future members. The Book of the Dead was the membership record which helped the living play their commemorative role in the *ars moriendi*. From the later Quattrocento they remembered all their deceased spiritual kin by name in an annual Requiem Mass and feast. While many confraternal statutes required that the company maintain a *libro delle morti* separate from the running matriculation list of professed members, most company secretaries simply annotated the existing matriculation lists, using either the symbol + or a phrase such as "mortus est."[18] Since the record keepers marked only those members in good standing when they died, we can use the lists to weed out the negligent and transient and to determine what percentage of members remained with the company until death.[19]

The appendix to this paper gives figures and percentages drawn from surviving Bolognese matriculation lists of the fifteenth and sixteenth centuries. The number of members who died in good standing, broken down into male and female where applicable, is compared to the total membership in two categories: first the founding or reforming group; and second the subsequent inductees. There are two points to note here: first, men routinely have a higher retention rate than women, reflecting the increasingly restricted opportunities for women in most late fifteenth- and sixteenth-century Bolognese confraternities;[20] second, founders and reformers had a far higher retention rate than later generations of members. They

had established a new group or, in some cases, broken from a lax parent company in order to set up a stricter devotional cell. They had drawn up the statutes to which later members merely assented. They had re-asserted the spiritual purpose of a confraternity with a new set of devotional exercises and duties that reinforced the bond of living members with the dead. It is not surprising that such a high percentage remained loyal to the company until their death. Similarly, subsequent generations in the matriculation list had a less emotional commitment to the confraternity, so it is not surprising that more would have allowed their membership to lapse.

The third aspect of confraternal care for the dead and dying is directly related to the question of retention and concerns those individuals who, like Eliseo Mamelini, joined more than one brotherhood. If widespread, the practice of multiple memberships distorts retention statistics. More importantly, it seems to violate frequent statute prohibitions against "serving two masters" and raises questions about how seriously brothers took the meaning and obligations of confraternal membership. We can certainly interpret multiple memberships as indications of either spiritual indifference or anxiety or as a purely practical means of expanding professional and political networks. I would argue that these spiritual and practical dimensions are united and deepened when seen through the complementary values of community and charity and in the context of Bolognese history.

In a Gospel passage familiar to all *confratelli*, Christ gives a lesson in charity and salvation (*Matthew* 25.31-46). He warns that when judging humanity at the end of time, he will separate the sheep from the goats and admit the former to eternal life while damning the latter to eternal punishment. Judgment will be based on charity: giving food and drink to the hungry and thirsty, clothing the naked, visiting prisoners and the sick, and sheltering strangers. Extending such charity to anyone extends it to Christ; refusing charity to anyone is a refusal of Christ, a refusal he will reciprocate. With the addition of burying the dead, the seven works of corporal charity moved to the center of Catholic theology and communal

spirituality. As John Bossy notes, "the state of charity, meaning social integration, was the principal end of the Christian life, and any people that claimed to be Christian must embody it somehow, at some time, in this world."[21]

Confraternal charity extended in two directions: inward as spiritual and physical assistance to fellow brothers and sisters, and outward as assistance to the needy. The two were sometimes distinguished as *caritas* and *misericordia* respectively, but both were equally parts of a whole spiritual life.[22] Inwardly directed charity strengthened individual bonds of brotherhood and hence the communal strength of the confraternity; no brother need fear hunger or the pauper's grave. Out of this communal strength arose charity to the community and strangers by which the brothers expressed thanks and service to Christ in the spirit of his promise: "Amen, I say to you, as long as you did it to one of these my least brethren, you did it to me." *Caritas* and *misericordia* always worked reciprocally in the confraternities and distinguished them from the guilds, which typically assisted only their own members. At the same time, some confraternities cultivated one or the other. Flagellant confraternities had traditionally concentrated their efforts within the brotherhood, making only token gestures of charity to the broader civic community in the form of periodic distribution of alms or bread. Praising confraternities (*laudesi*) dedicated themselves to the poor of Christ living in and passing through Bologna and from the early Trecento established *ospedali*, or hostels, each of which met a variety of needs. This focus on *caritas* or *misericordia* respectively reflected different conceptions of the meaning of brotherhood which are underlined in the injunctions against "serving two masters." The rule appears only in statutes of the close-knit and secretive flagellant brotherhoods and applies to members who might wish to join another such group. Patterning themselves after the brotherhood of Christ's disciples, the flagellants aimed for a much more intense and exclusive form of community than their praising counterparts. Flagellant brotherhoods did not object to members joining one or more of the more loosely structured and less demanding praising confraternities, nor did the praising confraternities themselves rule against

joining more than one group of this type.[23] Hence community and charity were complementary, and individuals could easily merge *caritas* and *misericordia* without violating confraternal statutes by joining one flagellant brotherhood and more than one praising brotherhood.

Changes in Bolognese *ospedali* from the later fifteenth century encouraged those who looked on multiple membership as having both spiritual and practical benefits. Through this period the praising confraternities began re-directing their efforts from undifferentiated charity to the poor towards specializing instead in particular actions.[24] The pattern began when four confraternities, amalgamating in 1450 to form S. Maria degli Angeli, took over an all but abandoned Benedictine hostel and transformed it into a civic foundling home on the model of Florence's recently opened S. Maria degli Innocenti. As costs mounted, more confraternities merged into the growing institution. At the end of this period, S. Maria del Baraccano transformed its hostel into a girls' orphanage in 1527, and S. Bartolomeo di Reno balanced this by turning its hostel into a boys' orphanage a few years later. Many changes occurred in the meantime. In the spreading wake of the "mal francese," S. Maria dei Guarini began sheltering and treating only syphilitics. Meanwhile, a new charitable company arose to deal with the problem of *poveri vergognosi*, the shameful poor. The Compagnia di S. Maria della Morte which assisted prisoners awaiting execution established a separate Scuola dei Confortatori to handle this work more expeditiously. And the Compagnia di S. Maria della Vita expanded its infirmary for ailing Bolognese. As these companies turned towards specializing in particular social problems, the confraternities of S. Francesco and S. Maria dei Servi expanded their hostels in order better to continue the traditional role of sheltering the thousands of pilgrims who streamed through Bologna on their way through the Apennine passes to Rome. By the end of the Quattrocento, each sheltered about 14,000 pilgrims annually.

Communal governments encouraged this specialization through concessions on gate and mill taxes, grants for capital expansion, periodic alms for operating expenses, and legislation encouraging or

requiring Bolognese guilds to support the new institutions of social welfare. Perhaps more significantly, politically dominant groups both under the Bentivoglio signory and under the papal regimes installed by Julius II in 1506 and again in 1512 realized that one means of consolidating a shaky hold on political power lay in gaining control of the institutions which sheltered Bologna's orphans, cared for its poor, and healed its sick.[25] In the specialization of confraternal *ospedali*, spiritual purposes combined with *raison d'état*. Giovanni II Bentivoglio demonstrated the methods of gaining control during his effort to cement power after the Malvezzi conspiracy of 1488. In 1494 he and his supporters swamped the financially flagging Compagnia di S. Maria degli Angeli and re-vitalized its foundling home by merging it with the ancient and well-endowed militia Compagnia dei Lombardi. Members of the latter were furious but powerless to alter the arrangement until after Giovanni II's fall when they quickly re-asserted their independence. The post-Bentivoglio oligarchs moved more carefully, gradually increasing their membership in the praising confraternities which sponsored *ospedali* and initiating constitutional changes which left these institutions in the care of a separate self-perpetuating Board of Governors whose patrician members served life terms. Many leading patricians enrolled themselves and their supporters in more than one confraternity and served as Governors of more than one *ospedale*.

This brings us back to Eliseo Mamelini. The Bolognese notary belonged to a reputable if not patrician family and had married into a family better than his own.[26] He had held some minor positions in the communal government and guild administration but was not closely identified with any faction.[27] Ready to trim his sails to the prevailing wind, he is more characteristic of Bolognese attitudes than those patricians whose convictions led them into revolution and exile. His legal skills and membership in Bologna's most prominent guild ensured that Mamelini could not avoid political involvement however carefully he might wish to separate it from the potentially damaging taint of factionalism. With this we have enough for a functional analysis of Mamelini's membership in many confraternities. Obliging and astute, he contributed to a process by which his

superiors could solidify their power and dispense patronage. Lorenzo de' Medici and Giovanni II Bentivoglio had modelled this cunningly detached approach long before with multiple memberships which allowed them to keep a finger on the political pulse of potentially disruptive groups.[28]

Adequate in itself, this analysis fails to recognize the confraternities as spiritual communities or the importance of charity in contemporary piety. Recent studies of late sixteenth-century French flagellant confraternities have shown that pragmatic politics and intensely devout piety need not be seen as opposite or competing categories.[29] Quite apart from his political life, the confraternities organized Mamelini's devotional life; they were not chosen at random but with a deliberate eye to fulfilling specific spiritual duties. The single flagellant group, the Compagnia di S. Croce, provided the closest structure of regular worship, spiritual kinship, and *caritas*. The numerous charitable confraternities channelled Mamelini's exercise of *misericordia* not in any random way but in fulfillment of all seven acts of corporal charity. Through S. Maria del Baraccano he clothed, fed, and dowered orphan girls; through S. Maria degli Angeli he cared for abandoned infants; through S. Maria della Morte he comforted prisoners' souls and buried their bodies; through S. Maria della Vita he assisted the sick; and through the Monte di Pietà he assisted the poor and widowed.[30] Particularly after Bologna's confraternities specialized their activities in the later fifteenth and early sixteenth centuries, multiple memberships could ensure that the prosperous and devout layman would perform all the canonical works of charity necessary in order to be counted among the sheep rather than among the goats at the Last Judgment. Political necessity required only that many be chosen; religious necessity required that each choice be deliberate. Hence, far from being a sign of spiritual indifference, multiple memberships among the highborn are signs of a devotion alive to the common view that damnation awaited those who had the means to perform the works of corporal charity but failed.[31] As such, they were consistent with the *ars moriendi* quite as well as with the *ars politica*. Each confraternity had its means of comforting the dying and remembering the

dead. *Confratelli* gathering at the deathbed graphically reminded the dying man that he had done what Christ required. More to the point, their annual prayers and requiems reminded Christ himself of the brother's charity.

If all the confraternities participated in the funeral procession, the dead man's family and neighbors would also see a clear and comforting demonstration of his pious charity, a demonstration as helpful to the *onore* of the house as to the salvation of its *patrone*'s soul. More likely, as with the case of Eliseo Mamelini, the dying man would appoint specific roles to individual confraternities within the extended ceremonies and among the competing professional and personal networks of his life. As his closest spiritual kin, the brothers of S. Croce won the right to dress Mamelini's body in their robes; as the most prestigious of all of Bologna's approximately eighty confraternities, the Compagnia di S. Maria della Morte led his funeral procession. The Notaries' Guild, the Dominicans, Lateran Canons, and parish priests took over other functions. Much as civic processions put the religious and political hierarchy on a moving stage, so the funeral procession was a religious and political biography, a story told by marching ranks of *confratelli*, guildsmen, and clerics, and understood by all who watched. Looking at multiple memberships in this way through the focus of a single individual and in the twin contexts of civic politics and confraternal community and charity allows us a deeper understanding of the intertwined spiritual and political concerns of those who joined more than one confraternity. The greatest—and to date unresolved—difficulty lies in determining how many Eliseo Mamelinis there were and how common the practice was beyond the patriciate. Since those whose multiple memberships are best known are civic leaders, it is tempting to see the phenomenon in the limited functional terms of political patronage and control. Matriculation lists survive for fewer than a quarter of the roughly eighty confraternities active in fifteenth- and early sixteenth-century Bologna, and not all extant lists overlap. *Ricordi* may provide a key, as in Mamelini's case, but they too give only a spotty sample. As John Henderson has found in Florence, most diarists were curiously taciturn in reporting their confraternal memberships.[32]

Changing confraternal rituals, fluctuating membership retention statistics, and the practice and meanings of multiple memberships each lend their own color to our picture of confraternal death and dying. The complex image which they together present should remind us to be cautious when making firm distinctions between *laudesi* and *disciplinati* confraternities or when emphasizing the practical or sociological functions membership may fulfill. We can assemble institutional differences into a picture of distinct strands within popular piety only to find our neat categories blurred by those *confratelli* who found spiritual benefits in diversity. We can itemize the insurance and burial benefits which brotherhoods afforded their members only to find that these were seldom drawn on. We can co-ordinate a member's age with confraternal type only to find that there may be a stronger pull between a member's type and confraternal age. One historian has suggested that flagellant confraternities were largely liminal groups for young patricians and praising confraternities were primarily burial societies for artisans of modest means.[33] While Bolognese confraternities did not record members' ages, their recruitment and retention appear to have had less to do with the life-cycle of individual members than with the life-cycle and institutional culture of the brotherhood itself.[34] Here too, political pragmatism and spiritual concern could find a happy union in individuals who joined both flagellant and praising confraternities in their search for community and charity.

The example of Eliseo Mamelini reminds us that confraternal statutes are only a beginning to understanding confraternal death and dying. Confraternal statutes set up a *desideratum* which might find only partial translation into reality: apart from those inevitable communities whose observance was lax, not all members used the full range of services offered by their brotherhood. Some left before death, others received similar services from their guild, family, or other confraternities. Like all who kept eternity in mind, Eliseo Mamelini fashioned a dense network of overlapping spiritual ties with mendicant orders, an individual confessor, and lay brotherhoods.

Membership Retention in Bolognese Confraternities

The table below[35] gives the absolute number and percentage of those who died as brothers or sisters in good standing. Statistics are taken from confraternal matriculation lists; the time span is indicated under the name of each group. Original Members are those inscribed when the list was begun, and Added Members are those who joined the confraternity through the life of the matriculation list.

	Original Members		Added Members	
	Number	%	Number	%
S. Bartolomeo di Reno	[m] 372 of 393	[94.66]	109 of 253	[43.08]
(1471 to c.1510)	[f] 14 of 26	[53.85]	5 of 20	[25.00]
S. Bernardino	[m] 53 of 82	[64.63]	218 of 337	[64.69]
(1454 to c.1570)	[f] 18 of 48	[37.50]	125 of 441	[28.34]
S. Francesco	[m] 107 of 145	[73.79]	161 of 457	[35.23]
(1466 to 1494)	[f] 98 of 146	[67.12]	49 of 445	[11.01]
S. Maria degli Angeli	[m] 132 of 302	[43.71]	36 of 164	[21.95]
(1479 to mid-16th c.)				
S. Maria del Baraccano	[m] 249 of 273	[91.20]	166 of 382	[43.45]
(1518 to mid-16th c.)	[f] 13 of 33	[39.40]	14 of 43	[35.56]
S. Maria della Carità	[m] 31 of 31	[100.00]	241 of 269	[89.59]
(1399 to c.1530)	[f] 50 of 52	[96.15]	92 of 167	[55.10]
S. Maria dei Guarini	[m] 116 of 128	[90.63]	132 of 499	[26.45]
(1428 to c.1530)	[f] 10 of 120	[8.33]	17 of 119	[14.29]
S. Maria della Pietà	[f] 61 of 71	[85.92]	81 of 215	[37.67]
(1547 to late-16th c.)				
S. Maria dei Servi	[m] 74 of 76	[97.37]	94 of 161	[58.38]
(1530 to 1569)				
S. Rocco	[m] 132 of 136	[97.06]	179 of 406	[44.09]
(1509 to early 17th c.)				

He joined a cluster of confraternities whose social services he did not need in order better to practice his daily worship, to fulfill his political duties, and to secure his eternal future. Artisans, small merchants, and all those lacking Mamelini's family sepulcher, high profession, political offices, or social connections would have more restricted networks but would still have to mediate between these. Confraternal membership gave them cooperative access to the spiritual resources that Mamelini enjoyed by virtue of his personal wealth and status: a confessor, indulgences, an honorable funeral, and interment in mendicant robes. Beyond this, family, guild, and parish all laid their claims. Regardless of class, *confratelli* were never merely *confratelli*. Not all who joined a brotherhood remained until death or needed its extensive services. What they drew from the brotherhood depended largely on the strength of other strands in their kin, occupational, and parochial networks and must often have resulted in very individual compounds. Our desire to abstract confraternal rituals risks isolating confraternities from this rich social context. Yet if confraternity studies are to have more than antiquarian interest, it rests on our ability to integrate brothers into their networks and brotherhoods into their contexts, and so put confraternities on the agenda of medieval and early modern history.

Notes

Abbreviations used:

ASB Archivio di Stato di Bologna
 CM Codici Miniati
 Dem Fondo Demaniale
 Osp Fondo Ospedale
 PIE Fondo Pii Istituti Educativi
BBA Bologna, Biblioteca Comunale dell'Archiginnasio
 Gozz Fondo Gozzadini
 Osp Fondo Ospedale
BBU Biblioteca Universitaria di Bologna

1. Three generations of Mamelini notaries contributed to the chronicle, which spans 1436-1580. A portion has been published: Valerio Montanari, ed., "Cronaca e storia bolognese del primo Cinquecento nel memoriale di ser Eliseo Mamelini," *Quaderni Culturali Bolognesi*, 9 (1979), 5-64; for Eliseo Mamelini's death, see pp. 63-64.

2. James R. Banker, *Death in the Community: Memorialization and Confraternities in an Italian Commune in the late Middle Ages* (Athens: Univ. of Georgia Press, 1988).

3. Descriptions of care for the dying and dead are drawn from the following confraternal statute books (*stretta* groups are cells of flagellants formed within praising confraternities): Congregatio Devotorum (1261-83), chaps. 15-19, in Giancarlo Angelozzi, *Le confraternite laicali* (Brescia: Queriniana, 1978), p. 95; S. Francesco (1317), chaps. 5-6, in C. Mesini, "La Compagnia di S. Maria delle Laudi e di S. Francesco di Bologna," *Archivium Franciscanum Historicum*, 52 (1959), 366-72; S. Geronimo (1433), BBA Gozz 206, No. 5, chap. 13; S. Domenico (1443 *stretta*), BBA Gozz 207, No. 2, chaps. 14-15; S. Bernardino (1454), ASB Dem 8/7639, No. 1; S. Maria dei Guarini (1454 *stretta*), BBA Gozz 210 No. 11, chap. 11; S. Maria della Vita (1454 *stretta*), BBA Osp, No. 10, chap. 17; S. Ambrogio (1456), ASB CM, No. 67, chap. 17; S. Francesco (1494), ASB CM, No. 61; S. Maria della Pietà (1503), BBA Gozz 206, No. 7, chap. 2; S. Rocco (c.1511-23), ASB Dem 6/6589, No. 2, chap. 3; SS.mo Crocifisso del Cestello (1514), BBA Gozz 206, No. 1, chap. 17; S. Maria Maddalena (1515), ASB PIE, No. 1, chap. 27; S. Maria della Carità (1518 *stretta*), BBA Gozz 210, No. 6, chap. 20; Buon Gesù (1521 *stretta*), ASB Dem 9/7631, No. 1, chap. 11; S. Maria del Baraccano (1521), BBA Gozz 213, No. 1, cap. 17; SS. Sebastiano e Rocco, (1525 *stretta*), ASB Dem 16/6620, No. 1, chap. 15; SS.mo Crocifisso del Cestello (1538) BBA Gozz, No. 2; (1570) BBA Gozz 206, No. 1b. See also John Henderson, "Religious Confraternities and Death in Early Renaissance Florence," in *Florence and Italy: Renaissance Studies in Honour of Nicolai Rubinstein*, ed. Peter Denley and Caroline Elam (London: Westfield College, Univ. of London, 1988), pp. 383-94.

4. Late-Cinquecento insurance systems effectively removed the truly needy from confraternal care. For example, the brothers of Buon Gesù, devising an insurance system in 1588, established it as the sole responsibility of a life-term *depositario* who kept accounts, made payments, and presented annual reports to the company. Professing members gave a penny (one *quattrino*) every Sunday and feast day. The sick received a visit from the company doctor and immediate payment of twenty *soldi*. The fund dispensed a further thirty *soldi* every fortnight for eight weeks, dropping to twenty *soldi* per fortnight thereafter. Benefits bore no relation to need; all members paid and received payments on pain of obedience, and those more than six months in arrears received no benefits of any kind when sick (Compagnia di Buon Gesù, ASB Dem 9/7631, No. 1 [revision of 2 May 1588]). The brotherhoods of S. Maria dei Guarini and S. Maria della Carità developed similar systems in this period. For similar developments in Florence, see Ronald F. E. Weissman, "Brothers and Strangers: Confraternal Charity in Renaissance Florence," *Historical Reflections/Reflexions Historiques*, 15 (1988), 35.

5. ". . . sera più devotione perché li varii obiecti o de femene o pianti o altri strepiti multa fano variare li sentimenti" (Compagnia di S. Maria della Vita, BBA Osp, No. 10, chap. 9).

6. John Henderson, "Piety and Charity in late medieval Florence: Religious Confraternities from the Middle of the Thirteenth Century to the late Fifteenth Century," Ph.D diss. (Univ. of London, 1983), pp. 112-13. In contemporary Venice, confraternities provided much of the grandeur for funerals of prominent public officials. Doge Leonardo Loredan's 1521 cortege included 119 *scuole*, Cardinal Corner's of 1525 had 111, and funeral processions for the French (1521) and Papal (1514) ambassadors had 96 and 64 respectively; see Richard Mackenney, *Tradesmen and Traders: The World of the Guilds in Venice and Europe* (London: Croom Helm, 1987), p. 140.

7. Gonzaga specified that no more than ten members of no more than one religious order join the funeral procession and that no bells be sounded. The funeral of Alberto Cattani, Doctor of Laws and member of the ruling *Reggimento*, one year later followed Gonzaga's guideline, whereupon the *Reggimento* backed up the Legate's decree with one of its own; see Hieronymo Bursellis, *Cronaca gestorum ac factorum memorabilium civitatis Bononie ab urbe condita ad anno 1497*, ed. Albano Sorbelli, Rerum Italicarum Scriptores, 23, Pt. 2, 103; L. Frati, *La vita privata in Bologna dal secolo XIII al XVII* (Bologna: Zanichelli, 1928), p. 51. Sumptuary legislation against funeral pomp declined in the fifteenth century, while that directed against women's dress increased; see Diane Owen Hughes, "Sumptuary Law and Social Relations in Renaissance Italy," in *Disputes and Settlements: Law and Human Relations in the West*, ed. J. Bossy (Cambridge: Cambridge Univ. Press, 1983), pp. 69-99.

8. Examples of the wide variety of private devotions required of members to mark the death of a brother or sister: S. Ambrogio (1456) required one hundred *Paters* and *Aves* or five recitations of the seven penitential psalms; S. Francesco (1494) required seven *Paters* and *Aves*; S. Geronimo (1433) ten daily recitations of the penitential psalms for fifteen days or, for illiterates, 150 *Paters* and *Aves*; S. Maria Maddalena (1515) a daily *Pater* and *Ave* for three months; S. Rocco (c.1511-23) twelve *Paters* and *Aves*. Buon Gesù had literates recite the Office of the Dead and illiterates the *Pater* and *Ave*. S. Bernardino (1451) had women say one hundred *Paters* and *Aves*, and men say fifty; SS.mo Crocifisso del Cestello (1538, 1570) had women say five *Paters* and *Aves* daily for a month; males said nothing.

9. The author of the anonymous treatise may have been a Viennese theologian, Nicholas of Dinkelsbuhl (d. 1433); see François Vandenbroucke, "New Milieux, New Problems," in Jean Leclercq et al., *The Spirituality of the Middle Ages* (London: Burns and Oates, 1968), p. 485. The editions of the *Ars moriendi* printed in Bologna were issued in 1475 and 1478; see Alberto Tenenti, *Il senso della morte e l'amore della vita nel Rinascimento* (Turin: UTET, 1957), pp. 80-102, 106n.

10. Patrician companies like Buon Gesù, SS. Sebastiano e Rocco, and S. Croce dressed the *defunto*'s body in confraternal robes as a matter of course; artisanal companies like S. Bartolomeo di Reno did so only if the robe had been paid for in advance: Compagnia di S. Bartolomeo di Reno (Statutes: 1471; ASB PIE, No. 1). Women in consororities subordinate to a flagellant confraternity shared in the company's merit through burial in its robes even though they had not flagellated or worn the robes in procession (Compagnia di S. Maria della Pietà [Statutes, 1548], ASB Dem 10/7696, No. 3, chap. 8).

11. Most confraternities held a requiem service on the feast of All Saints (Nov. 1), with such individual observances as the day following the company saint's day (S. Bernardino,

1454), the first Sunday in Lent (Buon Gesù, 1521), or the first Monday of every month (S. Francesco, 1494).

12. Brian Pullan, *Rich and Poor in Renaissance Venice: The Social Institutions of a Catholic State* (Cambridge: Harvard Univ. Press, 1971), pp. 76-78.

13. S. Francesco ordered all members to attend the monthly Mass for the dead, but prescribed no penalties for violators. Buon Gesù punished those who avoided funeral processions by relegating them to the novices' bench for a month and requiring them to kiss the feet of other *fratelli* at every festival through this period.

14. For a fuller treatment of recruitment, attendance, and expulsion, see Charles Nicholas Terpstra, "Belief and Worship: Lay Confraternities in Renaissance Bologna," Ph.D diss. (Univ. of Toronto, 1988), pp. 155-230.

15. S. Maria degli Angeli expelled 15 of 466 (3.22%) of members recruited from 1479 through the early sixteenth century (Compagnia di S. Maria degli Angeli, BBA Gozz 203, No. 5). Through roughly the same period, S. Maria del Baraccano expelled 18 of 722 (2.49%) members (Compagnia di S. Maria del Baraccano, ASB Osp, No. 3a). Meanwhile, the *stretta* of S. Maria della Carità pruned 46 of 146 (31.51%) members recruited from 1518 to 1546 (Compagnia di S. Maria della Carità, BBA Gozz 210, No. 6). See also n. 16, below.

16. John Henderson notes that most of the Florentine expellees from a Trecento company had been members for fewer than five years and that "periods of rapid growth led to high expulsion rates"; stated reasons included non-attendance (20.5%) and disobedience (9.6%), but most cases (56.2%) gave no indication of the offense. A second Trecento company gave non-attendance as its single greatest reason for disciplinary action (40.7% of cases); see Henderson, "Piety and Charity," pp. 90-92. For Bologna, see Terpstra, "Belief and Worship," pp. 193-200.

17. SS. Girolamo ed Anna expelled 20-25% of its members between 1492 and 1551 and re-admitted slightly over 24% of the expellees (Compagnia di S. Girolamo di Miramonte, ASB Dem 5/6722, No. 1). Of 393 men joining S. Bartolomeo di Reno during a 1471 reform, 25 (6.36%) were subsequently expelled, and 10 (40%) later returned. Roughly half of the 253 members recruited into the mid-sixteenth century were expelled (125), and of these 22 (17.6%) later returned. No one among the 1471 core of 26 women or the 20 subsequently recruited was expelled (Compagnia di S. Bartolomeo di Reno, ASB PIE, No. 1).

18. Bolognese archives contain at least three separate Books of the Dead. The manuscripts are not always designated as *Libri delle Morti* by either the confraternity or modern archivists, but judging by internal evidence and comparison with other matriculation lists for the companies in question, the following are likely Books of the Dead: Compagnia di S. Ambrogio, ASB Dem 5/6627 (from 1488); Compagnia del SS.mo Crocifisso del Cestello, BBA Gozz 206, No. 2 (from 1538); Compagnia di S. Maria della Pietà, BBA Gozz 206, No. 8 (early sixteenth century). Comparing S. Ambrogio's *libro delle morti* with a 1543 matriculation list reveals a very typical retention rate of 56.52% (13 of 23 members): Compagnia di S. Ambrogio, ASB Dem 3/6625, No. 2 (9/12/1543).

19. Ronald Weissman has noted that Florentine confraternities provided charity only to those members who had paid all their dues and debts to the brotherhood ("Brothers and Strangers," pp. 37-38). Indebtedness could be an additional reason for exclusion from the

libro delle morti, though no Bolognese statute books of this period mention it specifically.

20. For a full discussion, see my article "Women in the Brotherhood: Gender, Class and Politics in Renaissance Bolognese Confraternities," *Renaissance and Reformation* (forthcoming).

21. John Bossy, *Christianity in the West: 1400-1700* (Oxford: Oxford Univ. Press, 1985), p. 57.

22. *Caritas* was the love between equals, while *misericordia* was help offered to the disadvantaged; see Mackenney, *Tradesmen and Traders*, p. 6, and also "Charité," *Dictionnaire de Spiritualité* (Paris: Beauchesne, 1953), II, 507-661, as well as "Miséricorde (Oeuvres de)," *Dictionnaire de Spiritualité* (Paris: Beauchesne, 1979), LXVIII-LXIX, 1328-49.

23. G. Alberigo, "Contributi alla storia delle confraternite dei disciplinati e della spiritualità laicale nei secc. XV e XVI," in *Il movimento dei disciplinati nel settimo centenario dal suo inizio (Perugia: 1260)* (Spoleto: Deputazione di Storia Patria per l'Umbria, 1962), pp. 170-71.

24. For a more detailed discussion of this process, see Terpstra, "Belief and Worship," pp. 293-345.

25. Marvin Becker notes a similar drive to expand and control confraternal social assistance among Florentine patricians after the 1378 *Ciompi* revolt ("Aspects of Lay Piety in Early Renaissance Florence," in *The Pursuit of Holiness in Late Medieval and Renaissance Religion*, ed. Charles Trinkaus and Heiko A. Oberman [Leiden: Brill, 1974], p. 189).

26. Mamelini was reminiscent of the Florentine Marco Parenti. He was prominent enough to marry Tadia, the daughter of Lodovico de Dolpho in 1503, and receive from him a dowry of 1600 lire *de bolognini* and the promise that Tadia would inherit half of his considerable estate. Lodovico Dolpho was also a notary and served in 1503 as Procurator of Bologna; the family was included in a list of one hundred leading families compiled by Bentivoglio partisan Fileno della Tuate ("Memoriale di ser Eliseo Mamelini," ed. Montanari, pp. 11-12; BBU MS. 437; see also Mark Phillips, *The Memoir of Marco Parenti: A Life in Medici Florence* [Princeton: Princeton Univ. Press, 1987]).

27. Mamelini became a notary in 1486 and served as one of four *gonfalonieri del popolo* for the Quarter of San Procolo in 1505 and 1515; consul of the Notaries Guild for second semester of 1519 and again in 1521 when consuls first received payment of 50 lire; and notary of the Guild in second semester of 1524 ("Memoriale di ser Eliseo Mamelini," ed. Montanari, pp. 12, 34, 40, 43).

28. Giovanni II Bentivoglio joined at least three groups (S. Maria del Baraccano, S. Maria della Pietà, S. Maria dei Centurati). Lorenzo de' Medici joined six (Compagnia de' Magi, San Paolo, S. Domenico, Gesù Pellegrino, S. Maria delle Croce al Tempio, S. Agnese); of these, S. Agnese was Lorenzo's "neighborhood" confraternity in which he frequently held office; see Ronald F. E. Weissman, *Ritual Brotherhood in Renaissance Florence* (New York: Academic Press, 1982), pp. 169-70. In Venice, Antonio Tron, an unsuccessful candidate for the dogeship in 1523, was a member of six confraternities (Mackenney, *Tradesmen and Traders*, p. 139).

29. Robert R. Harding, "The Mobilization of Confraternities Against the Reformation in France," *Sixteenth Century Journal*, 11 (1980), 85-107. Andrew E. Barnes, "Religious Anxiety

and Devotional Change in Sixteenth Century French Penitential Confraternities," *Sixteenth Century Journal*, 19 (1988), 389-405.

30. Mamelini and his wife Tadia joined "la Compagnia del Monte dela Pietà" in 1508, paying annual dues of 13 soldi ("Memoriale di ser Eliseo Mamelini," ed. Montanari, p. 19).

31. In his 1560 revision of an earlier catechism used in Schools of Christian Doctrine, the Theatine Giovanni Paolo Montorfano noted that for those lacking the means it was enough to do the corporal works of charity "in desire"; those with sufficient means who failed to do them committed a grave sin, as proven by Christ's threat of damnation in *Matthew* 25.41-46. See Paul F. Grendler, *Schooling in Renaissance Italy: Literacy and Learning, 1300-1600* (Baltimore: Johns Hopkins Univ. Press, 1989), p. 348.

32. John Henderson, "Le confraternite religiose nella Firenze del tardo Medioevo: patroni spirituali e anche politici?" *Ricerche Storiche*, 15 (1985), 79. Alberigo notes that multiple memberships were common in different parts of Italy ("Contributi alla storia delle confraternite," pp. 170-71).

33. Weissman, *Ritual Brotherhood*, pp. 75-76.

34. Terpstra, "Belief and Worship," pp. 180-93. Banker also finds institutional life-cycle to be a major factor in recruitment (*Death in the Community*, pp. 181-83).

35. Sources: S. Bartolomeo di Reno, ASB PIE, No. 1; S. Bernardino, ASB Dem 8/7-639, No. 1; S. Francesco, BBA Osp, No. 73; S. Maria degli Angeli, BBA Gozz 203, No. 5; S. Maria del Baraccano, ASB Osp, No. 3b; S. Maria della Carità, ASB Dem 4/7673, No. 1; S. Maria dei Guarini, ASB Dem 6/6477; S. Maria della Pietà, ASB Dem 7/7693, No. 3a; S. Maria dei Servi, ASB Osp 3/188; S. Rocco, ASB Dem 6/6589, No. 2.

Cults and Contexts:
In Search of the Renaissance Confraternity

Ronald F. E. Weissman

From the History of Spirituality to the History of Sociability.
The image that comes to mind most vividly of the Renaissance
confraternity is, of course, that of a group of penitents lamenting
their sins, garbed in humbling and hooded sackcloth, faces covered
and egos masked, anonymous to the world. In the absence of mate-
rials more informative than statute books, we often tend to view the
confraternal experience as timeless, characterized by a dour same-
ness of devotional form and religious belief. And we often limit our
study of confraternities to the study of devotional forms and their
roots in forms of spirituality.

The historiography of confraternities has changed dramatically
during the past two decades. Particularly with respect to Italy and
France, during the nineteenth century confraternities were part of a
romantic historiography seen as an element of Europe's vanished
corporate and intimate culture[1] or as a defining feature of the van-
ished era of Christian Europe, a time of devout lay piety. The his-
tory of Renaissance confraternities is still commonly seen as part of
the history of spirituality, narrowly defined as devotional history or
as ecclesiastical institutional history. Studies typically emphasize the
devotional practice of one or another confraternal movement such as
the Flagellants or Rosarians. To the extent that confraternities have
been studied with respect to their contexts, such contexts tended to
be reduced to the moment of their foundation by an individual mo-
nastic or mendicant order. Beyond traditional devotional history,
studies have frequently focused on the history of a particular confra-
ternity in a particular place to serve often the antiquarian ends of

local history. Even now, comparative studies of the confraternal movement are quite rare. The very a-historicity and contextlessness of much of the traditional work on the subject have prevented the asking of comparative questions. For some, particularly historians of spirituality, this lack of broader context is not a problem; indeed, still current among some is the view that confraternities need little explanatory context beyond an understanding that these pious associations embodied the religious aspirations of late medieval Christians. These historians see little need to ask questions of context, for to ask such questions is to miss what is most important and obvious: Christians formed confraternities to practice piety. To understand the theology underlying confraternal devotion is to understand, even to explain confraternities.[2]

While I would not deny the importance of a solid understanding of theology for the interpretation of devotional practice, I would at the same time remind those who reduce confraternities to doctrine that the late medieval world offered the Christian many forms of spiritual, ritual, and pious practice. For the sociocultural history of religion, the question is not only "what doctrines underlay devotional practice," but also "how and why did Christians favor certain practices over others, and what meanings did laymen attribute to these practices?" "Why do some devotions fall from popular favor?" And, ultimately, "how and why do organized groups such as confraternities make the collective choices to favor one or another pious practice?" Viewing the history of piety as the history of choices made from among a wide range of doctrines and practices requires one to look at, among other things, the composition of the groups making such choices and their culture.

Doctrine and traditional spirituality do most certainly provide a context for the study of confraternities. Indeed, broad thematic movements in spirituality, devotion, and theology such as the *imitatio Christi*, the singing of lauds, flagellation, and the cult of saints should be viewed as global to European Christendom, providing a range of pious choices for devout laymen. But what I would also emphasize is that the how and the why of choice-making is often based on the meaningfulness of rites and devotions for those who

practiced them. We should not accept as an *a priori* fact the notion that confraternities are what the clergy has said they were supposed to have been.[3]

During the past two decades, some historians of piety have broadened significantly the contextual analysis of Renaissance and baroque confraternities and related movements of lay religion. Through the work of such scholars as Grendi,[4] Agulhon,[5] Pullan,[6] de la Ronciere,[7] Davis,[8] Galpern,[9] Bercé,[10] Gutton,[11] Henderson,[12] Chiffoleau,[13] Paglia,[14] Zardin,[15] Trexler,[16] Weissman,[17] Hoffman,[18] Rusconi,[19] Vincent,[20] Banker,[21] and Black[22] confraternities have been examined within the contexts of community, sociability, and the social and moral order in late medieval society. During the past decade, a flood of research has elevated the study of confraternities from the periphery to a central place in the history of lay piety and sociability. Through the work of recent historians, confraternities have begun to be placed in a world broader than theology and simple "devotional history." The contexts of community, sociability, and lay culture are now seen as fundamental to understanding the associational and spiritual life of Mediterranean townsmen.

Key to the modern interpretation of confraternities has been the understanding of the confraternity's place in the parish, town, and region; its relation to the clergy and to secular authority; its membership and recruitment; and its mechanisms of promoting internal solidarity and integration within the broader community. Indeed, the best of these studies have often been exemplars of local history, integrating the evolution of confraternal organization and practice into a broader history of relations among groups and among elite and popular ideologies and identities more broadly understood.

Given the wealth of recent studies, we can begin to ask comparative questions and form generalizations about European or at least Mediterranean confraternities. What, then, were the distinctive characteristics of the Renaissance confraternity?

Types of Piety. For the period under discussion, Renaissance confraternities offered a range of devotional behaviors and roles: the penitent, the supplicating client, the militant, the patron, the merciful

minister of justice, the civic-minded citizen, and the dutiful member of a lineage.

Most familiar is the activity of the penitent found in flagellant and penitential companies. The penitent, taking on the guise and garb of the anonymous pilgrim, sought to expiate personal and social sin by acts of mortification, debasement, and humiliation, understood as the imitation of Christ. Through mendicant-like acts of self-abasement, including flagellation, the penitential confraternity members experienced an extreme dissociation from the world and, once purified, a communal celebration of fellowship stripped of pomp, status, and rank. An intense preoccupation with interior religious experience and prayer characterized the devotional practices of these confraternities, thus creating for some laymen the role of contemplative or mystic.

Also familiar is the worshipful client, maintaining the altars of local churches, marching in procession and displaying the valued relics of the community, maintaining thereby the proper supplicant to patron relationship between the local community and the celestial court of paradise.[23] In a manner analogous to clients propitiating earthly patrons, confraternal *clientela* sought to gain the favor of patron saints by offering public praise, *laude*, and through feasts and other occasions commemorating the power and virtues of saintly patrons. And often associated with confraternal clientage was a celebratory piety associated with festive rites and rituals.

Beyond the best known flagellant, *laudesi*, mystic, and celebratory forms of fraternal piety were other important pious roles. Some confraternities allowed members to play the role of generous, charitable patron dispensing alms to the poor. In communities such as Florence and Venice and throughout Provence, certain confraternities behaved as quasi-public entities, distributing the official charity of the commune or government. In a world in which clear lines did not always separate the sacred from the civic, such confraternities offered the layman a chance not only to play the patron but also to exercise the sacred duties of stewardship of the community. Other confraternal forms of piety straddling the ambiguous boundaries between the sacred and secular and the public and private included

that piety associated with rites of justice and mercy—that is, the comforting of those in prison or those awaiting execution.[24]

Opposing heresy in the thirteenth century and fighting Protestantism in the sixteenth offered laymen the role of Christian knight, whose piety involved the militant display of orthodoxy, whether in support of the Inquisition or to display the Sacrament in taunting opposition to Protestant belief and practice.[25] Finally, through memorial Masses confraternity members practiced a commemorative familial piety centered around the cult of ancestors and the affirmation of bonds between the living and the dead.[26]

Several pious roles, including penitent, client, celebrant, Christian militant, minister of justice and mercy, mystic, patron, and obedient member of a real or fictive family, often appeared within the same confraternity. Each of these pious roles had its own degree of attraction for the very different organizations that we associate with the term 'confraternity' from the late Middle Ages through the Early Modern period. The confraternal movement of the late medieval and Early Modern period was quite varied. Confraternities can be categorized by formal devotional practices, including Marian, Penitential, Rosarian, Sacramental, and Oratorian; or by their organizing principles: parish, rural or urban community, guild or profession, geography of residence (parish or quarter), religious status (priests or laymen), class, nationality (especially for foreigners residing abroad), sex and marital status, including abandoned wives, widows, and ex-prostitutes, or by age. Confraternities can be distinguished by their religious activities: maintaining the altars at a local church, sponsoring a devotion or a cult, supporting the devotional activities of a parish, fostering association and social insurance among members of a craft, burying the dead, administering charity or the seven works of mercy throughout the community, providing mutual assistance to members, supporting an active ministry and the enforcement of orthodoxy, providing a community of prayer and assistance for urban clergymen, teaching Christian doctrine to laymen and their children, or organizing festive behavior on holy days.

Beginning of an Interpretation. In examining this variety of devotional and institutional forms, I would like to call attention to

six characteristics which distinguish the Renaissance confraternity from those that came before and after. By Renaissance confraternity I mean those associations which populated the Mediterranean world during the great flowering of confraternal devotion from the mid-fourteenth through the early sixteenth centuries. The essential characteristics of Renaissance confraternities were:

> their status as autonomous lay institutions;
> their corporate character and links to the community;
> their social heterogeneity;
> their synthesis of interior spirituality and collective action;
> their festive character; and
> their cultural fluidity.

Lay Religion and Lay Institution. The first characteristic common to Renaissance confraternities of virtually every type and region is their fundamental character as autonomous lay institutions. It is true though perhaps overemphasized that many Renaissance confraternities and movements of devotion owed their existence to the mendicant orders. But one must separate origins from the ongoing life of these institutions. As André Vauchez reminds us, confraternities exemplify a kind of Brownian motion, constantly undergoing birth, death, refoundation, and reform.[27]

However originally founded, the Renaissance confraternity, particularly when contrasted with forms of association in baroque Europe, was dominated by laymen. They were only loosely supervised by bishops, who, incidentally, acted more frequently to protect confraternal privileges from secular authorities than to impose order on confraternities. And, until the sixteenth century, they were generally free from the control of the parish clergy. Confraternities elected their own chaplains, frequently shared public confession of sin among their members, and imposed their own discipline on their brothers, a discipline supervised by the company's officers rather than by its hired priests. Some confraternities went so far as to bar priests not serving as chaplain from membership.[28] While it is certainly true that members of the clergy played critical roles in the

foundation of some confraternities—and here San Bernardino of Siena preaching in Tuscany or Manfredi da Vercelli preaching in Bologna come to mind—clerical sponsorship or direction of Renaissance confraternities was a transient thing, rarely lasting very long after an organization's foundation.

Particularly when contrasted with the confraternal organization of the European baroque, it is important to remember that the typical Renaissance confraternities were lay organizations—dominated, championed, and defined over the long term by their lay members. Laymen were proud and confident about their ability to foster as laymen the right practice of religion. As John Henderson has pointed out, the lay confraternity was popular in part because of its reliance upon a vernacular liturgy.[29]

Confraternity, Corporation, and Community. The Renaissance confraternity developed in an environment in which corporate groups flourished. Guilds, artisan associations, parish *opere*, kin-based alliances, political leagues, and societies of many kinds provided much of the organic structure of medieval and Renaissance society.[30] Urban governments—communes—were themselves often coalitions of just such corporate groups.

In the historiography of European confraternities, much has been made of mendicant and monastic models of piety and association. The similarity of the confraternity's lay governor to a monastery's abbot is a familiar topos in the literature of confraternities. Less has been made of the confraternity's relationship to medieval and Renaissance corporate culture more broadly. Certainly, several confraternity offices such as the governor, the master of novices, and those responsible for the maintenance of the confraternity's cult were modeled on monastic orders. Nevertheless, confraternities, particularly in Italy, often took on an organizational form similar to other corporate organizations modeled on the civic commune. Among the similarities to the commune were the practices of rapid rotation of offices, their electoral methods, and their offices and office-holding structure. Florence offers an extreme case of this phenomenon. The electoral practices of confraternities were so

closely modeled on Florentine civic practice that the election bags of some confraternities were even emblazoned with the arms of the Florentine Republic.[31]

Beyond institutional form and similarity to communes, I stress the corporate character of Renaissance confraternities for several reasons. First, late medieval and Renaissance piety had a strongly collective dimension. Penance and redemption, in part, were viewed as collective processes, depending on the collective action of the group—a sacred community.[32] Second, as corporate organizations in a corporate society, confraternities occupied an ambiguous place between our conceptions of public and private. As private voluntary associations, they were also called upon to perform public, quasimunicipal duties including pacification of quarrels and the distribution of alms in time of public crisis. In urban communities, certain confraternities such as the Scuole Grandi of Venice had official civic responsibilities, and confraternal officers were considered in part members of the civic administration.[33] In rural Europe, the relation between confraternity and community was even closer. Throughout much of Mediterranean France confraternities of the Holy Spirit served both as the primary focus of lay piety and as the primary form of village solidarity and municipal administration, arbitrating disputes, serving as a council of elders, even on occasion managing emergency farm supplies and organizing hunting parties for lost cattle.[34] The distinction between religious confraternity and craft fraternity was also often hard to discern. The personal basis of recruitment and sponsorship in many confraternities could transform socially heterogeneous devotional groups into craft societies. And craft associations, like devotional societies, used the language and symbols of religious association to express their bonds of solidarity. Both groups buried and commemorated their dead, provided mutual assistance to members, and gathered under the protection of a patron saint.[35] As corporations embodying the corporate ideals of the community, Renaissance confraternities fostered a sense of collective obligation and an activist this-worldly piety, rooted in collective action.

Finally, as corporations, the value of confraternal action did not depend as much on the individual actions of each member as on the

action of the confraternity as a corporate body. Valid confraternity
acts depended on the typically small number of members who at-
tended any particular meeting.[36] The officers and members in atten-
dance, the *corpo di compagnia* or body of the confraternity, was
legally constituted to perform works accruing to the benefit of all
members, including the living and the dead. Here again the confra-
ternity differed from one of its later baroque forms, the congrega-
tion, which was simply an aggregation of individuals praying under
the same roof.

Social Heterogeneity. Apart from craft fraternities, typical Re-
naissance confraternities were socially heterogeneous and included
members of the local patriciate, the middle classes, and wide repre-
sentation of urban artisans. Indeed, many organizations constituted a
broad sampling of the respectable social order, including all but the
most miserable of the urban poor.[37] In some organizations, women
enjoyed auxiliary or full-fledged memberships.[38]

Such heterogeneity was not incidental. Rather, it was an essen-
tial element of Renaissance lay piety. The social diversity of the
typical Renaissance confraternity provided a theater for Renaissance
ritual: rites of humiliation and inversion, and a practical forum for
ritual exchange. It was here that the Renaissance economy of salva-
tion took its fullest form in the exchange between the rich who pro-
vided alms and the poor who offered their prayers for the salvation
of the rich. Believing in the collective remediation of sin and the
utility of religion to safeguard the community, the social diversity of
the Renaissance confraternity offered a mirror of the social order, a
microcosm of the town in its search for saintly protection and inter-
cession and collective salvation.

The culture of the Renaissance confraternity does not divide
neatly into "high" and "low," "popular" and "learned." Its devo-
tional forms and themes—clientage and patronage and the peniten-
tial *imitatio Christi*—were valued by noble and commoner alike. In
that most cultivated of cities, Florence, even late fifteenth-century
Neoplatonist intellectuals shared common assumptions about lay de-
votion and pious practice with more humble members of fraternal
societies.[39]

Interior Devotion and Collective Action. Throughout this essay, I have stressed the corporate and collective nature of Renaissance confraternities. What is striking about Renaissance piety is its balance between collective, external formal action and inner contemplation, between ritual and the interior life. Flagellation and other penitential rituals such as rites of inversion and humiliation practiced on Holy Thursday did not stand in opposition to a deep interior piety of introspection, lamentation, and tears. For the Renaissance townsman, such rituals provided the purgative and cathartic experience required to reinforce a deep examination of the soul. The imitation of Christ was understood both as a mental attitude, a willingness to contemplate suffering, and as a real willingness to experience a brief moment of actual bodily suffering. Ritual suffering and humiliation led to deep introspection; ritual introspection, in turn, led to renewed fervor for holy action in the world, for peacemaking, reconciliation, and charity. In examining the Renaissance confraternity, we should not adopt a naively contemptuous Erasmian or Protestant-influenced hostility toward ritual as empty or as opposed to or inferior to the interior life of the soul. The religion of the Renaissance confraternity member assumed a reciprocity, a symbiosis between inner and outer, action and contemplation, private remorse and public reconciliation. Individualism and corporate collective action were complementary facets of the Renaissance religious experience.[40]

The Festive Character of Confraternities. One of the most important elements of confraternal life that has been ignored or treated scornfully by traditional historians of piety is the festive character of communities and their confraternities. The rehabilitation of festive life is perhaps one of the most striking contributions of contemporary Early Modern European social history. The Mediterranean town, large or small, is now understood to be an intimate, face-to-face community characterized by strong interpersonal bonds as well as pervasive jealousy, tension, status conflict, and ego competition similar to the interdependent individualism so often noted in peasant communities, medieval and modern alike. In such communities, suspicion and generosity, anger and charity coexist readily and easily.

Festive life, like ritual, often emphasized reconciliation and the recovery of social harmony after periods of intense conflict through cathartic experience or the restoration of right order through the ritual enforcement of a community's moral code. Confraternal banquets and other festive behavior accompanying the celebration of a holy day served such ends: the channeling of repressed violence and anger into such relatively harmless activities as carnivalesque revelry, tournaments, races, and animal combats, ritual inversion of social hierarchy and the restoration of right order through festive mockery, charivaris, abbeys of misrule, Italian *potenze* and *compagnie di piaceri*, the latter often so much a part of the life of "regular" confraternities. One should not differentiate too strongly the "festive" from the "pious." Many Renaissance companies were to a greater or lesser degree festive societies, run as traditional devotional confraternities most of the year, as was Santa Maria della Neve in Florence, one of the city's premier festive societies.[41] How should we interpret a confraternity's annual feast? A commemoration of the Last Supper? An occasion for cathartic revelry? A rite of integration and affirmation of corporate identity? It was, of course, all of these things, a mixture of carnival and communion, of the sacred and the profane. But what is essential to our understanding of the variety and importance of confraternal festive life in the European town is our understanding that such festivity was part catharsis, part fellowship, part affirmation of corporate identity, part interior penance, and part visible combat between the sacred and the profane.

The Fluidity of Cultural Boundaries. One of the traditional functions of religion is to establish social categories and cultural boundaries and thus to provide a cosmological justification for the social order and its categories, its ways of knowing, classifying, and describing things. Hierarchical societies are especially fond of boundary-making. The Renaissance confraternity distinguished itself by its acceptance of ambiguity and its lack of firm cultural or social boundaries. In contrast to movements of baroque piety, the Renaissance confraternity did not draw sharp boundaries between sacred and secular, sacred and profane, public and private, social classes or

groups, the interior life and external ritual, or between fraternal craft associations and devotional societies. What does stand out are boundaries between the sexes and between age groups—not surprising for organizations capable of generating strong male bonds and whose members varied their own participation across the life-cycle.[42] *Laudesi* companies tended to be more attractive to older married couples—again, not surprisingly in companies which sponsored the cult of familial piety and patronal worship through the burial of the dead and the commemoration of ancestors. Flagellant groups, practicing a cathartic flagellation ritual, on the other hand, attracted unmarried males from their late adolescence through their early thirties.[43]

From the Renaissance to the Baroque. To place the aforementioned characteristics of Renaissance confraternities in broader relief, it is necessary to contrast the Renaissance confraternity with what succeeded it, the baroque confraternity born out of the social and religious ferment associated with movements of religious reform in the sixteenth century. And here, the story of the transformation from Renaissance to baroque spirituality is constant across Mediterranean France, from Florence to Rouen, from Lombardy to Lyon.

In contrast to the relatively autonomous lay organizations of the fourteenth and fifteenth centuries, confraternities from the mid-sixteenth century onward came under increasing clerical control. Between the 1530's and 1604 essentially all the mechanisms were developed that reformers such as Borromeo and Vincent de Paul would find so useful in reforming lay spirituality: the parish confraternity molded after Rome's company of Santa Maria Sopra Minerva, which received official sanction in 1539, the catechetical Confraternity of Christian Doctrine, also parish-based, and the Papal Bull *Quaequinque* of 1604, which established the absolute authority of the Church over all confraternities. Increasingly, confraternities lost their autonomy, merged with or were succeeded by parish-based organizations run by the parish itself. By the end of Borromeo's episcopate in Milan, for example, 556 out of 772 parishes had founded a parish confraternity of the Holy Sacrament.[44] A handful

of parish confraternities had existed in Florence before the sixteenth century; by the end of the sixteenth century, nearly half of Florentine parishes had founded confraternities.[45]

In medieval and Renaissance Europe, clerical involvement in confraternities was an often brief moment at the company's foundation. The baroque confraternity, in contrast, was tied over the long term to that most stable of ecclesiastical institutions, the parish church.[46] The clergy, armed with papal bulls, indulgences from Roman archconfraternities, and a renewed sense of administrative competence and authority marked by better record-keeping and by a regular parish visitation process, was able to exercise permanent and systematic, not fleeting control over lay religion.[47]

Absorbed into the parish and becoming narrowly devotional in character, baroque confraternities lost much of their corporate and their festive character. And these confraternities also lost much of their municipal roles as supplement to town governments. Resurgent town or regional governments or the Church itself absorbed duties heretofore performed by confraternities. Those collective manifestations of communal association and identity, the confraternities of the Holy Spirit, for example, were suppressed throughout such dioceses as Lyon during the seventeenth century.[48]

In place of social heterogeneity, confraternities now exemplified social hierarchy. Socially mixed confraternities such as the old penitential companies adopted new membership rules to restrict entry of members to local elites. New confraternities were founded having an exclusively elite character. Among the most famous of elite societies were the White Penitents of the Gonfalon, the Black Penitents of the Crucifix, the Penitents of Mercy, and the Congregation of Messieurs in Lyon, and the Florentine Company of the Blood.[49] The baroque gentlemen's academy, too, had its origins in the growing cultural differentiation between learned and popular classes. Indeed, some academies developed directly out of the confraternal movement as an older confraternity became transformed not simply into a pious society for the elite but into an actual gentlemen's club.

In many sixteenth-century confraternities having Renaissance or late medieval origins, two classes of members emerged: those who

paid and those who prayed. Elites could receive benefits of member-
ship for a fee without performing most other confraternity obliga-
tions, particularly those now-distasteful rituals of humiliation and in-
version. Parish companies of the Holy Sacrament and craft-based
artisan confraternities on the one hand, and restrictive elite confra-
ternities for gentlemen, on the other, exemplified strong class divi-
sions between patrician and commoner and increased the social and
cultural distance between them.[50]

Throughout Mediterranean Europe one finds a widening gulf
between the pious practices of urban elites and the rest of the popu-
lation. Committed to aristocratic and courtly ideals of hierarchy,
honor, and purity, elites, shunning older forms of confraternal piety,
viewed feasts, festivals, and rites of catharsis and inversion as too
much a mingling of sacred and profane, honorable and base. Such
rites threatened too much social pollution. Elite identity, bound up
with aristocratic, exclusivist, courtly virtues and strict adherence to
the new codes of etiquette, stressed a learned, stylized, interior, and
private piety.[51] Often involved in the control of parish sacramental
confraternities, elites nevertheless generally eschewed participation
in actual parish rites and feasts.[52] In town after town, one finds elite
devots, encouraged by the reformed clergy, rejecting the actual prac-
tice of flagellation and refusing to participate in local processions.[53]

Reforming elites converted rituals of inversion and catharsis in-
to little more than moments of intense contemplation, stressing, for
example, the private adoration of the Sacrament or the meditative
recital of the Rosary.[54] One historian summarized eloquently the six-
teenth century's desire "to shift the emphasis in sacramental penance
from satisfaction following penance to interior discipline preceding
it."[55] In such a transformation, even the term 'discipline,' which had
heretofore signified penitential flagellation, took on a new meaning,
the systematic examination of conscience.[56] Those theaters of Re-
naissance ritual, sacred social exchange, collective action, and festiv-
ity, fifteenth-century penitential confraternities, were by the early
seventeenth century being transformed into more passive congrega-
tions. These congregations were places where groups came together
to pray and contemplate separately as individuals.

In contrast to the social and cultural fluidity of the Renaissance confraternity, the baroque confraternity drew boundaries of all sorts: between social classes, between the sacred and the profane, public and private, mind and body. Narrowly specialized confraternities of many kinds emerged, each with its own charity to patronize or its own interior devotion to sponsor. But lacking rituals of solidarity, these having been suppressed by the reformed clergy and being stripped of festive life, baroque associations, even parish confraternities, at best attracted modest levels of enthusiasm.

Indeed, among the most common elements of baroque religion was what Peter Burke referred to as the battle between the spirits of Carnival and Lent.[57] The reformed clergy and courtly elites sought to suppress the dangerous, ambiguous festive and cathartic ritual behaviors that gave the Renaissance confraternity its character and sought as well to break the link between now-favored interior piety and scorned ritual action and festivity.

The weak sociability of parochial sacramental confraternities is one sign of the resistance among urban artisans and the rural peoples of the Mediterranean to the Catholic Reformation ethos. A resurgent anticlericalism, particularly in villages and rural communities, is another sign of such resistance and a desire of many to maintain those traditional ritual and festive practices in which they had played a major role in shaping and which in turn had played a major role in defining their own communities.[58] As the members of one Iberian community explained when describing why they had killed their urbane, educated, reform-minded, festival-suppressing priest: "He's not a real priest. If he were, he wouldn't be trying to take our religion away from us."[59]

What, then, are the contexts for understanding the Renaissance confraternity? First, the similarity of Renaissance confraternities and the similar fortunes that befell these organizations during the sixteenth and seventeenth centuries should warn us against too much emphasis on purely local circumstances or situations. I do not mean that confraternities were not firmly embedded in the social order of their local communities—far from it. What I would suggest is that

the ways in which such embedding took place were fundamentally similar across communities and that the intimate, face-to-face nature of sociability and clientelist systems of symbolic reference were in fact similar across the Mediterranean. Too many of us, myself included, have tended to explain confraternities in terms of local contexts when in fact such contexts were common to the region.

I would certainly include the theology underlying ritual and devotion among the important objects of study worthy of our attention, but not as an explanatory factor as much as a thing in need of explanation. That Europeans viewed the process of catharsis, festivity, and inversion as fundamental components of religious experience explains why certain confraternal practices were popular. The theology of such practices illuminates the terms through which contemporaries legitimated and described their rituals, but it does not explain their popularity.

In the study of European confraternities, I would give as much weight to sociability as traditional historians have given to theology since it is after all from sociability and human experience that devotions come to have meaning for the people who created and chose to practice them—or, indeed, to reform, redefine, or ignore them.

Notes

1. André Vauchez, "Les confréries au Moyen Age: esquisse d'un bilan historiographique," *Revue historique*, 275 (1986), 467-77.

2. Most notable among such interpretations is the magisterial work of Gilles Gerard Meersseman, *Ordo Fraternitatis: confraternite e pietà dei laici nel medioevo* (Rome: Herder, 1977), 3 vols.

3. See, for example, how the townsmen of San Sepolcro grappled with their own conceptions of purgatory and the afterlife, despite official Church teaching (James Banker, *Death in the Community: Memorializations and Confraternities in an Italian Commune in the Late Middle Ages* [Athens: Univ. of Georgia Press, 1988], pp. 176-77). In Banker's analysis, Church doctrine and practice followed from, rather than determined lay behavior and belief.

4. Eduardo Grendi, "Morfologia e dinamica della vita associativa urbana: Le confraternite a Genova fra i secoli XVIe e XVIII," *Atti della Società Ligure di Storia Patria*, 79 (1965), 239-311.

5. Maurice Agulhon, *Pénitents et francs-maçons dans l'ancienne Provence* (Paris: Fayard, 1968).

6. Brian Pullan, *Rich and Poor in Renaissance Venice: The Social Institutions of a Catholic State* (Oxford: Oxford Univ. Press, 1971).

7. Charles de la Roncière, "La place des confréries dans l'encadrement religieux du contado Florentin au XIVe siècle: L'example de la Val d'Elsa," *Mélanges de l'Ecole française de Rome: Moyen Age-Temps Modernes*, 85 (1973), 31-77, 633-71.

8. Natalie Zemon Davis, "Some Tasks and Themes in the Study of Popular Religion," in *The Pursuit of Holiness*, ed. Charles Trinkaus and Heiko A. Oberman (Leiden: Brill, 1974), pp. 307-36.

9. A. N. Galpern, *Religions of the People in Sixteenth-Century Champagne* (Cambridge: Harvard Univ. Press, 1976).

10. Yves-Marie Bercé, *Fête et révolt: Des mentalités populaires du XVIe au XVIIIe siècle* (Paris: Hachette, 1976).

11. Jean-Pierre Gutton, "Reinages, abbayes de jeunesse et confréries dans les villages de l'ancienne France," *Cahiers d'Histoire*, 4 (1975), 443-53; *La Sociabilité villageoise dans l'ancienne France: Solidarités et voisinages du XVIeme au XVIIIeme siècles* (Paris: Hachette, 1979); "Confraternities, Cures and Communities in rural areas of the dioceses of Lyons under the Ancien Regime," in *Religion and Society in Early Modern Europe, 1500-1800*, ed. Kaspar von Greyerz (London: German Historical Institute, 1984), pp. 202-21.

12. John Henderson, "Confraternities and the Church in Late Medieval Florence," in *Voluntary Religion*, ed. W. J. Sheils and D. Woods, Studies in Church History, 23 (Oxford: Basil Blackwell, 1986), pp. 69-83; "The Flagellant Movement and Flagellant Confraternities in Central Italy, 1260-1400," in *Religious Motivation*, ed. D. Baker, Studies in Church History, 15 (Oxford: Basil Blackwell, 1978), pp. 147-60; "Society and Religion in Renaissance Florence," *Historical Journal*, 29 (1986), 213-25.

13. J. Chiffoleau, *La comptabilité de l'au-delà: les hommes, la mort et la religion dans la région d'Avignon à la fin du Moyen Age* (Rome: Ecole française de Rome, 1980).

14. Vincenzo Paglia, *'La Pietà dei Carcerati': Confraternita e Società dei Carcerati a Roma nei secoli XVI-XVII* (Rome: Edizioni di storia e letteratura, 1980).

15. Danilo Zardin, *Confraternite e vita di pietà nelle campagne lombarde tra '500 e '600: La pieve di Parabiago-Legnano* (Milan, 1981).

16. Richard C. Trexler, *Public Life in Renaissance Florence* (New York: Academic Press, 1980); "Charity and the Defense of Urban Elites in the Italian Communes," in *The Rich, the Well Born and the Powerful: Elites and Upper Classes in History*, ed. F. C. Jaher (Urbana: Univ. of Illinois Press, 1973), pp. 64-109; "Ritual in Florence: Adolescence and Salvation in the Renaissance," in *The Pursuit of Holiness*, ed. Trinkaus and Oberman, pp. 200-64.

17. Ronald F. E. Weissman, *Ritual Brotherhood in Renaissance Florence* (New York: Academic Press, 1982).

18. Philip T. Hoffman, *Church and Community in the Diocese of Lyon, 1500-1789* (New Haven: Yale Univ. Press, 1984).

19. Roberto Rusconi, "Confratemite, compagnie e divozioni," in *Storia d' Italia, Annali*, 9 (1986), 469-506.

20. Catherine Vincent, *Des charités bien ordonnés: les confréries normandes de la fin du XIIIᵉ siècle au début du XVIᵉ siècle* (Paris: Ecole normale supérieure, 1988).

21. Banker, *Death in the Community, passim.*

22. Christopher F. Black, *Italian Confraternities in the Sixteenth Century* (Cambridge: Cambridge Univ. Press, 1989).

23. Vincent, pp. 117-42.

24. Paglia, *passim*; Samuel Y. Edgerton, Jr., *Pictures and Punishment: Art and Criminal Prosecution during the Florentine Renaissance* (Ithaca: Cornell Univ. Press, 1985); Black, pp. 217-23; see also the paper by Kathleen Falvey in the present book.

25. Philip Benedict, "The Catholic Response to Protestantism: Church Activity and Popular Piety in Rouen, 1560-1600," in *The Religion and the People, 800-1700*, ed. James Obelkevich (Chapel Hill: Univ. of North Carolina Press, 1979), pp. 168-90.

26. On confraternities and the cult of the dead, see Galpem, *passim*; Banker, *passim.*

27. Vauchez, "Les confréries au Moyen Age," p. 472.

28. Some confraternities, such as Florence's Company of San Paolo, went so far as to bar all members of the clergy, except the company's elected chaplain, from membership; see Archivio di Stato di Firenze, Compagnie Religiose Soppresse, Capitoli, XXVII, fol. 26ᵛ (1472).

29. On the lay domination and weak role of the clergy in pre-Tridentine confraternities, see Hoffman, p. 26; and Banker, pp. 177-79.

30. Susan Reynolds, *Kingdoms and Communities in Western Europe, 900-1300* (Oxford, 1984), pp. 67-78, 167-83.

31. Weissman, *Ritual Brotherhood*, p. 63.

32. Banker, pp. 162-63.

33. Pullan, *passim.*

34. Gutton, pp. 202-03; Hoffman, p. 59.

35. On the blurred distinction between craft and religious confraternities, see Robert A. Schneider, *Public Life in Toulouse, 1463-1789: From Municipal Republic to Cosmopolitan City* (Ithaca: Cornell Univ. Press, 1989); Anthony Black, *Guilds and Civil Society in European Political Thought From the Twelfth Century to the Present* (Ithaca: Cornell Univ. Press, 1984), pp. 1-11.

36. Weissman, *Ritual Brotherhood*, pp. 130ff.

37. Black, pp. 38-43; Vincent, pp. 213-17; Banker, pp. 163-73; Weissman, *Ritual Brotherhood*, pp. 67-77. Pre-Tridentine membership lists of confraternities in Toulouse indicate a similar mix of occupations and status groups (Schneider, p. 111).

38. Black, pp. 34-38; Vincent, pp. 204ff. See also Sherrill Cohen, "The Convertite and the Malmaritate: Women's Institutions, Prostitution, and the Family in Counter-Reformation Florence," Ph.D. diss (Princeton Univ., 1985).

39. Weissman, "Sacred Eloquence: Humanist Preaching and Lay Piety in Renaissance Florence," in *Christianity and the Renaissance*, ed. Timothy Verdon and John Henderson (Syracuse: Syracuse Univ. Press, 1990), pp. 250-71.

40. On the penitential rites of Renaissance confraternities, see Weissman, *Ritual Brotherhood*, pp. 90-105.

41. Trexler, *Public Life in Renaissance Florence*, p. 400.

42. See Natalie Zemon Davis, "The Reasons of Misrule: Youth Groups and Charivaris in Sixteenth-Century France," *Past and Present*, 50 (1971), 41-75; Trexler, "Ritual in Florence: Adolescence and Salvation in the Renaissance," *passim*, on age gradations in confraternities.

43. On confraternity membership and the lifecycle, see Weissman, *Ritual Brotherhood*, chap. 3, for *laudesi* and *disciplinati* membership patterns in Florence, and Vincent, pp. 204ff, for membership in confraternities stressing familial piety and the cult of the dead in Normandy.

44. Zardin, pp. 20, 28, 69-73.

45. Weissman, *Ritual Brotherhood*, p. 206.

46. The parochialization of sixteenth-century confraternities has been documented by Weissman, *Ritual Brotherhood*, pp. 206-11; Black, pp. 75-76; Vincent, pp. 281ff; Hoffman, pp. 103-11. On the role of parish confraternities and Confraternities of Christian Doctrine, see Giancarlo Angelozzi, *Le confraternite laicali: un'esperienza cristiana tra medioevo e eta moderna* (Brescia: Queriniana, 1978), pp. 43-44. On the latter, see Paul Grendler, "The Schools of Christian Doctrine in Sixteenth-Century Italy," *Church History*, 53 (1984), 319-31; Black, pp. 223-28.

47. On the growing ecclesiastical control of confraternities during the course of the Catholic Reformation, see Black, pp. 62-65. On the new piety of the Catholic Reformation, see also Maureen Flynn, *Sacred Charity: Confraternities and Social Welfare in Spain, 1400-1700* (Ithaca: Cornell Univ. Press, 1989), pp. 115-45.

48. Hoffman, pp. 105-07.

49. Hoffman, pp. 38-39, 73; Weissman, *Ritual Brotherhood*, p. 198.

50. On the relationship between post-Tridentine confraternities and the growing cultural distance between social classes, see Robert Muchembled, *Popular Culture and Elite Culture in France, 1400-1750*, trans. Lydia Cochrane (Baton Rouge: Louisiana State Univ. Press, 1985), *passim*.

51. On the Jesuit-inspired elite devotions of the Catholic Reformation and elite fear of pollution, see Louis Chatellier, *The Europe of the Devout: The Catholic Reformation and the Formation of a New Society*, trans. Jean Birrell (Cambridge: Cambridge Univ. Press, 1989).

52. By 1609, for example, one Florentine parish recorded that none of its elite residents (*cittadini*) was willing to participate in parish sacramental processions (Weissman, *Ritual Brotherhood*, p. 218n).

53. Black, pp. 100-01; Weissman, *Ritual Brotherhood*, pp. 206-07, 220-34. By the early sixteenth century, one of the most elite and distinguished Venetian *Scuole Grandi* had forbidden its regular members to undertake the flagellation ritual and had hired flagellants for its Holy Thursday rite (Pullan, pp. 51-52).

54. For the suppression of popular festivity by the reformed post-Tridentine Church, see Gutton, pp. 204ff; Hoffman, pp. 90ff.

55. John Bossy, *Christianity in the West, 1400-1700* (Oxford: Oxford Univ. Press, 1987), p. 127.

56. Bossy, p. 57.

57. Peter Burke, *Popular Culture in Early Modern Europe* (New York: T. Smith, 1978), chap. 8.

58. Hoffman, pp. 111-14, provides rich evidence for the hostility felt by townsmen at the attempted suppression of festive culture by the agents of reform.

59. Unpublished work of Joyce Riegelhaupt on Portuguese anticlericalism in the seventeenth century.

Caritas/Controriforma:
The Changing Role of a Confraternity's Ritual

Jean S. Weisz

Confraternal *Caritas* can be an umbrella label covering infinitely varied and multi-layered motivations—religious and social, personal and public.* The long history of Florentine lay confraternities is closely intertwined with the changing political and economic conditions in Florence. Florentines in Rome found themselves continuing the confraternal tradition and with it the civic involvement in an increasingly complex religious/political arena.

The Confraternity of San Giovanni Decollato detta della Misericordia was a confraternity of Florentines resident in Rome founded in 1488 "per il pio ufficio dell'assistenza spirituale ai condannati a morte" ("for the pious service of spiritual assistance to those condemned to death"). The confraternity was approved by Pope Innocent VIII in a bull of 1490 in which the privileges of administering the last rites to the condemned, accompanying them to execution, and burying them were conferred. The bull also assigned to the confraternity a site occupied by the ruins of a medieval church, Santa Maria della Fossa, below the Campidoglio on the corner of the streets now called Via di San Giovanni Decollato and Via della Misericordia. On this site the confraternity built the church of San Giovanni Decollato and the adjacent oratory in which the members conducted business meetings and held religious services (fig. 13). Both structures were begun some time in the 1530's; the oratory must have been completed quickly (its decoration was begun about

*This paper is dedicated to James Ackerman on his seventieth birthday.

1536), but the church was not completed until mid-century, and decorated during the second half of the century[1] (figs. 14-15).

The obligations of the members followed long-established Florentine confraternal tradition including a variety of social and charitable activities, but the principal obligation—and this was also a Florentine tradition—was one of civic-public beneficence.[2] Like its Florentine prototype, the Compagnia dei Neri,[3] the principal function—in fact, the very *raison d'être* of the Confraternity of San Giovanni Decollato—was its pious mission to save the souls of the condemned by helping them to die well (*morire bene*), that is, penitent and confident of salvation, in fact believing that their execution was the very vehicle of their redemption. This practice has been treated at some length in Kathleen Falvey's paper in the present volume, and I will here only summarize the procedures that were involved.

On the eve of an execution (*giustizia*) the confraternity was notified, at which point between four or six brothers went to the prison and spent the night as *confortatori*, comforting the victim and exhorting him to repent his sins, to believe that he would be forgiven, and that his soul would be received in paradise. The *condannato* was encouraged to feel grateful that he was being given the opportunity to die fully prepared and thus assured of salvation. This state was contrasted to that of one who died in an accident or from illness, having hoped to recover and thus not being prepared for death. An admitted malefactor was encouraged to identify with the repentant thief who was crucified with Christ and went straight to paradise. If the *condannato* professed innocence, he was told that his fate was Divine Will, no more unjust than that of the Christian martyrs, St. John the Baptist, or Christ himself. In fact, he was to view his execution as a martyrdom, as an *imitatio Christi*. Small painted panels with handles (*tavolette*), on which were depicted images of the Crucifixion on one side and the decollation of St. John the Baptist or another saintly martyrdom on the reverse, were held before the prisoner's eyes throughout the night (fig. 16).

At dawn additional members of the confraternity assembled in the oratory, donned black robes and hoods, and, singing litanies,

carrying torches and a large crucifix as well as the *tavolette*, went in solemn procession through the streets of Rome to the prison (fig. 17). There they joined the officials, the *confortatori*, and the *condannato* and went in procession to the place of execution. The crucifix was placed facing the scaffold, and the prisoner was urged to kneel and kiss the feet of the Christ figure. One of the *confortatori* mounted the scaffold with the condemned man, held a painted *tavoletta* before him, and remained with him to the end (fig. 18).

The corpse would be left on public display all day. At night the *confratelli* would return, take the corpse, and, singing hymns, carry it on a bier covered with black draperies in a torchlight procession to the Church of San Giovanni Decollato. There the Mass for the Dead would be celebrated and the body interred in the cloister.

In a study of the Oratory of San Giovanni Decollato, I demonstrated that its decorations expressed and confirmed the commitment to the confraternity's mission on the part of the *confratelli* who assembled there.[4] The decorative program consists of a series of frescoes depicting the life of St. John the Baptist, the patron saint of Florence and titular saint of the confraternity, and an altarpiece of the Descent from the Cross. The episodes represented from the Baptist's life are those which parallel the life of Christ and emphasize St. John's role as precursor. This message becomes most pointed in the final phase of the program which includes the Arrest of St. John the Baptist and his Decollation. The placement of St. Andrew, who was a follower of St. John the Baptist before becoming Christ's disciple, between the fresco of the Decollation of St. John and the altarpiece of the Descent from the Cross further stresses the significance of the martyrdom of St. John as prototype for Christ's sacrifice (figs. 19-20).

This sacrifice for the salvation of man, the supreme act of Christian love (*Caritas*), is referred to repeatedly throughout the program in motifs appearing in the narratives and in the grisaille decorations surrounding them. These include the *Caritas* figures popular in Florentine painting of a woman suckling infants, the ewers and basins which symbolized the Eucharist and made a symbolic connection between the sacraments of Baptism and the Eucha-

rist, as well as the obvious symbol of the putto carrying a chalice in the Descent from the Cross (fig. 21, upper right). The theme of salvation through death also appears in some of the grisaille decorations in the form of motifs from antique sarcophaghi, including the Sleeping Ariadne and Dionysiac sacrifice scenes.

The special implications for the *confratelli* of San Giovanni Decollato, and for the *condannati* in their care of this association between the Dionysiac mysteries with their connotations of life achieved through death, the role of St. John the Baptist as precursor, and the death and resurrection of Christ for the redemption of man, are made explicit in the frescoes by topical reference to the Roman setting of the confraternity's activities. For example, in the Arrest of St. John the Baptist (fig. 19), the setting, with its rusticated fortress on the banks of the Jordan, refers to the Roman prison on the Tiber, the Tor di Nona, as it looked before the modern bankments were built. In the altarpiece (fig. 21) the inclusion of the thieves, an uncommon motif for this subject, reflects the advice given to the *condannati* to identify with the repentant thief, who is shown gazing up at the figure of Christ just as the condemned were to gaze at the image of the crucified Christ being held before them in their last moments.

The entire decorative program of the oratory vividly expresses the mandate of the confraternity, a mission of *Caritas* or Christian love. This mission included tending to the hunger, thirst, and nakedness of the prisoners in the brothers' charge as well as to the salvation of their souls.[5] Continuing the long tradition of charity among lay confraternities in medieval and Renaissance Italy, the brothers thus performed most of the Corporal Acts of Mercy.

If, on the most obvious level, *Caritas* was the primary function of the brotherhood, there was on another level an important social/ civic role played by practices of the confraternity. Public execution, accompanied by spectacle and followed by the display—and sometimes quartering, dismemberment, or other mutilation of the criminal's corpse—was intended to serve as an example, a deterrent, a warning of the wages of sin. During his travels in Italy, Michel de Montaigne noted that the post-execution mutilation of a *giustiziato*

had stronger effect upon the viewing public than the execution itself. He described an execution at which the people, "who had appeared to feel nothing at seeing him strangled, at every blow that was given to cut him up cried out in a piteous voice."[6]

The importance placed upon the instructive function of capital punishment in sixteenth-century Rome is emphasized by the location in which these events took place. The executions were performed in the major public squares of the city such as the Campidoglio, Piazza Navona, or the Campo dei Fiori and most frequently on the Piazza di Ponte Sant'Angelo or on the Ponte itself. Thus the whole theatrical/religious spectacle—the procession, the execution, and the public display of the corpse—was intended to provide a vivid experience for the ordinary Roman citizen. And the role played by art and ritual in the practices of the brotherhood by the religious images carried and the sacred music sung by hooded blackrobed *confratelli* in processions through the streets of Rome made this a religious spectacle which was at the same time a crowd pleaser, a warning, a pious rite, and a vehicle of salvation through death.

This role became even more important by the mid-sixteenth century when frequently the *giustizia* was not the hanging of a thief or murderer but the burning, sometimes alive, of a priest or scholar. It is apparent from the records of the confraternity and from other contemporary accounts of these executions, including eyewitness reports in the *Avvisi di Roma*, that a need was felt to create what was described as a "horrendo spettacolo per tutta Roma."[7] Thus by the mid-sixteenth century there was a new context for the confraternity's mission: the actions of the Holy Office, or Roman Inquisition, in its effort to stamp out the Lutheran heresy. It is of interest to note, in terms of the awareness on the part of the authorities of the importance of good public relations, that at least in the early years of the Inquisition in Rome the victims were primarily non-Romans and non-commoners; no risk was taken that witnessing the burning of one of their own might cause an unfortunate response on the part of the Roman populace.[8]

Historians have tended to characterize the pontificate of Julius III (1550-55) as a period of moderation and clemency in the pro-

ceedings of the Holy Office. This is true when compared to the pontificate of his successor, Paul IV Caraffa (1555-59), who, during the pontificate of Paul III (1534-49), had organized the Roman Inquisition and who, when he was elected pope Paul IV in 1555, ushered in a reign of terror so unpopular that his death in 1559 was celebrated by the public sacking and burning of the offices of the Inquisition.[9] This comparison, however, can be made only in retrospect. In fact, among the first acts of Julius III as pope was the confirmation of the Inquisition. In 1551 proceedings were instituted against the bishop of Bergamo; in 1552 seven Lutherans were tried in Santa Maria sopra Minerva; on 4 September 1553 a silk merchant from Perugia and a Franciscan friar, Giovanni Buzio from Montalcino, who had been preaching in SS. Apostoli, were also tried at Santa Maria sopra Minerva. They denied purgatory, the authority of the pope, and the doctrine of indulgences and declared that Julius III was the anti-Christ. At their hanging and burning in the Campo dei Fiori they were attended by the brothers of San Giovanni Decollato.[10]

It was precisely at this time, during the papacy of Julius III, that the decoration of the oratory of San Giovanni Decollato was completed and that of the church begun. The Decollation of St. John the Baptist by Giorgio Vasari (fig. 22) for the high altar of the church was commissioned in 1551 and installed in 1553.[11] In 1554, Bartolommeo Ammanati was charged with providing the design for the nave chapels. It was stipulated that in order to finish all of them quickly, stucco should be used instead of marble or travertine.[12] Nevertheless, for reasons unknown, the nave chapels were not completed quickly and most remained undecorated until the 1580's. This period of time, with an initial impetus in the 1550's and a final thrust in the 1580's, corresponds with the increasing involvement of the confraternity in the actions of the Inquisition.

When dealing with a heretic condemned to the stake, the task of the *confortatori* was to persuade the victim (always using the religious images) to recant, confess, take the Sacrament, and thus die "ben disposto." Sometimes the brothers were successful, as was the case in 1567 with Pietro Carnesecchi, the Florentine reformer,

humanist scholar, and former secretary and protonotary to Pope
Clement VII. Carnesecchi confessed, took communion, and said that
he wanted to die willingly and "nel grembo della santa romana
chiesa" ("in the bosom of the Holy Roman Church"). Perhaps it was
also for this reason and not only because of his station that he was
decapitated before being burned.[13] Archbishop Macario of Macedo-
nia, executed in 1562, was less tractable. He refused confession,
remained pertinacious in his "maledetta ostinatione," and thus, after
being degraded, was hanged and burned.[14]

The most recalcitrant heretics were burned alive. Such was the
case with Giordano Bruno, former Dominican monk, mnemonics
advisor to Pope Pius V, philosopher, and poet. The *confortatori*
from San Giovannni Decollato were aided in their exhortations by
priests, including two from il Gesù and two from the Chiesa Nuova,
but in vain. Nevertheless, they continued to exhort him and sang
litanies during the procession from the Tor di Nona through the city
streets to the Campo dei Fiori, one of the major public squares of
Rome. Here Giordano Bruno, on the site now marked by his statue,
was stripped and burned alive.[15]

It can hardly be coincidence that just at mid-century, when the
actions of the Holy Office against heretics were beginning in ear-
nest, some of the wealthiest and most powerful Florentine bankers
in Rome, joining the confraternity and becoming active participants
in the affairs of the brotherhood, held office, served as *confortatori*,
and walked in the processions. Among them were Bartolommeo
Bussotti, one of the bankers closest to and most favored by Pope
Julius III, and Bindo Altoviti, who had been a favorite of the previ-
ous pope, Paul III, and remained one of the major Florentine bank-
ers in Rome until his death in 1557.[16] It is interesting that Bindo,
who had been in Rome for almost four decades without previously
feeling the need to belong to San Giovanni Decollato, joined the
confraternity the year after the election of Julius III. This sudden
urge to participate in the activities of the brotherhood was certainly
motivated by political expediency and economic self-interest. Some
of the Florentine bankers in Rome were virtually in exile during the
regime of Cosimo de' Medici; some, including Bindo and his sons,

were among the *fuorusciti* actively attempting to unseat Duke Cosimo. In 1552 Cosimo actually asked Julius III to turn Bindo over to him, and in 1555 confiscated all the Altoviti property in Tuscany.[17]

During the second half of the sixteenth century, the Florentine bankers in Rome found themselves increasingly in competition with the Genoese for papal favor.[18] It seems apparent that some found it advantageous to demonstrate support for papal policy by participation in the activities of the Confraternity of San Giovanni Decollato. In fact, they could form an alliance with the papacy to cloak the actions of the Holy Office in a mantle of piety, Christian charity, and sacred ritual solemnity.

Active participation in the confraternity also included paying for the decorations of the church. For example, on 5 July 1579 the banker Giovanni Cerretani was granted the second chapel on the right and charged with having it decorated.[19] A 1579-81 date for the altarpiece of San Giovanni in Oleo (St. John the Evangelist in Boiling Oil, fig. 23) is confirmed by the documented presence of the artist, Battista Naldini, in Rome during those years.[20]

Between November 1582 and August 1583, payments were made for the decoration of the first chapel on the right (the Cappella del Crocefisso, fig. 24).[21] The money came from Orazio Rucellai, who was not only an important member of the Florentine banking community in Rome but was also a close friend of the powerful Cardinal Ferdinando de' Medici.[22] Thus through Orazio Rucellai the confraternity was intimately connected with the inner circles of the Church hierarchy. In the records of the confraternity the names of Giovanni Cerretani and Orazio Rucellai appear frequently during the 1570's and 1580's for serving as *confortatori*, walking in processions, and holding office. Rucellai was also among the *confortatori* of a priest hanged and burned as a heretic on the Piazza di Ponte Sant'Angelo, 23 June 1567.[23]

If we examine the altarpieces, their relationship to the practices of the confraternity becomes clear. First, Vasari's Decollation of St. John the Baptist (fig. 22) on the high altar refers, of course, to the specific dedication of the church to St. John the Beheaded—which in turn refers to the mission of the confraternity. However, it also

reflects the use of religious images in the practices of the confraternity—both the subject and the manner in which the decollation reflected the *tavolette* used by the *confortatori*. Vasari, who had joined the confraternity at this time, states in his biography that this picture is different from the way the subject was normally represented.[24] He would have been thinking of Francesco Salviati's recently completed fresco in the Cappella del Palio of the papal Cancelleria and of the fresco just then being painted in the oratory. In these, as had been traditional in Florentine painting, the event takes place outside in a public square, which in the oratory decorations functions as reference to the public executions. However, Vasari's painting, depicting the subject as it appears on the *tavolette*, represents the event taking place inside a dark, heavily rusticated prison very reminiscent of the Tor di Nona where sometimes, as would be the case with Pietro Carnesecchi, the victim was decapitated before being publicly burnt.

The new importance of the confraternity's role in the Counter-Reformation, specifically the actions of the Holy Office, was at the same time expressed in the oratory altarpiece (fig. 21) by the unusual position of the centurion. He may be helping to lower Christ's body in the manner often depicted, but he is also embracing Christ's feet, a role usually given to Mary Magdalene. This suggests that he is there as a repentant sinner. Of course his sin was not wrong-doing so much as wrong-thinking, and his repentance was not only contrition for his misdeeds but also conversion. According to the *Golden Legend*, the centurion experienced his conversion when the blood of Christ falling on his face healed his blindness.[25] This blindness would be taken as a metaphor for spiritual blindness. In the mid-sixteenth century spiritual blindness was synonymous with heresy. Thus, the inclusion of the centurion conveyed a timely reminder to the *confratelli* of their new mission to exhort the increasing numbers of those in their care condemned to death for heresy to recant, to die repentant of their errors, "nel grembo della santa romana chiesa."

If this interpretation is correct, then the two altarpieces commissioned in the same year can be seen as making the transition from

the expression of the brotherhood's mission to the more explicit reference in the church decorations to the actions of the Holy Office and to the images used by the *confratelli* for their participation in these actions. The next two altarpieces to be painted in the church, in the nave, were both commissioned by active participants in the ceremonial rites of the brotherhood. And they also reflect the images on the *tavolette* used during these rites, depicting the *Crucifixion* and a saintly martyrdom. A crucifix had earlier been placed in the chapel.[26] This, of course, was an object commonly to be found above an altar; here, however, it also recalled the crucifix always carried in the processions and placed facing the scaffold so that it and the image on the *tavoletta* would be the last things seen by the condemned. The addition of the painted background with figures of the Virgin and St. John, the cost of which was paid by Orazio Rucellai in 1582-83, created a devotional image of the Crucifixion. Such an image would subsequently appear in almost every church decorated during the late sixteenth century in Rome.

In Counter-Reformation church interiors, these images served as affirmation of the bodily presence of Christ in the Eucharist and pointed out that each celebration of the Mass is a re-enactment of the Passion. At the same time—and this may have been the primary motivation—the altarpiece in San Giovanni Decollato became a replica of the image most frequently depicted on the *tavolette*.[27]

A *modello* for the altarpiece has been attributed to Jacopo Zucchi, who also painted two other altarpieces in the nave[28] (fig. 25). Shortly after its completion, Zucchi, who was a member of the confraternity and took part in the processions, painted an altarpiece for the chapel in the Campidoglio prison.[29] By this time the confraternity had its own chapels in the various Roman prisons in which to comfort the condemned. There is no mention of the subject of Zucchi's picture in the confraternity's records, but since it was the well-documented practice of the brotherhood to keep the image of the crucified Christ constantly before the eyes of the *condannati* there is little doubt concerning the nature of the subject. A Crucifixion (fig. 26) attributed to Zucchi on stylistic grounds and now in the sacristy of the oratory[30] is very likely the one he painted for the Cappella della Conforteria.

There is also an anonymous painting of the Crucifixion in the sacristry of the oratory (fig. 27) which probably had been in the chapel of another Roman prison, perhaps the Tor di Nona. The similarity of the nave altarpiece to these two paintings suggests that it relates not only to the *tavolette* but also to another image used by the confraternity in its assistance to the condemned: the altarpiece of the Cappella della Conforteria.

With regard to the Martyrdom of St. John the Evangelist, it is logical to suppose that the choice of St. John as the subject of this altarpiece was due to the fact that he was the patron saint of Giovanni Cerretani. In addition, the depiction of his martyrdom made the picture a reflection of the third category of subjects on the *tavolette*—saintly martyrdoms. The flames also refer conveniently to the contemporary burning of heretics. However, the choice of this subject has even more significance. Only ten months before Giovanni Cerretani was granted the chapel and charged with having it decorated there was a multiple burning in Rome. A group of eight was hanged on the Ponte Sant'Angelo. They were not burned there, however, nor in the Campo dei Fiori or in the Piazza Navona, the usual sites of burnings. Instead, their bodies were transported on carts in solemn procession with the black-robed, hooded, singing *confratelli* across the entire city and burned in front of the Porta Latina.[31] This historic site commemorated by the octagonal shrine of San Giovanni in Oleo was where, according to Christian legend, St. John the Evangelist had been immersed in a cauldron of boiling oil on the orders of the emperor Domitian. The eight *giustiziati* burned at Porta Latina had not been Lutherans but Jews, most of them Spanish and Portuguese. Accounts of their trial on 9 August 1578 and of their execution on 13 August appeared in the *Avvisi di Roma* and referred to them as "maladetti Marrani" who had committed abominations.[32] The Spanish word *marrano* (literally, pig or swine) was applied to Jews who had converted to Christianity in Spain and Portugal in order to escape the Inquisition but who later, on coming to Italy, lapsed back into the practice of Judaism—a fairly frequent occurrence. It will be remembered that during the Counter-Reformation the persecution of Jews and *marrani* in Italy was almost as

vehement as the persecution of Lutherans. The Spanish Inquisition, which served as Cardinal Caraffa's inspiration, had, after all, been revived prior to the Reformation and was originally directed against Moors and Jews. Although Lutheranism was the major target of the Roman Inquisition, from the very beginning harsh measures were directed against the Jews as well, including the burning of books,[33] the institution of the ghetto, and the requirement of wearing yellow hats.[34] At the same time strong efforts were being made to convert Jews, though converts who relapsed were considered apostates and prosecuted by the Inquisition. Paul IV Caraffa, for example, believed that the *marrani* were particularly dangerous; during his papacy in 1556, twelve *marrani* were burned in the Papal States.[35] This persecution continued in the next decades, reaching its peak during the papacy of Gregory XIII (1572-85).[36]

A number of ironies emerge from these historical events. Anti-Christ, named in the epistles of John (*1 John* 2.18, 22; 4.3; *2 John* 7) and implied in the *Apocalypse*, was understood in part by the early Church to be a reference to Roman emperors such as Nero who persecuted the early Christians. While the historical understanding of Anti-Christ or the beast in the Bible is a complex matter, it became a simplistic weapon of sixteenth-century polemic. For Lutherans the Anti-Christ was the pope; to Catholics of the Counter-Reformation, it signified Luther. Paradoxically, the martyrdom planned for St. John the Evangelist by the emperor Domitian, the Anti-Christ, became in the sixteenth century the fate of the modern Anti-Christ, the Lutheran or any other heretic or apostate. Of course St. John the Evangelist did not die from this ordeal. In the didactic and very correct fresco in Santo Stefano Rotondo (c.1583), the inscription below informs the viewer that St. John emerged *sano* from the cauldron, and he is shown in the background on the island of Patmos (fig. 28). The modern victims of the Inquisition did not emerge *sani* from the flames. However, if they confessed, repented, and took the Sacrament, as did the eight burned at Porta Latina in 1578, they could die "nel grembo della santa romana chiesa," being thus provided, like the early Christian martyrs, with a vehicle of salvation through the *imitatio Christi*. Among the confraternity's

extant *tavolette* is one showing figures engulfed in flames looking for their salvation toward a vision of the Virgin (fig. 29). It is not possible to date these panels, but it is tempting to imagine that such an image originated during this period.

As part of the Counter-Reformation emphasis on the legends of the saints, images of martyrdoms became increasingly frequent. Between 1582 and 1590 numerous fresco cycles of martyrs were painted, including those in Jesuit colleges such as Santo Stefano Rotondo. Cardinal Cesare Baronius (1538-1607), who published a revised Roman martyrology in 1584 and who, incidentally, joined the *confortatori* of San Giovanni Decollato in exhorting a condemned heretic in 1585,[37] had his titular church, SS. Nereo e Achilleo, remodelled to resemble an early Christian church and decorated with frescoes of the martyrdoms of the Apostles.[38] Hardly a church was built and/or decorated in late sixteenth-century Rome without at least one image of a saintly martyrdom.

The purpose of these images was to proclaim the long tradition of the "santa romana chiesa" which in Roman times had endured and triumphed over persecution by the Anti-Christ. It happened that the martyred early Christians and the modern martyred heretics shared the same misfortune of being seen as threats to the Roman establishment. The practices of the Confraternity of San Giovanni Decollato—the processions, the ritual, and the use of these images—served to justify the actions of the Holy Office and to gloss over the contradiction inherent in the fact that instead of pagan Romans killing Christians, early Christian martyrs, the "santa romana chiesa" was making martyrs of Lutherans and Jews.

There is no indication in any of the confraternity's records or other contemporary sources that the brotherhood was motivated by anything but *caritas* and piety, but it seems clear—and should come as no surprise—that just as the impetus behind the Counter-Reformation was political and economic as much as religious, *caritas* and piety could serve as a mantle for a variety of motives, a mantle created by the ritual performed and the art commissioned by the pious *confratelli*.

Notes

Abbreviations used in the notes:

ASGD Archivio di San Giovanni Decollato
ASR Rome, Archivio di Stato
BAV Biblioteca Apostolica Vaticana

1. For the history of the confraternity and its activities, including the construction of the church and the oratory and the decorations of the oratory as documented in the preserved records of the brotherhood and other contemporary sources, see Jean S. Weisz, *Pittura e Misericordia: The Oratory of San Giovanni Decollato in Rome* (Ann Arbor: UMI Research Press, 1984).

2. See Richard Trexler, *Public Life in Renaissance Florence* (New York: Academic Press, 1980), and Ronald F. E. Weissman, *Ritual Brotherhood in Renaissance Florence* (New York: Academic Press, 1982).

3. For the practices of the Compagnia dei Neri, see Giovanni Battista Uccelli, *Della Compagnia di S. Maria della Croce al Tempio* (Florence: Tip. Calasanziana, 1861); Eugenio Cappelli, *La Compagnia dei Neri* (Florence: F. Le Monnier, 1927); Samuel Y. Edgerton, Jr., "A Little Known 'Purpose of Art' in the Italian Renaissance," *Art History*, 2 (1979), 5-61, and *Pictures and Punishment* (Ithaca: Cornell Univ. Press, 1985).

4. For a discussion and illustrations of these paintings, see Weisz, *Pittura e Misericordia*; see also Jean S. Weisz, "Salvation through Death: Jacopino del Conte's Altarpiece in the Oratory of S. Giovanni Decollato in Rome," *Art History*, 6 (1983), 395-405.

5. The records of the confraternity's expenditures include refreshments and clothing for the prisoners.

6. Michel de Montaigne, *The Complete Works*, ed. and trans. Donald Frame (Stanford: Stanford Univ. Press, 1958), pp. 315-16, 941-42.

7. An *Avviso di Roma* of 9 June 1571 describes the execution of Alessandro Pa[r]llantiero, who was decapitated in the Tor di Nona and whose his head was then taken on a "stora" to the Ponte Sant'Angelo "con horrendo spettacolo di tutta Roma" (BAV, Urb. Lat. 1042, fol. 71). This is confirmed by records of the confraternity preserved in the ASR, San Giovanni Decollato, *Giornale del Provveditore*, busta 3, reg 7, fol. 240, where Parlantiero is identified as the Bishop of Castel Bolognese. Throughout the second half of the sixteenth century the *Avvisi* and the *Giornale del Provveditore* of the confraternity contain descriptions, often in lurid detail, of the treatment of heretics being executed. For example, in 1581 Riccardo Archinzono (Richard Atkins), an Englishman, was led to St. Peter's square on the back of an ass, prodded with torches along the way, then his right hand was cut off, and finally he was burned alive (BAV, Urb. Lat. 1049, fol. 281; ASR, San Giovanni Decollato, *Giornale del Provveditore* busta, 5, reg. 11, fol. 124).

8. Not one person of Roman birth appears in the S. Giovanni Decollato records of *giustiziati* prior to the time of Pius V.

In 1571, when five commoners went on trial, the proceedings were not publicized in advance and were held secretly in the Sistine Chapel; this was done in order to avoid scandal (Ludwig von Pastor, *History of the Popes* [Wilmington, N.C.: Consortium Press, 1978], XVII, 312).

9. Ibid., XIV, 260, 276-87, 415-16. See also B. J. Kidd, *The Counter-Reformation* (Westport: Greenwood Press, 1980), p. 49.

10. Pamphlets condemning their execution were printed in Germany: one in 1553 called *A History of how Anti-christ in Rome again murdered two Christians this year*, and one in 1554 called the *True story of Montalcino who was martyred in Rome for his confession of faith* (Pastor, XIII, 210-24). See also Kidd, p. 45; Domenico Orano, *Liberi pensatori bruciati in Roma* (Rome: Tip. dell'Unione Cooperativa Editrice, 1904), pp. 1-4.

11. ASGD, *Rubricella generale di tutto ciò si contiene nei giornali del provveditore, compilata dal fratello Guido Bottari, archivista*, fol. 92, records the commissions. Also in ASGD, *Libro di entrata e uscita, 1550-1556*, fols. 36, 38-39, 44, 46, for records of payments to Vasari made in 1551 and 1553. See also Giorgio Vasari, *Le vite de' più eccellenti pittori, scultori, ed archittettori*, ed. G. Milanesi (Florence: Sansoni, 1978), VII, 695.

12. ASGD, *Rubricella generale*, fol. 91.

13. ASR, San Giovanni Decollato, *Giornale del Provveditore*, busta 3, reg. 7, fol. 78.

14. ASR, San Giovanni Decollato, *Giornale del Provveditore*, busta 2, reg. 4, fol. 211.

15. ASR, San Giovanni Decollato, *Giornale del Provveditore*, busta 8, reg. 16, fol. 87; BAV, Urb. Lat. 1068, fol. 110.

16. The *Rubricella generale* in the ASGD contains a *Catalogo dei fratelli* giving the names of the members and the year in which they joined the confraternity. For Bussotti's activities as papal banker, see Mario Caravale, *La finanza pontificia nel Cinquecento* (Naples: Univ. of Camerino, 1974), pp. 92-93, 110; for that of Bindo Altoviti, see Coriolano Belloni, *Un banchiere del Rinascimento, Bindo Altoviti* (Rome: Cremonese, 1935); and Jean Delumeau, "Vie économique et sociale de Rome dans la seconde moitié du XVI siècle," *Bibliothèque des Ecoles Françaises d'Athènes et de Rom* (Paris: E. de Boccard, 1957-59), CLXXXIV, 845-80.

17. Belloni, pp. 35-39; Delumeau, p. 210.

18. Delumeau, pp. 877-93.

19. ASR, San Giovanni Decollato, *Giornale del Provveditore*, busta 5, reg. 11, fol. 32.

20. Marcia B. Hall, *Renovation and Counter-Reformation: Vasari and Duke Cosimo in S.ta Maria Novella and S.ta Croce 1565-77* (Oxford: Clarendon Press, 1979), p. 71.

21. ASGD, *Libro di debitori e creditori 1575-1590*, fols. 127, 129. See also Edmund Pillsbury, "Drawings by Jacopo Zucchi," *Master Drawings*, 12 (1974), 15-16.

22. See Anna Calcagno, *Jacopo Zucchi e la sua opera in Roma* (Arezzo: E. Zelli, 1933); and Edmund Pillsbury, "Jacopo Zucchi: His Life and Works, unpubl. diss. (Courtauld Institute of Art, 1973).

23. ASR, San Giovanni Decollato, *Giornale del Provveditore*, busta 3, reg. 7, fol. 72.

24. ASGD, *Catalogo dei Fratelli*; Vasari, VII, 695.

25. Jacobus de Voragine, *Legenda Aurea*, ed. Th. Graesse (1890; rpt. Osnabrück: Otto Zeller, 1969), p. 202; Weisz, *Pittura e Misericordia*, pp. 62-63; "Salvation through death," pp. 401-02.

26. In the payment records for the painted decorations the chapel is referred to as the Cappella della Crocefisso (see n. 21, above).

27. There are altarpieces in Roman churches that seem to depend explicitly on the examples provided by San Giovanni Decollato. An altarpiece of the Crucifixion in the Church of Santa Maria in Trivio is a similar replica of the *tavolette* used by the *confortatori*, while in Madonna dei Monti and il Gesù are altarpieces combining the carved crucifix with painted background and figures of the Virgin and St. John the Evangelist, as in the San Giovanni Decollato altarpiece.

28. Pillsbury, "Drawings," pp. 15-16.

29. ASR, San Giovanni Decollato, *Giornale del Provveditore*, busta 6, reg. 12, fols. 145, 160; busta 7, reg. 14, fol. 107; busta 7, reg. 15, fol. 221. See also ASGD, *Rubricella generale*, fol. 91, and *Libro di debitori e creditori 1575-1590*, fol. 131.

30. Edmund Pillsbury, "Jacopo Zucchi in S. Spirito in Sassia," *Burlington Magazine*, 116 (1974), 438.

31. ASR, San Giovanni Decollato, *Giornale del Provveditore*, busta 5, reg. 10, fols. 174-76; ASGD, *Rubricella Generale*, fols. 145, 150.

32. BAV, Urb. Lat 1046, fols. 317, 324.

33. In 1553 Pope Julius III had agreed that the Inquisition should confiscate and burn the Talmud (Pastor, XIII, 214-15).

34. Ibid., XIV, 272-73.

35. Ibid., XIV, 274-76. See also Kidd, p. 47.

36. Pastor, XIX, 308-11.

37. Orano, p. 73.

38. For the most recent discussion of—and up-to-date bibliography on—Cardinal Baronius, his writings, and the renovation of SS. Nereo and Achilleo, see Alexandra Herz, "Cardinal Cesare Baronio's Restoration of SS. Nereo ed Achilleo and S. Cesareo d'Appia," *Art Bulletin*, 70 (1988), 590-620.

The Passion of Christ in the Art, Theater, and Penitential Rituals of the Roman Confraternity of the Gonfalone

Barbara Wisch

Camillo Fanucci, in his 1601 treatise on the pious works of Rome, acclaimed the oratory of the Gonfalone as the most beautiful in the city (figs. 30-31).[1] Few, indeed, were decorated as elaborately and extensively. This confraternity of *raccomandati della Vergine*, later known as the Gonfalone, was founded in Rome between late 1264 and early 1267.[2] Through aggregations, it had become a flagellant society by the late fourteenth century,[3] a fact which has not been brought to bear on art historical discussions of the oratory decoration. By the sixteenth century, the Gonfalone, renowned as the oldest confraternity in Rome, was among the most important and most famous.

A monumental fresco cycle of the Passion of Christ, executed from 1569 through 1576, fills three walls of the oratory.[4] Many of the most famous artists of the period worked there: Federico Zuccaro (figs. 32-33), Cesare Nebbia, Raffaellino da Reggio, and Marco Pino da Siena. Bertoia originated the exuberantly plastic and festive wall-membering system. Massive spiral columns, fluted in the lower part and decorated with sumptuous vines, recreate a kind of Solomonic Temple in the oratory space over which King Solomon himself reigns. Above each picture field is an illusionistic escutcheon containing the Gonfalone *stemma*, a red and white cross on a blue field. Twelve *quadri riportati* in imitation gilded frames depict the Passion episodes from the Entry into Jerusalem through the Resurrection. The two scenes on the inner entrance wall depicting the agonizing torture of Christ in Pilate's palace, the Flagellation and

Crowning with Thorns, are given unusual prominence (fig. 31). Between these scenes is the confraternity's symbol, the *Madonna della Misericordia*, who shelters a group of *confratelli* and Pope Gregory XIII under her mantle.[5] Prophets and sibyls, accompanied by angels and putti, inhabit the open space above the architrave and hold inscriptions (fig. 33). Small niches above the spiral columns contain gold grisaille Old Testament and allegorical figures.

Monumental Passion cycles were rare in central Italy in the fifteenth and first three-quarters of the sixteenth centuries. In the last quarter of the sixteenth century they became a phenomenon in their own right even if receiving little attention in the iconographic and art historical literature. Although Passion cycles were widespread in the thirteenth and fourteenth centuries, they were rarely separated from the entire life of Christ.[6] Independent Passion cycles, often with prophets and their prophecies, did commonly appear as part of the elaborate temporary decoration of the Easter sepulcher where the pre-sanctified host was "buried" during the Good Friday liturgy of the *Depositio*. Late sixteenth-century chroniclers recorded the great devotion excited by these richly ornamented *apparati*, which were visited one after another from Maundy Thursday at noon until Good Friday after dinner.[7]

The emergence of Passion cycles as permanent decoration in central Italy in the late Cinquecento may be generally understood as part of the intensified christological and Eucharistic devotion of the Counter-Reformation. However, the Gonfalone's choice of a Passion cycle as the central subject of the oratory's decoration, which ranks among the earliest, most extensive, and most monumental, has been considered a memorial to or substitute for the confraternity's famous Passion play, which had been prohibited by the pope in 1539. Moreover, the theatrical style and composition of the frescoes themselves have been regarded as being directly influenced by the play.[8]

I hope to demonstrate that the decorative program of the Gonfalone oratory was not directly dependent on the play itself but rather was intrinsically related to the confraternity's *contemporary* ritual observances of Holy Week. By focusing on one fresco of the cycle, Federico Zuccaro's 1573 *Flagellation of Christ* (fig. 32), and

by analyzing the significant iconographic innovation in the depiction of the scene, the confraternity's penitential practices—especially its famous public flagellant procession on the night of Maundy Thursday—are shown as *exempla* of militant Catholic reform and devotion.

In 1490 three members of the confraternity wrote in Italian verse a mystery play of the Passion of Christ. With the permission of Innocent VIII, it was performed that year on the evening of Good Friday in the Colosseum. The first dated printed edition of the play (1501) was entitled: *Income[n]za la passione di Christo historiato in rima vulgari secondo che recita e representa de parola a parola la dignissima co[m]pagnia del Confalone di Roma lo Venerdì Sancto in loco dicto Coliseo—Finita la rapresentatione della passione composta per più persone: per misser Iuliano dati fiore[n]tino e per misser Bernardo di maestro Antonio romano e per misser Mariano particappa.*[9] The play bore a similar title throughout the numerous editions printed in the sixteenth century, although its composition became almost solely associated with Giuliano Dati.[10] The crude woodcut illustrations accompanying the text varied in number from nine to thirty-one. In 1500 a play of the Resurrection was also performed in the Colosseum on Easter Saturday or Sunday. The plays of the Passion and Resurrection became enormously popular in Rome, and the Gonfalone spent hundreds of *scudi* on their production. In some years the plays were not performed because of a lack of funds, but in 1522-24 the *guardiani* decided against the presentation for fear of armed violence. When performed, the Passion play was preceded by a flagellant procession to the Colosseum. Even in the interim years when the play was not performed, the Good Friday procession remained a central part of the festivities.[11]

In 1539, the violence precipitated by the play could no longer be contained. The spectators, enraged at the savagery of Christ's treatment, rushed out of the Colosseum to stone the actors who had portrayed the Jews and Pilate's soldiers, but also stoning and killing Jews. The papal response was swift; Paul III at once revoked the privilege to perform the play. In 1561, the Gonfalone, unsuccessfully petitioning Pope Pius IV for the restoration of the privilege,

dramatized their plea by claiming, incorrectly, that the central purpose of the confraternity's foundation in the thirteenth century was the presentation of the Passion play.

In 1562, the *confratelli* performed another play, that of the Annunciation at S. Maria in Aracoeli, and in 1566 yet another at their church of the Annunziata.[12] Because of the difference between an enormous outdoor religious spectacle directed by the laity that had swayed the populace to riot and a small-scale representation held in a chapel, overseen by the clerics of the church, the latter was allowed to be performed in Rome. Perhaps the Gonfalone looked longingly to Todi on Good Friday 1563 when the confraternities of that city performed *Il Trionfo della Passione* in the piazza before the Duomo. *Il Trionfo della Resurrezione* then followed on the Sunday after Easter.[13] This was the last great outdoor performance of a *sacra rappresentazione* of the Passion of which I know for this period in Italy,[14] and already the context had changed markedly. First, the whole production was organized by a Capuchin cleric to augment the Monte della Pietà. Second, all confraternities of the city were required to take part, each wearing its own habit. Even such controlled religious performances were finally prohibited by Gregory XIII. In a consistory of 26 January 1574, Gregory declared that it was not compatible with the dignity of cardinals to attend even edifying religious plays, and that the colleges and seminaries should refrain from all *sacre rappresentazioni*. Only the Jesuits received special permission to continue to perform instructional religious drama in their colleges.[15]

One might ask whether in this changed religious climate the confraternity sought simply to memorialize on the walls of its oratory the play that had not been performed for thirty years, although it was still being printed with the Gonfalone name. In my opinion, this is to mistake an individual aspect of the traditions leading to the depiction for the more complex and vital meaning of the whole. Rather, the contemporary Holy Week activities of the confraternity, given both support and direction by the Church hierarchy, are the key to this most impressive decoration.

For all flagellant confraternities, Holy Week represented the culmination of the penitential *imitatio Christi* of their rituals. The

special offices for Matins of Holy Wednesday, Maundy Thursday, and Good Friday included flagellation.[16] The Gonfalone statutes indicate that by the end of the fifteenth century the *confratelli* no longer practiced flagellation regularly as they had in the fourteenth and early fifteenth centuries. Although the whip remained part of the prescribed habit, the Good Friday procession was the only time that special care for the *battuti* is recorded in the late fifteenth and first half of the sixteenth centuries.[17] At some point after the prohibition of the Passion play, this procession changed its destination from the Colosseum to St. Peter's. In 1550 the Gonfalone was awarded a papal plenary indulgence for this great spectacle of public penance.[18]

In 1556 or 1557, the Gonfalone's public focus on Holy Week was newly celebrated in a great torchlight flagellant procession to the Pauline Chapel in the Vatican Palace and then to St. Peter's on Maundy Thursday. This replaced the Good Friday procession. In fact, Camillo Fanucci reported that the Gonfalone, along with the confraternity of SS. Crocifisso di S. Marcello, originated this practice. By the end of the century, almost all the other Roman companies participated.[19] In 1579 Gregory XIII extended a plenary indulgence to the Gonfalone for this procession.[20] The Statutes of 1584 went so far as to proclaim that the Maundy Thursday procession was one of the confraternity's "ancient and principal" customs for which it bore the name *disciplinati*.[21]

After the traditional foot-washing and feeding of the poor in the oratory on Maundy Thursday in imitation of Christ's washing the feet of the Apostles and the Last Supper, the great penitential procession began. The account by Gregory Martin significantly named the Gonfalone first among the "more honorable Confraternities."

> [They] prepare them selves to marche, every one from their owne Church . . . and are now ready to beginne in the Evening on Thursday after Candle lighting, which is the very tyme when Christ our Saviour after his supper entred into his agonies toward his bitter Passion. Then of purpose do they beginne, namely the Companies, of Confalóni, of S. Marcello. . . . The lesser Companies first, the greater last, al of one Companie together, observing their tyme and place; . . . and every one in every Companie that marcheth onely and doth nothing else, carieng

a long torche of waxe; so that for three houres space . . . the streate
from the Castel to the Palace is ful of lightes as it were the firmament
besett with great starres. The Wardens of the Companies, and the
Nobles (which are al of some Confraternitie or an other) goe that night
in colour and garment as the rest, but with long staves having the upper
part of silver, and theyr servant carying theyr torche by them . . . but
the mervelous sight of al, is to see the *Flagellanti* that is in most of
these Companies the third part voluntarily whypping them selves al the
way upon the bare backe, where theyr garment is made open of pur-
pose the compasse of a large circle, so vehemently that theyr whippe
and garment round about is al blouddie. And to salve them there are
that carie bottels of vinegre to spirte eftsones upon the place affected,
and this they doe muffled (as the rest) and not knowen, for their owne
sinnes and for the whole Citie and al the world, especially at that tyme
of Christes agonie and blouddie sweate, to suffer with him, not as cer-
ten Heretikes sometyme called *Flagellantes* because they thought it
necessarie to Salvation: but of voluntarily penance for theyr sinnes, and
willing compassion with Christ our Saviour, and joyful bearing of his
Crosse after him.

Thus then they marche up to the Palace and so to the Sepulchre [in
the Pauline Chapel] kept by the Popes gard, whence after adoration of
the b. Sacrament, and meditation of Christes burial, they turne downe
. . . into S. Peters Churche, where there is shewed to every Companie
as they passe, first *Vultus sanctus* called the *Veronica* . . . then, the
verie poynt of the speare that pearced his holy side, al the people upon
theyr knees, crying misericordia, and making doleful shoutes, and the
Flagellanti then especially whipping theyr bodies and punishing theyr
flesh.[22]

From the 1550's through the 1570's the Gonfalone numbered
between 250 to 300 men in these processions, a little more than half
of whom wore the special flagellant garments, the *sacchi busciati*.
Their whips of rope with hard knots were also fitted with sharp little
silver stars. After the processions the *flagellanti* of the Gonfalone re-
turned to the lower level of the oratory, where they were bathed in
large wooden vats filled with hot wine, had powdered myrtle leaves
applied to their wounds, and were fed.[23]

Although the recurrent theme in the contemporary descriptions
of these processions that the streets of Rome were bathed or stained

with the blood of the flagellants[24] was surely an exaggeration, the *topos* created the specific image of the city repentant: as Rome had been hallowed by the blood of the martyrs, once again it became purified through the imitation of Christ and the true penitence of the flagellants. The Protestants had denied the sacrament of penance. The Catholic defense of self-mortification as a voluntary penitential "work of satisfaction" or expiation increased with the escalating militancy of the Church's response to the heretics.[25] The Holy Thursday procession in which the Gonfalone took a leading role underscored the notion that the Roman Catholic Church was the true follower of Christ.

The special status accorded this flagellant procession and its increasing popularity with the other Roman confraternities were also the result of a concerted plan to renew the spiritual life of the people through a revitalization of confraternities—a plan literally codified by Cardinal Carlo Borromeo. The three types upon which he concentrated were the flagellants, the Christian Doctrine, and the Holy Sacrament. At the Second Provincial Council of Milan in 1569, he announced the publication of a general Rule for flagellant confraternities which was later approved and enriched by indulgences in 1572 by Pope Gregory XIII. Under the impulse of Borromeo, flagellant confraternities had an enormous diffusion. Contrary to the penitential devotions of the past, in the late sixteenth century the renewal came in great part from the initiative of the hierarchy.[26] This fact, however, did not seem to negate the penitential seriousness and fervor of the Roman companies.

The Passion cycle in the Gonfalone oratory must thus be considered in the light of the renewed public stature of penitential piety and, more specifically, in relation to the confraternity's renowned Holy Week celebrations (figs. 30-31). The frescoes span the complete cycle of Holy Week, from Palm Sunday (Entry into Jerusalem) through Easter Sunday (Resurrection).[27] They do not correspond exactly in theme or in number to those given emphasis in the play or to the accompanying woodcuts.[28] The cycle is divided into the symbolically rich number of twelve scenes. The episodes were carefully paired across the walls to bring out their sacramental and litur-

gical meanings—a common organizational scheme. For example, the Agony in the Garden and the Crucifixion, the first and final moments of Christ's physical suffering and blood-letting during the Passion, are both centrally placed among the five scenes on each long wall. The Last Supper and the Foot-Washing, Christ's institution of the Eucharist, humble act of purification, and command to repeat these rituals, faces the Deposition, commemorated by the burial of the *Corpus Domini* during the *Depositio*.[29] These ceremonies were celebrated by the *confratelli* in the oratory. The two scenes of scourging in Pilate's Palace are aggrandized by their juxtaposition on the inner entrance wall (fig. 31). The Eucharistic aspects of the fresco cycle are complemented by the liturgical instruments for the celebration of a solemn high Mass represented in the carved and gilded wooden ceiling of 1568 (fig. 34). Furthermore, most of the inscriptions accompanying the prophets and sibyls occur as verses in the Holy Week liturgy.

The *confratelli* might well have viewed their unique monumental fresco cycle in relation to temporary Easter sepulcher *apparati*. This sense of festival decoration made permanent was probably lost on later spectators as sepulchral decoration changed and as frescoed Passion cycles became popular in their own right.[30] However, by recognizing temporary Easter sepulcher decoration as a contemporary model for the Gonfalone Passion cycle, the frescoes maintain a more vital relationship to Holy Week observances.

The central role played by the Maundy Thursday flagellant procession offers a precise ritual context for our focus on a single fresco within the Gonfalone Passion cycle and helps to explain the important iconographic innovation.[31] In the 1573 Flagellation of Christ, Federico Zuccaro depicted, for the first time, Christ bound to a "short" column (fig. 32).[32] After the Gonfalone fresco, the use of the "short" column in representations of the Flagellation rapidly became accepted. By the 1590's in Rome it appeared in almost all versions of the subject.[33] In the seventeenth century, the short column became the standard form of the Flagellation column throughout Europe.

Federico set the scene of the Flagellation in front of a centralized monumental arch framed by a pair of colossal marble col-

umns. The Flagellation itself is raised on a stage-like platform with Christ turning slightly on the central axis. The action is arrested precisely before Christ is to be struck again. In front of the platform are carefully arranged soldiers and spectators. One might well speak of a *mise-en-scène* since the architectural background representing Pilate's praetorium is a generalized classicizing structure similar to the central portion of a *scenae frons* that often was the backdrop for Renaissance theater as an alternative to the Serlian illusionistic stage-set.[34] Because of the "short" column, Christ stands without support and fully exposed to his tormentors in contrast to the Sebastiano del Piombo altar fresco (Borgherini Chapel, S. Pietro in Montorio, 1516-24), based on a drawing by Michelangelo, and probably the most famous earlier representation (fig. 35). In Federico's version, one scourger, thrusting his arm into Christ's back, tilts forward, almost off-balance. The soldiers in front of the platform and the spectators within the scene reinforce the sense of drama in-the-round and the crueler torment that the "short" column allows.

The "short" column that Federico depicted is a relic in the church of S. Prassede in Rome (fig. 36). The representation of the relic in painting and sculpture has previously been mentioned only briefly as a late sixteenth-century or Counter-Reformation phenomenon, with Émile Mâle's discussion as the key reference.[35] Mâle contrasted Christ's being tied to the S. Prassede relic to his receiving the scourging with the physical support of the traditional "tall" column and found the Counter-Reformation solution "plus émouvante" and "plus douleureux." I would question Mâle's conclusion simply by comparing Federico's depiction with his older brother Taddeo's fresco from the Giacomo Mattei Chapel (S. Maria della Consolazione, 1553-56, fig. 37). In Taddeo's work, Christ succumbs, slipping down the column towards the picture plane, suffering overtly, though patiently. His pale, vulnerable nakedness is accentuated as he collapses to the eye-level of the viewer. A Roman spectator of the late 1550's might well have been shocked to witness Christ's scourging at such close range as a permanent life-size decoration. Even in the last quarter of the sixteenth century when Passion cycles with a similar layout became common in Rome, the

scene of the Flagellation was normally relegated to a less dominant position in a lunette or a section of the ceiling. This analysis of why the Gonfalone chose to initiate the new depiction of the column of the Flagellation will not rely on a too general concept of Counter-Reformation religious sensibility, however, but will instead attempt to focus on more concrete and more complex evidence.

The relic of the "short" column at the church of S. Prassede had been brought from Jerusalem in 1223 by Cardinal Giovanni Colonna, Titular Cardinal of S. Prassede and Legate to the Holy Land under Honorius III (fig. 38).[36] The transport of the column of the Flagellation was part of the great *adventus reliquarum* of the thirteenth century. Competition was bitter, and theft appropriated the hallowed name of *translatio*.[37] Relics of the Passion were extremely valuable. Cardinal Colonna was probably allowed by the Franciscans to remove the column from the church of the Last Supper on Mt. Zion because he was instrumental in the official establishment of the friars there in 1219; he must not have desired the column solely on account of the happy coincidence of his name and the object itself. At the time, however, who could have venerated the *Colonna Santa* in S. Prassede, the station church for the Monday of Holy Week, without remembering the Titular Cardinal Legate who had translated it to Rome after commanding the papal troops in the Fifth Crusade (1217-22)?

Cardinal Colonna placed the column in the Oratory of S. Zeno, a chapel also called the *Hortus Paradisi* because of its many relics of early martyrs, especially the martyred popes. The chapel was considered so holy that the entrance of women was prohibited. The original location of the column was on the floor of the chapel under a sarcophagus with the remains of SS. Valentino and Zeno. It remained there until 1699 when Monsignor Ciriaco Lancetto decided to raise it to a more eminent position so that it might be more easily venerated. The column has remained in the chapel to this day although the reliquary is a late nineteenth-century replacement. The column, made of black and white mixed marble, is 63 cm. high with a diameter of 40 cm. at the base and 20 cm. at the top. Although small and having an unusual shape, it is a full column with proper

base and capital. It originally had an iron ring at its top which was sent to King Louis IX in exchange for three thorns from the Crown of Thorns. Above the column hung a painting of the Flagellation of Christ attributed by Vasari to Giulio Romano (fig. 39).[38] There was a vast discrepancy between the pictorial tradition and the relic. Technically the confusion should have arisen as soon as the short column was brought to Rome; in reality no one thought much about it. The original placement of this small column under a sarcophagus did not allow a close examination of the evidence. Moreover, there was no trial. Well-known eyewitness accounts by some of the most esteemed members of the Church provided vastly conflicting testimonies concerning the original appearance of the column of the Flagellation. The majority seemed to agree that the S. Prassede column was a fragment of the whole in spite of its shape and certain knowledge that an iron ring had been inserted into the hole at its top. There was simply no pressing reason to alter abruptly the pictorial tradition.

St. Jerome was among the early eyewitnesses. He reported that the column, stained with the blood of Christ, was sustaining the portico of the Temple of Jerusalem. Two centuries later, the Venerable Bede wrote that the same column was in the Church of the Last Supper on Mt. Zion where pilgrims came to kiss it and decorate it with bands of cloth. In 1372 St. Bridget of Sweden saw a column that she believed to be one half of the column of the Flagellation preserved in a chapel near the Church of the Holy Sepulcher in Jerusalem. Medieval pilgrims would often have themselves tied to this column fragment and then flagellated in penance. The other half of the *Colonna Santa* she had already seen in S. Prassede.[39]

A third major fragment of the column of the Flagellation, a 75 cm. portion of a red marble column from the church on Mt. Zion, was translated by Father Bonifazio di Ragusa in 1553 to the Church of the Holy Sepulcher in Jerusalem. There the column was highly venerated, and fragments from it were sent to various churches and to the pope himself.[40] Another opinion associated the column with the Solomonic columns in St. Peter's. Since Jerome had seen it sustaining the portico, surely the column had been brought to Rome by

Constantine or Helena. One, also called the *Colonna Santa*, was noted for its miraculous healing powers.[41]

The Protestant attack on the veneration of saints, relics, and images forced Catholics to provide answers when faced with confusion such as this. Part of the Catholic defense was the introduction of a Christian archaeology to prove by authenticated facts that the Roman Catholic Church was the true heir of primitive Christianity. In 1578 the catacombs were "discovered." Knowledge of them had fallen into oblivion since the late Middle Ages, but now they were the priceless monuments of Christianity during the persecutions. New relics were found, and existing ones were glorified, especially those exemplifying a saint's life as an imitation of Christ. A revised Roman martyrology was published in 1582. In 1588, Cardinal Baronio published the first volume of his great ecclesiastical history. In 1591, Antonio Gallonio published a detailed volume on every instrument of martyrdom with full explanations of the methods of torture and complete illustrations.[42]

The confusion concerning the column of the Flagellation was also resolved. An inscription was placed under a newly painted representation of the Flagellation (since destroyed) in the Chapel of S. Zeno in 1585, and Sixtus V officially approved it the following year.[43] The inscription explained that there were in Jerusalem *two* columns of the Flagellation. The first, of which Jerome had spoken, was that of the portico of the Temple where Jesus was flagellated during the night by order of Caiaphas. The second, the short column, was in Pilate's praetorium. It allowed the victim to be beaten more cruelly on the back as well as on the chest. This column, continued the text, had been venerated throughout the centuries before being brought to Rome by Cardinal Colonna.[44] The next official sanction of the "two Flagellations" theory that combined word and image is a 1591 engraving by Martin Fréminet (fig. 40). The text follows the S. Prassede inscription almost verbatim.[45]

In this climate of official written sanction of the true history of the S. Prassede relic and its widespread appearance in frescoes in Rome in the 1580's and 1590's, it may seem surprising that Baronio did not subscribe to the theory. As late as 1624, Cardinal

Federico Borromeo in his book *De pictura sacra* still reported that authorities did not agree about the height of the column of the Flagellation. The new explanation became standard only in 1630 in Giovanni Severano's *Memorie sacre delle sette chiese di Roma.*[46]

The final threads in this tapestry of the relic's veneration are woven by none other than the revered Cardinal Carlo Borromeo, Titular Cardinal of S. Prassede from 1564 until his death in 1584.[47] In 1564 he became Archpriest of S. Maria Maggiore and thereby, like the canons of that church, a member of the Gonfalone. In 1565, he donated 1559.5 *scudi* and, in 1567, fifty *scudi* to the confraternity to be distributed as dowries.[48] Although Borromeo resigned his position of Archpriest in 1572, he maintained the title of Titular Cardinal of S. Prassede throughout his life. The Cardinal was extremely devoted to the veneration of the column of the Flagellation. His biographers relate that he would often spend the night in silent prayer before the column and in the morning would invite his household to join him, praising the relic in a sermon.[49]

Borromeo's extraordinary devotion to relics, especially those of the Passion, was described in vernacular accounts by contemporaries. In Rome during the Jubilee, the Cardinal ascended the Scala Santa every day on his knees until they were bloody. In Milan in 1576 he ordered great processions of the Holy Nail to assuage God's wrath and the plague because he felt that the relic "had not in times past received the veneration to which it was entitled, having been but seldom shown to the people." The Cardinal had facsimiles of the Nail made so people might keep them in their homes. In 1578 the translation of the Holy Shroud from Chambéry to Turin was glorified by Borromeo's presence.[50]

The Cardinal's devotion to the Passion and the cult of relics was representative of the models of his personal piety and austerity. Gregory Martin reported that his penitential practices were "verie famous in word and writing, and a very representation of the Primitive and Apostolical perfection." Borromeo's biographer Father Giussano wrote that he wore a coarse hairshirt and used the discipline so severely throughout the year that marks of it were found on his body after his death. "Spiritual consolations flowed in upon the

saint," continued Giussano, "in proportion as he afflicted his mortal body." In a eulogy upon his death in 1584, Cardinal Sirleto of Verona is reported to have said, "Martyrdom stopped short of him, not he of martyrdom."[51]

Carlo Borromeo achieved extraordinary fame and stature during his lifetime. His uncle Pope Pius IV and life-long friends begged him to moderate his ascetic severities. He ardently promoted the cult of relics and the particular relics in his titular church of S. Prassede. He actively supported flagellant confraternities and, as noted above, had been a member of the Gonfalone, which as we have seen was renowned for its great penitential procession. In my opinion, all these factors led to the first depiction of the S. Prassede "short" column of the Flagellation in the oratory of the Gonfalone (fig. 32).

The relic was further glorified by Federico Zuccaro's use of the fictive curtains which visually give the scene special emphasis among the other narratives. Federico seems to have directly borrowed the illusionistic curtain rod and green curtains from Raphael's *Sistine Madonna* (c.1513, fig. 41). This traditional motif signified a *relevatio*. It is *not* a theater curtain, no matter how theatrical the effect. The symbolic interpretation was given by the Christian Fathers, who unanimously held that the veil of the Temple, rent asunder at Christ's death, signified the revelation of the truth of the new faith to the Christians as opposed to its unavailability to the Jews.[52] A comparable pictorial revelation of the relic was used in an engraving of 1700 only a year after its actual elevation above the sarcophagus. In the oratory, as in the engraving, the curtains affirm the authenticity of the relic and its proper veneration. Moreover, the contrast between the relic and the spiral columns of the Temple portico, the oratory's illusionistic architecture, anticipated the "two Flagellations" theory.

It is doubtful, however, that the decision to use a new iconography would be left to the artist or even the confraternity members after the Council of Trent's strict decree in the Twenty-Fifth Session (1563):

> No one is permitted to erect or cause to be erected in any place or church . . . any unusual image unless it has been approved by the

bishop; also that no new miracles be accepted and no relics recognized
unless they have been investigated and approved by the same bishop.[53]

The Cardinal Protector of the Gonfalone was Alessandro Farnese,
the most important art patron in Counter-Reformation Rome and
probably the most powerful cardinal of the sixteenth century. He
had been directly involved with the decorative program of the
oratory from its inception by sending Bertoia to Rome to plan and
execute the frescoes, and later he moved artists between the oratory
and his villa at Caprarola. Surely the Cardinal had approved if not
suggested the innovation.[54] Perhaps it was Cardinal Otto Truchsess
von Waldburg, a member of the Gonfalone, whose coat-of-arms is
paired with that of Farnese in the carved wooden ceiling of 1568
(fig. 34). Like Cardinal Farnese with whom he shared the central
role in the ceremony of laying the cornerstone of the Gesù in 1568,
he seems to have had a direct role in choosing one of the painters in
the oratory. Moreover, he regarded relics with the highest
veneration, and his vast collection even included a fragment from
the column of the Flagellation. He was also interested in early
Christian "authenticity" if we may judge from the uncommonly
careful restoration of the S. Sabina apse by Taddeo Zuccaro in 1560
which he authorized as Titular Cardinal.[55] But perhaps it was
Girolamo Mattei, whose coat-of-arms appears in the *Flagellation*
and who probably paid for the fresco. In 1573 he was a prelate in
the Roman Curia as auditor in the Apostolic Chamber and a
guardiano of the confraternity. He may have wanted to be
associated with this special scene since his uncle had commissioned
Taddeo Zuccaro's intensely powerful version twenty years earlier
(fig. 37).[56] Members of the Colonna family also belonged to the
Gonfalone although they were neither officers nor generous donors.
Their presence in a Gonfalone procession to gain the 1575 Holy
Year indulgence was noted by the chroniclers.[57] The fame of
Marcantonio Colonna as the victorious admiral of the papal fleet at
Lepanto (7 October 1571) and the imperial triumph accorded him
upon his return to Rome (4 December 1571) may also have fueled
interest in the relic, translated from the Holy Land by a prominent

cardinal in the family who had also led papal troops against the infidel. Moreover, Vasari consulted with the Admiral on 1 March 1572 in preparation for his two frescoes of the battle of Lepanto in the Sala Regia,[58] so Colonna's personal interest in historically accurate depictions may have been aroused.

Whoever was the *eminenza grigia* behind the new iconography, Federico Zuccaro's representation of the Flagellation in the oratory of the Gonfalone provided a powerful image whereby the members could imitate Christ through their own penitential whippings on Maundy Thursday. This interpretation is supported by the inscription with the prophet and sibyl in the upper register (fig. 32) who share a single verse from Psalm 72(73).14: ET/ FVI FLA/GELLATIO TOTA DIE and ET/ CASTIGA/TIO IN MATV/TINIS ("And I have been scourged all the day; and my chastisement hath been in the mornings"). This penitential psalm is the fifth of the Office of Tenebrae for Matins of Maundy Thursday. A flagellant confraternity would traditionally have held its Holy Week ritual of self-morti-fication immediately following this ceremony.[59] The other sibyls in the oratory bear inscriptions from the famous oracles recorded by St. Augustine, among which could be found a specific reference to fla-gellation.[60] The inclusion of the full verse of the penitential psalm, presented by both the prophet and sibyl, emphasizes the liturgical office and the flagellation ritual.

The new and "historically accurate" version of the Flagellation, depicting the crueler torment that the short column allowed, must have incited the members to mortify their flesh "swiftly and fer-vently," as Borromeo had stated in the flagellant Rule. Moreover, the fresco would instruct the faithful in the accurate teachings of the Church. The Council's emphasis on the special importance of images in confirming the articles of faith was proven correct by this example. In the end, decades before the detailed scholarly argument was printed, the image corrected popular belief and reinforced the singular validity of this relic. By initiating the new depiction of the Flagellation and by setting that scene within its oratory "con-structed" as the New Temple in the New Jerusalem, the Gonfalone associated itself with the great work of the reform of the Roman Catholic Church, perhaps even with the person of Carlo Borromeo, and sanctified its own ritual observances.

By the end of the fifteenth century the devotion of the Gonfalone to the cult of the suffering Christ reached equal status with the cult of the Virgin, the confraternity's original dedication. With the performance of the Passion play and the accompanying flagellant procession, the Gonfalone's public association with this devotion also equalled its public celebration of the Virgin, in which the feast of the Assumption was traditionally highlighted by the confraternity's great procession with the *Salus Populi Romani* icon of S. Maria Maggiore. When the mystery play was no longer a viable public expression of the confraternity's Holy Week rituals, a new practice, consonant with the demands of the Church hierarchy, replaced the old. The Maundy Thursday torchlight flagellant procession won papal acclaim and brought the *confratelli* nearer salvation by virtue of the plenary indulgence. By voluntarily whipping themselves in public "in memory of the Passion of Christ" —a phrase which recurs in the statutes of all flagellant confraternities—the *confratelli* shared his sufferings and could identify more closely with the Incarnate Christ. By initiating this procession, the most venerable confraternity in Rome became an exemplar of the heightened christological and penitential devotion that characterized the age of religious reform. This was not only public propaganda for the efficacy of "works" and the sacrament of penance but also a return to the values of the early and medieval Church where the rites of penance were meted out in arduous regimes of self-mortification, often performed in public, and where Maundy Thursday had been marked as a day of public reconciliation of penitents.[61]

Ronald F. E. Weissman has noted the distinctive change in the rites of Maundy Thursday in the Florentine confraternities whereby pomp replaced penance.[62] This parallels precisely the findings of Brian Pullan, who has stated that Borromeo's Rule had no effect in reviving the flagellant ritual in late sixteenth-century Venice. Pullan specifically noted that *ersatz flagellanti* were hired to march in the Maundy Thursday procession in the stead of the Scuole members.[63] The Roman *confratelli* exhibited a different attitude.[64] In the Gonfalone processions during the third quarter of the century, more than half of the men wore the *sacchi busciati*. That all the male *confra-*

telli did not flagellate, even on the single day on which the ritual took place, indicates a definitive change from the way the *disciplinati* had originally conceived their confraternities—and a considerable departure from the ideal which Borromeo demanded as well. As noted above, the changes were already well underway by the late fifteenth century; however, this divergence did not negate the mimetic and penitential seriousness of those 160 *flagellanti*—or their meaning for the entire confraternity, for the other worshippers on their way to St. Peter's to venerate the Passion relics, or for the pope. Even if the nobility did not flagellate in these processions and were distinguished by silver-colored staves and servants, the onlookers, impressed by the same hierarchical distinctions, still admired the fact that they took part "vestiti di sacchi, come i più poveri del numero." Some, like the Colonna, were recognized only upon raising their hoods to kiss the relics.[65]

In the late 1560's when the decorative program for the oratory was devised, the Gonfalone had no need to memorialize the prohibited play. The living celebration of Holy Week and the Gonfalone's leading role in the penitential procession led to the depiction of the Passion and the iconographic innovation in the scene of the Flagellation. This "showcase" of the Passion provided a year-round opportunity for the *confratelli* to contemplate the sacraments of the Eucharist and of penance, both emphatically denied by the Protestants. These are the same two sacraments that Borromeo described in his Rule as the twin columns that permanently support the spiritual edifice of a flagellant confraternity.

In the prologue to his *Instructiones Fabricae et Supellectilis Ecclesiasticae*, written shortly after 1572, Borromeo also praised the ancient tradition of ecclesiastical splendor, recognizing how much a dignified and impressive religious spectacle can emotionally affect the viewer. In the oratory, Christ's Passion is displayed with a splendor, grandeur, and theatricality no less than the contemporary Roman liturgical and paraliturgical ceremonies. The images are a magnificent and powerful expression of the spiritual values which the confraternity, in concert with the hierarchy of the Roman Catholic Church, sought to promulgate.

Notes

All the documents cited for the Gonfalone are located at the Archivio Segreto Vaticano, Fondo Arciconfraternità del Gonfalone at Rome.

1. Camillo Fanucci, *Trattato di tutte l'opere pie dell'alma città di Roma* (Rome, 1601), p. 201.

2. L. Ruggeri, *L'Archiconfraternità del Gonfalone* (Rome: Morini, 1866), pp. 18-23; L. Kern, "Notes sur la fondation de la confrérie des Raccommandés à la Vierge et ses rapports avec les flagellanti," in *Il movimento dei disciplinati nel settimo centenario del suo inizio, 1260* (Perugia: Deputazione di Storia Patria per l'Umbria, 1962), pp. 253-56.

3. Ibid.; Anna Esposito, "Le 'confraternite' del Gonfalone (secoli XIV-XV)," *Ricerche per la storia religiosa di Roma*, 5 (1984), 91-136.

4. For a documented history of the oratory decoration and full bibliography, see Barbara Wollesen-Wisch, "The Archiconfraternità del Gonfalone and its Oratory in Rome: Art and Counter-Reformation Spiritual Values," Ph.D. diss. (Univ. of California, Berkeley, 1985).

5. For a full discussion of this image, see my article "The Roman Church Triumphant: Pilgrimage, Penance and Processions Celebrating the Holy Year of 1575," in *"All the world's a stage . . .": Art and Pageantry in the Renaissance and Baroque*, ed. Barbara Wisch and Susan Scott Munshower, Papers in Art History from The Pennsylvania State University, 6 (University Park: Pennsylvania State Univ., 1990), pp. 82-117.

6. Helga Moebius, *Passion und Auferstehung in Kultur und Kunst des Mittelalters* (Berlin, 1979); Kurt W. Forster, *Pontormo* (Munich: Bruckmann, 1966), p. 55, with a list of the major fresco cycles before Pontormo; Wolfgang Braunfels, "Leben Jesu: Manierismus und Barock," *Lexikon der christlichen Kunst* (Freiburg i. B.: Herder, 1928), I, 408-507; Gertrud Schiller, *Iconography of Christian Art*, trans. Janet Seligman (Greenwich, Conn.: New York Graphic Society, 1972), II, 14ff. Émile Mâle, *L'Art religieux de la fin du XVIe siècle, du XVIIe siècle et du XVIIIe siècle: Étude sur l'iconographie après le concile de Trente*, 2nd ed. (Paris: A. Colin, 1951), pp. 67ff, discusses the new representations of the sacraments, especially the Eucharist (pp. 77ff) and individual scenes from the Passion (pp. 262-94) but makes no mention of Passion cycles. Recent important books and articles discussing major redecoration programs of churches with Passion cycles make no mention of comparative programs or the general context—e.g., Marcia Brown Hall, *Renovation and Counter-Reformation: Vasari and Duke Cosimo in S.ta Maria Novella and S.ta Croce 1565-1577* (Oxford: Clarendon Press, 1979); Rosamund E. Mack, "Girolamo Muziano and Cesare Nebbia at Orvieto," *Art Bulletin*, 56 (1974), 410-13.

In the early sixteenth century, monumental frescoed Passion cycles did appear in northern Italy, especially in Lombardy and Piedmont; see Charles E. Cohen, "Pordenone's Cremona Passion Scenes and German Art," *Arte Lombarda*, 42-43 (1975), 74-96.

For Passion iconography in northern Europe, see James Marrow, *Passion Iconography in Northern European Art of the Late Middle Ages and Early Renaissance: A Study of Sacred*

Metaphor into Descriptive Narrative, Ars Neerlandica, 1 (Kortrijk: Van Ghemmert, 1979).

7. The English papist Gregory Martin, who lived in Rome from late 1576 until the summer of 1578, provides the most detailed contemporary description: *Roma Sancta (1581)*, ed. George Brunner Parks (Rome: Edizioni di Storia e Letteratura, 1969), pp. 91-92. See also Giorgio Vasari, *Le vite de' più eccellenti pittori, scultori ed architettori*, ed. Gaetano Milanesi (Florence: G. C. Sansoni, 1878-85), VII, 87 (Taddeo and Federico Zuccaro's c.1560 *apparato* for the oratory annexed to S. Giovanni dei Fiorentini, Rome) and 31-32 (Salviati's 1550 *apparato* for S. Maria sopra Minerva); Pamela Scheingorn, "The Easter Sepulchre: A Study in the Relationship between Art and Liturgy," Ph.D. diss. (Univ. of Wisconsin, 1974), and *The Easter Sepulchre in England*, Early Drama, Art, and Music, Reference Ser., 5 (Kalamazoo: Medieval Institute Publications, 1987), pp. 3-73; Solange Corbin, *La déposition liturgique du Christ au Vendredi Saint: Sa place dans l'histoire des rites et du théâtre religieux* (Paris and Lisbon: Les Belles Lettres, 1960).

8. Federico Zeri, *Pittura e Controriforma: L' "arte senza tempo" di Scipione da Gaeta*, 2nd ed. (Turin: G. Einaudi, 1957), p. 62; Josephine von Henneberg, *L'Oratorio dell'Arciconfraternita del Santissimo Crocifisso di San Marcello*, Biblioteca di Cultura, 58 (Rome: Bulzoni, 1974), p. 58; Claudio Strinati, "Gli anni difficili di Federico Zuccaro," *Storia dell'Arte*, 21 (1974), 101; Luigi Salerno, Luigi Spezzaferro, and Manfredo Tafuri, *Via Giulia: Una utopia urbanistica del '500*, 2nd ed. (Rome: A. Staderini, 1975), p. 346; Claudio Strinati, "Marcantonio del Forno nell'Oratorio del Gonfalone a Roma," *Antichità Viva*, 15 (1976), 20; A. Vannugli, C. Tiliacos, and C. Mastrantonio, "L'oratorio del Gonfalone," *Oltre Raffaello: Aspetti cultura figurativa del cinquecento romano* (Rome: Multigrafica, 1984), pp. 145, 161.

9. The most important study of the Gonfalone Passion play remains Marco Vattasso, *Per la storia del dramma sacro in Italia*, Studi e Testi, 10 (Rome: Tipografica Vaticana, 1903), pp. 69-101. See also *La Passione di Cristo in rima volgare secondo che recita e rappresenta di parola a parola la Compagnia del Gonfalone di Roma*, ed. G. Amati (Rome, 1866); G. Biasiotti, "L'importanza e la funzione storica della Confraternità del Gonfalone a Roma," *Atti del II Congresso Nazionale di Studi Romani* (Rome, 1931), II, 69-76; Paul Colomb de Batines, *Bibliografia delle antiche rappresentazioni italiane sacre e profane stampate nei secoli XV e XVI* (Florence: Società Tipografica, 1852), p. 19.

10. The other dated editions are: Florence, 1511; Venice, 1514; Rome, 1515; Perugia, 1524; Florence, 1534 and 1559; Venice, 1568 and 1582; Siena 1582; Florence, 1587 and 1601; Treviso, 1603; Venice, 1606; Rome, 1672; Todi, 1679; Turin, 1728.

11. Vattasso, p. 86, mentions this procession in passing for 1538. Esposito, pp. 103-04, notes flagellation on Good Friday but not the procession. The earliest conclusive evidence that I have found for the procession is *Camerlengo* 1516, fol. 54v, a payment "ali ma[n]datari ch[e] a[n]daro[n]no a culiseo cola procesione alli frustatori." In 1532 when the play was not presented, a flagellant procession was held on Good Friday (*Camerlengo*, fol. 52r) and a *carro* accompanied it (ibid., fol. 53v). The expenditures continued throughout the 1540's and early 1550's. The last year that specifically mentions the Good Friday procession is 1554. From 1557, only expenses for a Holy Thursday procession are recorded (*Spese Minute*, 1544, fol. 3r; *Spese Minute*, 1545, fol. 14v; *Spese Minute*, 1546, fol. 28r; *Spese Minute*, 1547, fol. 38v; *Spese Minute*, 1549, fol. 69v; *Spese Minute*, 1550, fol. 12; *Camerlengo*, 1554, fol. 32v; *Camerlengo*,

1557, fol. 19ᵛ).

12. *Camerlengo*, 1566, fol. 33ᵛ. The assertion of Vattasso, p. 89, that the Aracoeli performance was the Gonfalone's last in the sixteenth century should be corrected.

13. Mario Pericoli, *Il trionfo della Passione e Resurrezione a Todi nella Pasqua 1563*, Res Tuderinae, 3 (Todi: Biblioteca Capitolare di Todi, 1963).

14. In 1579, a Passion play was presented by the confraternity of S. Maria in Rieti, but I know no details about the performance. See A. M. Terruggia, "In quale momento i Disciplinati hanno dato origine al loro teatro?" in *Il movimento dei disciplinati nel settimo centenario dal suo inizio*, p. 457; P. Toschi, *Le origini del teatro italiano* (Turin: Einaudi, 1955), p. 702, says that the Gonfalone Passion play continued to be performed in Velletri "in un teatro stabile in muratura, che occupava tutto un lato della piazza."

15. Ludwig F. von Pastor, *La storia dei papi dalla fine del medio evo*, trans. P. Cenci (Rome: Desclée, 1955), IX, 788f.

16. The standard form of the Holy Week ritual was printed, for example, by an unnamed confraternity in Spoleto, *Libro da Compagnia: ovvero fraternita, con l'officio del Santissimo Sacramento, e con l'officio della Madonna ordinato secondo i tempi, E con l'Officio della Settimana Santa distinto per i suoi giorni* (Venice, 1556), fols. 157ʳ-158ᵛ; see also fol. 74ʳ: "No[n] si fa raccom[m]andigia nessuna in q[ues]te tre sere . . . Lagrime. Discipline. Miserere." C. Fanucci, pp. 358-59, describes the same ritual for the confraternity of S. Caterina della Natione Senese: "La Settimana Santa cantano i tre officij delle Tenebre Quali finiti si spengono tutti i lumi & uno così al scuro fa un Oratione, sopra la Passione . . . li fratelli si danno la disciplina." For the Maundy Thursday rituals of the Florentine confraternities, see Ronald F. E. Weissman, *Ritual Brotherhood in Renaissance Florence* (New York: Academic Press, 1982), pp. 99-105, although he does not emphasize flagellation.

17. See n. 11, above; Esposito, pp. 96-97, 103-04; G. Alberigo, "Contributi alla storia delle confraternite dei disciplinati e della spiritualità laicale nei secc. XV e XVI," in *Il movimento dei disciplinati*, pp. 179, 182, suggests that in general a change had taken place among the flagellant confraternities by the end of the fifteenth century. Flagellation was *one* devotion, no longer *the* devotion.

18. Ruggeri, pp. 228-29, quotes the papal document which names the flagellant procession on the night of Good Friday beginning at the Gonfalone church of S. Lucia Nuova (a short distance from the oratory) and culminating at St. Peter's.

19. See n. 11, above; Fanucci, p. 265. Pastor, VI, 466, records that one way in which Pope Paul IV sought to enhance devotion to the Eucharist was to have an elaborate temporary sepulcher erected in the Pauline Chapel during Holy Week. Payments show that the first *apparato del sepolcro* was constructed in 1556, a date which corresponds exactly with the Gonfalone documents and confirms Fanucci's claim. The sepulcher included four large stucco prophets and painted decoration (Karl Frey, "Studien zu Michelagniolo Buonarroti und zur Kunst seiner Zeit," *Jahrbuch der Königlich preussischen Kunstsammlungen*, 30 [1909], 164-65; Christoph Luitpold Frommel, "Antonio da Sangallos Cappella Paolina: Ein Beitrag zur Baugeschichte des Vatikanischen Palastes," *Zeitschrift für Kunstgeschichte*, 27 [1964], 40n). This description matches Gregory Martin's account (p. 92): a picture of Abraham about to

sacrifice Isaac, placed above the Blessed Sacrament; to the left, Moses and Daniel with accompanying inscriptions (*John* 3.14, *Daniel* 9.26); to the right, Aaron and Isaiah with their inscriptions (*Exodus* 8.12, *Isaiah* 11.10). Although one of the important functions of the Pauline Chapel was the preservation and display of the Eucharist, the opening of this private papal chapel to two flagellant confraternities for a procession entering from the adjacent Sala Regia (the newly decorated audience hall of the palace) to venerate the *Corpus Domini* and then exiting through the back door down the stairs to St. Peter's marked a new stage in the increased status accorded flagellant confraternities in Counter-Reformation Rome.

20. *Breve Omnipotentis* of 26 April 1579, recorded in the *Statuti della Venerabile Archiconfraternità del Confalone* (Rome: Bartholomeo Bonfadino & Tito Diani, 1584), p. 230 [*sic* 130]. The Good Friday procession is not named among the celebrations which continued to offer a plenary indulgence.

21. Ibid., p. 55.

22. Martin, pp. 89ff.

23. For the full documentation, see Wollesen-Wisch, pp. 23-24 and esp. 346-47n.

24. R. Riera, *Historia utilissima et dilettevolissima delle cose memorabili passate nell'alma città di Roma l'anno del gran Giubileo M.D.LXXV* (Macerata: Sebastiano Martellini, 1580), pp. 28, 76-77, 95-96.

25. P. Galtier, "Satisfaction," *Dictionnaire de Théologie Catholique*, XIV (Paris: Letouzey et Ane, 1939), 1129-1210; A. Michel, "Pénitence," *Dictionnaire de Théologie Catholique*, XII (1933), 722-1127, esp. 1050-1117.

26. Alberigo, pp. 202-14; Giuseppe Alberigo, "Carlo Borromeo come modello di vescovo nella Chiesa post-tridentina," *Rivista Storica Italiana*, 79 (1967), 1031-52; Paolo Prodi, "San Carlo Borromeo e il cardinale Gabriele Paleotti: due vescovi della riforma cattolica," *Critica Storica*, 3 (1964), 135-51; Antonio Rimoldi, "I laici nelle regole delle confraternite di s. Carlo Borromeo," in *Miscellanea Carlo Figini* (Venegono: La scuola cattolica, 1964), pp. 281-303; *Acta Ecclesiae Mediolanensis*, ed. Achillis Ratti (Milan: Apud Raphaelem Frerraris Edit., 1888-92), III, 269-70, 275-76, 295ff, for the flagellant Rule and the papal brief.

27. Reading clockwise from the altar (Crucifixion): side wall: Entry into Jerusalem, Last Supper and Foot-Washing, Agony in the Garden, Arrest of Christ, Christ before Pilate; inner entrance wall: Flagellation, Crowning with Thorns; side Wall: Ecce Homo, Way to Calvary, Crucifixion, Deposition, Resurrection.

28. For example, after the prologue that sums up the story through the Crucifixion, the opening scenes in the play dramatize Judas speaking with the Pharisees through the payment. Christ and the disciples are first presented leaving the Last Supper on their way to the Garden of Gethsemane. The first illustration in the 1606 edition is the Agony in the Garden.

29. See n. 7, above.

30. Mark S. Weil, "The Devotion of the Forty Hours and Roman Baroque Illusions," *Journal of the Warburg and Courtauld Institutes*, 37 (1974), 218-48. Weil's statement, p. 220, that sepulcher decoration remained relatively small until the seventeenth century should be modified. Unfortunately, *apparati* were not recorded in prints and drawings in the sixteenth century as they were in the seventeenth.

31. A general connection among the increase in the number of penitential confraternities in France in the 1570's and 1580's, their public processions, the militant Church of the Counter-Reformation, and the depiction of Christ bound to the short column was suggested by Robert A. Schneider, "Mortification on Parade: Penitential Processions in Sixteenth- and Seventeenth-Century France," *Renaissance and Reformation*, 22 (1986), 123-46, esp. 137.

32. Federico Zuccaro signed the fresco in the lower left on the soldier's shield with his coat-of-arms, the sugar loaf and lilies. All the contemporary sources name Federico as the artist, and a stylistic analysis of the preparatory drawings and the final work confirm their report. The laconic yet acute commentary by Carel van Mander, who visited the oratory during his Roman sojourn 1573-76, focused on this central distinguishing factor: "Noch is van Frederijck te sien in een Kerck oft Bede-huys der Gonfalons, in strada Iulij, de geesselinge daer Christus aen een cleen colomne (ghelijck te Room te sien is in eenich Clooster) gebonden ist: het is een aerdich en fraey stuck" ("Still to be seen in the church or chapel of the Gonfalone in the Via Giulia by Federico is a Flagellation in which Christ is bound to a small column [similar to the one seen in a lovely cloister in Rome]: it is a nice and lovely work") (Helen Adert Noë, *Carel van Mander en Italië* [The Hague: M. Nijhoff, 1954], p. 250).

33. P. Nogari, Orsini Chapel, SS. Trinità dei Monti, after 1575; C. Nebbia, Borghese Chapel, SS. Trinità dei Monti, after 1582; Anonymous, Mattei Chapel, S. Maria in Aracoeli, 1585-90; G. Valeriano, Chapel of the Passion, Gesù, 1589-90; V. Salimbeni, Scala Santa, 1589; A. Ciampelli, nave, S. Prassede, 1590's; S. Pulzone, Crucifixion Chapel, S. Maria in Vallicella, 1590's.

34. David Rosand, "Theatre and Structure in the Art of Paolo Veronese," *Art Bulletin*, 55 (1973), 220-21.

35. Mâle, pp. 262-67. Keppler, "Die Darstellung der Geisselung," *Archiv für christliche Kunst*, 2 (1884), 44-45, incorrectly says that Michelangelo first used the short column in the drawing for Sebastiano del Piombo's fresco, followed by Giulio Romano in his painting in S. Prassede (for the latter see below in the text and notes 38 and 43). Karl Künstle, *Ikonographie der christlichen Kunst* (Freiburg i. B.: Herder, 1926-28), I, 434, says inaccurately: "Seit dem 16. Jahrhundert ist er meist an eine niedere Säule gebunden. . . ." Louis Réau, *Iconographie de l'art chrétien* (Paris: Presses universitaires de France, 1955-59), II, Pt. 2, 453, mentions the change in the column due to the Counter-Reformation, then cites Mâle. Gertrud Schiller, II, 69, mentions the short column with the ring only in connection with the increasingly popular representation in the seventeenth century of "Christ in the Dungeon." C. Schweicher, "Geisselung Christi," *Lexikon der christlichen Ikonographie* (Rome: Herder, 1970), II, 128, says that the short column appears in representations only after the Council of Trent and cites Mâle. John Baptist Knipping, *Iconography of the Counter Reformation in the Netherlands* (Nieuwkoop: De Graaf, 1974), I, 222-23, only mentions the change in the columns.

36. The most detailed history of the chapel and the relic is found in Benigno Davanzati, *Notizie al Pellegrino della Basilica di Santa Prassede* (Rome: Antonio de' Rossi, 1725), pp. 227-32, 409-35; see also Primo Vannutelli, *La Santa Colonna che si venera in Roma a S. Prassede* [extract from *L'Arcadia*] (Rome: Romana, 1896). *Brevi Cenni sulla Basilica di S.*

Prassede (Rome: Desclée, Lefebvre, 1898), pp. 54-59, provides a description of the 1891 reliquary and its iconography; see also Gaetano Moroni, "Colonna, Giovanni, Cardinale," *Dizionario di erudizione storico-ecclesiastica* (Venice: Tip. Emiliana, 1842), XIV, 300.

37. Hans Belting, "Die Reaktion der Kunst des 13. Jahrhunderts auf dem Import von Reliquien und Ikone," *Il medio oriente e l'occidente nell'arte del XIII secolo,* ed. Hans Belting, Atti del XXIV Congresso Internazionale di Storia dell'Arte, 2 (Bologna: C.L.U.E.B., 1982), pp. 35-41. Relics flowed into the West in unprecedented numbers after 1204, which marked the capture and scandalous plundering of Constantinople by the crusaders; see Patrick Geary, *Furta Sacra* (Princeton: Princeton Univ. Press, 1978).

38. For a full discussion of the history of attributions of the painting and its restoration in 1965, see Ilaria Toesca, "La 'Flagellazione' in S. Prassede," *Paragone,* 193 (1966), 79-85.

39. Davanzati, pp. 409-35, provides the most complete account of testimonies concerning the relic. For Jerome and Bede, see J. P. Migne, *Patrologiae cursus completus,* ser. lat., XXII (Paris, 1878), col. 884 (Ep. CVIII), and XCV, col. 362. For St. Bridget's pilgrimage to the Holy land, Johannes Jørgensen, *Saint Bridget of Sweden,* trans. Ingeborg Lund (London: Longmans Green, 1954), II, 232-91; Felix-Marie Abel, *Jerusalem: Recherches de Topographie, d'Archéologie et d'Histoire, II: Jérusalem Nouvelle* (Paris: Gabalda, 1914), III, 578.

40. Vannutelli, p. 15. Charles Rohault de Fleury, *Memoire sur les Instruments de la Passion de N.-S. J.-C.* (Paris: L. Lesort, 1870), p. 266, says that relics of the column exist in Rome (S. Prassede, S. Giovanni Laterano, S. Maria in Trastevere, S. Marco), Anagni, and Florence (S. Lorenzo, the monastery of the Cappuccini, S. Maria Verdiana, S. Anna al Prato, the Ognissanti, the Duomo).

41. John Shearman, *Raphael's Cartoons in the Collection of Her Majesty the Queen and the Tapestries for the Sistine Chapel* (London: Phaidon, 1972), pp. 56-57, esp. nn. 69, 71.

42. Pietro Fremiotti, *La riforma cattolica del secolo XVI e gli studi di archeologia cristiana* (Rome: Libr. Pontifica F. Pustet, 1926); Franz Xavier Kraus, *Roma Sotterranea: Die römischen Katacomben* (Freiburg i. B.: Herder, 1873). The discovery was made by workmen in a vineyard in the Via Salaria. Limited investigations, such as pious pilgrimages, had begun again in the fifteenth century, predominantly by Franciscan monks. In the early sixteenth century, the Roman Academy under Pomponio Leto was only mildly interested in the early Christian inscriptions found there. In 1578, particularly after the publication of the *Centuries of Magdeburg* (1559-74), works were already in progress documenting Roman Catholic ecclesiastical history; see Pastor, IX, 134-35, 191, 202-03; Antonio Gallonio, *De SS. Martyrum Cruciatibus: Quo totissimum instrumenta, & modi, quibus ijdem Christi martyres olim torquebatur, accuratissime tabellis expressa describuntur* (Rome: Ex typographia Congregationis Oratorij apud s. Mariam in Vallicella, 1591). Gallonio also published the work in Italian in the same year under the title *Trattato de gli strumenti di martirio.*

43. Davanzati, p. 433. The official approval of Pope Sixtus may have been due to his removal of a sizeable fragment from the column which he then divided among various churches. Perhaps at this time, the Giulio Romano panel was overpainted to make the column conform to the size and shape of the relic (I. Toesca, p. 84n).

44. "Columna, quae in hac sacra Cappella reconditur, huic depictae omnino similis, non

ea est, quae templi porticum substentabat, ad quam Dominus noster Jesus Christus in sua Passionis nocte alligatus, illusus, & vituperatus fuit; Sed ea est, quae in Pilati Praetorio pro fustigationis supplicio aderat, ad quem Dominus Noster Jesus Christus, jubente Pilato flagellatus est. Integra enim est, nec major erat, ne posterior flagellandi hominis pars ab altiori columna tegeretur, quam Joannes Cardinalis Columna etc. Comprobatur A.D. MDLXXXVI sedente Sixtus V" (B. Davanzati, pp. 418, 421). See also B. Mellini, *Dell'Antichità di Roma*, Biblioteca Apostolica Vaticana, Vat. Lat. 11905, fols. 420r-421v.

45. Paris, Bibliothèque Nationale, Cabinet des Éstampes, Da6, "Cu privil. S. D. N. Greg. Pp. xiiii p anos x." Gregory XIV's short pontificate lasted from December 1590 to 15 October 1591. Mâle, pp. 263-64, was the first to mention the engraving in this context, although he did not discuss the relation of the text to the inscription in S. Prassede.

46. Cesare Baronio, *Annales Ecclesiastici* (Rome, 1588), I, 167 (Anno 34); Federico Borromeo, *De pictura sacra*, ed. C. Castiglioni, Collana Federiciana, 1 (Sora: P. C. Camastro Edit. Tip., 1932), p. 34; Giovanni Severano, *Memorie sacre delle sette chiese di Roma* (Rome, 1630), p. 679.

47. Conrad Eubel, *Hierarchia Catholica Medii et Rencentioris Aevi* (Regensburg: Monasterri, 1923), III, 41; Pio Paschini, "Il primo soggiorno di S. Carlo Borromeo a Roma (1560-1565)," *Cinquecento romano e riforma cattolica*, Lateranum, n.s. 24, Nos. 1-4 (Rome: Facultas Theologia Pontificii Athenaei Lateranensis, 1958), pp. 93-181.

48. *Camerlengo*, 1565, fol. 8r; *Camerlengo*, 1567, fol. 8r. Borromeo's charity to the *donzelle* of S. Maria Maggiore, mentioned by Paschini, p. 169, was administered directly by the Gonfalone, a fact which has gone unnoticed.

49. Giovanni Giussano, *Istoria della vita, virtù, morte e miracoli di Carlo Borromeo* (Milan, 1610), Book VII, chap. 1. Davanzati, p. 434; Severano, p. 683. Mâle never made the connection between Borromeo, Titular Cardinal of S. Prassede, and the relic.

50. Giussano, *passim*. See Hubert Jedin, *Carlo Borromeo*, Bibliotheca Biographia, 2; (Rome: Istituto della Enciclopedia Italiana, 1971), pp. 53-54; Fremiotti, esp. pp. 48ff; Adriano Peroni, "Il Collegio Borromeo: Architettura e decorazione," *I quattro secoli del Collegio Borromeo di Pavia* (Milan: Alfieri and Lacroix, 1961), pp. 133-57, for discussion of the "rinnovamento del culto delle reliquie," the central theme of the vault frescoes of the Salone. See Mario Bendiscioli, "Politica, ammistrazione e religione nell'età dei Borromeo," *Storia di Milano* (Milan: Fondazione Treccani degli Alfieri per la Storia di Milano, 1957), X, 240ff, who cites the contemporary literature; Pietro Savio, "Pellegrinaggio di San Carlo Borromeo alla Sindone in Torino," *Aevum*, 7 (1933), 423-54.

51. Martin, p. 93; Giussano, Book III, chap. 6; Book VIII, chap. 8, and esp. chap. 21, "Of his Spirit of Penance and Austerity of Life"; Pastor, VII, 92-93.

52. Johann Konrad Eberlein, "The Curtain in Raphael's Sistine *Madonna*," *Art Bulletin*, 65 (1983), 61-77, esp. 66-70; Richard Cocke, "Raphael's Curtain," *Art Bulletin*, 66 (1984), 327-30; Johann Konrad Eberlein, "Reply," *Art Bulletin*, 66 (1984), 330-31.

53. Henry Joseph Schroeder, *Canons and Decrees of the Council of Trent* (St. Louis: Herder, 1960), 215ff. I do not agree with Mâle, p. 264, that the Church approved the *artists'* new iconography.

54. Wollesen-Wisch, pp. 123-28, 304-10, with bibliography. Most recently, see

Elizabeth Clare Robertson, "The Artistic Patronage of Cardinal Alessandro Farnese (1520-89)," unpubl. Ph.D. diss. (Warburg Institute, Univ. of London, 1986).

55. Wollesen-Wisch, pp. 311-21, with bibliography.

56. Eubel, III, 51; *Instrumenta B*, 1573, fol. 241r; Marcantonio Ginanni, *L'Arte del Blasone* (Venice: G. Zerletti, 1756), No. 818, "Prelati della Corte Romana." Cardinal Mattei was later Cardinal Protector of the Gonfalone from 1589 to 1605 (F. Cancellieri, *Storia dell'Archiconfraternita del Conf. e suo Oratorio, & Notizie del Culto di S. Lucia alla Chiavica e descriz. della sua chiesa*, p. 52 [Biblioteca Apostolica Vaticana, Vat. Lat. 9176]).

57. Riera, p. 73.

58. Karl Frey, *Der literarische Nachlass Giorgio Vasaris* (Munich: Georg Müller, 1930), II, 652, "per saper molte minutie."

59. See n. 16, above. Alberigo, "Contributi," p. 224, transcribes the 1459 statutes of the confraternity "de Madona Sancta Maria de la Vita" of Bologna. In chap. 9, concerning the ritual of flagellation: "e lo sacristano in quelo meco amorte le lume, aco che nuj seguitamo el sancto propheta che in persona del signore dixe Io fuj batuto tuto el di e la castigatione mia foe in lora matitutina. E si per la memoria de christo yeshu e si per la remissione de li nostri peccati e per mortificatione de la carne facase disciplina per quelo modo che se contene in lo libro nostro novo de lofficio."

60. *City of God*, Book XVIII, chap. 23, for quotation from Lactantius, *Divine Institutes* I.6.

61. See n. 25, above; Oscar Daniel Watkins, *A History of Penance* (London: Longmans Green, 1920); Josef A. Jungmann, *The Mass of the Roman Rite*, rev. ed., trans. Francis A. Brunner (New York: Benziger Brothers, 1961), pp. 534-35; Ludwig Eisenhoffer and Josef Lechner, *The Liturgy of the Roman Rite*, trans. A. J. and E. F. Peeler (New York: Herder and Herder, 1961), p. 192; G. Martin, p. 95: "Our cold countrie men wil laugh at this perhaps, that any man should punish him selfe. . . . But if they would looke to S. Paul, who by his owne testimonie chastised him selfe very many wayes; if to the ashes and hare clothes, and fastings in the old testament; if to al the Sainctes of the new testament, that dwelt in desertes, lay upon the ground, lived with bread and water, ware sacke cloth, whipped them selves, fasted, watched, prayed, as al auncient stories agreably do declare; then would they easily find that this is the narrow way that leadeth to life, and the fewer sort find it."

62. Weissman, pp. 195-235, esp. 228-29.

63. Brian Pullan, *Rich and Poor in Renaissance Venice* (Cambridge: Harvard Univ. Press, 1971), pp. 51-52.

64. The seriousness of the new French penitential confraternities of this period is discussed in two important articles by Andrew E. Barnes, "Religious Anxiety and Devotional Change in Sixteenth Century French Penitential Confraternities," *Sixteenth Century Journal*, 19 (1988), 389-405, and Schneider, esp. p. 133, where he succinctly sums up the significance of flagellant confraternities in the late sixteenth century: "They constituted a new elite, not a social elite based upon rank and privilege, but a moral or spiritual elite defined by the embrace of penitence as their central devotion. The regime of discipline was the school of this elite, the penitential procession its stage."

65. Riera, p. 73.

Index

Illustrations

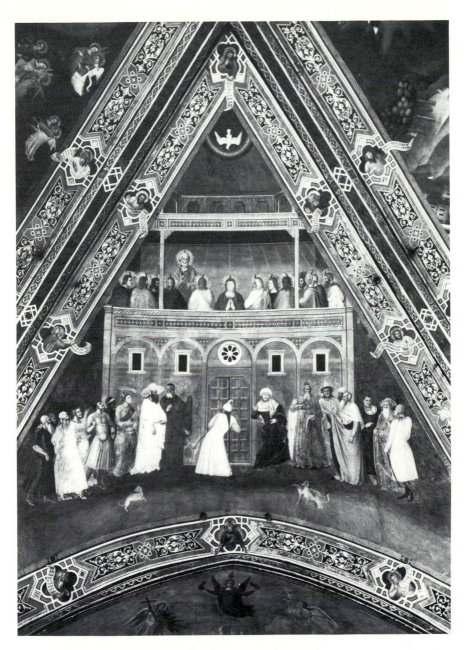

1. Andrea di Buonaiuto, *Pentecost*. Florence, Santa Maria Novella, Spanish Chapel (vault). 1366-68. Photo: Alinari/Art Resource.

La festa del miracolo dello spirito sancto

3. *La festa del Miracolo dello Spirito Santo*
(Florence: Bartolomeo de' Libri, c.1490) in A1

2. *Laudario della Compagnia dello Spirito Sancto.*
Florence, BNCF, BR 18 (già II.I.122), fol. 2ʳ.

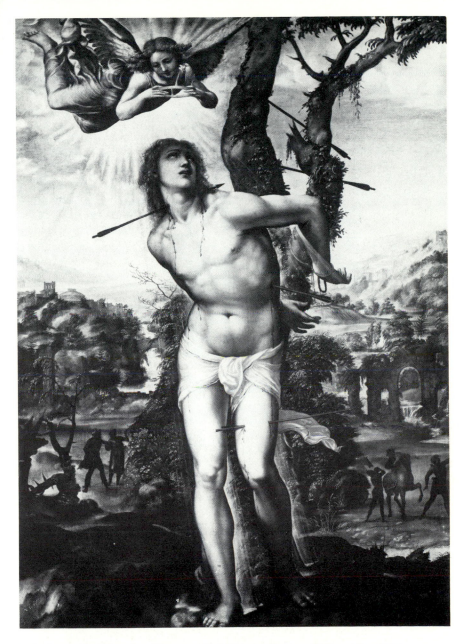

4. Sodoma, *St. Sebastian*. Florence, Pitti Palace. Canvas. Photo: Alinari/Art Resource.

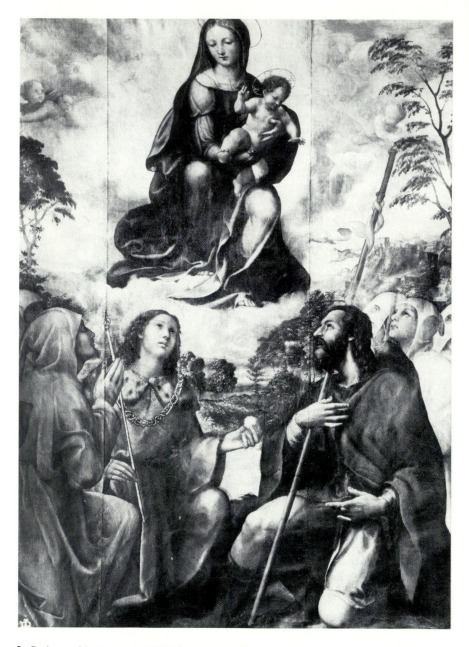

5. Sodoma, *Madonna and Child with Saints and Confraternity Members* (reverse of fig. 4). Florence, Pitti Palace. Canvas. Photo: Alinari/Art Resource.

D honore laude & gloria dello onnipotente sapiente
& clemente idio & dela sua gloriosa madre madonna
santa maria fontana di pieta & del beato messer .s.
michele arcangelo & del beato messer santo giovanni
baptista & del gloriosissimo euangelista et di messer
.s. mattheo & di messer .s. filippo & di messer .s. bar
tholomeo & di messer .s. stefano primo martire & di messer .s.
lorenzo & di messer .s. romolo & di messer .s. alexandro & di
messer .s. chimento & del beato dottore messer .s. hieronimo
primo nostro diuoto & aduocato & di messer .s. Agostino & di
messer .s. zenobio & del beato messer .s. Benedetto & del beato
messer .s. francesco & di messer .s. domenico & dela beata ma
donna .s. maria madalena & di madonna .s. reparata vergine
& martire & di tutti gliangeli santi & sante & spiriti beati dela
corte di uita eterna & ad honore & buono stato del nostro
beatissimo padre messer lo papa & de reuerendi nostri pastori
messer lo uescono di firenze & messer lo uescouo di fiesole & ad
honore & riuerenza del pacifico stato del comune di firenze &
de suoi subditi & di tutto lauanzo del mondo secondo il piacere
di dio & a mantenimento & accrescimento della santa fede crist
iana & a distruchione & spegnimento dogni heresia & a salute
consolazione & frutto spirituale delanime & de corpi dogni fedel
cristiano & spetialmente di quelli di questa compagnia & loro
congiunti & benefattori & dogni altra congregatione che al
nome di dio fusse ordinata & spetialmente di qualunche con
questa legata & da questa principiata et a utilita consolazio
ne & soccorso de poueri bisognosi & prima deglinfermi uedoue
& pupilli & di qualunche altro che con misericordia si potesse aitare

Queste sono osseruanze & ordinamenti santi di quelli che sono
& che pinanzi saranno dela compagnia di .s. maria dela
pieta principiata nel poggio di fiesole luogo di .s. hieronimo luogo
detto del curo doue habitano i romiti suoi che al presente sono
frate carlo del conte antonio & suoi compagni correnti glianni
domini .m.cccc.x. il di della annuntiatione di nostra donna di xxv.

6. Attributed to Battista di Biagio Sanguigni, *Libro dei Capitoli della Confraternita
di S. Maria della Pietà*, fol. 12ʳ. Florence, Oratorio di S. Girolamo e S. Francesco
Poverino già di S. Filippo Benizi. Photo: AFS-BAS FI.

8. Attributed to Antonio di Filippo di Ventura, *S. Girolamo penitente entro medaglione.* Florence, Oratorio di S. Girolamo e S. Francesco Poverino già di S. Filippo Benizi. Photo: AFS-BAS FI.

7. Attributed to Battista di Biagio Sanguigni, *Libro dei Capitoli della Confraternita di S. Maria della Pietà,* f. 56ʳ. Photo: AFS-BAS FI.

9. Domenico Fantini and Liborio Bracci, *Scanni da compagnia*. Florence, Oratorio di S. Girolamo e S. Francesco Poverino già di S. Filippo Benizi. Photo: AFS-BAS FI.

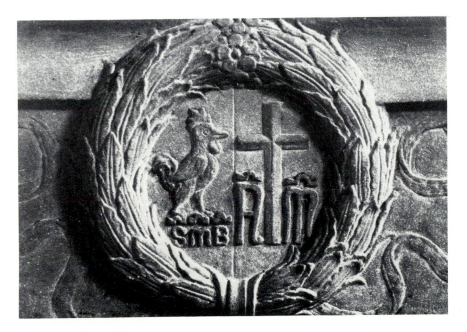

10. Emblem of the Confraternite del Bigallo e della Misericordia. Florence, Museo del Bigallo.

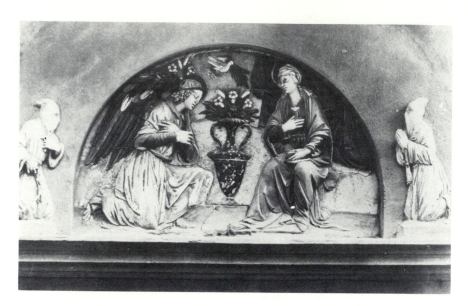

11. Santi Buglioni, *Annunciazione*. Florence, Ex-oratorio della SS. Annunziata.
Photo: AFS-BAS FI.

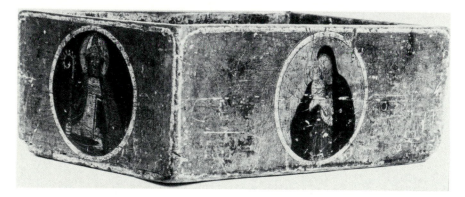

12. Florentine (anon.), *Scatola per votazioni*. Calenzano (FI), Pieve di S. Niccolò.
Photo: AFS-BAS FI.

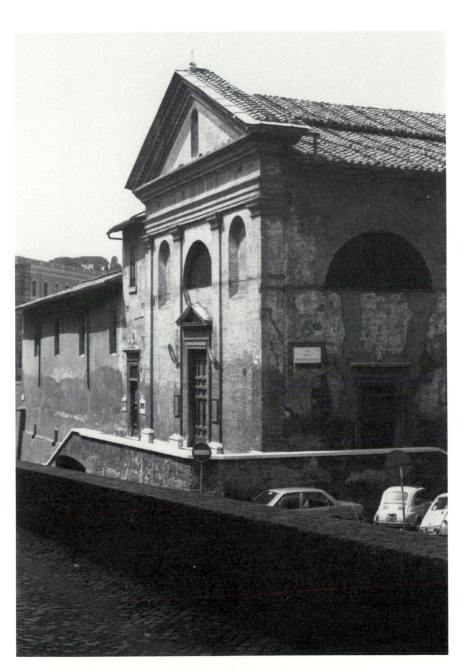

13. Church and Oratory of San Giovanni Decollato, Rome.

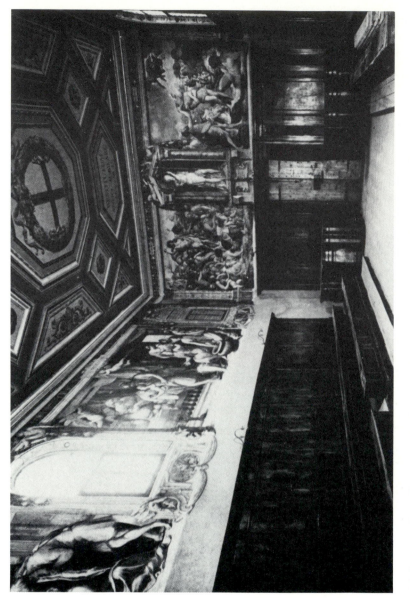

14. Interior of the Oratory of San Giovanni Decollato (view towards the entrance). Photo: Soprintendenza per i Beni Ambientali e Architettonici del Lazio, Rome.

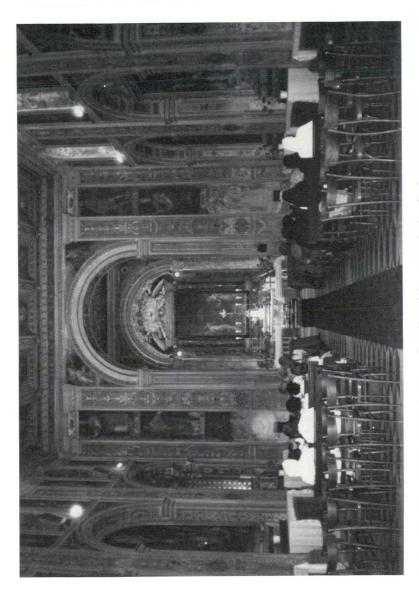

15. Interior of the Church of San Giovanni Decollato (view towards the altar).

16. *Tavola* with Decollation of St. John the Baptist and Crucifixion. Camera Storica, San Giovanni Decollato, Rome. Photo: courtesy of the Arciconfraternita di San Giovanni Decollato and of Samuel Y. Edgerton, Jr.

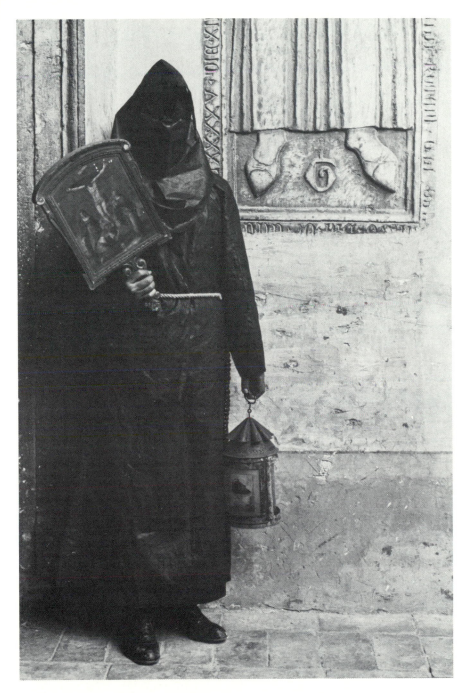

17. A *confratello* of the Arciconfraternita di San Giovanni Decollato dressed in black robe and hood and holding a *tavola* and lantern. Photo: Gabinetto Fotografico Nazionale, Rome.

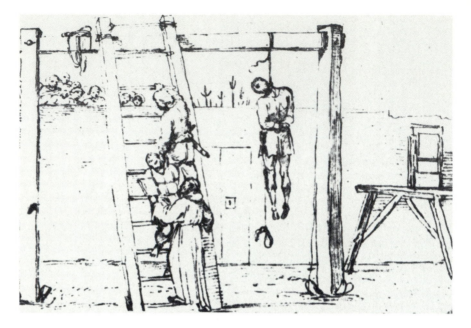

18. Annibale Carracci, *A Hanging*. Drawing. Royal Library, Windsor Castle.
Courtesy of the Royal Library.

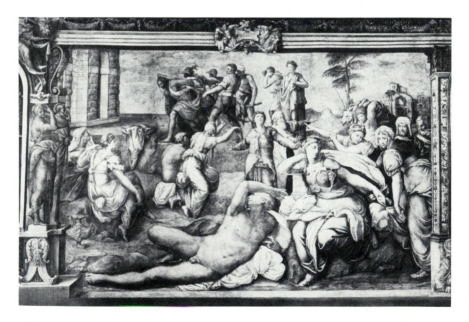

19. Battista Franco, *Arrest of St. John the Baptist*. Oratory of San Giovanni
Decollato, Rome. Photo: Gabinetto Fotografico Nazionale, Rome.

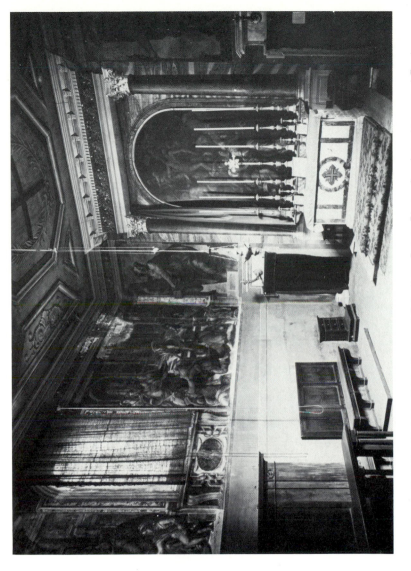

20. Altar wall of the Oratory of San Giovanni Decollato, Rome. Photo: Soprintendenza per i Beni Ambientali e Architettonici del Lazio, Rome.

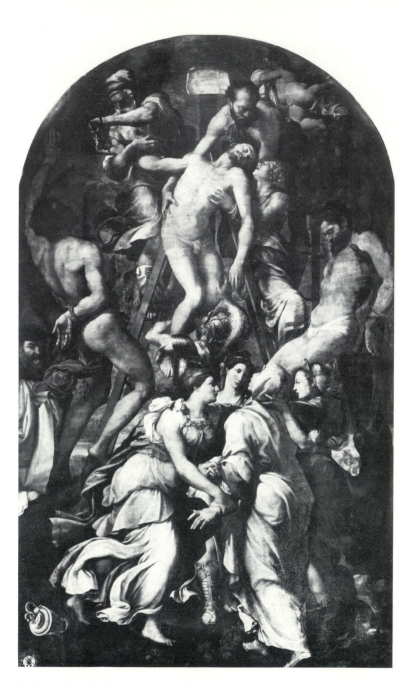

21. Jacopino del Conte, *Descent from the Cross*. Oratory of San
Giovanni Decollato, Rome. Photo: Alinari (Anderson).

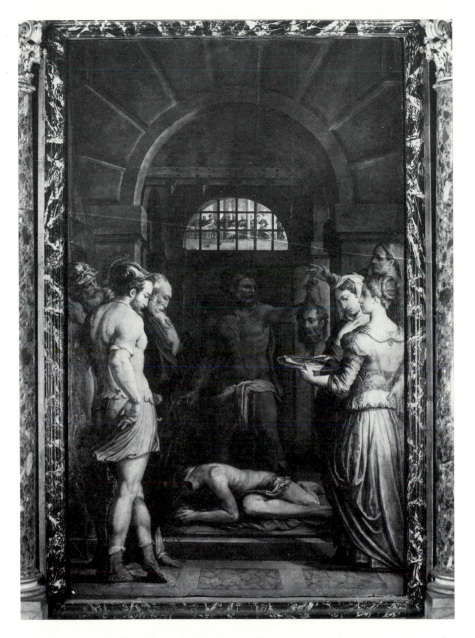

22. Giorgio Vasari, *Decollation of St. John the Baptist*. San Giovanni Decollato.
Photo: Gabinetto Fotografico Nazionale, Rome.

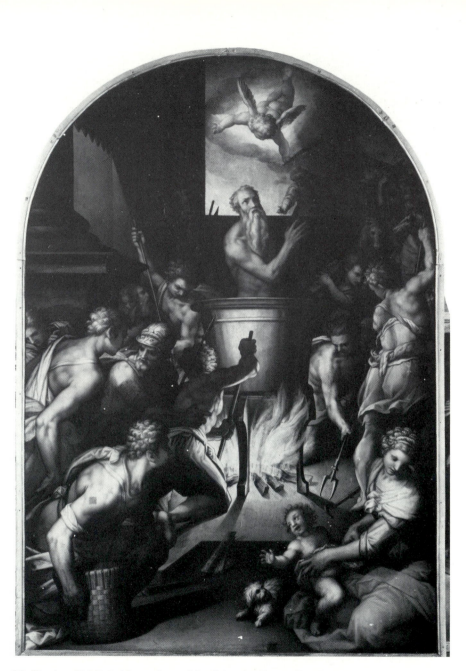

23. Battista Naldini, *Martyrdom of St. John the Evangelist*. San Giovanni Decollato, Rome. Photo: Gabinetto Fotografico Nazionale, Rome.

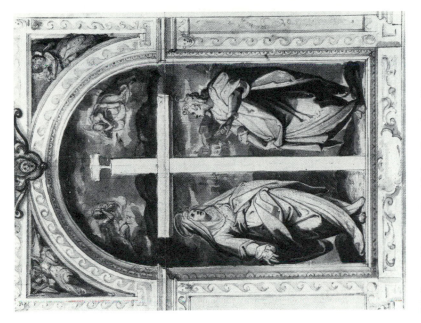

25. Jacopo Zucchi, *Crucifixion*. Drawing. Vienna, Albertina. Courtesy of the Albertina.

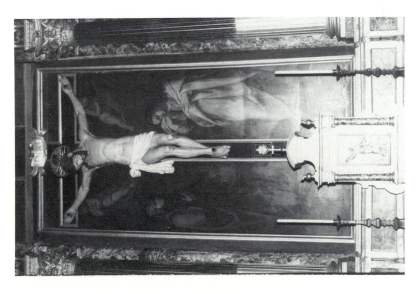

24. Cappella del Crocefisso. San Giovanni Decollato, Rome.

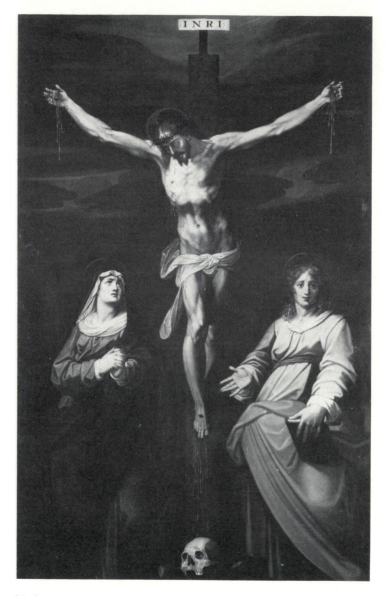

26. Jacopo Zucchi, *Crucifixion*. Sacristy, Oratory of San Giovanni Decollato, Rome. Photo: Gabinetto Fotografico Nazionale, Rome.

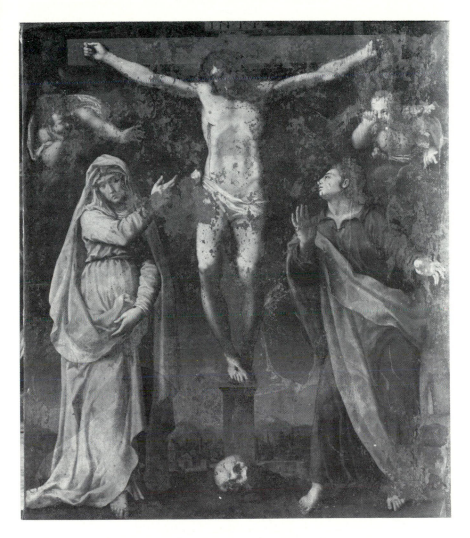

27. *Crucifixion*. Sacristy, San Giovanni Decollato, Rome. Photo: Gabinetto
Fotografico Nazionale, Rome.

29. *Tavola* with figures engulfed in flames appealing to the Virgin. Camera Storica, San Giovanni Decollato, Rome. Photo: courtesy of the Arciconfraternita di San Giovanni Decollato and of Samuel Y. Edgerton, Jr.

28. Nicolò Circignani, *Martyrdom of St. John the Evangelist*. Santo Stefano Rotondo, Rome. Photo: Fototeca, Biblioteca Herziana, Rome.

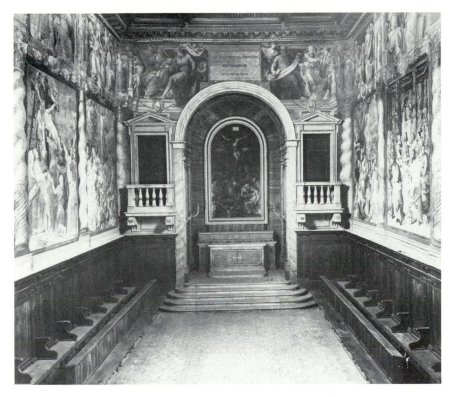

30. Oratory of the Gonfalone, Rome (view toward the altar). Photo: Gabinetto
Fotografico Nazionale, Rome.

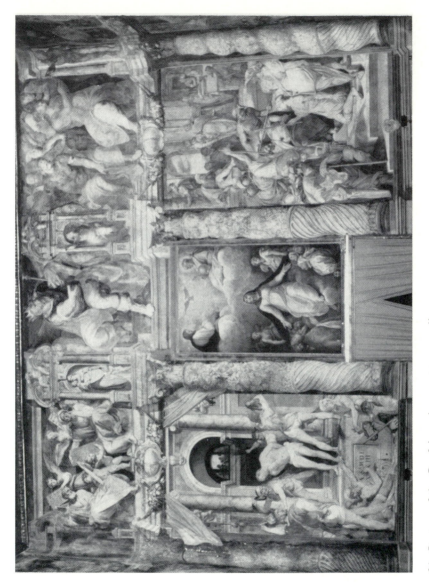

31. Oratory of the Gonfalone, inner entrance wall.

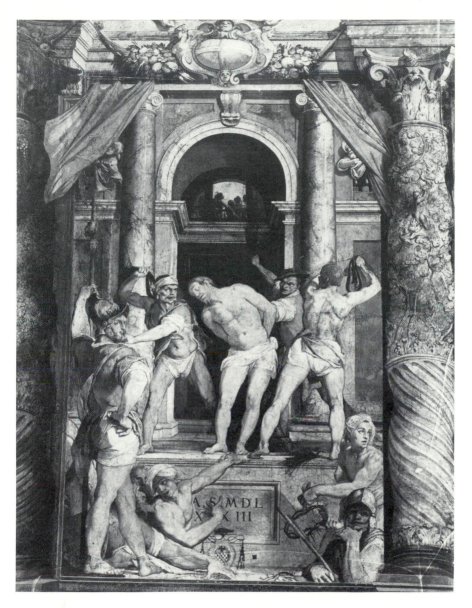

32. Federico Zuccaro, *Flagellation*. Oratory of the Gonfalone. Photo: Gabinetto Fotografico Nazionale, Rome.

33. Federico Zuccaro, *Prophet and Sibyl*. Photo: Gabinetto Fotografico Nazionale, Rome.

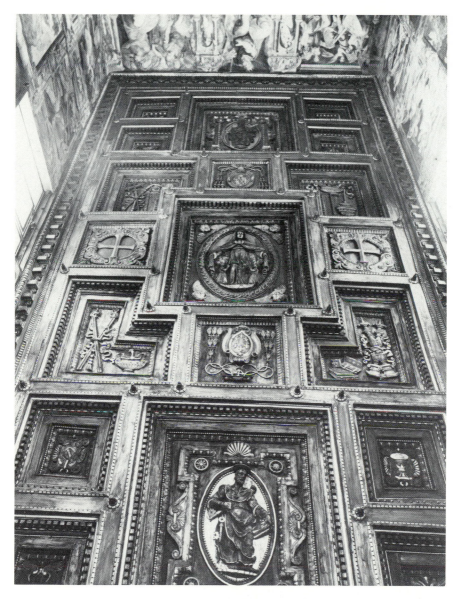

34. Ambrogio de' Bonazzini. Oratory of the Gonfalone, ceiling. Photo: Bibliotheca Hertziana.

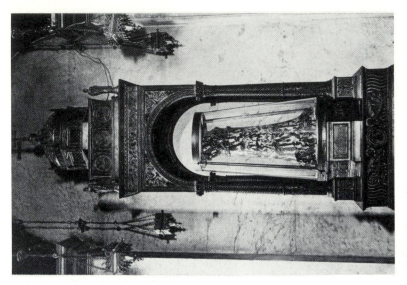

36. Relic of the Column of the Flagellation. S. Zeno Chapel, S. Prassede, Rome.

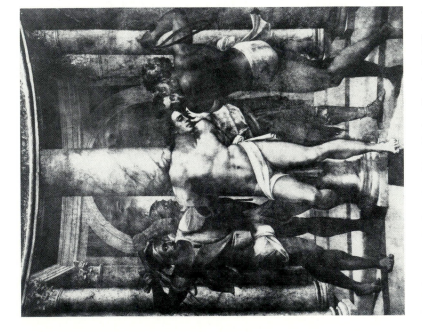

35. Sebastiano del Piombo, *Flagellation*. Borgherini Chapel, S. Pietro in Montorio, Rome. Photo: Alinari/Art Resource.

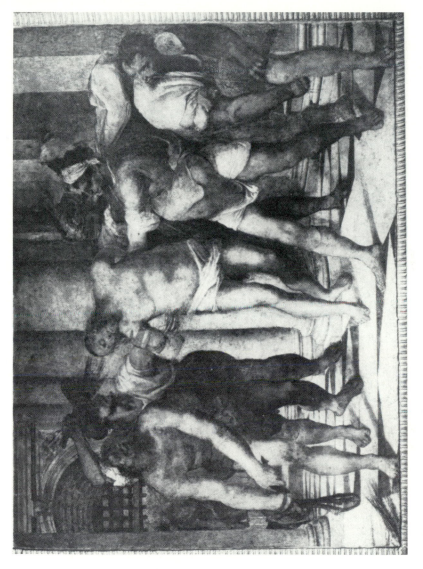

37. Taddeo Zuccaro, *Flagellation*. Mattei Chapel, S. Maria della Consolazione, Rome. Photo: Alinari/Art Resource.

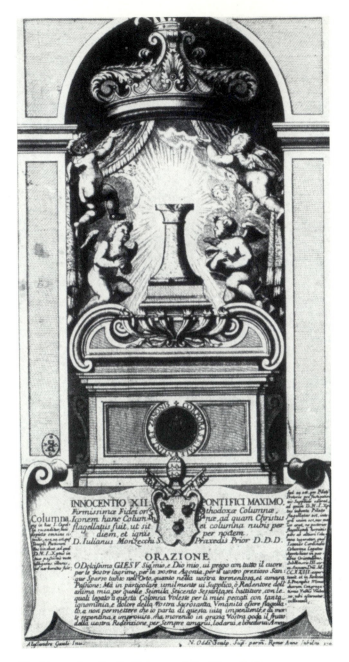

38. Alessandro Gauli, *Column of the Flagellation*.

40. Martin Fréminet, *Flagellation*. Bibliothèque Nationale, Paris.

39. Attributed to Giulio Romano, *Flagellation*. Sacristy, S. Prassede, Rome.

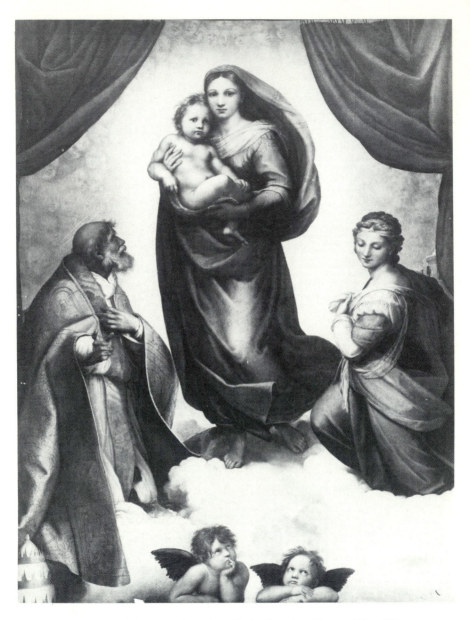

41. Raphael, *Sistine Madonna*. Gemäldegalerie, Dresden. Photo: Alinari/Art
Resource.